900 Years of
St Bartholomew the Great

PINXIT FRANK E. BERESFORD 1932

The Vision of St Bartholomew

900 Years of St Bartholomew the Great

THE HISTORY, ART AND
ARCHITECTURE OF LONDON'S
OLDEST PARISH CHURCH

Edited by Charlotte Gauthier

AD ILISSVM

First published on the occasion of the 900th anniversary of St Bartholomew the Great

Texts © the authors
Images © the editor unless otherwise stated
Images pp. 113–34 © Euan Roger

All rights reserved. No part of this publication may be transmitted in any form or by any means, electronic or mechanical, including photocopy, recording or any storage or retrieval system, without the prior permission in writing from the copyright holder and publisher.

ISBN 978-1-915401-03-8

British Library Cataloguing in Publication Data
A catalogue record for this book is available from the British Library

Produced by AD ILISSVM
an imprint of Paul Holberton Publishing, London
www.paulholberton.com

Printing by Gomer Press, Llandysul

FRONT COVER *Prior Bolton's window seen from the north aisle*, by Gerard Stamp, 2022, watercolour
FRONTISPIECE *Prior Rahere's vision of St Bartholomew*, from the choir panels by Frank Beresford, 1932

Contents

- 6 Acknowledgements
- 7 Contributors
- 8 Abbreviations
- 9 Maps
- 15 Foreword CHARLES SPENCER
- 19 Introduction CHARLOTTE GAUTHIER

MEDIEVAL

- 31 A History of St Bartholomew's Priory to its Suppression in 1539 CHRISTINE MERIE FOX
- 59 The Architectural History of St Bartholomew's Priory up to the Death of Prior Bolton (1532) STEPHEN HEYWOOD
- 87 The Medieval Funerary Monuments at St Bartholomew's Priory CHRISTIAN STEER
- 113 St Bartholomew's Hospital to the Reformation EUAN ROGER

EARLY MODERN

- 137 Dissolution and Reformation at St Bartholomew's Priory and Hospital NICK HOLDER
- 151 The Long Decline, c. 1559–1864 STEVEN BRINDLE
- 175 The Early Modern Funerary Monuments of St Bartholomew the Great JON BAYLISS

MODERN

- 199 St Bartholomew the Great in the Nineteenth and Twentieth Centuries JEREMY HASELOCK
- 225 The 'Great Restoration' of Aston Webb and Sons EVAN MCWILLIAMS

ARTS AND MUSIC

- 247 Music in the Priory Church NICHOLAS RIDDLE
- 267 The Modern Works of Art in St Bartholomew the Great PETER DELANEY
- 289 Notes on the Sculpture and Lesser Artworks of St Bartholomew the Great JEREMY HASELOCK AND JEREMY WARREN

- 293 Afterword MARCUS WALKER

APPENDICES

- 297 I. Annual income for the Priory of St Bartholomew according to the *Taxatio Ecclesiastica*, 1291
- 300 II. Testamentary evidence for the Priory of St Bartholomew, Smithfield, 1258–1540
- 308 III. Act of Surrender for St Bartholomew's Priory
- 309 IV. Deed to the canons at the Priory's suppression, dated 20 November 1539

- 310 Index

Acknowledgements

The editor would like to take this opportunity to thank all those who have helped to bring this book to fruition. The project has benefitted from the generous advice and support of several distinguished academic colleagues, including Clive Burgess, Peregrine Horden, and Diarmaid MacCulloch. Profound thanks to Caroline Barron, who provided invaluable suggestions and corrections on several chapters, as well as the benefit of her unparalleled knowledge of London history and her kind interest throughout. Our friends at the Hospital — especially Kate Jarman, archivist at Barts Health NHS Trust, and Will Palin, CEO of Barts Heritage Trust — have lent their enthusiastic support to the project, for which we are in their debt. We are likewise indebted to Ian Dungavell, who generously shared his research on the Webb restoration with us, and to Daryl J. Oliver for her research assistance.

Thanks to Sophie Lamb and Nick Holder for producing the most accurate maps yet published of the historic Priory and Hospital, and to the London Transport Museum, the College of Arms, the Royal Collection Trust, the Corpus of Romanesque Sculpture in Britain and Ireland, the National Archives, the Museum of London, the British Library, and Barts Health NHS Trust for their kind permission to reproduce images of their collections. Warmest thanks also to Gerard Stamp for allowing us to use his beautiful watercolour of Prior Bolton's window, commissioned for the 900th anniversary of the priory church, as the cover image. Paul Holberton Publishing has turned our collection of words and pictures into a thing of beauty almost worthy of such an ancient and glorious place. Thank you.

The lively interest shown by the congregation of the priory church has been a continual source of support and inspiration. This book is dedicated to them and to all those who have built and sustained St Bart's over the past 900 years. Among the living, deepest gratitude goes to Gordon Furry, Eloise Harris, Ian Kelly, Sarah Kelsey, Rose Murphy, Susy Rodriguez Freire, Roy Sully, Marcus Walker, and most especially to Jeremy Haselock and Charlie Spanton, without whom this book would not have been possible. May God bless you all.

This book has been supported by generous publication grants from the Paul Mellon Centre for Studies in British Art and from the Marc Fitch Fund. We also gratefully acknowledge the support of the congregation and Friends of Great St Bartholomew.

Soli Deo honor et gloria.

Charlotte Gauthier
Royal Holloway, University of London

In festo sancti Bartolomei apostoli
MMXXII

Contributors

CHARLES SPENCER, 9TH EARL SPENCER is a journalist, broadcaster and author of the *Sunday Times* bestselling non-fiction book *The White Ship*.

CHARLOTTE GAUTHIER is a doctoral researcher at Royal Holloway, University of London. Her PhD focuses on the ecclesiastical, political and diplomatic history of fifteenth- and sixteenth-century English involvement in crusading, and the history of the English Church in the decades leading to the Reformation.

DR CHRISTINE MERIE FOX is a Research and Writing Advisor in the Biomedical Science Department at UMC Utrecht and lecturer for the History of Medicine MA at Utrecht University in the Netherlands. Her PhD from the University of London focused on the almshouses of Henry VII, and she has published several articles from this work and on the history of medieval and early modern London.

STEPHEN HEYWOOD, FSA is an architectural historian, historic buildings consultant, and former conservation officer at Norfolk County Council. He has published extensively on medieval architectural history, especially on medieval round-towered churches.

DR CHRISTIAN STEER, FSA is an Honorary Visiting Fellow at the University of York. He has published extensively on medieval commemoration and on monuments of the dead from the City of London, in particular on patterns of memory and commemoration in the mendicant churches of London.

DR EUAN ROGER is a Principal Medieval Records Specialist at The National Archives, specializing in the records of late medieval and early Tudor English government, the central law courts and the secular clergy, with a particular interest in social, medical, political and material history. He has worked extensively on medieval hospitals – especially on St Bartholomew's Hospital and the hospital community in the fifteenth century.

DR NICK HOLDER, FSA is an urban landscape historian. Initially an archaeologist, he completed a history PhD and worked at Regent's University London and the University of Exeter. He is now Senior Properties Historian at English Heritage. He has written about medieval and Tudor London, including *The London Guildhall* (2007), *The Spitalfields Suburb 1539–1880* (2015) and *The Friaries of Medieval London* (2017).

DR STEVEN BRINDLE, FSA is a Senior Properties Historian at English Heritage. He has published a number of books on architectural history, including *Brunel: The Man Who Built the World* (2006) and *Windsor Castle: A Thousand Years of a Royal Palace* (2018).

JON BAYLISS, FSA has published extensively on early modern funeral monuments, including those in St Bartholomew the Great.

THE REVEREND CANON DR JEREMY HASELOCK, FSA is the former Precentor and Vice-Dean of Norwich Cathedral, Chaplain Emeritus to Her Late Majesty the Queen, and Associate Priest of St Bartholomew the Great. He has published on various aspects of medieval art history, especially on medieval stained glass and the rood screens of Norfolk churches.

THE REVEREND DR EVAN MCWILLIAMS is Hospitaller of Great St Bartholomew's. His PhD from the University of York explored the influence of the English Use movement on liturgy, ceremonial and architecture in the Church of England between 1899 and 1965.

NICHOLAS RIDDLE is the former CEO of Edition Peters music publishing group and a trustee of the Royal School of Church Music.

THE VENERABLE DR PETER DELANEY MBE is Archdeacon Emeritus of London and Associate Priest of St Bartholomew the Great. His PhD from the University of London focused on the history and art historical significance of the Isenheim Altarpiece.

DR JEREMY WARREN, FSA is Honorary Curator of Sculpture at the Ashmolean Museum in Oxford and Sculpture Research Curator of The National Trust. From 2001 to 2015 he was Collections and Academic Director at the Wallace Collection in London. He has published widely on Renaissance and Baroque sculpture, and on the history of collecting from the Renaissance into the twentieth century.

THE REVEREND MARCUS WALKER is Rector of Great St Bartholomew's.

Abbreviations

LMA	London Metropolitan Archives
Moore, *Foundation*	*The Book of the Foundation of St Bartholomew's Church in London: Sometime belonging to the priory of the same in West Smithfield*, ed. Norman Moore (London: 1886)
ODNB	*The Oxford Dictionary of National Biography*, ed. H.C.G. Matthew and B. Harrison (Oxford: Oxford University Press, 2004)
Stow, *Survey*	*A Survey of London by John Stow*, ed. C.L. Kingsford, 2 vols. (Oxford: Clarendon Press, 1908)
TNA	The National Archives, Kew
Webb, *Records*	Edward A. Webb, *The Records of St Bartholomew's Priory and of the Church and Parish of St Bartholomew the Great, West Smithfield*, 2 vols. (Oxford: Oxford University Press, 1921)

Maps

MAP 1: Map of c. 1300 showing the priory precinct. The choir and nave were complete; chapels radiated from the apse, as at Norwich Cathedral. A range of domestic buildings for had begun to take shape to the south.

MAP 2: Map of c. 1500 showing changes in the priory precinct. The former prior's range had become a guest house, and the domestic buildings expanded to include an infirmary wing and splendid new lodgings for the prior. Roger Walden's chapel extends from the north transept towards the east.

MAP 3: Map of c. 1550 showing the division of the former priory precinct into four areas: the parish church and churchyard, Richard Rich's mansion, a close of tenements and a fairground. The old priory precinct was now the parish of St Bartholomew.

MAP 4: Map showing the changes to the parish of
St Bartholomew between 1556 and 1559: the Dominican friary,
Richard Rich's smaller mansion, the shorter parish church and
the tenements ('T') in the close (the latter largely unchanged).

MAP 5: St Bartholomew's Hospital, c. 1450

Henrici nati pelago perierunt ad aquitan[...]
filia que remanet imperiale tenet

Henricus Rex filius conquestoris genuit

Willm̄
qui periit
in mari

Rič
qui periit
in mari

Ria
fit Impat
ac qui
abiit

Matil
dem Imp
Attem

Regis
Henrici
sedi

Henř pm̃ regn xxxv ann̄ iij mensib; 7 iacet Radingi

Foreword

CHARLES SPENCER

HENRY I WAS ONE OF ENGLAND'S GREATEST KINGS. If he is not famously so, this is due to the fads of historical teaching; today, with history an optional subject at school, students are more likely to be served up Henry VIII and Hitler, rather than learn about events 900 years ago. By the standards of his time, Henry I was a ruler of the first rank, providing unbroken peace at home, conquests abroad, a strong economy, and (for the first two decades of his rule) the promise of a secure legacy. The fact that the latter dissolved into dust is the reason why his courtier – and perhaps jester – Rahere, chose to found St Bartholomew's Priory, as we shall see.

Henry was the fourth and youngest son of William the Conqueror and his wife Matilda of Flanders. He was born a couple of years after the Norman triumph at Hastings, and it seems possible that he was destined for the church: Henry was entrusted to the care of a bishop as a boy, and was literate — his unusual level of learning, for a member of the royal family, gained him the nickname 'Beauclerc'.

In 1087, during a military action, William the Conqueror was fatally struck in the stomach by the pommel of his saddle. Henry stayed with his father as he lay on his deathbed. William, who had been at daggers drawn with his eldest son, Robert Curthose, was persuaded by the Norman aristocracy that, in the interest of future peace, he must leave Normandy to Robert. The Conqueror agreed, but insisted on leaving his prize of England to his second son, William Rufus. Henry was disappointed to be left no title or land, but rather several thousand pieces of silver. When he asked his father why he was being left comparatively unprovided for, the Conqueror was said to have comforted Henry with the prophecy that, one day, he would be greater than both of his brothers.

The next thirteen years were challenging for Henry. Robert Curthose and William Rufus treated him with contempt as they drifted between alliance and hostilities with one another. Twice, Henry was thrown into prison by a brother. We even lose sight of Henry altogether for some of the 1090s. It looked like he was destined to be no more than a footnote to history.

Everything changed in August 1100 when Henry joined William Rufus in a hunting party in the New Forest. On that summer's day an arrow caught William Rufus flush in the chest. Rufus snapped off some of the arrow's shaft, then silently fell forward on to his knees

0.1. King Henry I mourning the loss of *The White Ship*,
Royal MS 20 A. II, f. 6v (© The British Library Board)

before tumbling face first on to the ground and driving the rest of the arrow through his chest. Henry left his elder brother to stiffen in death in the forest, and galloped off to secure the treasury at Winchester before riding on to London, where he was quickly crowned.

Henry's main duty was to secure his dynasty. He married Matilda, a princess of Scotland whose father was the vanquisher of the real-life Macbeth, and whose mother was from the ancient royal line of England, with Alfred the Great an ancestor. Two children followed: Matilda, and then the longed-for male heir, William.

Early in his rule Henry had to see off an invasion of England by his brother Robert Curthose, who had recently returned from the First Crusade as a hero. At the insistence of England and Normandy's barons, a peace was agreed between the brothers that guaranteed the crown of England for Henry in return for an annual payment to his brother. Henry watched, appalled, as Curthose ruled Normandy with catastrophic weakness. In 1106 he invaded the Norman dukedom with an English army supported by well-paid mercenaries, and defeated Curthose in battle, after which he confined his eldest brother to prison for the remainder of his long life. Henry had fulfilled his father's deathbed prophecy, reuniting England and Normandy as they had been under the Conqueror.

For much of his reign Henry was at war with the French king, Louis the Fat. It was intolerable to Louis to view Henry's immense power; Normandy was a dukedom proud of its Viking roots and had long been a thorn in France's side. Meanwhile, England was immensely wealthy. The union of the two was something that Louis was desperate to dismantle. Louis pulled together a succession of alliances to take on Henry. These all seemed to come to nothing in 1119, when Henry won the decisive battle of Brémule, after which Louis the Fat was obliged to recognize Henry's son and heir, William, as the rightful future duke of Normandy. This was the pinnacle of Henry's rule: he had bested his brothers, settled England peacefully, defeated his enemies overseas, and had a healthy heir.

All this changed on the night of 25 November 1120. Prince William, together with two of his illegitimate half-siblings, various cousins, and the flower of the Anglo-Norman aristocracy, boarded *The White Ship* for the ten- or twelve-hour voyage north from Norman Barfleur to Southampton. A party took place, which saw passengers and crew get mighty drunk. The vessel struck the mighty Quillebœuf Rock, and went down with all 350 on board — bar a butcher, Berold, eyewitness to the greatest maritime tragedy to overtake England.

The shipwreck led in time to the end of Norman rule, with the Plantagenets taking the throne for more than 300 years. All Henry's dreams for his dynasty perished that night in the Channel, and soon led to Rahere's decision to leave on pilgrimage for Rome.

lambe / the temple of the holy ghost ¶ This spirituall howse almyghty god shalle ynhabite / and halowe yt and glorifie yt And his yen shall be opyn / and his Eerys yntendyng on this howse nyght and day / that the asker yn hyt schall resceyue / the seker shall fynde / and the vynter or knokker shall entre ¶ Trewely every soule convertid / penytent of his synne / And in this place prayyng / yn heuyn graciously schall be herde. The seeker with pfite herte / for whatsueuyr tribulacion withowte dowte / he schalle fynde helpe / To them that co feithfull desire knoke At the doyr of the Chyrche / assistent Angelys shalle opyn the ȝatis of heuyn / receyuyng and offeryng to god the pyers and sobbys of feithfull peple ¶ Wherfore thyn handys be ther comfortid in god / hauyng in hym truste. So thou manly Nehmy of the costis of this bildynge dowte the nothyng / onely yeve thy diligence / and my parte schall be to prouyde necessaries / directe bilde & ende this werke and this place / to me acepte / with euydent tokenys and signys protecte and defende contynually hyt. vndyr the schadowe of my wyngys / and therfore of this werke knowe me the maister ¶ And thy self onely the mynyster / vse diligently thy seruyce / and J. shall schewe my lordeschippe. In these wordes the vision disparyschyd ¶ What he yn hym self trowd of thys vision

¶ Capitulum .ij.

He awakid began to reuolue wysly in his mynde that he hadde seyn / Jn that meene while / to his flittyng soule was mevyd to haue a dowtable sentence whethir it schulde be hadde / and take for a fantastykke illusion / that ofte happyth to men / yn ther slepe / or for an heuynly warnyng or Answere / the whiche he demyd hi self nat worthy to haue. Thus stryvyd to theyr in his herte feithfull mekenesse / and drede / and vncertayn he

Introduction

CHARLOTTE GAUTHIER

This spiritual house Almighty God shall inhabit, and hallow it, and glorify it: and His eyes shall be open and His ears intending upon this house night and day, that the asker in it shall receive, the seeker shall find, and the ringer or knocker shall enter. Truly, every soul converted [and] penitent of his sin, and in this place praying, shall be graciously heard in heaven.[1]

THOSE WHO HAVE GREETED VISITORS to the Priory Church of St Bartholomew the Great – the church that Rahere built in fulfilment of his vow to Saint Bartholomew, and about which the Apostle spoke the words quoted above – will countless times have heard some variation of the sentiment 'I don't really believe in God, but there's something about this place …'. There *is* something about it, though whether what the visitor experiences the moment they enter is the presence of God or the comforting weight of history or the palpable expression of what the Creed means by 'the communion of saints' must be left to their own understanding.

Certainly, many of our forebears would have traced the workings of God's Providence in the 900 years of the priory church's history. We live in an age that is (perhaps justly) wary of metanarratives – of overarching interpretations of history that seem to mould all events together into a cohesive story, as though they had been consciously shaped for a particular end. Historians more than anyone should be cautious about the human tendency to shape facts to fit our individual desires. Yet in some sense our forebears had the advantage of us: they did not share our modern embarrassment about ascribing to Providence (rather than to a stream of implausibly fortuitous happenstance) the events and people that have made it possible for St Bartholomew the Great to have served God and the people of the City of London continuously for the past 900 years.

1 Moore, *Foundation*, p. 49.

1.1. Prior Rahere's vision of St Bartholomew, from the 15th-century manuscript of the *Book of the Foundation*, Cotton MS Vespasian B. IX f. 43v (© The British Library Board)

This book chronicles those 900 years, bringing once more to life those events and those people that have contributed to the church's history and to its miraculous preservation from the ravages of man and time. The careful reader will discern three themes running throughout the following chapters like leitmotifs: hiddenness, devotion, and a continual cycle of decay and renewal. These themes emerged after the research was done and the history written – the chapters have not been organized around them in any deliberate way – and it is worth briefly considering each of them in turn, for it may be that these golden (or tarnished) threads running through the priory's history provide the key to understanding it.

HIDDENNESS

Another continual refrain of visitors who stumble upon St Bartholomew the Great is 'I never knew this church existed'. It is a phrase as likely to be uttered by someone who has lived in the neighbourhood thirty years as by the tourist who arrived in London yesterday. Screened from Smithfield by an ancient gate and a sunken narrow path, and from Cloth Fair by a pleasant churchyard that looks like nothing so much as a garden belonging to the surrounding residences, the church is easy to miss. It was as easy – or perhaps easier – to miss in 1839, when the architect and antiquarian George Godwin called it

a most interesting relic of olden time, which, although situated in the midst of the city of London, and open to the inspection of all its inhabitants, is comparatively little known and less sought for, even by those who are curious in such matters.[2]

St Bartholomew's Priory resisted the efforts of its late-medieval inhabitants to turn it into a place of mass pilgrimage. It unobtrusively decayed behind rows of smothering buildings – bits of it being alienated at need for secular uses – for several centuries after the Dissolution of the Monasteries. As a Victorian parish church, it remained largely hidden in what was then a slum even as the great and good descended upon it to open various parts as they were restored by the Webb family of architects during the decades of their involvement. It remains largely hidden today despite its appearance in numerous feature films and its frequent use as a concert venue.

As with all hidden gems, however, if you know, you know. When a new visitor can be enticed down the path or through the churchyard, it is a source of unending delight to watch them as they experience the church for the first time – and turn, many of them, in an instant from tourists into pilgrims. Once they visit, they tend to return.

2 George Godwin, *The Churches of London* (London: C. Tilt, 1839), § 2, p. 2.

1.2. Priory Church of St Bartholomew the Great: Rahere's tomb.
Drawing by John Carter, c. 1781. Wellcome Collection

DEVOTION

Is't not true,
Great lives of great denials most do come?
So 'twas at least with him whose effigy
Doth here so sweetly pardon supplicate.
For he was rich – in favour with his king –
Love plighted – famous in the lists of song,
And as I doubt not in the lists of men;
For kings they love not cowards. Read you now,
How much he took in barter, and for these
The things men cherish most, and, seeking, oft
Will wear away the well-spring of their lives –
"Primus canonicus."[3]

In what might seem an irony to anyone who has not read Scripture, we know Rahere's name precisely (and only) because he gave up worldly wealth and fame in order to follow God. That act of devotion – of oblation – has won him 900 years of just praise, as those served by the church and hospital he founded have lifted his name to God in thanksgiving.

3 Edward Hardingham, 'Rahere', in *The Romance of Rahere and Other Poems* (London: Stock, 1896), p. 123.

Centuries of quiet lives have been given in devotion to St Bartholomew's, from that of its first canon and first prior, and those canons and priors who followed him, to the rectors during the Webb restoration who spent both their personal wealth and their own heart's blood to minister to the people and bring the church back from ruin, to the curate (himself later rector) who spent nights kicking incendiary bombs from its roof during the Blitz at the risk of his own life. Centuries of laypeople, known and (mostly) unknown – from the possibly apocryphal children who helped Rahere gather stones for the foundation; to Charlotte Hart, for over thirty years parish sextoness, who on her death in 1889 left the church her unsuspected wealth; to the Webb family, to whom we owe both the church as it presently stands and much of our understanding of its history; to the pioneering Mrs Burne, the only female rector's warden in the City of London in 1937; to those who sit and worship in their accustomed seats or serve in their accustomed places each Sunday in the present day – have given their time and money and prayers for its preservation. The church is built upon them as much as upon its piers of stone. This book has not been able to do any of them justice, unless it is to say that, because of them, the place yet stands.

DECAY AND RENEWAL

Writing of Canonbury Tower, built by Prior Bolton and owned by the canons of St Bartholomew's before the Dissolution, the American author Washington Irving called it

An ancient pile
To various fates assigned; and where, by turns,
Meanness and grandeur have alternate reigned.[4]

As with its appurtenances, so with the church itself. The cloister, quondam stables, the north transept, quondam smithy, and the Lady chapel, quondam printers' workshop and later fringe manufactory, echo Irving's words with silent eloquence.

If at present we inhabit an age of (relative) grandeur, we would do well to remember and to shun the meanness that has gone before, as Rector Savage reminded the congregation and friends of the church in his appeal for funds to maintain and further improve it after the Webbs had completed their great work.[5] What has been made new by the labour, dedication, and sacrifice of human hands can easily be unmade by malice or indifference, whether expressed through active destruction or through its slower brother, neglect.

From its beginning, the priory church has gone through cycles of wealth and expansion, followed by reverse and decay. Prior Rahere's great beginning in 1123 was punctuated by long stoppages of work as funds ran out; the priory was still incomplete at its founder's death. The impecunious canons of the later Middle Ages nearly beggared themselves by improving the church and extending hospitality in accordance with the rule of their Order. The orgy of wanton destruction we euphemistically call the Dissolution of the Monasteries

[4] Washington Irving, *Oliver Goldsmith; the Sketch-Book*, The Works of Washington Irving, 10 vols. (London: Bell & Daldy, 1866), II, p. 122.
[5] The Rev'd Canon E. Sidney Savage, 'Rahere Yesterday and Today, and His Priory Church of St Bartholomew, Founded in 1123: Its chequered story and an appeal' (London: 1930).

was followed by centuries of neglect, which brought the church to the point of ruin. The vision, generosity, and painfully slow and difficult labour of several generations then effected its glorious renewal, the fruits of which we enjoy today.

RAHERE AND THE PRIORY CHURCH IN POPULAR LITERATURE

The Webb restoration sparked – for the first time in several centuries – a renewed popular interest in the priory church, and especially in its founder, Rahere, the story of whose conversion from court jester to Augustinian canon through the intervention of St Bartholomew caught the popular imagination. This interest brought with it a raft of prose and poetry which is now largely unknown and unread, even by parishioners.

The earliest literary productions inspired by the Webb restoration are in that genre of morally improving melodrama so beloved of the late-Victorian public. Mary M. Channing's *Prior Rahere's Rose*, about a street urchin who comes to Christ through the intervention of the kindly Hospitaller of St Bartholomew the Less, is the tear-jerking exemplar of this genre.[6] Rather better is Edward Hardingham's 'Rahere', the metrical romance quoted above, though its action mostly concerns the founder's namesake, the Royalist teenaged daughter of a deceased rector of the priory church during the Civil War, rather than the prior himself.

Rudyard Kipling was not the first (though he was probably the best) poet to describe Rahere's own state of mind as he contemplated the unfillable emptiness of a life spent in pursuit of worldly power, wealth and fame:

Suddenly, his days before him and behind him seemed to stand
Stripped and barren, fixed and fruitless as those leagues of naked sand
When St Michael's ebb slinks outward to the bleak horizon-bound,
And the trampling wide-mouthed waters are withdrawn from sight and sound.
Then a Horror of Great Darkness sunk his spirit and anon,
(Who had seen him wince and whiten as he turned to walk alone)
Followed Gilbert the Physician, and muttered in his ear,
"Thou hast it, O my brother?" "Yea, I have it," said Rahere.[7]

The poem follows Rahere to 'reeking Smithfield where the crowded gallows are' and shows as the future prior sees, possibly for the first time in his empty and dissipated life, an expression of the full, perfect and imperishable Love of which the Scriptures speak.

Rahere earlier appeared in Kipling's short story 'The Tree of Justice'. One character calls him 'more of a priest than a fool and more of a wizard than either' – an apt description, as the reader finds when the black-and-scarlet-clad Rahere makes his memorable entrance some paragraphs later.[8] The Rahere of Rosemary Sutcliff's rather enjoyable 1970 children's book *The Witch's Brat*, about the foundation of the hospital and priory, seems to owe his incisive, sardonic wit and haunted pensiveness to Kipling's portrayals.

6 Mary M. Channing, *Prior Rahere's Rose: A story of St Bartholomew's, Smithfield* (London: Stock, 1895).
7 Rudyard Kipling, 'Rahere', in *Debits and Credits* (London: Macmillan, 1926), pp. 117–19.
8 First published in *The Delineator*, 1 February 1910, and collected in *Rewards and Fairies* (London: Macmillan, 1910).

Time and obscurity might permanently have claimed some of the artefacts of the early twentieth-century revival of interest in St Bartholomew's. Feared lost are the scripts for two pageant plays of the 1920s and 1930s – *The Acts of Rahere* by E. Werge-Oram and *Rahere* by Jean Scott-Rogers – that were acted in the priory church to great acclaim in order to raise money for its maintenance.[9]

The priory church and its founder have also inspired their share of modern poets. John Betjeman is perhaps the best known of these, though one could be forgiven for preferring the efforts of other sometime parishioners.[10] Most striking of all is the imagery in George Barker's 'Elegiacs for T. S. Eliot', in which the poet imagines the spirit of his dead friend – whose resemblance to Rahere he had often noted in life – might take on an afterlife of its own. Barker feared lest

his effigy serenely sleeping there
in the Norman shadows of St Bartholomew's
inexplicably and splendidly disguised as Rahere
that devout joker, founder and priest, choose
to rise and bear a plate among the pews.[11]

Other works exist, but a brief overview must suffice to demonstrate that, centuries after its foundation, St Bartholomew's and its founder continue to fire imaginations. It is to be hoped that the priory church's ninth centenary will prove as fruitful as its eighth.

HISTORIOGRAPHY

The earliest historiography on the priory and its sister foundation was produced within the priory itself. A twelfth-century Latin hagiography of Rahere and a history of his joint foundation survives in a fifteenth-century manuscript alongside a Middle English trans-lation and extension of the text made circa 1400. These together are known as 'The Book of the Foundation'. E.A. Webb quotes extensively in his *Records* (about which more later) from an English translation he commissioned of the Latin text. A transcription of the Middle English can be found in Webb's appendices; a critical edition was first privately printed by Norman Moore, a physician at St Bartholomew's Hospital, and later issued for the Early English Text Society.[12] The other major surviving source of evidence from the Middle Ages is the Hospital cartulary, in which are transcribed documents relating to its foundation and the privileges and rights it enjoyed.[13] These documents also often reference the priory due to the joint nature of the foundation and the numerous long-running disputes between hospital and priory.

9 For more information on these pageant plays, see Jeremy Haselock's chapter in this book.
10 John Betjeman, *Church Poems* (London: John Murray, 1981); Leonard Clark, *Twelve Poems from St Bartholomew's* (London: Priory Church of St Bartholomew the Great, n. d.); Virginia Rounding, *Awaiting an Epiphany* (London: Priory Church of St Bartholomew the Great, 1997).
11 George Barker, 'Elegiacs for T. S. Eliot', in *Dreams of a Summer Night* (London: Faber and Faber, 1966), p. 30, ll. 6–10.
12 For full references to these, see 'Abbreviations' above, p. 8.
13 St Bartholomew's Hospital Archives, SBHB/HC/2/1.

St Bartholomew the Great appears in numerous antiquarian guides to the churches of the City of London.[14] Their accounts of the founding and early history of the priory contain numerous factual errors and have been superseded by Webb, though their authors' eye-witness descriptions of the interior of the priory church in their own day remain interesting snapshots of moments in its architectural history. Still useful despite being first published over a century ago are Norman Moore's concise history of the priory church and his two-volume history of the hospital, and Minnie Reddan's brief overviews of the history of the medieval priory and hospital written for the London volume of the Victoria County History (VCH), which have been reprinted with introductions detailing recent research.[15]

Scholarly interest in the priory church and its monuments has seen a recent revival, though one by no means proportional to its interest and importance as a place – enough remains to be done to fill the working lifetimes of several historians. Maybelline Gormley has used archaeological records to revise our understanding of how and when the cloister was built, and later rebuilt.[16] Jane Spooner has written about one of the most important fragments of medieval painting yet discovered in the City of London, excavated in a site adjacent to the church.[17] Martin Dudley, himself a former rector, chronicled changes in the worship, fabric and furnishings of the priory church in the fascinating period from 1828 to 1938.[18] Sally Badham and Jon Bayliss have written about the commissioning, dismembering, and incorrect reassembly of one of the church's most prominent monuments.[19] Sally Badham has also discussed five incised slabs known previously to have been located in the medieval priory and subsequently presumed lost.[20] We are delighted to report that her 'St Bartholomew the Great, London II' is in fact *not* lost – see Christian Steer's chapter in this book for more details. Laura Varnam has argued that the Middle English translation of 'The Book of the Foundation' was commissioned to establish a sacred identity for St

14 A sampling of the more interesting of these includes: T.G. Bonney, *Cathedrals, Abbeys, and Churches of England and Wales* (London: Cassell, 1891); W.A. Delamotte, *An Historical Sketch of the Priory and Royal Hospital of St Bartholomew* (London: Cunningham, 1844); William Dugdale, *Monasticon Anglicanum: a History of the Abbies and other Monasteries, Hospitals, Frieries, and Cathedral and Collegiate Churches, with their Dependencies, in England and Wales*, 8 vols., (London: Bohn, 1846), VI PT I, pp. 291–97; Godwin, op. cit.; James Peller Malcolm, *Londinium Redivivum, Or, An Ancient History and Modern Description of London*, 4 vols. (London: Nicholas, 1803), I, pp. 266–311; Normanus (pseud.), *An Illustrated Account of St Bartholomew's Priory Church, Smithfield* (London: G.J. Evans, 1874); Walter Thornbury, *Old and New London: a Narrative of Its History, Its People, and Its Places* (London: Cassell, 1889), pp. 351–63.

15 Norman Moore, *The Church of St Bartholomew the Great, West Smithfield: Its Foundation, Present Condition, and Funeral Monuments* (London: Collingridge, 1892); Norman Moore, *The History of St Bartholomew's Hospital*, 2 vols. (London: C.A. Pearson, 1918); Minnie Reddan, 'The Priory of St Bartholomew, Smithfield', and 'The Hospital of St Bartholomew, Smithfield', in *The Religious Houses of London and Middlesex*, ed. Caroline M. Barron and Matthew P. Davies (London: University of London, 2007), pp. 90–95, 149–54.

16 Maybelline Gormley, 'St Bartholomew-the-Great: Archaeology in the Cloisters', *London Archaeologist*, 8(1) (1996), pp. 18–24.

17 Jane Spooner, 'A Fragment of Medieval Painting Discovered Next to St Bartholomew the Great, Smithfield', *The Antiquaries Journal*, 82 (2002), pp. 339–43.

18 Martin Dudley, '"The Rector Presents His Compliments": Worship, Fabric, and Furnishings of the Priory Church of St Bartholomew the Great, Smithfield, 1828–1938', *Studies in Church History*, 35 (1999), pp. 320–32.

19 Sally Badham and Jon Bayliss, 'The Smalpace Monument at St Bartholomew the Great, London, Re-Examined', *Church Monuments*, 20 (2006), pp. 81–93.

20 Sally Badham and Malcolm W. Norris, *Early Incised Slabs and Brasses from the London Marblers*, Reports of the Research Committee of the Society of Antiquaries of London, 60 (London: Society of Antiquaries of London, 1999), pp. 8, 27, 51, 97–98, 108–09, 111, 116.

Bartholomew's Priory as a place of pilgrimage by cataloguing the many miracles that had occurred there, and that it grew out of the programme of restoration and beautification which gave us, *inter alia*, Prior Rahere's tomb and the baptismal font.[21] Some recent work has also been done on the medieval hospital and its close by Caroline Barron and others.[22]

Legitimate and useful scholarly disagreement exists over how to interpret our often limited evidence – that's what makes history, as differences of opinion make horse racing. The contributors to this book have not had an artificial consensus imposed on them. When we have come to a genuine scholarly agreement on disputed issues such as the year of Rahere's death (which the literature has placed in 1143, 1144 and even 1145; we believe contemporary evidence points convincingly to 1143), that consensus has been stated as fact. On other issues, such as Varnam's contention that Roger Walden instigated the Middle English translation of 'The Book of the Foundation' during his period of association with the priory, we have not come to such a consensus. The reader will be able to note where these differences occur, and to examine each historian's arguments for their interpretation.

CONSPECTUS

The book has been divided into three roughly chronological sections covering the medieval, early modern, and modern eras. A fourth section covers the priory church's musical and artistic tradition from its foundation to the present day.

The Middle Ages was a time of literal feast (including a £188,401 debt for ale) and metaphorical famine for St Bartholomew's, which underwent dramatic periods of expansion and relative decline as the religious, political and social landscape changed dramatically around it. Rahere's choice of a joint foundation brought some of its own difficulties, leading to a series of running battles between priory and hospital as each sought to carve out a distinct identity and role in the medieval City of London. Christine Fox records the changing fortunes of the priory and its resident canons during the four centuries from its foundation to the Dissolution, and the integral role played by the priory in medieval London society. Stephen Heywood discusses the building and growth of the priory, which, by fits and starts, transformed one corner of Smithfield from marshy waste ground to Romanesque and Gothic splendour. Christian Steer details the funerary monuments that once richly adorned the medieval priory church, which – though most are now lost – yield fascinating insights about its residents and the wider community it served. Euan Roger chronicles the centuries-long struggle of the hospital to become independent of its sister foundation, and

21 Laura Varnam, '*The Book of the Foundation of St Bartholomew's Church*: Consecration, Restoration, and Translation', in *The Church as Sacred Space in Middle English Literature and Culture* (Manchester: Manchester University Press, 2018), ch. 2.
22 See for example: Caroline Barron, 'The People of the Parish: The Close of St Bartholomew's Hospital in Fifteenth-Century London', in *The Urban Church in Late Medieval England: Essays in Honour of Clive Burgess: Proceedings of the 2017 Harlaxton Symposium*, ed. David Harry and Christian Steer, Harlaxton Medieval Studies, 29 (Donington: Shaun Tyas, 2019), pp. 353–79; Euan Roger, 'Blakberd's Treasure: A Study in Fifteenth-Century Administration at St Bartholomew's Hospital, London', in *The Fifteenth Century* XIII, ed. Linda Clark (Woodbridge: Boydell, 2014), pp. 81–108. For details of other sources on the hospital, see works cited in Euan Roger's chapter in this book.

introduces readers to the community of lawyers and civic and royal officials who made their homes in the hospital precinct in the later Middle Ages.

The early modern era was a time of transforming fortunes for the former St Bartholomew's Priory. The hospital, at last wholly independent of the newly formed parish of St Bartholomew the Great, here recedes into the background of our story. The former priory precinct was home to wealthy and influential courtiers and to a group of parishioners determined to forge a parochial identity for their community, but their task was not an easy one. Nick Holder chronicles the two-decade transformation of St Bartholomew's from a priory into a parish, introducing the two men of wildly different convictions – the unscrupulous political operator Richard Rich and the Dominican friar William Peryn – who held the fate of the priory church in their hands during a time of radical social and religious transformation. Steven Brindle traces the troubled legacy of Richard Rich and his successors from the 1560s, when the priory church escaped annihilation by a hair's breadth, through the religious and political struggles of the Civil War, to the first attempts to restore the church, which had been damaged by centuries of neglect and nearly destroyed by a devastating fire in 1830. Jon Bayliss describes the early modern funerary monuments still to be found in the priory church, which portray a rather different community than that which had flourished at St Bartholomew's Priory in the Middle Ages.

The modern era saw the nadir of the former priory's fortunes – and also its magnificent rebirth. The transformation was spiritual as well as architectural; St Bartholomew's had earlier been a bastion of Laudian worship, and in the late nineteenth century it would embrace Tractarianism (if not always wholeheartedly) and work to educate and improve the lives of working-class parishioners in what had by then become one of the worst of London's Victorian slums. Jeremy Haselock tells the story of the nineteenth and twentieth centuries through the eyes of the remarkable rectors – Abbiss, Panckridge, Savory, Sandwith, Savage and Wallbank – who presided over the transformation. Evan McWilliams recounts the difficult but ultimately successful half-century of the priory church's architectural rebirth, from the formation of the first Restoration Committee in 1864 to the re-opening of the east walk of the cloister in 1928.

Music and the visual arts have a long association with St Bartholomew's, and today the priory church enjoys a reputation for excellent music and a collection of modern art unusual for a parish church of its size. Nicholas Riddle chronicles the musical tradition of St Bartholomew's, from the medieval hospital's grammar and song school to the modern revival of the priory church's choral tradition under a series of innovative directors of music. Peter Delaney introduces the extraordinary collection of modern art that today adorns the priory church, from Damien Hirst's shocking *Exquisite Pain* to Richard Harrison's deeply challenging *Golgotha*. Notes by Jeremy Haselock and Jeremy Warren profile some of the lesser-known artworks within the priory church, including a seventeenth-century painting formerly hung in the Lady Chapel and a fifteenth-century sculpture of the Virgin on the masonry screen between the choir and north transept.

An afterword by the present rector, Marcus Walker, shows what the vibrant community of the priory church is doing to reach out to newcomers beyond the boundaries of the parish and to preserve our heritage for future generations.

IN MEMORIAM EDWARD ALFRED WEBB

To conclude, it is a duty and a joy to acknowledge the great debt owed by everyone who has worked on this book to Edward Alfred (E.A.) Webb, for many years rector's warden of St Bartholomew the Great.

Webb did not 'claim to be an historian, or to have any literary skill', and seems not to have set out to write a book when he began.[23] His two-volume *Records of St Bartholomew's Priory and St Bartholomew the Great, West Smithfield* grew out of the research he conducted for a series of lectures he gave on the history of the church to raise funds for its restoration, and from correspondence with experts of his day on matters that perplexed and interested him, as his brother and nephews undertook their great work of restoration, uncovering more and more of the art and architectural history of the church as a result.[24] While Alfred Webb was indeed not a professional historian, a contemporary review noted that, despite minor blemishes and errata in detail, *Records* is 'a valuable work, obviously the fruit of many years of loving labour'.[25] Nor have the intervening 101 years since its publication diminished its value; readers of Webb's great work will still see how remarkably far he got in his careful and thorough research, and feel his profound love and devotion for St Bartholomew's shining forth from every page. It is, and remains, the seminal history of the priory church.

If this book has been able to correct some of Webb's minor errors in fact or interpretation, or to present historical sources unknown to him, it is only because of the running start he gave us. It is to be hoped that, in another hundred years, some other person who loves St Bart's with every atom of their marrow will step forward to correct *our* infelicities. No doubt such people will exist; the place seems to inspire such devotion. It deserves to.

Saint Bartholomew made this promise to Rahere as he lay dreaming over nine centuries ago:

Neither the costs of this building doubt thee nought. Only give thy diligence, and my part shall be to provide necessaries, direct, build, and end this work, and this place to me accept with evident tokens and signs, [and] protect and defend it continually under the shadow of my wings. And therefore of this work know me the master, and thyself only the minister. Use diligently thy service, and I shall show my lordship.[26]

The Apostle has been as good as his word for nine hundred years. May he be so still. And so may we.

23 Webb, *Records*, I, p. vi.
24 Webb, *Records*, I, pp. v–viii.
25 'Short Notices', *History*, 8.30 (1923), pp. 151–56 (p. 153). The notice was written by Eliza Jeffries Davis, at that time Reader in the History and Records of London at the University of London – one of the pioneers in the study of London history.
26 Moore, *Foundation*, p. 49.

MEDIEVAL

For asmoche / that the meritory and notable operacions of famose goode / and devoute faders yn god / sholde be remembred for instruction of after-comers to theyr consolacion / and encres of devocion / thys Abbreviat Tretesse shal compendiously expresse and declare / the wondreful and of celestial councel gracious fundacion / of oure hooly placys callyd the Priory of seynt Barthol yn Smythfyld and of the hospital by olde tyme longyng to the same / with other notabilites expedientely to be knowyn And most specially / the gloriouse and excellent myraclys wroghte with yn them / by the Intercessions suffragys and merytys of the forsayd benygne feythfull and blessid apostyl Saint Bartholomy / yn to the laude of almyghty god and attribucion of his infinite pouere.

A fyrst shal be shewyd who was ffunder of owre hoely places / And howgh by grace / he was ffyrst pryor of othyr Priory / and by howgh longe tyme that he contynued yn hys churche yn the honoure ¶ The same of most blessid Bartholomeus Apostle / fundid Rayer / of goode remembraunce and ther yn to serue god / aftyr the reule of the moost holy fader Austyn attendyng to trewe religiouse men / and to them was place. xxij. yere vsyngge the office and dignyte of a Priore / Not havyngge cunyngge of liberal science / but that that is more emynente than all cunyngge. ffor he was riche yn puryte of conscience ¶ Aueyng god by devocyon Aueyng his brethryn by humylite. Aueyng his enemyes with a benyuolente. And thus hym self he exercased them pacyently sufferyngge / whose prouyd puryte of soule bryght maners with honeste probyte / exprete diligence yn dyuyne huyre /

A History of St Bartholomew's Priory to its Suppression in 1539

CHRISTINE MERIE FOX

THE PRIORY OF ST BARTHOLOMEW, West Smithfield, located just outside the medieval city wall to the north of Aldersgate and situated just east of Smithfield between Duke Lane on the west and Long Lane to the north, was one of the most important monasteries in medieval London. Its origins have often been attributed to King Henry I, but the true inspiration for its foundation came from its first prior, Rahere (d. 1143).

Nearly everything we know about Rahere and the foundation of St Bartholomew's comes from 'The Book of the Foundation' (*Liber fundacionis ecclesie Sancti Bartholomei Londonarium*) (fig. 2.1).[1] The text contains a colourful and romantic description of Rahere, the foundation of the hospital and priory, and the miracles that took place there. Written c. 1400, the text contains two versions of the same story (one in Latin and another in English), based on a twelfth-century Latin text that no longer survives. Little is known about the original twelfth-century author other than that he was a canon of St Bartholomew's and would have had at least second-hand knowledge of its founder and the monastery.[2]

Studies into the origins of the fifteenth-century manuscript have focused on the motivations behind its transcription and translation. The fifteenth-century priory was undergoing considerable change and was in need of both physical and spiritual revival. Laura Varnam has argued that Roger Walden, archbishop of Canterbury 1397–99 and bishop of London 1404–06, was behind the manuscript's commissioning.[3] Her argument is based on the fact that Walden, who was living within the priory close, had invested considerable sums of money in the rebuilding of the priory. However, there is no definitive proof for this theory,

The world is a better place thanks to those who generously share their time to help others. I am eternally grateful to Professor Caroline Barron for her support and mentorship over the last two decades. Thank you for introducing me to St Bartholomew's Priory and for stimulating my understanding of its place in medieval London's history. I would also like to thank Dr Christian Steer. Working on this project together has been a real joy. I would also like to extend my gratitude to Charlotte Gauthier for bringing this book together and for thinking along with me about my chapter design. Your advice and support has been well appreciated. I would also like extend my deepest thanks to the Medieval London Seminar group for all the brilliant research presented in the last two years. You have filled my mind with knowledge and made these challenging times that bit easier. I would also like to thank Dr Nick Holder for his careful reading of my chapter and advice. Last but not least, I would like to thank Dr Claire Martin, who has not only been my dearest friend but who has also painstakingly read through this chapter too many times to count. I am extremely grateful for all your time and investment.

1　Moore, *Foundation*.
2　Judith Etherton, 'Rahere [Rayer] (d. 1143x5), founder of St Bartholomew's Hospital and priory, London', *ONDB*.
3　Laura Varnam, *The Church as a Sacred Space in Middle English Literature and Culture* (Manchester: Manchester University Press, 2019), pp. 61–122.

2.1. The beginning of the 15th-century English translation of 'The Book of the Foundation' Cotton MS Vespasian B. IX f. 41r (© The British Library Board)

and an argument can be made that the commissioning of the text could have also been by St Bartholomew's prior John Eyton *alias* Repyngdon (1391–1404) or, even more likely, by his successor John de Watford (1404–14).

RAHERE

The date and place of birth of the founder of St Bartholomew's is unknown. We do know he was from humble lineage, most likely born in the reign of William the Conqueror (r. 1066–87), and may have come from the eastern part of Brittany.[4] Rahere did not begin his career in the Church. He was a social opportunist who, 'haunting the households of nobles', gained friendships through his 'flattering and jokes'.[5] Through these friendships, he became a regular member at the court of Henry I (r. 1100–35) where he developed close relations with the king and his courtiers, including Richard de Belmeis, bishop of London (d. 1127), who would become one of Rahere's most influential patrons and advisors.

There is debate surrounding the exact role Rahere played within Henry I's court. His biography suggests he might have been the king's minstrel or jester. At the time, minstrels could be the reciters of poems, storytellers and, sometimes, even jugglers, as well as musicians. They would have followed the king around the country on his progress and were often part of the king's inner circle. In Thomas Deloney's popular tale 'Thomas of Reading' (c. 1543–1600), Rahere was the most skilled musician of his time.[6] Such talent would have made him a favoured member of Henry's court.

At some point, however, faith intervened. Around 1115, Richard de Belmeis's nephew William de Mareni, dean of St Paul's, made Rahere a canon of the cathedral. In the twelfth century, there were around twenty canon places (stalls) at St Paul's. Each stall was provided an income from an ecclesiastical position in or around the city of London. Rahere was given the stall of Chamberlainwood (Willesden), a position he held until his death in 1144. This appointment would have provided Rahere with an income, and at this time was often given to members of the bishop of London's household.[7] It would have also allowed Rahere to hold offices and duties outside of the cathedral and did not require him to be regularly present – a benefit of which he took advantage in 1120 when he left on pilgrimage to Rome.

Rahere's motivation for going on pilgrimage is unclear, though some have argued that the sinking of *The White Ship* (25 November 1120), which took the lives of Henry I's son William, heir to the throne, William's half-sister Matilda and his half-brother Richard, along with hundreds of courtiers, may have brought about Rahere's newfound conviction.[8] It is easy to imagine that such a sobering event, in which some of his closest friends and

4 Norman Moore, 'Rahere', *ODNB* (1896), pp. 1–7.
5 Moore, *Foundation*, p. xlv.
6 *Early English Prose Romances with Bibliographical and Historical Introduction*, ed. William J. Thoms, 2nd edn. (London: Nattali and Bond, 1858), p. 16; Judith Etherton, 'Rahere [Rayer]'.
7 Derek Keene, 'From Conquest to Capital: St Paul's c. 1100–1300', in *St Paul's The Cathedral Church of London 604–2004*, ed. Derek Keene, Arthur Burns and Andrew Saint (New Haven: Yale University Press, 2004), pp. 117–32 (p. 123).
8 *The Ecclesiastical History of Orderic Vitalis* ed. Marjorie Chibnall, 6 vols. (Oxford: Clarendon Press, 1969–80) VI, pp. 294–307.

confidants had died, might have caused Rahere to reflect upon his life. A journey to Rome was in order.

While in Rome, Rahere visited the holy sites of St Peter, St Paul and the Three Fountains, where he contracted malarial fever.[9] In the throes of his illness, fearing he had not repented for his misdeeds, it is said that Rahere 'poured out his heart like water in the sight of God' and promised that if he survived this ordeal he would return to England and erect a hospital for the restoration of poor men, and that he himself would minister to their needs. Rahere's prayers were answered and he made his way back to England. While still recovering from his illness, he had several visions. One of the more detailed of these involved Rahere being attacked by a winged monster, from which he was saved by St Bartholomew the Apostle. After rescuing him, St Bartholomew instructed Rahere to build a church as well as a hospital and indicated Smithfield as the site.[10]

THE FOUNDATION OF ST BARTHOLOMEW'S PRIORY AND HOSPITAL

Returning to London a changed man, Rahere declared to his friend and patron de Belmeis, and to the citizens of London, his intentions for the building of a hospital and priory on the outskirts of the city in Smithfield. London and its concentration of potential patrons and almsgiving craftsmen and merchants made it a popular location for religious houses.[11] However, property was not cheap and land was sometimes difficult to come by and not always easy to build on. The Smithfield site was said to 'abound with filth and muddy water' and to smell 'like a marsh' – an insalubrious atmosphere which seemed to plague the area for many centuries.[12] Smithfield was also the location of the royal horse and livestock market and the city elms (gallows where criminals were executed). Hence, Rahere had to seek permission from Henry I who, still anguished by the *White Ship* disaster, had become a solemn and devoted religious patron. Upon hearing Rahere's story, Henry quickly gave his authority to build the hospital, priory and cemetery on the Smithfield site. Work began in March 1123.[13]

Building a new priory and hospital would take more than the king's permission, however: Rahere would also need considerable sums of money to fulfil his vow. Where this money came from is unclear. Rahere would have had his income from his position at St Paul's and potentially may have had an income from the bishop of London, the king, and other wealthy patrons. Rahere's biographer, who is not a completely reliable source, mentions that some of the funds came from charitable locals and further that Rahere had persuaded local children and servants to help with sourcing his building materials and building the two foundations.[14]

9 Moore, 'Rahere', p. 2.
10 Moore, *Foundation*, p. xlvii.
11 Nick Holder, 'Founding and Building Religious Houses in London and its Suburbs', in *The Urban Church in Late Medieval England: Essays from the 2017 Harlaxton Symposium Held in Honour of Clive Burgess* ed. David Harry and Christian Steer, pp. 197–221 (p. 197).
12 Moore, *Foundation*, p. lvii.
13 Webb, *Records*, 1, pp. 37–55.
14 Moore, *Foundation*, p. lvii.

The project not only required substantial funds but also the practical expertise of someone familiar with the design and construction of religious buildings. According to Rahere's biography, this experience came from three Greek noblemen who had travelled to London on pilgrimage.[15] Others have suggested this expertise came from an old man by the name of Alfune who had previously worked on St Giles Cripplegate and who is considered the first master of the hospital.[16] The most likely candidate, however, would be Rahere's trusted friend and advisor Richard de Belmeis, bishop of London, who had founded and built the priory of St Osyth in Essex around 1121.[17]

At an interim stage of construction, the site was consecrated. The monumental task of building, however, was not fully completed until 1133, when Henry I showered more favours upon the house and provided it with a number of endowment lands to help with its charitable work. These favours created rancour and jealousy amongst Rahere's peers, who conspired to murder him. Fearing for his life, Rahere appealed to the king for protection. Henry I, understanding the gravity of the situation and concerned about the success of his new foundation, pledged in his royal charter to protect Rahere and also defend St Bartholomew's 'as he would his own crown' – a protection that would extend to every aspect of the priory including the annual fair, which was held on St Bartholomew's eve (23 August) and ran for three days.[18]

With his great work completed, Rahere ruled over his twin foundations for only four years before retiring to the priory and leaving the care of the hospital to a clerk named Hagno. There he dedicated himself to a life of study and service to the poor and became a popular preacher. During this time, the priory and hospital grew in popularity, which was increased by a number of miracles and acts of healing attributed both to the prior and to the holy relics which were held by the two foundations.[19] The most important of these relics was a fragment of the Holy Cross, which was held by the hospital and to which the hospital church was dedicated.[20] However, the popularity of St Bartholomew's as a healing location never fully matured into a cult. There was also no attempt to canonize Rahere for the miracles associated with him; thus, it might be that these stories were more part of an agenda to increase donations in the twelfth and fifteenth centuries and a failed attempt to make the priory a pilgrimage destination.

Rahere died on 20 September 1143 and was buried on the north side of the altar in the priory church, where his tomb and later stone effigy can still be seen today (fig. 2.2).[21]

15 Moore, *Foundation*, p. lvi.
16 C.L. Kingsford, *A Survey of London by John Stow*, 2 vols. (Oxford: Clarendon Press, 1908), II, pp. 22, 78.
17 See also Stephen Heywood's chapter in this book.
18 Webb, *Records*, I, pp. 477–89.
19 Varnam, ch. 2.
20 Webb, *Records*, I, pp. 55–75.
21 See Christian Steer's chapter in this book.

2.2. Tomb and effigy of Rahere in St Bartholomew the Great

THE AUSTIN CANONS

When Rahere decided to found St Bartholomew's priory and hospital there were a number of issues he needed to consider. His most important decision was which religious order would oversee his new foundation. The Canons Regular of St Augustine were a newly established community in twelfth-century England and a favoured religious order of Henry I, his wife Matilda and Rahere's mentor Richard de Belmeis. The Austin (Augustinian) Canons, also known as the Black Canons because of the black habits they wore, were created in response to religious reforms introduced by Pope Gregory VII (1073–85) in the eleventh century.[22] Because of their limited and flexible rule and because of the relatively small size of their houses,[23] Augustinian foundations were particularly popular in urban areas such as medieval London, which had six within the city and its suburbs. The first Augustinian house to be founded in London was St Mary Overy, circa 1106, followed by Holy Trinity, Aldgate in 1107 and St Bartholomew's in 1123. St Bartholomew's foundation as a priory and hospital appears to have set a trend in the city, because the next three Augustinian houses founded in London were St Mary Bishopsgate (1197), St Thomas Southwark (1215) and Elsyngspittal (1331), which were all attached to hospitals.

Upon its foundation, St Bartholomew's hospital and priory each supported thirteen members. The hospital had one master, eight brothers and four sisters, while the priory had thirteen canons. (Thirteen represented Jesus and his disciples and was a common number used in religious foundations.) The life of a canon at the priory would have resembled that prescribed by St Augustine and his followers. Canons Regular were priests who lived

22 These reforms focused on creating a more centralised institution where the Church (or rather, the pope) had more control over religious appointments and compulsory celibacy of the clergy: John Compton Dickinson, *The Origins of the Austin Canons and Their Introduction to England* (London: S.P.C.K., 1950), pp. 26–59.
23 C.H. Lawrence, *Medieval Monasticism: Forms of Religious Life in Western Europe in the Middle Ages*, 2nd edn. (London-New York: Longmans, 1989), pp. 165–68.

together as a brotherhood and shared a common dormitory and refectory. The rules of their order bound them to obedience, poverty, chastity, ecclesiastical fasts and following the seven canonical hours (prayers at dawn, sunrise, mid-morning, midday, mid-afternoon, sunset and before they went to bed). Their days would have been occupied in prayer, study, education, charity, hospitality and good works. Unlike cloistered orders, such as the Benedictine monks of Westminster Abbey, the canons were allowed to go outside the priory precincts to collect alms or victuals for the poor, and would have been a common sight on the streets of London. They also valued intellectual pursuits over manual labour, a preference that was frowned upon by some religious orders.

The canons had a generous and diverse diet, including two meals a day – dinner and supper. Depending on the day of the week, meals would consist of bread, pottage (a thick soup or stew made with vegetables and grains), fish, vegetables and small amounts of meat. They would have drunk a high-calorie home-brewed ale with a very low alcohol percentage, which they would have taken at dinner, supper and before bed.[24] While we do not know the amount of food provided for each canon, we do know that the bread loaves at St Bartholomew's were small – weighing only 17 ounces – as against 30 ounces at Holy Trinity, Aldgate, and 52 ounces for the large loaves and 26 ounces for the small ones at St Paul's.[25]

According to Henry I's 1133 charter, the priory had the oversight of the hospital both spiritually and financially. This oversight was the responsibility of the head of the monastery, known as the prior or prelate. The prior had his own horses and a separate house with its own chapel, kitchen and servants. It was his duty to say mass on certain days and to preside at chapter. The prior was also responsible for the appointment of the hospital's master – which would later become a major point of contention between the two foundations – and for supplying the hospital brethren with food and clothing. While the two institutions functioned somewhat independently of each other (helped by the fact that they were not physically attached to each other), the brothers of the hospital were still expected to attend feast days at the priory, and to share a communal cemetery.[26]

The election of the head of a religious house was an important decision that could make or break an institution. Henry I understood this, and in his 1133 charter stipulated that, if there was not a suitable candidate within the priory, another man should be chosen from some other convent of the same order.[27] While the canons of the priory would have had a voice in this decision, it would appear that both the king and the bishop of London played a significant role in the appointment, especially in the late fifteenth and sixteenth centuries. At times when the prior was not available, the sub-prior would take his place. In addition to the sub-prior there was also a sacrist, cellarer, kitchener, chamberlain, almoner, steward, clerk, and several lesser offices.

24 Webb, *Records*, I, pp. 19–34; James A. Galloway, 'Driven by Drink? Ale Consumption and the Agrarian Economy of the London region, c. 1300–1400', in *Food and Eating in Medieval Europe*, ed. Martha Carlin and Joel T. Rosenthal (London: The Hambledon Press, 1998), pp. 87–100.
25 Webb, *Records*, I, pp. 19–34.
26 Caroline Barron, 'The People of the Parish: The Close of St Bartholomew's Hospital in Fifteenth-Century London', in *The Urban Church in Late Medieval England: Essays in Honour of Clive Burgess: Proceedings of the 2017 Harlaxton Symposium*, ed. David Harry and Christian Steer, Harlaxton Medieval Studies 29 (Donington: Shaun Tyas, 2019), pp. 353–79.
27 Webb, *Records*, I, p. 62.

EARLY GROWTH AND THE PRIORY'S RELATIONSHIP WITH THE HOSPITAL

When Rahere died in 1143 the priory was still in its infancy. Tensions between the hospital and priory were building and an experienced and competent replacement was necessary to ensure their success. It is clear these requirements could not be met within the priory itself and that the king and the bishop of London had to find the right man for the job. Prior Thomas (1144–74) from the monastery of St Osyth's in Essex was that person.

One of the first responsibilities of Prior Thomas was to resolve the tensions between the two foundations. In his ordinances of 1147, Thomas reaffirmed the priory's commitments both spiritually and financially to the hospital and made it clear that they both should 'assist each other in turn without reluctance on either side'.[28] This ordinance brought about a period of peace between the two foundations and allowed Thomas room to focus on his plans to expand the monastery from thirteen canons to thirty-five and extend the choir of the church to accommodate this growth.

Between 1153 and 1173, Thomas secured several grants and privileges from Popes Anastasius IV, Adrian IV and Alexander III – something Rahere had always intended to do but never achieved. Additionally, in 1162 Thomas secured a grant from Thomas Becket, archbishop of Canterbury, who took the canons of monastery under his protection as Henry I had done.[29] These protections and grants served several purposes. They not only helped establish the reputation of the house amongst its peers but it also provided assurances to those leaving bequests that their money was going to a good and worthy cause.

At the end of Prior Thomas's life, tensions between the hospital and priory began to resurface. Between 1173 and 1192 the hospital sent four different emissaries to Rome requesting its protection and criticizing the priory for not adhering to its responsibilities. The hospital was granted its requests; however, the priory also received papal grants of protection during this period, which most likely caused confusion between the two foundations over control and oversight. Matters came to a head in 1185 when one of the hospital emissaries recounted a story of a disagreement between the prior and master of the hospital which resulted in the prior seizing the candles at a funeral of one of the brethren of the hospital and threatening excommunication of those involved in this dispute.[30] The cause and outcome of this event are unknown. However, what is clear from these interactions is that from the beginning the hospital wanted independence from the priory and that these struggles spilled out into the larger religious sphere, involving not only the pope but also a number of other religious figures both in England and abroad. Wanting to put an end to this involvement, both King John (r. 1199–1216) and Henry III (r. 1216–72) issued new charters to the priory stating:

28 Webb, *Records*, I, p. 490.
29 Webb, *Records*, I, pp. 97–98.
30 Webb, *Records*, I, pp. 76–92.

If any one shall intend to withdraw the hospital house from the church and rule of the prior and canons, he shall be subject to the royal prerogative and it shall be done unto him as unto one who shall intend to diminish the liberty of our crown.[31]

The royal charters put a temporary end to the issue of oversight of the hospital and also brought an end to papal involvement in it. However, they did not make the relationship between the two foundations better. Rather, they refocused their dispute to other areas of conflict such as the communal cemetery. This issue became more pronounced during the Great Interdict (1208-14) of Pope Innocent III, when King John refused to accept the appointment of Stephen Langton as archbishop of Canterbury. The interdict forbade all rites of the Church, including the ringing of bells and the use of tapers. Churchyards were closed and the dead were to be interred in unconsecrated ground without a service. Baptisms, confessions of the dying, and prayers and sermons were, however, allowed in churchyards, and marriages were permitted at the church door.[32]

The interdict put many churches and monasteries in a difficult situation. However, Pope Lucius III's charter to the hospital in 1185 had clearly stated that in the case of a general interdict the brethren might celebrate the divine offices in a low voice and with closed doors, without the ringing of bells or admission of excommunicated people. It would appear that William de Sainte-Mère-Église, bishop of London (1198-1221), was aware of this agreement, and possibly another which was made to the priory, because in his ordinances to the hospital in 1209 it is stated that the dying 'were to be buried as usual during the interdict in order to prevent a quarrel between the church and the hospital'.[33]

The priory's relationship with the hospital would remain strained until 1373, when a settlement was finally reached.[34] The priory was able to maintain its general authority over the hospital – for example, the brothers had to ask leave of the prior to elect a new master – but for all other purposes the hospital had gained its independence financially and spiritually.

This final accord made the relationship between the two foundations less fraught. In 1433, the priory's water supply, which came from one of their estates in Islington, was in serious need of repair. At the time, the priory did not have the funds to fix the lead pipes, and thus the two foundations worked together to solve this communal problem. The hospital was given access to half the water supply in return for carrying out the necessary repairs.[35] These repairs eventually made it possible for the priory to grant Thomas Knolles, grocer and mayor (d. 1435), permission to convey superfluous water belonging to the priory to both Newgate and Ludgate prisons for the relief of the poor prisoners.[36]

31 Webb, *Records*, I, pp. 477-89.
32 Webb, *Records*, I, pp. 106-29.
33 Ibid.
34 See Euan Roger's chapter in this book.
35 Barron, 'People', pp. 357-58.
36 The work had begun in October of 1435 but was completed by Knolles's son, also named Thomas (d. 1445): *Calendar of Letter Books of the City of London: Letter Book K*, ed. R. R. Sharpe (London: 1911), p. 189; *Calendar of Letter Books of the City of London: Letter Book L*, ed. R. R. Sharpe (London: 1912), p. 4; and Stow, *Survey*, I, p. 37.

VISITATIONS

From the time of its foundation, the Priory of St Bartholomew was an institution favoured by the Crown, the City of London and also the Christian community. Thus, the alarming event of the forced visitation of the house in May 1250 by Boniface, archbishop of Canterbury (1241–70), shook the institution to its core.

Boniface was the son of the count of Savoy and uncle to Eleanor of Provence, wife of Henry III. Against the wishes of some of the English clergy, Henry nominated Boniface to the see of Canterbury in February 1241. In an attempt to placate the king, the hesitant and newly elected Pope Innocent IV confirmed the appointment on 16 September 1243. Being a foreigner, Boniface had spent very little time in England. In fact, he was not officially enthroned until 1249, when he returned to England after six years of being absent only to find his diocese in considerable debt. Boniface's response to this revelation was to obtain a grant from the pope to tax his clergy for seven years. As can be imagined, this did not make him a popular archbishop. Those that refused to pay their taxes were threatened with suspension or even excommunication. While these taxes brought in considerable sums of money, we are told by Matthew Paris – a Benedictine monk and contemporary chronicler – that this was not enough for Boniface, who, in 1250, claimed the right of visitation over the whole province of Canterbury. This act was deeply unpopular, especially in London.

According to Matthew Paris's entertaining but also biased account of the event, Boniface first visited his monks in Canterbury, Faversham and Rochester, where he extorted considerable sums of money. He then continued to London, where he first visited Fulk Basset, bishop of London, to demand food, drink and harnesses for his horses. Once he had finished with the bishop, Boniface went on to visit the chapter of St Paul's, where the canons opposed him and said they would appeal to the pope. In response, Boniface excommunicated the dean and several canons of the cathedral. Seething in anger, the archbishop then went to the Priory of St Bartholomew, where he was met by a solemn procession in his honour comprised of Robert the sub-prior (the prior was away on an unknown errand) and canons dressed in their ceremonial gowns. Unimpressed by their display, Boniface announced he was there on visitation. One of the canons responded by telling the archbishop that they had a respectful and careful bishop who held that office and that they would not be visited by any other. Hearing this response, the archbishop became angry and rushed on the sub-prior, inflicting blows with his fist. He then began to yell at the sub-prior and drew his sword. The canons rushed to their sub-prior's aid, rescuing him from the 'jaws of death' and pushing the archbishop backwards. His robes were thrown aside, exposing the armour that he shockingly wore underneath. While this was happening, the archbishop's armed retinue cruelly attacked the rest of the unarmed canons, causing considerable injuries.[37] Once the skirmishes were over, four of the canons who had not been badly injured sought the advice of the bishop of London, who advised them to raise their complaint with the king. King Henry III, not wanting to get involved, refused to see the canons.

37 *Matthew Paris's English History from the Year 1235 to 1273*, trans. by J.A. Giles, 3 vols.. (London: Henry G. Bohn, 1852–54), II, pp. 346–50.

On hearing about the canons' mistreatment, Londoners became enraged and threatened to cut the archbishop to pieces. Boniface, in secret, hurried to the king and his niece the queen and made a complaint against the canons. Fearing the City's reaction, but also not wanting to displease the archbishop, Henry sent a proclamation to the City forbidding anyone from harming him. Boniface then proceeded to his palace in Lambeth, where he renewed his sentence of excommunication against the canons of St Paul's and St Bartholomew's. He then returned to Canterbury and made preparations to visit the Roman court, where he held great influence. The dean of St Paul's along with several canons of the church also went to Rome, where they made heavy complaints against the archbishop. In the end, the pope decided not to excommunicate the dean and the canons; however, in 1252 he did decide against them for objecting to the archbishop's visitation. The pope then issued a mandate allowing the archbishop from that day forward the right of visitation of London. The canons of St Bartholomew never received any compensation for their suffering.[38]

It is difficult to say how much of Paris's story was true. The sub-prior who was supposedly badly injured in the attack went on to become prior and served in the office for eleven years. Boniface on the other hand is also a complicated figure. Matthew Paris detested the man, while more modern histories of him see him as a respected and reforming archbishop. What is important to note about this event is that the king did not honour his royal charter to protect the canons (a charter which was first issued by Henry I and re-issued by subsequent kings). In fact, in 1252 Henry III decided to issue a new charter to the priory reiterating his commitment to St Bartholomew's (much like earlier royal charters) but specifically focusing on the protection of the monastery's physical possessions new and old and not of the canons themselves. By focusing on the property of the priory, the king would no longer be put in the politically difficult situation of choosing between the canons and archbishop.

After the forced visitation of the priory in 1250, it would seem the priory maintained a good relationship with the Crown. In fact, in 1294, when Edward I (r. 1272–1307) needed to raise money for the war with France, the priory granted the king a moiety (portion) of what the monastery paid in ecclesiastical tax for that year.[39] While this gift seemed to have appeased the king, it did not make Robert Winchelsea, archbishop of Canterbury (1293–1313), very happy. Robert, who in 1297 had headed the revolt against Edward I's taxation of the clergy for his wars, decided in 1303 to exercise the right of visitation given by Pope Innocent IV in 1252. The result of the visitation was a list of injunctions for the monastery to follow.

The first of these injunctions was a direct response to the priory's financial gifts to the king and stated that the priory should not be allowed any sale (or grant) of any goods belonging to the monastery for any cause unless they acquired licence from the proper religious authorities. The injunctions then referred to the brethren's dress and stated that the canons were not to receive money to pay for their garments, but were to be given new clothes when their old ones needed replacing. They were also expected to return their old

38 Webb, *Records*, I, pp. 121–27.
39 Webb, *Records*, I, p. 138.

garments, which suggests that the canons may have been using the funds for other purposes or that there were noticeable differences between the canons' dress.[40]

The next injunction was a commentary on the canons' way of life and on some of them not abiding by the Augustinian rules. It ordered that:

the brethren keep [...] better than they have been wont to do [...] silence according to the observance of their rule [...] and that the prior, or the persons holding his place, impose upon any brother [...] for every time when he shall so have broken silence, one day's Friday fast of bread and water, or mark one so convicted by punishing him according to the frequency of the fault committed.[41]

The ruling went on to mention that the gate of the close and of the houses within should be 'more strictly guarded and kept shut at the due hours' to guard against 'the frequent coming of seculars, as has been wont to happen'. This injunction was then followed by three more minor rulings. The first of these addressed the sick brethren in the infirmary and insisted they be given more (meat) dishes and, 'more freely than the whole brethren, suitable cereal food'. This was followed by a recommendation expressing concern for the elderly prior and his feeble state, ordering that he was not to walk alone in the garden or elsewhere in a 'lonely place' but rather have an 'honourable companion' with him when he desired to walk or stroll, so that if he fell he would have someone to help him. The final injunction ordered the prior to 'read aloud openly and exactly' these rulings and the priory's ordinances four times per year to remind the canons of their duties.[42]

From these injunctions it is clear there was not much at fault with the house. There was no mention of serious financial mismanagement or misconduct between the priory and hospital. Nor is there mention of the brethren seriously misbehaving, which was a common feature in visitation records for this time. For instance, during the 1304 visitation of the Abbey of St Osyth in Essex, the canons were found guilty of not keeping their religious hours, partaking in unworthy gossip instead of conversations about faith, leaving the abbey without permission, not visiting the sick in the infirmary, not providing funds to the poor, inviting women into areas of the house they were not allowed, and entertaining their friends in town with monastery funds.[43] St Bartholomew's Priory, on the other hand, was a place where the king and Church sent other monks either for safekeeping or for penance. Such was the case of an unnamed monk who was implicated in the robbery of the king's treasury at Westminster Abbey in 1303, or of a canon from St Osyth's, Robert de Stratford, who in 1308 was sent there for penance after being convicted of unspecified grave charges 'which tended to the scandal of the order'.[44]

40 Webb, *Records*, I, p. 143.
41 Webb, *Records*, I, p. 144.
42 Webb, *Records*, I, p. 144.
43 'Houses of Austin Canons: Abbey of Chich or St Osyth's', in *A History of the County of Essex: Volume 2*, ed. William Page and J. Horace Round (London: Victoria County History, 1907), pp. 157–62.
44 Webb, *Records*, I, pp. 144–45.

INCOME

The Fair

The priory derived income from a number of different sources, one of which was its annual fair. Henry I's 1133 charter granted the priory a portion of the income generated from the fair, which the king shared with the City of London. Originally, the fair had been a horse and livestock market; however, it later became an important location for the selling of cloth – one of the most valuable commodities for the English economy. This is probably why the street east of Smithfield is named Cloth Fair.[45]

For the first 200 years of its existence, the fair was held inside the walled precinct of the priory, on the north side of the church and extending into the graveyard.[46] Merchants would set up their booths and stalls within the walled grounds and each night the gates would be locked to ensure the safety of the traders' valuable goods. Protection for the traders was granted in Henry I's 1133 charter, which was reconfirmed by subsequent kings for the next 250 years. The charter's protection extended not only to those selling at the fair but also to anyone travelling to attend it, including exemptions from paying tolls coming into the city and outside the city walls. The income for the fair was collected by a royal servant such as one of the London sheriffs or by one of the canons, who would sit outside the main priory gate opening on to Smithfield and the postern gate opening on to Long Lane collecting the dues.[47]

While the monastery was a popular location for local charity, the fair would appear to have been a point of contention between the City and priory. The first real rumblings of this came in 1246 when the monastery tried to introduce a new 'tron' (weighing scales) at their fair. This would have been financially beneficial to them, and also convenient for those selling and buying, because at the time there was only one set of scales in the city to which sellers and buyers had to take their products to be weighed. City officials, seeing the possibility for corruption and loss of revenue, quickly quashed this idea and the priors yielded without a fuss.[48] Matters between the two were not made easier in 1292, when Edward I took away the City's privileges (including self-government, and tax and trading exemptions). However, he still allowed St Bartholomew's its rights over the income from its fair.[49]

Despite the waning popularity of fairs in the fourteenth century due to buyers and agents purchasing goods directly from merchants, Bartholomew Fair continued to be a popular event for the city. It also became known for disorder and rowdiness. Pleasure-seekers flooded into the area not only to buy cloth and other goods but also to take part in the spectacle of the event. Revellers could see jesters, tumblers, stilt walkers, and enjoy plays and music, listen to sermons, watch wrestling matches, and even attend scholarly

45 William Fitz-Stephen, 'A Description of London', trans. by H. E. Butler, in F. M. Stenton, *Norman London: An Essay*, Historical Association Pamphlets, 93, 94 (1934), pp. 26–32 (pp. 28–29).
46 Stow, *Survey*, I, pp. 74–75 and II, p. 27.
47 Caroline M. Barron, 'The Government of London and its Relations with the Crown 1400-1450' (unpublished doctoral thesis, University of London, 1970), p. 228 n. 3.
48 Webb, *Records*, I, pp. 298–317.
49 Gwyn A. Williams, *Medieval London from Commune to Capital* (London: Athlone Press, 1970), pp. 243–63.

debates by local grammar school pupils.[50] The fair was also known for public executions. Sir William Wallace, the Scottish rebel, was hanged, drawn and quartered in 1305 in sight of the jostling crowds. Fairgoers were said to have watched the spectacle and then quickly returned to the festivities.[51] The fair had become such a riotous event that in 1363, fearing for their own safety and for the safety of their goods, several important merchants decided not to return. On hearing this, King Edward III (1327–77) issued new protections to fairgoers, which were reissued in 1373 and 1376.[52]

By 1377, the fair had not only expanded from three days to four, it had also outgrown the priory precinct and spilled out into neighbouring Smithfield. This blurred the lines between those who had the rightful oversight of the fair and, more importantly, those who financially benefitted from the trading levies. The City, seeing an opportunity, quickly responded by placing regulations and fees on traders selling outside the priory. By 1400, Henry IV (r. 1399–1413) had granted all dues and customs to the citizens, possibly in response to the priory's inability to maintain the peace at their fair. However, by 1430 the priory, in desperate need of funds, prosecuted Henry Barton (mayor 1428–29) for having prevented them from enjoying the profits of the fair.[53] An agreement was eventually reached in 1447 between the City and the priory, and it was decided that they would return to their original agreement whereby the City and the priory would each place representatives (wearing the City arms and the badge of the Crown, respectively) within the fair and equally share the profits from the collected dues.[54]

St Bartholomew's Fair remained an important trading event and source of income for the city and the priory up to the priory's dissolution. The valuation given for the income of the Fair in 1539 was £65 (£27,388 today), just under a tenth of the total income of the priory at its suppression.[55] The dissolution of the priory, however, was not the end of the fair. In fact, the fair continued into the mid-nineteenth century. It was eventually suppressed because it no longer generated enough revenues for the city and because it became a location of public disorder and immoral behaviour.[56]

Landed Endowments

The majority of the priory's income came from its diverse property portfolio. Webb's history of the priory provides a detailed breakdown of the monastery's holdings from its foundation in 1123 to its suppression in 1539.[57] According to Webb, the monastery initially survived on random donations of food and money. It also drew an income from a handful of properties outside the City of London granted by Henry I. Between 1144 and

50 Cornelius Walford, *Fairs, Past and Present: A Chapter in the History of Commerce* (London: Elliot Stock, 1883), pp. 164–243 and Stow, *Survey*, I, p. 74.
51 This same location also saw the execution of Wat Tyler, leader of the Peasants Revolt in 1381. A plaque for each man is displayed on the northern wall of St Bartholomew's Hospital today.
52 Webb, *Records*, I, p. 302.
53 Barron, 'The Government of London', p. 228 n. 4.
54 Ibid.
55 Webb, *Records*, I, p. 298. Modern valuations come from the National Archives Currency Converter: https://www.nationalarchives.gov.uk/currency-converter/.
56 Webb, *Records*, I, p. 317.
57 Webb, *Records*, I, pp. 321–77, 428–89, 528–57.

1174, however, there was a noticeable increase in grants of property – particularly religious endowments – many of which were located in the City of London such as St Michael Bassishaw, St Martin Pomery and St Sepulchre.[58] These bequests often came from wealthy 'foreigners' (people from outside the City of London but from England) and the income they generated came from the collection of tithes or through the appointment of a parish priest, which had monetary advantages.

By the late thirteenth to mid-fourteenth century, the priory had expanded its land holdings through bequests in wills which were proved and then enrolled in religious and lay courts. The oldest of these courts was the Husting, where pleas concerning the tenure of land were heard and where Londoners would often prove their wills if they related to property in the City. According to these wills, the priory was a popular outlet for charitable Londoners who often left bequests of money and land for the maintenance and repairs of the priory and also for the canons and their charitable work.

The estimated income of the priory in 1291 was just over £176 per annum (the equivalent of £129,716 today) and their property assets extended to Essex, Hertfordshire, Buckinghamshire, Suffolk and Middlesex together with rents and tenements in 49 different parishes across London.[59] However, the priory's fortunes were about to change. By the mid-fourteenth century, bequests of land began to decrease and were eventually replaced by small pecuniary gifts for prayers and burial, a trend which was not seen in earlier periods.[60]

The decline in bequests of land can possibly be attributed to a royal crackdown on the granting of property. Religious houses across England had seen a steady increase in their land bequests – often given in perpetuity – in the twelfth and thirteenth centuries. This meant that the Crown could no longer generate an income from the land, nor did it have much legal authority over its use. In an attempt to stop this loss of potential revenue, the Statutes of Mortmain (which translates as 'dead hand') were enacted in the late thirteenth century. These statutes were meant to help generate an income for the Crown and also to deter the granting of land through complicated legal arrangements. As a result, many religious houses across the country saw a steady decrease in their property gifts. The Statutes of Mortmain also gave the Crown the authority to assess the property holdings of religious houses, which resulted in the seizing of numerous estates across the country because they had not gained proper licence.[61] St Bartholomew's Priory was just one of many houses the Crown decided to assess and, in 1374, after discovering the priory had not gained proper licence for any of their gifted lands, the priory was fined 40 marks (£8,338 today) but was allowed to keep the majority of their estates on account of the king's 'affection'.[62]

The decline in property bequests to the priory can also be attributed to several other circumstances. For instance, Londoners were now investing considerable sums of money in their local parish churches and religious fraternities (small religious groups within a

58 Minnie Reddan, 'The Priory of St Bartholomew, Smithfield', in *The Religious Houses of London and Middlesex*, ed. Caroline M. Barron and Matthew Davies (London: University of London, 2007), pp. 90–95 (p. 92).
59 See Appendix I for a full breakdown of the rental property income from the 1291 *Taxatio ecclesiastica*.
60 See Appendix II.
61 Helena M. Chew, 'Mortmain in Medieval London', *The English Historical Review*, 60.236 (1945), pp. 1–15 (p. 14).
62 *Calendar of Patent Rolls, Edward III: 1370–1374* (London: His Majesty's Stationery Office, 1916), pp. 426–28.

parish church). St Bartholomew's Priory was also a wealthy and well-established religious house at this time with an estimated income in 1379 of 500 marks (£205,513 today).[63] Testators would have known this about the priory and were more inclined to invest in institutions which were struggling or were more embedded in service to the community such as London's hospitals, which saw an increase in bequests in the late fourteenth and fifteenth centuries.[64] There were also a handful of new institutions in London, such as the Charterhouse, founded in 1370 just north of the priory in Smithfield.[65] These institutions would have reflected the religious values of that age, and thus St Bartholomew's had to compete against a number of different factors for their bequests.

This decline in property bequests overlapped with the monastery losing its oversight of the hospital (1373) and its rights over the income from the fair (c. 1400). These losses, along with the transformative events of the time, brought about a period of hardship for the priory.

TROUBLED TIMES

The Black Death, which swept across Europe between 1347 and 1351, had a profound impact on the second half of the fourteenth century, killing an estimated 30% of the population, or roughly 25 million people. London was hit particularly hard. Over the course of eighteen months (1348-50), its population – estimated to have been around 60,000 – was reduced by over half.[66] Religious houses were the perfect breeding ground for plague because of their close living arrangements; across Europe and England entire monastic communities were completely wiped out.

There are a limited number of sources that tell us about the loss of life within the priory. It would appear that the prior of St Bartholomew's, John de Pekesden, died from plague in 1350, near the end of the first wave, and that Prior John de Carleton died of plague in 1361, following a later outbreak. The Clerical Subsidy of 1379 also helps shed light on this event; it mentions only 23 people living at the priory at this time; the prior, fifteen canons, four clerks and three others.[67] This would have been a significant reduction from the 35 canons established in 1173.

The disruption caused by the Black Death not only significantly reduced the population, but was also a catalyst for trouble within the Church. The Papal Schism (1378-1417), when two and later three men simultaneously claimed the title of pope, exacerbated the already growing resentment and mistrust within the Christian community, some members of which began calling for reforms. One of the key figures behind this movement was John Wycliffe (c. 1330-1384), an English scholastic philosopher and theologian from the University of Oxford who wrote a number of treatises on the reform of the Church.

63 Webb, *Records*, I, pp. 168-77, 365-77.
64 This trend can be seen in both the Husting and Commissary Court wills for the time. See Appendix II for further details.
65 D.C. Knowles, 'The London Charterhouse', in *Religious Houses*, pp. 247-59 (pp. 249-50).
66 Barney Sloane, *The Black Death in London* (Stroud: The History Press, 2011), p. 15.
67 Webb, *Records*, I, pp. 163-64, 172.

Wycliffe's followers were often referred to as Lollards. The prior of St Bartholomew's, John Eyton *alias* Repyngdon (1391–1404) was not only a colleague of Wycliffe's at Oxford but also one of his sympathizers. Circa 1382, while studying at Oxford, Eyton published a series of sermons called *Sermones super euangelia dominicalia* ('Sermons on the Sunday Gospels') and in 1387 a work called *Tractatus de usura* ('Treatise on usury'), both of which echoed some of Wycliffe's more conservative ideologies.

Unlike those of some followers of Wycliffe, Eyton's relatively orthodox treatises were not intended for the general public, but rather for those studying at university, and focused more on eradicating corruption in the Church than dismantling its fundamental beliefs. Therefore, his writings did not attract the attention of William Courtenay, archbishop of Canterbury (1381–96), who brought charges of heresy against both Wycliffe and Philip Repyngdon, bishop of Lincoln (1404–24), who, in the sixteenth century, was mistakenly credited with writing Eyton's sermons. John Eyton had been a canon at Repton Priory in Derbyshire before attending graduate school in Oxford. It is thought that he may have picked up his *alias* while at Oxford because in the documentation for his appointment as prior in 1391 both names were mentioned. The coincidence that both he and Bishop Repyngdon had been at Oxford at the same time and that both were known Wycliffe sympathizers has caused considerable confusion over the years. Nevertheless, contemporaries would have understood who to credit for these particular sermons.[68]

When Thomas Arundel became archbishop of Canterbury (1396–97 and 1399–1414), he took up Courtenay's torch of rooting out heresy. With the support of Henry IV (r. 1399–1413) and his Parliament, the statutes *De haeretico comburendo* ('Concerning the burning of heretics') were passed in 1401, giving clerical heads permission to burn heretics, something which Henry's predecessor Richard II (r. 1377–99) had resisted.[69] The statutes had not yet been formally promulgated when the execution of the Lollard priest William Sawtrey was ordered by royal decree. Sawtrey had come to London in 1401 from his native Norfolk and was the parish priest of St Benet Sherehog. Sawtrey preached and endorsed Lollard beliefs such as the rejection of saints and the sacrament of the Eucharist. While Eyton sympathized with certain Lollard beliefs, this most likely would have been a step too far for him. Sawtrey was burned at the stake just outside St Bartholomew's priory gates.[70] It is not clear whether Eyton played a role in this event.

The next Lollard was not burnt in Smithfield for nearly ten years. According to contemporary chroniclers, in 1410 the prior of St Bartholomew's, John de Watford, was present at the burning of John Badby, the first layman to suffer capital punishment in England for the crime of heresy. Badby, a tailor, openly spoke against the real presence of Christ in the Eucharist and refused to renounce his beliefs when brought to trial. Being found guilty of heresy, Badby was taken to Smithfield, put in an empty barrel, bound with chains to a stake, and surrounded by dry wood. Prior Watford then brought the Holy Sacrament with

68 Richard Sharpe, 'John Eyton *alias* Repyngdon and the *Sermones super euangelia dominicalia* attributed to Philip Repyngdon', *Medium Ævum*, 83.2 (2014), pp. 254–65.
69 Alison McHardy, '*De Heretico Comburendo*, 1401', in *Lollardy and the Gentry in the Later Middle Ages*, ed. Margaret Aston and Colin Richmond (Stroud: Sutton, 1997), pp. 112–26.
70 Charles Kightly, 'Sawtre [Sawtrey], William (d. 1401)', *ODNB*.

twelve torches before him and asked Badby what he believed. Badby responded by saying that he believed it was holy bread but not the blessed body of Christ. The king's eldest son, Henry of Monmouth (later Henry V), charged Badby to abandon his Lollardy and save himself. Badby refused and the barrel was lit. As Badby screamed out in pain, Monmouth called to extinguish the fire and offered Badby a pension if he would renounce his heretical beliefs. Badby refused and Monmouth ordered the fire lit again. Badby was burnt to ashes.[71] Badby's trial was 'a show trial of national importance' – a key set-piece in a contemporary struggle between the Crown and Parliament, which (emboldened by the scandal of Henry of Monmouth's friendships with alleged Lollards) had petitioned for the confiscation of ecclesiastical revenues. The secular arm, not the Church, was responsible for burning heretics, and John de Watford's part in the burning seems to have been confined to bringing the Blessed Sacrament before the condemned man.[72]

The priory was experiencing a number of troubles at the turn of the fifteenth century. Several of its buildings were suffering from considerable neglect and needed repair. Roger Walden, later bishop of London, invested considerable sums of money towards the rebuilding, which included work to the bell tower, high altar, choir, clerestory, arches and roof of the priory church.[73] These overzealous building works, which began at the end of the fourteenth century and continued into the mid to late fifteenth century, would place significant strain on the priory's finances. The priory had also seen a noticeable drop in its income due to the loss of the hospital, the income from the fair, a reduction in lucrative bequests, and the depreciation of its properties after the Black Death. For instance, one of their properties in Yarmouth and tenements in London, which ten years earlier were bringing in an income of 100 marks (just over £98,000 today) was now yielding half that sum. Several of the tenements the priory owned in London had also suffered considerable damage from the flooding of the Thames and were no longer habitable; thus, they did not provide an income.[74]

While the priory struggled with its debt, its prior, John de Watford, would play a significant role in religious history. Out of patience with the Papal Schism and the scandal it was causing within the Church, a college of cardinals summoned a full independent council at Pisa (25 March 1409), which Prior Watford attended along with Nicholas Bubwith, bishop of Bath and Wells, and Richard Clifford, bishop of London. At this council, the two popes, Gregory XII and Benedict XIII, were deposed and Pope Alexander V was elected. Watford evidently played an important role at this council and on his return to the priory received a number of tax exemptions and allowances. Additionally, Pope Alexander V, who was pope

71 Thomas Walsingham, *The St Albans Chronicle, 1406–1420*, ed. V. H. Galbraith (Oxford: Clarendon Press, 1937), pp. 51–52; Webb, *Records*, I, p. 196.
72 Peter McNiven, 'Badby, John (d. 1410)', *ODNB*.
73 This period was referred to by Webb as the 'great restoration'. However, this term was not used by contemporaries. When Webb wrote his history of St Bartholomew the Great, the parish church was undergoing considerable restoration. Webb, being the Secretary of the Restoration Committee, most likely used this term because he wanted to draw a comparison/connection between the modern nineteenth century church and its medieval past. For more on the medieval restoration, see the chapter by Stephen Heywood; for more on Roger Walden, see the chapter by Christian Steer, both in this volume.
74 Webb, *Records*, I, pp. 198–99.

for a year, granted the monastery for ten years 'the same indulgence and remission of sins as those who visited St Mark's in Venice'. These gifts could be used on Ascension Day, Maundy Thursday, Good Friday, Holy Saturday and the day of the Assumption. According to the grant, visitors were expected first to give alms to the priory for its repair and conservation and then receive their indulgence (forgiveness of sins).[75] These indulgences, along with the commissioning of the translation of the priory's foundation book, were probably part of an attempt to revive the spiritual reputation of the monastery and to help increase donations. Both Watford and Pope Alexander V expected the indulgences to generate enough income to cover the rising costs of the priory's extensive restoration works. Unfortunately, this plan did not turn out to be the money-spinner that they had anticipated. Nor is there proof of the priory becoming the spiritual destination they had intended.[76] One possible reason for this is that the lay community had begun to question such arrangements and instead focused their attention on acts of charity, such as helping their local parish churches and religious fraternities, rebuilding of local infrastructure, marriage of unwed women, and support of orphans and hospitals.

Extensive building works and the loss of income continued to drive the monastery deeper into debt. By 1433 Robert Gilbert, bishop of London, took the administration of the priory under his control 'for the benefit of the church and the reformation of defects found on his regular visitation'.[77] This was not uncommon for the time: in fact, a number of London's religious houses such as Holy Trinity Priory and the hospitals of St Giles, St James and St Thomas of Acre had been briefly seized by the king and the bishop of London because they were either not fulfilling their purpose or were in significant debt.[78] The bishop's oversight of the priory lasted for three years; however, the priory would continue to struggle financially. While the building works and loss of income were major factors in the priory's financial problems, the canons claimed in a 1440 appeal to King Henry VI for exemption from paying and collecting subsidies that their financial struggles were due to hospitality.[79]

As part of their foundation charter, the priory was required to care for the poor and offer succour to those in need. One possible sign that hospitality was placing a financial strain on the monastery was the fact that in 1439 it had racked up the unbelievable debt of £293 (£188,401 today) on ale, which they owed to John Spencer, former master of the Brewers' guild in London, who sought to recover the debt in 1444. In this dispute, the prior argued that the debt had been settled in 1439 by a payment of £60, which was read to Spencer in English in the prior's chamber surrounded by a number of canons and a clerk of the exchequer. Spencer claimed the acquittance was a forgery; the court, however, ruled in the priory's favour.[80]

75 Webb, *Records*, I, pp. 196–98.
76 While there was an increase in burial requests for the priory in the fifteenth century, these bequests do not appear to be associated with Prior Watford and Pope Alexander's spiritual agenda. This trend is most likely due to the increase in testators requesting where they wished to be buried in fifteenth century London wills.
77 Webb, *Records*, I, pp. 493–95.
78 Caroline M. Barron, 'Introduction', in *Religious Houses* op. cit., pp. 5–24 (p. 22).
79 Webb, *Records*, I, pp. 204–06.
80 Webb, *Records*, I, pp. 499–500.

It is difficult to say who was at fault in this case. A settlement of £60 suggests Spencer may have exaggerated the scale of the debt. However, the priory did host a number of guests, which would have required large amounts of ale. The main drink of the canons at each meal would have also been ale, and it is probable that this bill had been running for several years, given the priory's financial situation. Nevertheless, by the end of the fifteenth century the priory's luck began to change.

BUILD-UP TO THE SUPPRESSION

One of the first positive developments we can see in the priory's fortunes is in the appointment of novices. Over the course of the fifteenth century, Augustinian houses across England saw a steady decrease in their ability to recruit new members. However, this was not the case in London and the surrounding suburbs. From 1400 to 1439, St Bartholomew's recruited nineteen new novices; this was greater than other institutions outside the city, but significantly lower than other Augustinian houses such as Holy Trinity and St Osyth's in Essex, which each ordained 45 new novices during this period. It is possible that these low numbers are a reflection of the financial issues the priory was having at the time. However, between 1490 and 1529 St Bartholomew's ordained 54 new novices, making it the most popular and desirable Augustinian house in the London area, if not the entire country.[81]

There are a number of explanations for this. First, by the beginning of the sixteenth century the priory had managed to re-establish its financial stability. This was most probably due to the improvement in rental income, the completion of the restoration building works, and the priory's close relationship with the Crown. This relationship became even more pronounced with the king's appointment of Prior William Bolton (1505-32). Prior Bolton was one of Henry VII's (r. 1485-1509) trusted advisors, and in 1509 was named master of the king's works, overseeing the completion of Henry's Lady chapel at Westminster Abbey. Henry VIII (r. 1509-47) continued his father's patronage, assigning Bolton the oversight of a number of royal building projects at the Tower of London and Cambridge University, and the rebuilding of New Hall near Chelmsford in Essex.[82]

It is difficult to imagine how much responsibility Bolton would have had at St Bartholomew's Priory. It can be assumed that the sub-prior was responsible for the majority of the everyday functioning of the house. Bolton, however, oversaw a number of building projects on the priory church, including the rebuilding of the prior's lodgings and its glorious oriel window, which would have allowed the prior to observe the services in the church while remaining in his house.

Nevertheless, Bolton's commitment to St Bartholomew's may be questioned. In 1518, he was fined £10 by the canons for not appointing a deputy to oversee his duties, especially those related to the visitation of the priory. This fine, however, did not seem to discourage Bolton from taking on more roles. In 1522, he became rector of Harrow on the Hill in Middlesex and was said to have built a house there. Where Bolton spent most of his time

81 Virginia Davis, *Clergy in the Late Middle Ages: A Register of Clergy Ordained in the Diocese of London Based on Episcopal Ordination List, 1361–1539* (London: Centre for Metropolitan History, 2000), pp. 36–37.
82 Judith Etherton, 'Bolton, William', *ODNB*.

remains uncertain. According to John Stow's *Survey of London*, Bolton had only 'bestowed some small reparations on the parsonage house [...] [and] builded nothing there more than a Dovehouse'.[83] However, a serious illness in 1527 would render Bolton immobile for the rest of his life. He eventually died in London on 5 April 1532 and was buried before the high altar of the priory church.[84]

Being prior of St Bartholomew's was a lucrative and powerful position, and when Bolton became ill in 1527 many were anxious to secure this highly coveted post. For instance, shortly after Bolton fell ill, William Fynch, cellarer of the priory, petitioned Cardinal Wolsey, offering £300 towards the building of Christ Church – Wolsey's Oxford college – in exchange for preferment to prior when Bolton died.[85] This offer was not enough to sway the cardinal or king. However, the king had his heart set on a number of valuable properties held by the priory, and that drew his attention to another interested candidate.

Robert Fuller was abbot of Waltham Holy Cross in Essex, one of the wealthiest and most important abbeys in England. Fuller had recently granted the king a number of valuable lands in Hertfordshire and Essex, and it would appear had struck a deal with the king regarding the priory's coveted manors in Canonbury and Cutlers in the parish of Islington in return for his appointment. In a letter written on 22 May 1532 to Thomas Cromwell (then master of the king's jewel house), Fuller appealed to Cromwell:

Please continue your goodness towards finishing this matter for the house of St Bartholomew's, as liberal motions have been set forward. Such matters shall be largely recompensed on my part, not only in reward for your labours, but also for such yearly remembrance as you shall have no cause to be sorry for.[86]

Fuller was elected prior on 28 June 1532 and, within three months of his appointment, had granted Cromwell (on behalf of the king) a lease to both manors. This transaction took place not long after Henry VIII and Anne Boleyn's five-day visit to Waltham Abbey during Henry's summer progress that year.[87] This deal and many that occurred later are characteristic of the relationship Fuller had with both Cromwell and the king. Fuller's associations with Waltham Abbey proved a valuable asset to Henry, and thus Fuller was able to maintain his post at the abbey together with his oversight of St Bartholomew's.[88] At the helm of both institutions, Fuller helped orchestrate a number of valuable property exchanges to the financial benefit of the king and both religious houses. At one point it was even suggested that St Bartholomew's be appropriated by Waltham Abbey in exchange for the manor of

83 Stow, *Survey*, II, pp. 26–27.
84 Webb, *Records*, I, pp. 223–29.
85 Webb, *Records*, I, p. 236.
86 Webb, *Records*, I, pp. 242–43.
87 David Starkey, *Six Wives: The Queens of Henry VIII* (New York: Harper Perennial, 2004), p. 454.
88 Waltham Abbey was a popular location for Henry VIII's court because of its close proximity to the royal hunting grounds in Waltham Forest. In fact, from 1532–34, a number of royal summons were issued from Waltham Abbey suggesting the monastery had become a pseudo palace-monastery much like Westminster Abbey during the Lancastrians (1399–1471): James G. Clark, *The Dissolution of the Monasteries A New History* (New Haven: Yale University Press, 2021), p. 203.

Epping.[89] This would have been a valuable acquisition for the abbey; however, this never came to fruition possibly on account of Fuller's other post as commissioner of the religious houses in England.

The commission of religious houses was created in 1535 after Henry VIII passed the Act of Supremacy declaring himself and his successors Supreme Head of the Church in England. The commission's job was to survey the finances of all religious houses in England, Wales and parts of Ireland, and their report is known as the *Valor Ecclesiasticus*. Unlike Prior Bolton, Fuller did not allow his royal appointments to distract him from his responsibilities at the priory and abbey. He played an active role at both institutions, helping secure their financial stability and promoting the careers of his fellow canons and monks. For instance, in 1536, Fuller created the position of parish clerk of the chapel of All Saints (located in the priory church) for a man by the name of Stephen Fyndley. Fyndley had already been serving in this role for several years; however, it had not been a formal appointment, which he would have needed in order to secure a pension. This official appointment ensured Fyndley a pension of £3 8s per annum and an allowance of meat, drink and clothing.[90] Nevertheless, there were complications and in 1541 Fyndley's pension was in jeopardy, but, after bringing his case and signed documentation before the Court of Augmentations (an administrative body dealing with the confiscated lands and physical possessions of the religious houses), Fyndley was granted his pension for life.

As a commissioner of the religious houses, Fuller served with a man named Richard Rich, who would later become chancellor of the Court of Augmentations. Fuller and Rich appear to have maintained a close relationship up until Fuller's death in 1540. In fact, Fuller's will left Rich £20 'for such goodness he had found in him'.[91] It is difficult to say whether Fuller was more active in the design and execution of the dissolution of the monasteries. While he was obviously on good terms with Henry, Cromwell and Rich, he could easily have been one of many that were swept along with the process and personally made the most of it. His signature cannot be found on the Act of Supremacy, but it can be assumed he complied with the king's wishes or else he would have been executed for treason like John Fisher, Sir Thomas More and seventeen of the monks from the neighbouring Charterhouse.[92] Fuller's name was, however, on a handful of other Parliamentary Acts including the 'Six Articles', which confirmed the doctrines of transubstantiation, communion in one kind only, compulsory celibacy of the clergy, perpetual obligation of vows of chastity, use of private masses, and auricular confession. Much like the Lollards in the fifteenth century, anyone who spoke against these articles was executed by the secular arm. Such was the case in 1538 of John Forest, Catherine of Aragon's confessor, and of Anne Askew, an English writer, poet and Protestant preacher, who was burnt outside St Bartholomew's Hospital in 1546 (fig. 2.3).[93]

89 Webb, *Records*, I, p. 243.
90 Webb, *Records*, I, pp. 245–46, 248.
91 Webb, *Records*, I, p. 261.
92 Knowles, 'The London Charterhouse', p. 257.
93 Webb, *Records*, I, pp. 248–50.

2.3. Woodcut of the burning of Anne Askew, for heresy, at Smithfield in 1546, from John Foxe's *Acts and Monuments*, 1563

SUPPRESSION OF THE PRIORY

When Henry VIII first set out to reform the Church in England, it is unlikely that he planned to suppress all monastic houses. His initial intentions were driven more by a need for funds and were carried out with the advice and counsel of Thomas Cromwell and Richard Rich. Nevertheless, by 1538, their agenda became clear as the greater and more important religious houses began to fall victim to their plans. The wave of suppression finally made its way to the doorsteps of St Bartholomew's Priory on 25 October 1539, when it and the hospital were both dissolved. St Bartholomew's was one of the last religious houses suppressed, and the transaction went remarkably smoothly. This was probably the result of Robert Fuller's relationship with the king, Cromwell and Rich, and his awareness of the imminent suppression. In fact, only four months before its dissolution, Fuller finally sold the coveted manor of Canonbury to the king.

The deed of surrender for the priory (fig. 2.4) was sealed in the chapter house and a translation has been provided in APPENDIX III. It is worth noting that Fuller's other house, Waltham Abbey, was eventually dissolved 23 March 1540, making it the last monastic house in the country to be suppressed. It was not until a year after the priory's suppression, however, that St Bartholomew's canons received their official pension letters from the Court of Augmentations. Each deed was identically worded, except for the amount of the pension and the name of each pensioner. A translation of the sub-prior's letter has been provided in APPENDIX IV. The agreement set out by the Court of Augmentations was that each canon was to be given food and clothing to sustain them along with an annual pension that was to be paid at Michaelmas (29 September) and Lady Day (25 March).[94] A canon's pension was to cease if the recipient was advanced by the king to any ecclesiastical office. The letters were

94 TNA E315/234.

2.4. The original act of surrender for St Bartholomew's Priory. TNA E322/136

dated 20 November 1540 and witnessed by Richard Rich at Westminster. Table 1 shows the list of the thirteen canons and their allocated pensions. The pension deeds do not explain why certain canons received more income than others, though this may have been established on seniority, which could have been based on either length of time within the house or the recipient's official duties. It is also interesting to note that Stephen Fyndley, the parish clerk whom Fuller helped secured a pension, received a considerably smaller annual pension than the canons of the priory. This is probably because he was a parish priest and not an official canon of the house.

TABLE 1 *List of Canons and their Pensions at the Dissolution* [95]

	£	s	d
Robert Glasier, sub-prior	15	0	0
William Barlowe	10	13	4
John Smyth (senior)	10	13	4
Henry George	6	13	4
John Smyth (junior)	6	13	4
Christopher Reynolds	6	13	4
Peter Wade	6	13	4
Robert Stokys	6	13	4
Robert Kenham	6	13	4
Richard Duffe	6	13	4
John Sutton	6	13	4
George Chapman	5	0	0
Matthew Dyll	5	0	0

95 TNA E315/234; Webb, *Records*, I, p. 255.

The Dissolution of the Monasteries involved not just the seizing of religious houses and their endowment properties. Religious houses were also stripped of their images and belongings, which were either destroyed or sold for the benefit of the Crown. Belongings such as furniture were usually sold by public auction and the inventories from the sales were preserved by the Court of Augmentations overseen by Richard Rich. Unfortunately, there are no surviving inventories for St Bartholomew's. It is possible that Fuller may have sold the priory's belongings privately or that Richard Rich inherited at least some of the items when he moved from his home at Austin Friars in London to the prior's lodgings at St Bartholomew's shortly after the priory was dissolved.[96]

For his services to the Crown, Rich was later gifted all the property within the monastery precinct including the courtyards, gardens and orchards with various houses, with a rentable value of £117 7s 11d per annum.[97] Rich then instructed a man by the name of John Scudamore, one of the auditors and receiver of suppressed lands, 'to make sale of bells and superfluous houses and have the lead melted into plokes and sows, weighed and marked with the king's marks'.[98] Six of the bells were sold to St Sepulchre (one of the priory's holdings gifted by Henry I), while five of the bells can still be heard today in the bell tower of St Bartholomew the Great.[99] The building materials of the church such as lead, stones and timber had quickly been removed and sold or used by the king for other purposes.[100]

The priory's plate, jewels, ready money, copes and vestments were sent to Sir John Williams, the master and treasurer of the royal jewels and plate. The total amount of what he received from the monastery can be seen in Table 2. When compared to the total of other religious houses in London, St Bartholomew's appears to have had significantly less plate in their possession, especially considering the priory's income valuation upon its suppression.

TABLE 2 *List of London Religious Houses' Plate at their Suppression* [101]

Westminster	8,808 oz
Grey Friars	2,890 oz
St John Clerkenwell	2,445 oz
Blackfriars	1,132 oz
St Bartholomew's	1,271 oz
White Friars	458 oz
Charterhouse	447oz

96 In a letter addressed to Sir Thomas Arundel (fellow commissioner of the dissolution of the monasteries), Rich invited Thomas, his wife and members of his household to come and stay at his home at St Bartholomew's. In his letter, Rich promises to provide the 'hardest beds' for Arundel and his wife, potentially referring to the monastic furniture: Webb, *Records*, I, p. 263.
97 Webb, *Records*, I, pp. 264-67 and II, pp. 159-80.
98 Webb, *Records*, I, p. 256.
99 Stow, *Survey*, II, p. 28.
100 Webb, *Records*, I, p. 270.
101 Webb, *Records*, I, p. 257.

In 1535, as part of the re-valuations of the religious houses, the gross rental income for St Bartholomew's had been £773 per annum, just over £493 of which came from its London holdings.[102] This total did not include any profits in connection to the property given to Richard Rich, nor did it include the priory's expenses, which were thought to amount to £80 per annum, leaving a net income of £693 (£292,000 today). This total was significantly higher than many of the religious houses in London (see Table 3). Curiously, unlike some of the entries in the *Valor Ecclesiasticus*, the priory's annual spending on charity, which would have provided certain tax exemptions, had not been recorded. St Bartholomew's, however, was not alone: There were several London houses whose annual spend on poor relief was not mentioned. One possible reason for this is that exemptions were only given when a beneficiary had specifically left money to the institution for that purpose, and were disallowed for houses which voluntarily provided aid to the poor. It has been estimated that most religious houses in London were spending less than 2% of their gross income each year on charity.[103] This is, however, more than historians have previously thought at the time of the dissolution. If this was the case for St Bartholomew's, then 2% of their gross income would amount to £14 per annum (roughly £6000 today). However, this total would not include what the priory spent on hospitality. While this might not have been a large sum of money, pooled together with other religious houses in the city, London's poor would have seen a major decease in their financial support after the dissolution of the monasteries.

TABLE 3 *Annual Income from other London and Middlesex Houses at their Dissolution*[104]

	£	s	d
Westminster	2800		
Charterhouse	736		
St Bartholomew's	733		1¾
St Mary Graces	602	11	10½
St Mary Overy	624	6	6
St Helen's Bishopsgate	376	6	
Holy Trinity, Aldgate	355	13	6
Haliwell Priory	345		

Seven months after the priory's suppression, Fuller received his official pension from the Crown. Like many of Henry's close circle of friends and administrators, Fuller was treated generously by the king. Not only did he receive a payment of £200 (more than £84,000 today) after the suppression of Waltham Abbey, he was also granted, for life, nearly the

102 *Ibid.*
103 Barron, 'Introduction', *Religious Houses*, p. 17.
104 Data for this table comes from Barbara Harvey, *Living and Dying In England 1100-1540: The Monastic Experience* (Oxford: Clarendon Press, 1993, repr. 2002), p. 4; *Religious Houses*, pp. 74, 79, 87, 94, 99, 259, 268, 272.

whole of the possessions of St Bartholomew's Priory with all the buildings in London and elsewhere, except the chief dwelling houses, outbuildings and lands, which were officially given to Richard Rich in 1544. Fuller was only able to enjoy his possessions for less than a year; on 12 August 1540, he drew up his will, which was proved on 4 October 1540.[105]

CONCLUSIONS

From its foundation in 1123 to its dissolution in 1539, the Priory of St Bartholomew was one of the most important monastic houses in London. Its royal patronage set it apart from other religious foundations in the city and its role within the Christian community extended all the way to Rome. While its relationship with the hospital would always be strained, their story highlights the complexity of the medieval religious hierarchical system, in which they would remain intertwined until the priory's dissolution. In its first 250 years, the priory was one of the wealthiest religious houses in the London. This wealth can be attributed not only to the favours granted by the king, such as their right to Bartholomew Fair, but also to the generosity of Londoners and their gifts of lands and tenements in and around the city. The canons would have been well-known in their community and a regular sight on the streets of London. However, their relationship with the city was not always easy. The privileges granted to the priory by the king sometimes caused problems between the two. Nevertheless, they always found an amicable solution. While the Black Death created a number of problems for many religious houses, St Bartholomew's managed to survive this period, although not entirely unscathed. By the end of the fourteenth century, many of the monastery's buildings needed serious repair. This began the long process of restoration that created serious financial issues for the canons. Not even papal intervention could financially save the priory, and eventually the house's administration was seized by the bishop of London. While this may have been the end of the road for many religious houses, St Bartholomew's Priory managed to change its fortunes. With the help of the strategically appointed priors Bolton and Fuller, the priory regained its honourable position amongst the religious houses in England and at its dissolution was once again one of the wealthiest in the city of London.

TABLE 4 *Priors of St Bartholomew's, West Smithfield* [106]

AUGUSTINIAN PRIORS	
Rahere	1123; died 1143
Thomas	elected 1144; died 1174
Roger	occurs 1185, 1187

105 Webb, *Records*, I, p. 258-61.
106 This list has been taken from *The Heads of Religious Houses: England and Wales, 940–1216*, ed. David Knowles, C.N.L. Brooke and Vera C.M. London, 3 vols. (Cambridge: Cambridge University Press, 2001), I, p. 174; II, p. 417; III, pp. 473-75.

Alan[107]	occurs 1180, 1189
Richard	occurs 1196, 1206
G. of Osney	1213
John (Blund)	occurs 1226, resigned 1232
Gerard	Elected 1232; occurs 1238
Peter le Duc	occurs 1246; resigned by 1255
Robert de Novo Loco	Elected 1255; dead by 1261
Gilbert de Waldon	Elected 1261; dead by 1263
John Bacun	Elected 1264; occurs 1265
Hugh de Hendon[108]	occurs 1273; died 1295
John de Kensington[109]	occurs 1306; died 1316
John de Pekesden	occurs 1321; died 1350
Edmund de Braughing	elected 1350; resigned by 1355
John de Carleton	elected 1355; died 1361
Thomas de Watford	elected 1361; died 1382
William Gedney	elected 1382; resigned 1391
John Eyton *alias* Repyngdon	elected 1391; died 1404
John de Watford	elected 1404; resigned 1414
William Coventree	elected 1414; resigned 1436
Reginald Colyer	elected 1436; died 1471
Richard Pulter	elected 1471; died 1480
Robert Tollerton	elected 1480; died 1484
William Guy	elected 1484; died 1505
William Bolton	elected 1505; died 1532
Robert Fuller, Abbot of Waltham	elected 1532; priory suppressed 1539; died 1540
Suppressed by Henry VIII	25 October 1539

107 Master of the Hospital. Calls himself 'prior and brother of the hospital'.
108 See Christian Steer's chapter in this book.
109 Webb mentions Kensington as prior in 1295, but the first official surviving documentation places him as prior in 1306. The evidence tells against Webb here; the visitation of the priory in 1303 mentions that the prior is very old and should not be allowed to walk without a companion lest he fall. Contemporary records do not describe Kensington as extremely elderly, and given that he died thirteen years after this visitation, it is unlikely that he is the prior mentioned. It is possible that there was a prior between Hendon and Kensington of whom no record survives.

The Architectural History of St Bartholomew's Priory up to the Death of Prior Bolton (1532)

STEPHEN HEYWOOD

IT IS LARGELY THANKS TO Edward Alfred Webb's exhaustive account that we are able to piece together the evidence from the foundation of St Bartholomew's in 1123 through its life as an Augustinian priory for regular canons. The church and conventual buildings were complete by the middle of the thirteenth century, and were improved and extended until the Priory's suppression in 1539, when the nave and transepts of the church were ruinated and when the churchyard and monastic buildings were confiscated and sold. An interlude of five years reversed the trend when Mary I installed Dominican friars. The story continues with the gradual repurchase, repair, and restoration of the easternmost part of the church building, its transepts and the east walk of the cloister. Webb witnessed the destruction of the dormitory in 1870 and the chapter house in 1912. Despite these losses, a valuable amount of the medieval fabric survives, covering the Norman style and its gradual change to the Gothic of rib vaulting, myriad mouldings, and proto tracery of c. 1240 – unimaginatively named the Transitional style. Clearly, by the Reformation, many later enlargements and improvements had been undertaken; the most important of these which survive at all are the Lady chapel replacing the original axial chapel and also the early fifteenth-century east walk of the cloister – both fortuitously recovered and repaired recently. All the Norman windows were replaced with traceried ones, which in turn lost their tracery. These have been carefully restored or reinstated owing to arduous fundraising for the work of recovering the land and buildings and restoring them as faithfully as possible (fig. 3.1).

THE NORMAN BUILDING

St Bartholomew's Priory was founded in 1123 and, as was customary, the building began at the east end, with the aim of completing the choir and occupying it before embarking on the nave. The monastic choir extended at least one bay into the nave. Here at St Bartholomew's, there is only one nave bay of the original, but it may have extended further west. This denial of what one may see in the crossing of the transepts as the logical place for a pause, is the norm in medieval monastic choirs, and practical in terms of getting natural light to the stalls from the so called 'lantern tower'. The fact that the crossing tower at St Bartholomew's had no windows was not enough to change an established custom.

3.1. The choir, looking east from the organ loft

The remains of the original axial chapel were discovered beneath the floor of the present Lady chapel. A portion of the north wall of the chapel was found with the suggestion of a curve at its eastern end, indicating an apse.[1] The reconstructed proportions fit the typical plan for an axial chapel – the easternmost chapel on the main east-west axis having the distinction of being where the building started and where the foundation stone was laid. The plan is of ambulatory with radiating chapels. The columns of the main arcade form an apse and the aisles wrap around behind it with chapels off them. This is the classic plan-type associated with the great later eleventh- and twelfth-century pilgrimage churches on the road to Compostela; their origins lie with the Carolingian outer crypt for the veneration of relics, allowing for circulation such as those at St Philibert-de-Grandlieu (Loire-Atlantique) (836–47), St Germain, Auxerrre (Yonne) (841–59) and particularly the cathedral of Clermont-Ferrand (Puy-de-Dôme) (before 989).[2] In England, the type first appears at St Augustine's Abbey, Canterbury, soon after the Conquest – a copy of the Norman version at Rouen. A generation after the Conquest, the type departed from French models and adopted storeyed radiating chapels of different adventurous plans such as triangular at Worcester, towers at Canterbury Cathedral, polygonal and of three storeys at Gloucester, and the two-storey form at Norwich of a circular nave intersected by an apse and turrets where they meet and where they join with the ambulatory.[3]

No other Augustinian foundation used the plan-type, yet Rahere no doubt chose to follow the example of his royal supporter Henry I, whose abbey at Reading, founded in 1121, had an ambulatory with three radiating chapels.[4] Rahere differed in his choice of radiating chapel, using the very distinctive Norwich type instead, without the turrets.[5] The more commonly used type of east end for major aisled churches was the apse echelon system, where the aisles terminate in apses flanking the main apse and followed by stepped chapels from the transepts. At St Bartholomew's, the foundations of a Norwich-type south chapel can be seen today, having been revealed again only in 1913.[6] There is no evidence to suggest that the chapel was of two storeys like at Norwich. It is assumed that the north chapel was of the same design, but any sign of it has been obliterated by the construction of a stair turret in its place. The nearest building in London which has an ambulatory is the chapel of St John in the Conqueror's White Tower of c. 1070–1110.[7] This castle chapel is on three storeys. The main storey has groin-vaulted aisles and ambulatory, a barrel-vaulted nave ending in a semi-dome, and a barrel-vaulted gallery. The arcades are on circular piers with cushion, scalloped and volute capitals. It is unthinkable that Rahere was unaware of this building, completed just as he started building the priory church, but it is unlikely that a castle chapel influenced Rahere's choice of plan.

1 E. A. Webb, 'The Plan of St. Bartholomew's, West Smithfield, and the Recent Excavations', *Archaeologia*, 64 (1913), pp. 165–76.
2 For all these, see Eric Fernie, *Romanesque Architecture: The First Style of the European Age*, Pelican History of Art (New Haven: Yale University Press, 2014), chapters 1 and 9.
3 Eric Fernie, *The Architecture of Norman England* (Oxford: Oxford University Press, 2000), pp. 250–51.
4 Fernie, *Norman England*, pp. 171–72.
5 Stephen Heywood, 'The Romanesque Building', in *Norwich Cathedral: Church, City, and Diocese, 1096–1996*, ed. Ian Atherton and others (London: Hambledon Press, 1996), pp. 88–89, figs. 25 and 26.
6 Webb, *Records*, II, p. 126, pl. LXV.
7 Fernie, *Norman England*, pp. 58–59.

3.2. Surviving buttress to exterior of south side

The aisles are groin-vaulted in the manner to be expected and have been largely rebuilt, but retain some of their transverse arches. The outside walls are intact but badly damaged and obscured. There are just the battered remains of a typical pilaster buttress in ashlar in the fourth bay of the south aisle (fig. 3.2). The ashlar is of Kentish Rag – a hard limestone used throughout the building, and most impressively for the interior elevations, where the regular coursing of the ashlar blocks is a display. Kentish Rag is nearly white in its natural state, but owing to the atmosphere or exposure to smoke and soot the stone is now quite dark.

The main arcades of the choir have arches of two orders – a plain, unadorned inner order and an outer order with a relatively slight angle roll with a cavetto or hollow roll and a hood mould decorated with just a single row of billet. The arches are supported on circular piers, except for the westernmost pair, which are larger with rectangular cores. There are no pilasters or shafts to articulate the elevations further – not even a vertical to mark the chord of the apse. The piers have scalloped capitals and chamfered abaci. The scalloped shape is a development of the Norman cushion capital, of which there are no examples here.[8] The variety is interpreted in many different combinations, and in several cases includes chevron ornament in the scallops. The rebuilt narrow arches of the apse are necessarily stilted in order to maintain the level. The two missing apse columns were rebuilt in 1864 when the apsidal shape

[8] In principle, the cushion capital is a merging together of a cube and sphere. It was introduced from the Empire at the time of the Conquest.

3.3. Choir arcade, detail of outer order

3.4. Choir arcade, detail of inner order

3.5. Compound pier on south side from west

was recovered, and a further pair of damaged columns two bays west were replaced or just refaced. The width of the main space of the choir increases eastwards and the bay widths decrease eastwards, slightly but deliberately – this tapering is in order to accentuate the prominence of the altar, it is supposed (figs. 3.3 and 3.4).

The westernmost pair of piers in the choir are not circular, but considerably larger and compound (figs. 3.1 and 3.5). Halfway through the southern pier there is a vertical offset (occurring also at triforium level on the other side of the same pier), which has been interpreted as a break at the end of a campaign, but the masonry courses are uninterrupted. It may have been a minor adjustment to line up with the crossing pier. Something more suggestive of a pause is found above the westernmost arch, where the ashlar courses go wildly off alignment as the courses coming from the crossing pier are too large. The larger piers suggest that there were angle towers in these positions over the aisle bays.[9] That the larger piers were to reinforce the crossing, which is also sometimes suggested, is a possibility, but lacks contemporary parallels. More telling, perhaps, is that the flat surfaces which only these piers have, were to provide a suitable support for the choir stalls which occupied this bay.[10]

The triforium level in the choir exists up to the chord of the apse. The present apse at this level is part of the late nineteenth-century Norman restoration work. The large arches of the triforium are supported on rectangular piers. They are filled with smaller arcades with carved capitals (fig. 3.6). It is no doubt correct that these small arcades were added as an afterthought. They are almost certainly additions because there was no provision in the piers for them, and no respond to carry the end arches, which just have to die into the piers. Subdivided arches are not unusual and can be traced back to antiquity. The containing arches have single billet hood moulds and angle rolls, but with reeded decoration instead of the cavetto. There is a plain inner order and the tympanum is set back. All the tympana are faced with ashlar except for bay three north, which is of rubble with broken pieces of stone. After the Suppression, several of these openings were sealed up.

9 Jill A. Franklin, 'The Eastern Arm of Norwich Cathedral and the Augustinian Priory of St Bartholomew's, Smithfield, in London', *The Antiquaries Journal*, 86 (2006), pp. 110–30 (pp. 120–25).
10 Jeremy Haselock, personal communication, March 2022.

3.6. Capitals in bay three north side of the triforium.
The right hand capital is shown in detail in fig. 3.7

3.7. Detail of the easternmost capital of bay three north side,
showing a beaded single scallop with dropped volute

The capitals of the small arcades (figs. 3.6–3.8) are mainly of scallop variations, but on the north side in bays two and three from the apse chord there are some capitals of exceptional interest. The easternmost capital in bay three is a unique combination of scallop and volute – a single scallop hollowed out in the centre of each of three faces with beading. At a corner facing the nave flows a scrolling leaf with the scroll knot itself below, rather than in the normal position for a volute (figs. 3.6 and 3.7). It occurs on one corner only, as the other has been knocked off. No parallel for this capital has been found, but it marks the introduction of foliate sculpture, and beading. Also, in bay two, there are some examples of the distinctive trefoil-type capital that divides a face into three parts by depressing the segments, giving the impression of panelling with moulded borders. This type of capital occurs at Henry I's Augustinian foundation at Dunstable and the king's abbey at Reading, founded in 1121, where the recovered cloister capitals display the type in various ways (fig. 3.9).[11] At St Bartholomew's, it is in the triforium where beaded decoration, characteristic of Transitional sculpture, begins. No further examples of the trefoil capital have been found at St Bartholomew's. Does this suggest the involvement of Henry I's masons from Reading, where the type is found in profusion? If so, the king's death in 1135 might explain the lack of further examples of the type.

The choir clerestory was replaced during the fifteenth century, but there was a typical Norman tripartite version with wall passage, in all probability like – but perhaps not so grand as – the celebrated clerestories at Norwich Cathedral, and reused decorated fragments of it were recovered from the walls at that level.[12] The decoration is of pellets and a basic chevron of a sort not found elsewhere in the building.[13] A horizontal stringcourse above the tower arch defines the level of the original ceiling. No vaulting was envisaged except the groin vaults of the aisles, barrel vaults to the wall passages and possibly semi-domes and groin vaults to the radiating chapels.

The transepts (figs. 3.10, 3.11) have been recovered from total ruin and unsuitable uses and rebuilt to shorter dimensions. The crossing has suffered from subsidence, as the distorted north arch and the rebuilt north-east crossing pier show. The crossing arches corresponding to the transepts are narrower and pointed. The use of pointed arches is a departure from the normal practice of stilting to compensate for the lower arch which the narrower span produces. The pointed arch is a far more effective, and novel, way of achieving this. All four arches are each of two orders and have double soffit rolls, angle rolls with cavetto and chevron hoods. The west nave arch is supported on fourteenth-century corbels and the north transept arch has double shafts, but with similar fourteenth-century capitals. The east nave arch has just double scallop capitals on corbeling, whilst the south transept arch is furnished with double shafts and scallop capitals, of which the western ones are decorated with beading and a hollow-chamfered abacus.

11 Fernie, *Norman England*, pp. 171–72; R. Marks, 'The Sculpture of Dunstable Priory c. 1130–1220' (unpublished MA dissertation, Courtauld Institute of Art, 1970).
12 Heywood, 'The Romanesque Building', n. 5, figs. 21, 39, 40.
13 Webb, *Records*, II, pp. 40, 128, pl. LXVI(1).

3.8. Detail of trefoil capitals in bay two north side

3.9. Trefoil capital from Reading Abbey. Image courtesy of the Corpus of Romanesque Sculpture in Britain and Ireland (www.crsbi.ac.uk)

The internal walls of the crossing have at their corners a single blind arch in each spandrel linked and decorated with hyphenated lozenge chevron – i.e., forming lozenges to angle (fig. 3.12a). Also, there is in each spandrel a large, diagonally set square stone divided into four heart-shaped rings of vegetal stems, each tied and filled with pairs of beaded leaves, scrolls, and a central unfurling leaf (fig. 3.12b). As pointed out by Franklin, this very bold decoration of repeated heart-shaped palmettes of leafy stems is remarkably similar to Gundrada de Warenne's tombstone of Tournai marble from Lewes Cluniac priory, now at Southover church, Lewes. The priory was founded by William de Warenne in 1077. Gundrada died in childbirth at Castle Acre in 1085. They were both buried at Lewes priory. The tombstone is of about 1145, when the remodelling of the monastic buildings, including the chapter-

3.10. View of crossing from south

3.11. Triforium opening to south transept west side and capitals to south-west crossing pier

3.12a. Blind arches and palmettes at south-east corner of crossing

3.12b. Detail of fig. 12a, palmette at south-east corner of crossing

3.13. Cat corbel at angle between west wall of south transept and south-west crossing pier

house where they were buried, took place. The tombstone is the work of an important sculptor, with related material at Glastonbury under the patronage of Henry of Blois.[14] The appearance of the distinctive palmette ornament at St Bartholomew's is another indication of its links with the great sculptors at work at Lewes Priory and Reading Abbey. Monks from Lewes were the first to occupy Henry I's great foundation, where he was eventually buried in 1136 before its completion.

The south transept has an opening at triforium level with a late-Norman hyphenated lozenge chevron to the arch, of which the outer order is of an angle roll with cavetto supported on nook shafts. A hood mould has been cut away (fig. 3.11). Next to this arch, fitted into the corner, is a cat's head corbel with pointed ears and wide eyes (fig. 3.13).

The choir extends one bay into the nave. The main arcade arches and those to the triforium can be identified, but at this point there is a radical change of plan involving tall rib vaults eliminating the triforium level and the introduction of plate tracery. Transitional sculpture still features, but mainly in the loose fragments that have been recovered since the ruination of the nave. Some volute capitals remain *in situ* with expressive scrolled

14 George Zarnecki, 'Gundrada's Tombstone', in *English Romanesque Art 1066–1200*, ed. George Zarnecki, Janet Holt and Tristram Holland (London: Arts Council of Great Britain, 1984), pp. 181–82.

3.14. Bunched shafts and ribs in north-east corner of south nave bay

volutes. These demonstrate a departure from the cuboid to adopt the foliate. Some of the billet remains *in situ* too. It has changed, though, to threaded billet incorporating a thin roll passing through the ornament. Many voussoirs have been recovered, of which three in particular were the central parts of interlaced arcading of threaded billet. Only one genuine waterleaf capital is evident – i.e., with reversed volutes. The bold classic volute is more represented in amongst the recovered pieces.

There are a number of very fine deeply carved voussoirs of c. 1170, two of which have found their way to the Victoria and Albert museum. They were recovered during the 1864 works and belong to two orders of the arch of a doorway or large window.[15] One of them is a replica of a voussoir kept in the church. All three are hollow mouldings decorated with pierced, beaded scrolling foliage with berries.[16] The two identical ones each have scrolling foliage with berries flanking an arrow head.

THE EARLY GOTHIC BUILDING

In the south-east bay of the nave aisle (the ground floor level of the seventeenth-century tower), the shafts and ribs of the new vaults survive – disappearing through the ceiling (fig. 3.14). This is virtually all that remains of the tall rib vaults that covered the aisles, rendering

15 Webb, *Records*, II, pp. 10, 128, pl. LXVI(4).
16 *Catalogue of Romanesque Sculpture*, ed. Paul Williamson (London: Victoria and Albert Museum, 1983), pp. 94–95.

the Norman triforium in the easternmost bay redundant. The nave was thoroughly demolished after the Suppression, leaving only the easternmost bay, which was part of the choir. Twelfth-century monastic choirs commonly occupy the crossing and the easternmost bays of the nave. At St Bartholomew's, the style changed in mid-bay by transforming the Norman version. Enough remains of the Gothic transformation to identify the adoption of Early English vocabulary in the south aisle bay with the bunched and ringed shafts and the bell capitals carrying slender vault ribs.[17] On the north side, where there is no surviving aisle, the Norman arch of the former main arcade can be seen with the Gothic arch above it which spanned the Norman aisle bays and rose into the blocked triforium (fig. 3.15).

It appears that the aisle bays and the main arcades were built according to the new idiom. The arcades resemble those at Stone near Dartford in Kent, although here without the rather superior rib-vaults of St Bartholomew.[18] There was insufficient room to include a triforium. The very tall rib-vaulted aisles would have looked odd without a nave vault, although Webb favours a flat ceiling suggested by a string course above the corresponding crossing arch. The pair of surviving clerestory windows to both sides of the nave are each of two lights with an oculus – a type first used in Northern France, with Chartres Cathedral as an illustrious precedent at an early date (c. 1194–1220).[19] The type is close to breaking through to bar tracery, which appears for the first time at Rheims after 1210 and in England at what appears to be Binham Priory in Norfolk by 1244, if we believe the contemporary chronicler Mathew Paris.[20] The royal Westminster Abbey acquired the window type just after.[21] It is possible that the west window of St Bartholomew's had the cusped oculi of early bar tracery or a traceried rose. But plate tracery is not simply replaced by the bar variety, as Crossley points out. Again, at Stone the richly moulded and decorated aisle windows are plate-traceried. Also, the north doorway at Stone, of an earlier phase than the Westminster Abbey-inspired interiors, provides a context for the floral boss (with surviving paint) in the collection of fragments at St Bartholomew's. Similar *in situ* bosses decorate the jambs of the doorway, which also has hyphenated chevron and some dogtooth.

The majority of the recovered fragments at St Bartholomew's are of Transitional or late Norman date with few of Gothic date. However, a piece of plate tracery with undercut Early English mouldings and a pretty stiff-leaf capital was recovered from the chapter house, and there is an exceptional figure of a kneeling monk in bas relief holding the edge of a curved shape, carved in relief on what is thought to be the arm of a chair (fig. 3.16).[22]

The other surviving part of the early Gothic church is the present arched entrance to the precinct, which formed the west end of the south aisle. Three of the heavily restored

17 The damaged capital at the north-east corner of the south aisle bay has a possible figure of an angel.
18 Paul Crossley, 'The Nave of Stone Church in Kent', *Architectural History*, 44 (2001), pp. 195–211; John Newman, *Kent: West and the Weald*, Buildings of England, 2nd edn (Harmondsworth: Penguin Books, 1975), pp. 547–50.
19 Christopher Wilson, *The Gothic Cathedral: The Architecture of the Great Church 1130–1530* (London: Thames & Hudson, 1990), p. 96.
20 Nikolaus Pevsner and Bill Wilson, *Norfolk 1: Norwich and North-East*, Buildings of England (Harmondsworth: Penguin, 1997), pp. 389–92. The Binham west window resembles in particular the choir clerestory of St Denis of the 1230s.
21 Wilson, pp. 178–283.
22 Webb, *Records*, II, pp. 128, pl. LXVII(11, 12), 146.

3.15. North elevation showing redundant Romanesque main arcade arch with c. 1200 arch rising above it to a wide and high span. Restored plate-traceried clerestory window

four orders of the arch are supported on modern scalloped corbels – probably replacing the freestanding columns which may have existed in the first instance. The innermost order certainly did have columns that have been removed, and the original bell capitals survive. There are four orders: each has dogtooth ornament of the late twelfth- to mid-thirteenth centuries, with busy mouldings of narrow rolls and undercut hollow rolls in between. The thickness of the wall suggests the possibility that the façade had twin towers, but there is no other evidence. Just behind this arch and high up are the substantial remains of the westernmost aisle rib vault, which proves beyond doubt that the gateway was in fact the south-west entrance. The present timber-framed superstructure is post-medieval.[23]

3.16. Bas-relief sculpture of kneeling monk on the side of a chair or bench

LATER MIDDLE AGES

Of the Lady chapel there are fragmentary remains – three out of four buttresses, the jambs of some of the windows, and presumably the core work of most of the medieval walls. There was probably an east window, and the side windows have been rebuilt incorporating the fragments which survive. Wills point to a mid-fourteenth-century date, and the plan and proportions are what they were until the priory's suppression. The construction of the chapel to an increased width brought about the rebuilding of the ambulatory vaults of the three corresponding bays, with new pointed transverse arches being provided. Lady chapels had a rough time following the Reformation, especially during the Civil War and Commonwealth. New uses were found for the building, which only recently has been recovered and its original purpose restored (fig. 3.17).[24] Beneath the easternmost bays of the Lady chapel is the charnel house or crypt of 1895, rebuilt in concrete on the original site where its fourteenth-century remains were found. It is covered by a shallow barrel vault, strengthened with five transverse arches which existed in the original.

The most significant fifteenth-century alteration to the priory church was the squaring off of the east end of the nave by the construction of a straight wall one bay east of the chord of the apse, which rose up to replace the clerestory with two large traceried windows. From

23 For more on the construction of the Tudor gatehouse, see Nick Holder's chapter in this book.
24 For more on the restoration of the Lady chapel, see Evan McWilliams's chapter in this book.

3.17. The restored Lady chapel

AVE MARIA GRATIA PLENA

the fragments of tracery recovered, a very tentative reconstruction is proposed in Webb.[25] The clerestory to the north and south of the choir was also replaced; the openings survive, but the tracery has been renewed. A second wall further east was built on removal of the two easternmost circular piers. This enclosed a room, possibly used as a feretory, which came to be called 'Purgatory'. This work is thought, on the evidence of indulgences granted by Pope Alexander V in 1409 to those who gave alms to the works, to have taken place in the early years of the fifteenth century. Reference to the high altar is in a list also mentioning the chapter house, the cloister and the bell tower. In addition, a will of 1387 leaves £20 to be spent on the high altar and thus a date around 1400 is likely.[26] The late-medieval abhorrence of the apse was widespread in small parish churches as well as in the great churches of the land. The reasons for this are not clear, but it is fortunate that at St Bartholomew's it was chosen to disguise the apse with the demolition of just two piers rather than to carry out a wholesale replacement.

THE CONVENTUAL BUILDINGS

With the suppression of the Priory went the conventual buildings, which were sold off along with the nave of the church. Just enough was left to provide for parochial use. Thus, their architectural history is largely of what was existing up until 1912 and has since been lost or valiantly recovered.

The plan of the cloister and the buildings around it followed the standard monastic layout as exists in the Ideal Plan of St Gall produced in the early ninth century.[27] This is a square garth surrounded by walks. The position of the east walk is defined by the south transept. Beyond the south transept comes the slype or passage and then the chapter house, which is the one function which does not follow the St Gall plan and only became the rule in the eleventh century. Further south is the dormitory on an undercroft with a staircase. Since the addition of the chapter house to the east range, it often extends beyond the position of the south range, which is the refectory with the kitchen at its west end. The west range is the cellarer's, where provisions are stored. Later in the Middle Ages, the function of this range often changes to become a guest range. The north walk abuts the church. (On the St Gall plan, it is where chapter meetings are held.) The twelfth-century south-east entrance survives at St Bartholomew's. It is of two plain orders and has a pair of restored engaged nook shafts supporting one scalloped capital and the remains of another. It has a hood mould on the south side only and is not situated on the axis of the east walk.

Eight bays of the east walk have been recovered by the parish. Towards its south end is the surviving arched entrance to the former chapter house which now accommodates the bar. The remains of this building and the slype between the chapter house and the former south wall of the south transept were excavated and recorded in 1912 before demolition.

25 Webb, *Records*, II, p. 19, pl. XXVa.
26 For details of wills mentioning St Bartholomew's Priory, see Appendix II.
27 Walter Horn and Ernest Born, *The Plan of St. Gall: A Study of the Architecture & Economy of & Life in a Paradigmatic Carolingian Monastery*, California Studies in the History of Art, 19, 3 vols. (Berkeley: University of California Press, 1979). Images online. But see also Warren Sanderson, 'The Plan of St. Gall Reconsidered', *Speculum*, 60.3 (1985), pp. 615-32.

3.18. 12th-century entrance to dormitory stair and 15th-century vault respond

The photograph of the east side of the archway, now encased, is included in Webb's account and shows ogee and hollow chamfered mouldings to the arch and jambs.[28] The full thickness of the arch can still just be seen – double ogee to east and west followed by narrow rolls and hollow chamfers to west, and to the east a wide and shallow recess finishing with a hollow chamfer to the angle. The arch and jambs on the west side survive and have badly damaged or restored mouldings to the jambs, with the best surviving mouldings in the arch. The flanking former windows are also still in evidence; their oddly compressed shapes were necessitated in order to accommodate the north and south walls of the chapter house, which do not correspond to the bay widths of the vaulted walk. In the next bay, there is a late Norman doorway with a segmental arched tympanum decorated with three shallow recessed cusps and the containing arch with the Norman classic (if in miniature) angle roll with cavetto. This must have been to the dormitory stair. The north jamb of this doorway has been cut away, reducing the span of the containing arch by about 70 centimetres, in order to accommodate the vault rib respond which was inserted in the later Middle Ages (fig. 3.18).

28 Webb, *Records*, II, pp. 146, pl. LXXV, 147.

The surviving Norman chamfered plinth of the south transept in the northernmost bay of the walk is noted by Webb.[29] The careful measurement and analysis of the walk by Gormley notes that in the next bays the plinth is covered by a thickening of the wall associated with attempting to make a level surface for the fifteenth-century vault.[30] The hood mould on the north door and its eccentric position in relation to the east walk, in combination with the diverging alignments of the Norman dormitory with the west wall of the south transept, lead her to postulate that there was no covered walk originally and that the dormitory was originally built as a freestanding building. Gormley suggests that the 1160 date for the chapter house proposed by Webb is incorrect. The dormitory doorway shows that the wall extended further north originally by, at the very least, the thickness of an end wall; Gormley suggests that the northern bays may have housed the original chapter house, leaving space for the slype. The architectural details recovered in Aston Webb's 1912 excavation led Gormley to propose a thirteenth-century date for the chapter house. The exceptionally fine dormitory stair doorway with its arched tympanum would have just fitted into the corner with the stairs against the south wall of the new chapter house.

Perhaps at the same time, or later in the thirteenth century, an east walk was created. The only evidence for this is a mutilated Early English base in the seventh bay.[31] This base is exactly opposite the west end of the south wall of the chapter house, and it is not difficult to devise reasonable bay lengths which favourably accommodate two openings into the chapter house and one into the slype. The pope, in his grant of indulgences in 1409, mentions that the prior has rebuilt the chapter house, which Webb regards as a part-rebuild only.[32] Work that can be seen to be of this early fifteenth-century date is the three-bay façade with central entrance already described above. This façade is wider than the chapter house, with the north and south walls abutting the side openings, causing the distorted arches. The vaulting was installed in c. 1400, replacing the thirteenth-century walk. It is a tierceron rib vault with transverse and longitudinal ridge ribs, with carved bosses where they intersect; they elegantly die into each other on to bell capitals and half-shafts. The east walk was recovered by the parish – initially just the three bays at the northern end, but the recovery was completed and the vaulting reinstated by 1928.[33] Fallen or failed sections of ribs and bosses have been carefully incorporated in the rebuilding. The reticulated tracery in the two northernmost bays was installed in 1905, and the rest more recently.

The vaulted undercroft of the dormitory was recorded by Thomas Hardwick in 1791 and described by others. Most of it extended beyond the position of the former south range. It was of two aisles each of ten rib vaults, springing from octagonal columns and supporting the dormitory floor.[34] The dormitory itself was still standing during most of the nineteenth century. It was demolished in 1870 and replaced by an office block, which was itself later

29 Webb, *Records*, II, p. 140.
30 Maybelline Gormley, 'St Bartholomew-the-Great: Archaeology in the Cloisters', *London Archaeologist*, 8.1 (1996), pp. 18–24.
31 Only part of this base is now visible. Gormley describes it as having two surviving shafts and provision for a third (p. 20).
32 Webb, *Records*, II, p. 145.
33 For more on the restoration of the east walk of the cloister, see Evan McWilliams's chapter in this book.
34 Webb, *Records*, II, p. 136, pls. LXXII and LXXIII.

3.19. Detail of Agas map of 1564 (Image courtesy
of the Map of Early Modern London project

replaced by a block of flats. No fabric survives from the south and west walks, but the frater was recorded in an excavation by the Roman and Medieval London Council in 1955 and published without a plan in 1968.[35] Maybelline Gormley consulted the plans in the archive of Grimes's excavation and, combining this with Webb's records and the new survey of the east walk, published the plan with the frater included and the ninth bay of the east walk.[36] It shows just a plain hall with a curiously unaligned east wall. The full extent of the dormitory is shown, but no record of the west range.

THE WALDEN CHAPEL

Dedicated to All Saints or All Hallows, this chapel was founded just north of the north aisle of the priory church. The first burial within it is of 1396, and Roger Walden's own will of 1405 mentions the chapel he had 'newly caused to be made'. Many wills refer to it being on the north side.[37] The only fabric which can be associated with it is the three recessed arches sunk into the north wall of the aisle with typical late-medieval shafted responds with facetted bell capitals and bases. These recesses were open and connected with the chapel proper, now lost, which was a projection from the north transept. The westernmost bay of the north aisle has the wider arches and larger pier, suggesting the possibility that it was the church tower. Both Wyngaerde's map of c. 1543 and Agas of c. 1564 show a tower on the north side of the church and no crossing tower (fig. 3.19). Norman crossing towers are famously unstable and evidently it was given up on here after being struck by lightning.[38] St Bartholomew the Great close was a parish in its own right from the foundation of the priory in 1123 and there was provision for the parish church or chapel in and around the north transept. The two four-centred arches dividing the choir stalls from the north transept are decorated with fifteenth-century mouldings on the north transept side only within

35 W. F. Grimes, *The Excavation of Roman and Mediaeval London* (London: Routledge & Kegan Paul, 1968), pp. 198–99.
36 Gormley, p. 24, fig. 7.
37 Grimes, pp. 97–99. For more on the Walden chapel, including extensive discussion of these wills, see also Christian Steer's chapter in this book.
38 Grimes, p. 110, pl. LVI.

3.20. Dividing arches in north transept

the parish chapel. The arches were surmounted by the exterior wall of the church after the Suppression. This exterior wall was removed and the present transept and chapel built to the designs of Aston Webb during his restoration of the church (fig. 3.20).[39]

It is by no means unusual for a monastic church to have part of its space belonging to the parish. For example, at Wymondham Abbey in Norfolk, the nave, excluding the aisles, its east bays and the west tower, belonged to the parish, leading to a bizarre arrangement at the Suppression and the partial collapse of the nave arcade.[40] At Wymondham and at most suppressed monasteries with partial parochial roles, it was the monastic choir, conventual buildings and quite often the aisle chapels that were closed and pulled down, to maximize the revenue from the sale of lead and ashlar. At Smithfield, however, the nave and north transept were taken down – probably under the influence of Richard Rich, who envisioned a parish church of a more manageable size, attached to his residence. Converting the monastic choir into the parish church would also allow the former nave to be used as a parish burial ground and site for the lucrative Bartholomew Fair. The nave and the north-transept part of the parish chapel or church were specifically pulled down in about 1542. It appears that the tower and Walden's part of the parish chapel were left standing because, as reported by Webb, John Stow in the 1603 edition of his *Survey of London* says that, when the friars installed by Queen Mary were expelled in 1559, 'the old parish church

[39] See Evan McWilliams's chapter in this book. For an image of the north wall arrangement as it was in 1880 before Webb's restoration, see fig. 9.1.

[40] *Wymondham Abbey: A History of the Monastery and Parish Church*, ed. Paul Cattermole (Wymondham: Wymondham Abbey, 2007).

3.21. Medieval 'Westminster' floor tiles recovered at St Bartholomew's

was wholly as it stood in the last year of Edward VI [...] since the which time that old parish church has been pulled down.'[41] After the parish moved into the formerly monastic presbytery, the tower was left standing. Stow reports: 'The parish have lately repaired the old wooden steeple to serve their turn'.[42] The tower was finally demolished in 1628 and built anew in the south-east nave aisle bay, where it stands to this day.[43]

Important survivals from pre-Reformation times are the five church bells – which are indeed a very remarkable and rare treasure, cast by Thomas Bullisdon of Aldgate and installed between 1505 and 1510. They were originally part of a ring of twelve, the other seven having been sold off to the neighbouring parish of St Sepulchre's by the Commissioners and subsequently lost in the Great Fire of 1666. The remaining bells are dedicated to St Bartholomew, St John the Baptist, St Katherine, St Anne and St Peter. Each bell has the trademark shield of a bell with the initials TB for Thomas Bullisdon. They were probably originally hung in the parish tower, which, as just shown, stood on the north side of the church and was built, it is proposed, over the north-west aisle bay.[44]

Another remarkable survival from before the Reformation is a collection of 'Westminster' floor tiles that have been recovered and are now attached to the north wall of the chapel at the east end of the south aisle/ambulatory. This type is found most sympathetically used at Westminster Abbey, but to distinguish the type from that used at Westminster Abbey

41 Webb, *Records*, II, pp. 95–97 (quote p. 96).
42 Quoted in: Webb, *Records*, II, p. 97.
43 For more on this tower, see Steven Brindle's chapter in this book.
44 For more on the bells, see Steven Brindle's chapter in this book.

3.22. Baptismal font (c. 1405) and cover (unknown date)

inverted commas are used. The tiles are of small scale – approximately 4 in. square – plain black or plain off white and often with a decorative design applied by a stamp to the wet tile, leaving an indent to which a white slip is applied, and the whole lead glazed on firing (fig. 3.21). The designs were geometric patterns, heraldry, fleurs-de-lys and mythical beasts; they are often distorted by the firing, but attempts have been made to trace the designs, because the same stamps would be used. The 'Westminster' tile was recognized by the designs initially and then by analysis of the clay and its association with a tilery discovered at Farringdon Road – close, it so happens, to Smithfield. The 'Westminster' tile was in demand over a fifty-year span from 1250 to 1300 and found around London, but with an

important offshoot at King's Lynn in Norfolk.[45] Nine designs have been identified in the tiles at St Bartholomew's – there are plain black and plain white examples with geometric types and the fleur-de-lys in evidence.

Mention also needs to be made of St Bartholomew's baptismal font, which has the distinction of being one of only two fonts in London that survived the iconoclasm of the Civil War and the strictures of the Commonwealth which forbade their use.[46] The stone font has a large octagonal bowl on a stem and a base on the same principle, with a simple roll moulding between the different sections. There is a rectangular indent for a former metal clasp for a lockable lid. Today there is an early modern crocketed wooden canopy as font cover (fig. 3.22).

WILLIAM BOLTON'S WORKS

Prior Bolton was an important figure in Tudor England. He was responsible for the completion of Henry VII's chapel at Westminster Abbey and for building Boreham New Hall for Henry VIII in Essex, amongst other royal commissions.[47] He built for himself a splendid lodging adjoining the south-east side of the priory church. In 1912, some foundations of the house were uncovered, consisting of a long wing going southward, entered through a doorway in the south wall of an eastward extension built by Bolton, taking out part of the ambulatory wall between the Lady chapel and the south chapel.[48] At the upper floor level, the triforium crossing the south chapel was taken over. Thus the triforium, which connected with the widening on the whole side, became part of Bolton's house; this provides a good explanation for his oriel window, which is such a striking feature of the elevation (fig. 3.23). It is a canted bay in cantilever from which services could be attended in comfort and isolation. It has a low wall decorated with blind tracery of cusped arches enclosing shields to the canted sides and, in the centre, William Bolton's rebus of a crossbow bolt piercing a barrel or tun enclosed in an embellished quatrefoil and flanked by plain pointed quatrefoils. It is glazed in small arched lights, cusped to an upper tier, plain four-centred below, divided by a transom. The glazing is of diamond quarries with heavy vertical saddle bars.

A comprehensive survey of the house was undertaken in 1616, when it was in the occupation of Arthur Jarvais.[49] The rooms must have had a similar function as during Bolton's day. At ground-floor level there was a great hall in the east wing with kitchens and the like next to it. The upper floor of this wing was at the same level as the triforium, and was connected to it as already seen. There was a large courtyard to the east of the hall and an inner court to the west with another court to the south-west. The east walk of the cloister was part of the monastery until its suppression in 1539, so the transformations made afterwards do not concern this chapter. The foundations of Bolton's brick great hall were uncovered in

45 Ian M. Betts, *Medieval 'Westminster' Floor Tiles*, MoLAS Monograph Series, 11 (London: Museum of London Archaeology Service, 2002).
46 Alfred C. Fryer, 'Three Pre-Reformation Fonts in London', *Archaeological Journal*, 71.1 (1914), pp. 167–70; Webb, *Records*, II, pp. 57–58, pl. XLVIa.
47 Judith Etherton, 'Bolton, William (d. 1532)', *ODNB*.
48 Webb, *Records*, II, p. 134, pl. LXXI.
49 Webb, *Records*, II, pp. 159–67.

3.23. Prior Bolton's window

1912 up to Middlesex Passage.[50] Further south, indications of walls were found; attempts to link these to the 1616 descriptions were made by Webb but are difficult to substantiate. It is clear, however, that buildings continued southwards above and beyond Middlesex Passage, which led into a court divided by a wall from the inner court, which corresponded to the main domestic quarters of the prior. The excavations revealed an outshut on the east side of the hall, thought to be the foundations of a timber-framed staircase. A second small outshut on light foundations was uncovered and interpreted as the porch to a screens passage. The putative passage is in line with the slype and could have provided access to the monks' graveyard, which was directly to the east of the prior's lodging. On the west side, the foundation of a large chimney stack was revealed. It was on this foundation that the carving of a praying monk (fig. 3.16) was found. There was certainly an infirmary, but no indication of where it stood. Webb proposes a position at the south end of the open court close to the passage through the dormitory undercroft.

CONCLUSION

It remains to address the questions raised from some of the observations made in this account. The first question is why should Rahere have chosen to copy the radiating chapels of Norwich Cathedral? The chapels are so distinctive, with only one similar known, in a different context, at Mehun-sur-Yèvre (Cher). Jill Franklin has shown that there were particular links between the two foundations, which could explain it.

Apart from both foundations being endowed by Henry I, one of the places given to St Bartholomew's Priory by the king was the church at little Yarmouth, a suburb of Great Yarmouth, where the Norwich Cathedral priory had a cell also. Both were dedicated to St Nicholas, and the nomination to the vicarage was with the bishop of Norwich. Rahere may have known Bishop Eborard personally, as both were prebendaries at St Paul's at the same time. Eborard became bishop in 1121 and completed the construction of the cathedral in 1140, which had been started by Herbert de Losinga in 1096. The seals of both institutions were remarkably similar.[51]

It is significant that Rahere chose to copy the Norwich radiating chapels, not just because of their peculiar shape, but also because he wished to associate his new priory with Norwich Cathedral Priory (which was still being built at the time) and its episcopal status with an ancient diocese. The instantly recognizable shape was created in competition with the wealthier East Anglian monastery of Bury St Edmunds. Both great churches – and in particular their radiating chapels – are the primary source for the region's predilection for round western towers to their parish churches.[52]

It is observed that the aisle bays corresponding to the transepts have extra orders to their arches and compound piers of different and larger dimensions than the circular piers of the

50 Webb, *Records*, II, p. 134, pl. LXXI.
51 This is a very brief summary of the arguments put forth by Dr Franklin: Franklin, n. 8. See also Christine Fox's chapter in this book.
52 Stephen Heywood, 'Towers and Radiating Chapels in Romanesque Architectural Iconography', in *Architecture and Interpretation: Essays for Eric Fernie*, ed. Jill A. Franklin, T. A. Heslop and Christine Stevenson (Woodbridge, Suffolk: Boydell Press, 2012), pp. 99–110.

arcades. The tower of 1628 occupies the south-west one of these bays, and this chapter proposes that the north-east one was the parish church bell tower immediately adjacent to the parish chapel. Franklin cautiously suggests that each of the four strong bays were for towers surrounding the crossing. The striking and unusual sight this would have made would justify the hyperbolic statement made in the foundation document that 'all men were greatly astonished [...] at the novelty of the rising fabric'.[53]

As Franklin herself says, there are problems with such a proposition: aisle bays for towers are used normally at west ends, and rarely for towers over the bays around the crossing. These extra-strong aisle bays were part of the initial work; therefore, if they were built, they would have been part of the fabric. There is no sign of this, though if they were of timber there would be little sign anyhow, and this would have disappeared with the 1830 fire, if not before. Of course, John Stow tells us that the parish tower was timber-framed.[54] It could have been easily accommodated on the strong bay without leaving much evidence when it was removed. There is no documentary evidence of anything similar in the other two single bays, except to note that another of the strong aisle bays was chosen for the parish tower in 1628. Given the lack of further evidence, it must be assumed that the builders thought that it was adding strength to the crossing piers, or that the piers provided flat surfaces suitable for accommodating stalls. There was plenty to astonish all men – not least to see a church founded on the former site of violent executions and capital punishment.

In summary, then, this history begins with the foundation of the church, hospital and parish in 1123. The first prior, Rahere, had the favour of the bishop of London and the king, who allowed and supported the project. The ambulatory with radiating chapels was chosen dutifully following the example of Henry I with his foundation of Reading Abbey in 1121. Rahere completed the eastern arm with ambulatory and the three chapels before his death in 1143. His successor Prior Thomas was appointed from another community and inserted the little arcades into the triforium arches. Some capitals on the north side are more advanced than the scalloped variations. These are of the trefoil type, which is not seen elsewhere at St Bartholomew's, but is in abundance at Henry I's Augustinian foundation at Dunstable and especially at Reading Abbey, his final resting place. Thomas went on to complete the crossing, transepts and one bay of the nave. Further advances were made with the sculpture – hyphenated chevron, threaded billet, the decorated blind arches in the crossing arch spandrels, and the panels of repeating heart-shaped palmettes in the footsteps of the royal or at least baronial patrons. For the narrow transepts he erected pointed crossing arches. A pause of a few years – which occurred in many foundations on completion of the choir – ensued; it is no surprise that such a hiatus occurred at St Bartholomew's, with no firm successor until Richard in c. 1200.

By the time building began again, fashion had changed completely. Rib vaults were installed in the two existing nave aisle bays and the building continued as an early Gothic building with tall arcades on shafted piers, a tiny or no triforium, plate-traceried clerestory, and possibly a rib-vaulted nave. It ended up in c. 1240 with a façade on to Smithfield – a

53 Franklin, p. 127, n. 57, quotes the Latin text. English translation in Webb, *Records*, I, p. 52.
54 See above, n. 42.

west window with elaborate plate tracery, perhaps. The conventual buildings were still in building during the thirteenth century, with the insertion of a chapter house over the northernmost bays of the formerly freestanding dormitory and the creation of a cloister east walk replaced in the fifteenth century by the recently reconstructed tierceron vault. The fifteenth-century entrance to the former chapter house survives; more remarkable is the dramatic twelfth-century doorway to the dormitory stairs with an arched tympanum displaying a recessed trefoil.

The Lady chapel was the first major alteration – completed by 1335 when a bequest was made to the newly completed chapel of St Mary. Early in the fifteenth century, major works were undertaken – the straightening of the east end with a wall, the modernization of the clerestory with large traceried windows, the rebuilding of the north-west crossing pier, and the vaulting of the east cloister walk. During or just before this time, Roger Walden built a chapel off the east wall of the north transept. All that remains of this work are the arches and responds of three former entrances from the north aisle, which have now been sealed with windows. The four centred arches dividing the transept from the choir also belong to this development.

Just before the Suppression in 1539, William Bolton built a luxurious lodging which was entered through a doorway from a new chapel off the south-east ambulatory. Part of this work was the oriel window which projects from the triforium and bears William Bolton's rebus of a crossbow bolt or arrow through a barrel or tun. The events of the following years brought about the dispossession, partial destruction and ruination of the Priory buildings (with a brief Dominican interlude under Mary) and the valiant recovery undertaken in the nineteenth and early twentieth centuries. The equally eventful post-medieval history is covered in subsequent chapters.

+ hic jacet Raherus Primus Canonicus et Primus P...r hujus Ecclesie

The Medieval Funerary Monuments at St Bartholomew's Priory

CHRISTIAN STEER

VISITORS TO THE CHURCH OF ST BARTHOLOMEW THE GREAT cannot but wonder at the magnificence of this sacred space. It is, above all, a place of worship, yet this great Norman church, which has survived for nine centuries, can claim only one surviving medieval funerary monument from the original priory church, that of its founder, Rahere (fig. 4.1). The effects of Reformation, iconoclasm, neglect and reordering have all played their role in the loss of generations of memorials. Medieval commemoration is, as a consequence, conspicuous by its absence at St Bartholomew's, and this is made the more remarkable given the impressive collection of post-Reformation funerary art adorning its floors and walls.[1] Fragments of a handful of medieval memorials were found during later rebuilding programmes on the site, but what can be said of the other slabs and brasses which once carpeted its interior?

An examination of the surviving probate registers for the city of London has identified 80 wills of testators who requested burial at St Bartholomew's, several of which described the form and composition of their now lost tombstones.[2] An important heraldic account, drawn up around 1505, provides further evidence about lost monuments from the priory and reveals the identity of 33 tomb patrons commemorated in the church.[3] This manuscript was used by John Stow, merchant taylor, one of the city's foremost antiquaries, who copied some of their names into his *Survey of London*, first published in 1598; curiously he omitted nine

It is a pleasure to thank Caroline M. Barron, Clive Burgess, Christine M. Fox, David Lepine and Christopher Wilson for their comments, help and advice in the preparation of this chapter. Dr Fox's enthusiasm for this church is infectious, and our Zoom meetings during the Covid-19 pandemic were not only informative and inspiring, but great fun too. I also take the opportunity to thank Stephen Freeth, Tim Hudson and Paul Simpson, for their help with the Latin texts, and Ann Adams and Charlotte Gauthier for their observations and comments on Rahere's tomb during our visit to the church in October 2021.

1 See the chapter by Jon Bayliss in this volume.
2 The earliest probate registers for the city of London began in 1258, when wills were first copied into the rolls of the court of Hustings. Probate for other wills took place at the Commissary court of the bishop of London and these registers survive from 1374; a third court, under the jurisdiction of the archdeacon of London, granted probate for the estates, generally, of the less affluent, but only one volume has survived for the period 1393 to 1415 (the registers before 1393 and between 1415 and 1549 are altogether lost.). The Prerogative court of the archbishop of Canterbury dealt with probate for those with goods within the jurisdiction of the archbishopric (including the city of London) and they survive from 1385. Wills were sometimes copied into the registers of both bishops of London and archbishops of Canterbury. The earliest will to refer to the priory of St Bartholomew was drawn up in 1272 (Elias de Wycumbe) and the last was proved on 28 January 1539 (Richard Bellamy). A list of the surviving medieval wills for those interred at the priory is included in an Appendix to this volume with full references to their court, register and folio number.
3 London, College of Arms, MS C.G.Y. 647, ff. 40v–41. I am grateful to Robert Yorke for his discussion of this manuscript with me.

4.1. The funerary monument of Rahere

monuments, almost all of which were for women.[4] Stow died in 1605, but other antiquaries were increasingly drawn to the monuments of past worthies, and they prepared similar accounts. One of them was John Weever, who, in the year of his death in 1631, published a selection of epitaphs for the dioceses of London, Canterbury, Rochester and Norwich; he noted two extant memorials at the priory church.[5] When taken together these different written sources – heraldic and antiquarian – reveal 39 medieval funerary monuments from the priory church (including the surviving memorial for Rahere) with a further three examples found during rebuilding works on the site (Table 1).

TABLE 1 The medieval funerary monuments from the priory of St Bartholomew's Smithfield based on the surviving examples and those recorded in the written sources: London, College of Arms MS C.G.Y. 647, ff. 40v-41; *A Survey of London by John Stow*, ed. C.L. Kingsford, 2 vols. (Oxford, 1908), II, pp. 27-28; John Weever, *Ancient Funeral Monuments* (London, 1631), pp. 434-35; and those noted in testamentary records. A number of funerary monuments are repeated in the different accounts, but they also reveal new examples omitted elsewhere. The final column is the calculation after duplicate entries have been removed.

	Monuments extant or found on site	Monuments described by herald (1505)	Monuments recorded by John Stow (1598)	Monuments noted by John Weever (1631)	Monuments mentioned in wills	Total monuments recorded
before 1299	2	1	1	1		2
1300-49	2	1	1			3
1350-99		3	3		1	4
1400-49		5	6	1	5	9
1450-99		9	9		2	9
1500-38		1			1	2
no date		13	5			13
TOTAL	4	33	25	2	9	42

This chapter will examine the evidence for funerary commemoration at St Bartholomew's and consider the types of memorials constructed, and for whom. The founder's impressive sepulchre, commissioned some 250 years after his death, will be considered as one of two case studies. It was built at the same time as 'Walden's chapel' where the remains of Roger Walden, archbishop of Canterbury (deposed in 1399), were thought to lie. His chapel

4 *A Survey of London by John Stow*, ed. C.L. Kingsford, 2 vols. (Oxford: Clarendon Press), II, pp. 27-28. On Stow's selectiveness see: Christian Steer, 'Commemoration and Women in Medieval London', in *London and the Kingdom. Essays in Honour of Caroline M. Barron: Proceedings of the 2004 Harlaxton Symposium*, ed. Matthew Davies and Andrew Prescott, Harlaxton Medieval Studies, 16 (Donington: Shaun Tyas, 2008), pp. 230-45.

5 John Weever, *Ancient Funeral Monuments* (London: Thomas Harper, 1631), pp. 434-35.

became a popular location for the graves of Walden's household and family during the first half of the fifteenth century and it also attracted the bones of a spectacularly wealthy canon of St Paul's (see below). The use of the priory church as a repository of the dead increased during the fifteenth century, continuing until the eve of the Reformation. By the time of its suppression in 1539, the priory church possessed an impressive tombscape accommodating and remembering generations of past friends and visitors.

1. BODIES, BONES AND BURIALS: c.1150–1400

The foundation of the priory of St Bartholomew in the twelfth century coincided with a time of increased demand for burial inside medieval churches. The founders of churches and, by extension, their family and descendants were guaranteed interment within 'their' church, usually close to the high altar or in a private chapel. Those unrelated to the founder were generally laid to rest in the graveyard. Yet over the course of the twelfth century an increasing number of rich, well-born and well-connected dignitaries, courtiers and senior clergy demanded intra-mural burial, and medieval churches 'opened up' to receive their remains also.[6] Only two memorials for those buried in the priory during the twelfth and thirteenth centuries have survived, and a further two examples can be dated to the early fourteenth century: Prior Rahere, who died in 1143 (discussed below); Hugh de Hendon, the thirteenth prior, who died in 1295; Simon de Papnei, possibly a canon or visiting cleric, who died around 1300; and an unidentified lady who died c. 1320–30 (fig. 4.2). In addition, three fragments of incised inscriptions from the early fourteenth century have been found, but the texts are too incomplete to reveal the identity of who they once commemorated.[7] There were no doubt other tombs, especially for other priors and senior churchmen, but none of these has survived.

4.2. Incised slab to an unknown lady, c. 1320–30, found at St Bartholomew-the-Great, 1913 (credit: reproduced from Sally Badham and Malcolm Norris, *Early Incised Slabs and Brasses from the London Marblers*, Reports of the Research Committee of the Society of Antiquaries of London, No. 60 (London, 1999), p. 51)

The graves of Hugh de Hendon and Simon de Papnei were marked by incised slabs. This form of funerary monument was flat, flush to the floor, with the carving incised directly on to the surface, and usually of Purbeck marble from the Isle of Purbeck (Dorset). An inscription around the circumference of the slab could be accompanied by a cross in the middle, either raised in relief form or carved into the marble, or by a figure or semi-figure

6 Nigel Saul, *English Church Monuments in the Middle Ages: History and Representation* (Oxford: Oxford University Press, 2009), pp. 25–26.
7 Sally Badham and Malcolm Norris, *Early Incised Slabs and Brasses from the London Marblers* (London: Society of Antiquaries, 1999), p. 51 (unknown lady); pp. 97–98 (inscriptions); pp. 108–09 (de Hendon) and pp. 109–11 (de Papnei).

c. A.D. 1300.
Fragment of Stone Coffin-lid, Priory of St. Bartholomew.

4.3. Incised slab for Hugh de Hendon (d. 1295), found at St Bartholomew the Great, 1843, reproduced from Charles Boutell, *Christian Monuments in England and Wales* (London, 1854), p. 38

showing the upper portion of the deceased. The inscriptions of these two discoveries were carved in Lombardic lettering; these are comparable with other examples to survive elsewhere and dateable to the late thirteenth century. They have been attributed to the 'Basyng' workshop which operated briefly, probably in London (or perhaps Southwark), during the 1290s.[8] The earlier of the two from St Bartholomew's – the upper part of a Purbeck marble slab with a relief cross with fleur-de-lis terminals – was found in 1843 near the northern entrance to the church, and illustrated in 1854 (fig. 4.3).[9]

At the time this fragment was in the possession of William Chaffers, a dealer in antiquities, who sold a number of items to the British Museum.[10] The inscription, unusually, went anti-clockwise, with each word separated by double stops. It read, in expanded form, + HW / E: DE: HEN[DON: GIST: ICI: DIEV: DE: SA:] ALME : EIT: ME / RCI ('Hugh de Hendon lies here, on whose soul God have mercy'). It is not known whether Prior Hugh made arrangements for his memorial during his lifetime or whether the community did so after his death. What is clear is that another example was commissioned from the same workshop for another burial in the priory at about the same time. In 1913 an incised slab, attributed to the early fourteenth century, was found during works to the south wall of the church.[11] By 1930 it was in the east walk of the cloister, when it was rubbed by Frank Greenhill (figs. 4.4a and b). It too had a cross, although unlike the one for Hugh de Hendon this was cut into the marble, as shown in the rubbing by the trefoil-ended foot of the cross. The inscription, like that of Hendon, was incised into the slab, but the text is incomplete. The words were separated by three stops. The rubbing also shows that the inscription was bordered by a pair of incised fillets, which is a characteristic associated with the early fourteenth century.[12] Only a portion of the text has survived but this is enough to provide the identity of the deceased: [MES]TRE: SIM / UND: DE: PAPNEI ('Master Simon de Papnei'). It is not clear who he was, although the prefix 'master' suggests that he was educated at a university and was, probably, a cleric. What is clear, however, is that at the turn of the fourteenth century senior churchmen at the priory

8 Badham and Norris, *Early Incised Slabs and Brasses*, pp. 109–11.
9 Charles Boutell, *Christian Monuments in England and Wales* (London: George Bell, 1854), p. 38.
10 'Appendix', *Archaeologia*, XXX (1844), p. 548. On Chaffers: *ODNB* entry online by Thomas Seccombe, revised by Annette Peach, accessed 8 January 2022. I thank Stephen Freeth for information about William Chaffers.
11 Webb, *Records*, II, pp. 441–42.
12 Paul Binski, 'The Stylistic Sequence of London Figure Brasses', in *The Earliest English Brasses: Patronage, Style and Workshops 1270–1350*, ed. John Coales (London: Monumental Brass Society, 1987), pp. 69–132 (p. 74).

4.4a, b. Incised slab for Simon de Papnei, c. 1300, found at St Bartholomew the Great, 1913, reproduced from Sally Badham and Malcolm Norris, *Early Incised Slabs and Brasses from the London Marblers*, Reports of the Research Committee of the Society of Antiquaries of London, no. 60 (London, 1999), p. 111

were commemorated by incised slabs and that they availed themselves of the latest designs produced by the new tomb workshops in the city.

The evidence for burial and commemoration at the Priory of St Bartholomew's from the time of the foundation to the end of the fourteenth century is slight. A little more can be gleaned from the herald's account of selected monuments compiled c.1505 when he visited 44 parish and monastic churches within the city of London, and also the great abbey of St Peter at Westminster. It was undoubtedly those monuments with heraldic arms that caught his eye; at the priory church the herald recorded 33 funerary monuments, albeit only occasionally noting the occupation or rank of the person commemorated.[13] Of these, four can be satisfactorily dated to the fourteenth century. The earliest is for Sir Thomas Bacon of Norfolk, a Justice of the King's Bench, who died in 1336. The heraldic record suggests that the memorial was in a worn state by the early sixteenth century, for all it noted was 'Sir [blank] Bawcon knyght'. It is thought to record the Justice of that name who in his will appointed the prior and sub-prior as his executors.[14] Moreover, he left property to the priory in order to establish a chantry (a series of daily masses) for his soul.[15] The dovetailed relationship between the tomb and commemorative masses for an individual patron became increasingly popular during the later Middle Ages.

It is difficult to say what form of funerary monument Sir Thomas Bacon had at his grave. The inability to read the inscription in the early sixteenth century suggests that it had partly worn away. It was either an incised slab, similar to those discussed above for the past priors

13 London, College of Arms, MS C.G.Y. 647, ff. 40v–41.
14 G. O. Sayles, ed., *Select Cases in the Court of King's Bench*, v, Selden Society 76 (London, 1958 for 1957), p. 103; see also the *ODNB* entry online by Henry Summerson, accessed 3 October 2021. I am grateful to Dr Summerson for his comments on Sir Thomas Bacon.
15 *Calendar of Patent Rolls 1370–1374* (London: His Majesty's Stationery Office, 1914), pp. 426–28.

of St Bartholomew's, or – perhaps more likely – an early form of monumental brass with individual lettering around the edge of the slab, comparable to other examples of the age. The 1330s witnessed 'a revolution in almost every aspect of monumental brasses' with an increased elegance now seen in the formation of the figure of the deceased.[16] It is likely that other examples noted in the herald's list, such as Prior John de Carleton, who died during the second wave of Black Death in 1361, and John Malwayn, esquire, a Londoner by birth who was to marry Elizabeth, the widowed countess of Athol, were also commemorated by brasses.[17] At the time of Carleton's death, the London marblers were in decline as so many had died during the pestilence. His would probably have been a small and straight-forward composition, but by the time of Malwayn's death in 1378 the workshops had revived, with larger compositions re-emerging from the 'A' workshop and its rival 'B', run by Richard Lakenham and later his son Henry. The Lakenham workshop is noted for pro-ducing three-dimensional effigies as well as state-of-the-art monumental brasses, including a number of high-status commissions for members of the royal court. Lady Athol, who died in 1375, is commemorated by a (now) badly mutilated brass in the parish church of St Mary in Ashford (Kent), which at the time of her death was truly magnificent.[18] Her widower John Malwayn is likely to have had something similar over his own grave in St Bartholomew's. Only two other monuments are known from the late fourteenth century, that of prior Thomas de Watford, who died in 1382, and John Royston, esquire, who died five years later. Royston's memorial was noted in the herald's account; it is through the will of John de Guldeford, a 'paneter' or steward of Stamford (Lincs.), who wished to be buried at the feet of Watford, that we learn of the prior's probable monument.[19]

The evidence for funerary monuments between c.1150 and 1400 is incomplete; nevertheless, what we have suggests that the early priors of St Bartholomew's were com-memorated with incised slabs and, as fashion changed, by monumental brasses. Sir Thomas Bacon and John Malwayn were both well-born members of the laity who also chose to be buried and commemorated at the priory. So by the end of the fourteenth century wealthy lay people also considered St Bartholomew's an appropriate place for their own sepulchre. This coincided with a great rebuilding enterprise at St Bartholomew's, which included the retrospective funerary monument for Rahere and the construction of the Walden chapel.

2. THE FOUNDER'S TOMB

On the north side of the present-day sanctuary is the recumbent effigy of an Augustinian canon. It is on the north side of the high altar at the *dexter domini* and located in one of the most prestigious and sought-after locations of any medieval church. It is possible it was used as an Easter Sepulchre. The inscription identifies the effigy as Rahere, founder of the priory and hospital, who is thought to have died on 20 September 1143.[20] His date of death

16 Binski, 'The Stylistic Sequence of London Figure Brasses', p. 103.
17 Appendix II, will 30.
18 J.R. Scott, *Memorials of the Family of Scot* (London, 1876), p. 76.
19 Appendix II, will 33.
20 *ODNB* entry online by Judith Etherton, accessed 27 November 2021.

was not recorded on the inscription. The surviving monument is a retrospective commission and can be dated to about 1400.

Monuments in the twelfth century were, on the whole, simple in design. The larger and elaborate superstructures were reserved for the wealthiest tomb patrons – kings, bishops, and the nobility. A simple floor slab, either a cross-slab or incised, as used for Hugh de Hendon and Simon de Papnei, was the customary design for funerary commemoration at the time. Basic inscriptions were increasingly used, although it was rare for the date of death to be included in the text before the Black Death. There is no documentary or archaeological evidence from St Bartholomew's for a twelfth-century funerary monument for Rahere, but it would have been unusual for his grave to have gone unmarked. It was probably identified by a simple inscription engraved on to a marble slab recording his name and status as founder and first prior. By the end of the fourteenth century, the time had come to commission a more appropriate funerary monument for the founder in the fashion of the day. This coincided with two initiatives in the closing years of the fourteenth century, the translation of 'The Book of the Foundation' of St Bartholomew's into Middle English – which included an account of the miracles which had taken place there – and the rebuilding programme at the priory.[21] Both were part of a coordinated campaign to promote the priory and to put St Bartholomew's on the 'tourist map' for late medieval visitors to London.

Rahere's tomb is truly magnificent (fig. 4.1). It is enclosed in a vaulted canopy which was originally of six bays. The two additional bays at the east end provided a doorway into the north ambulatory (fig. 4.5), but these were destroyed during the restoration of 1867.[22] John Stow referred to a previous restoration programme by Prior Bolton in the early sixteenth century, but without commenting on what alterations may have been made to Rahere's tomb.[23] The effigy has evidently been repainted many times, although thankfully not as luxuriantly as examples in Southwark or Westminster. The inscription at the top of the tomb chest is brief and to the point: HIC IACET RAHERUS PRIMUS CANONICUS ET PRIMUS PRIOR HUIUS ECCLESIAE ('Here lies Rahere the first canon and first prior of this church'). This may seem a somewhat uninspiring text, but note the blank wall in the bay immediately to the east of the tomb recess. This seems out of place. It is possible that a *tabula* once hung here, either of wood or of parchment, with a more generous epitaph on Rahere's life and achievements. It was not unusual for such tables to accompany late medieval funerary monuments. There are three distinct aspects of the structure to note: the exquisitely carved arcade at the top; the effigy, flanked on either side by two bedesmen 'reading' to the founder, with an angel at his feet; and the tomb chest itself, upon which are four coats of arms.[24]

21 Laura Varnam, *The Church as Sacred Space in Middle English Literature and Culture* (Manchester: Manchester University Press, 2019 edn), pp. 67–70. On the rebuilding of the church, see the chapter in this volume by Stephen Heywood.
22 Webb, *Records*, I, p. 73; discussed more recently by Julian M. Luxford, 'The Idol of Origins: Retrospection in Augustinian Art during the Later Middle Ages', in *The Regular Canons in the Medieval British Isles*, ed. J. E. Burton and K. Stöber (Turnhout: Brepols, 2011), pp. 417–42 (pp. 434–38). I am grateful to Prof. Luxford for his advice on Rahere's tomb.
23 *Survey of London*, ed. Kingsford, II, p. 25.
24 Bridget Cherry, 'Some New Types of Late Medieval Tombs in the London Area', in *Medieval Art, Architecture and Archaeology in London*, ed. Lindy Grant, The British Archaeological Association Conference Transactions for the Year 1984 (Leeds: W. S. Maney and Son Limited: 1990), pp. 140–54 (pp. 143–44); Webb, *Records*, I, pp. 70–75.

4.5. The funerary monument of Rahere with the lost two bays at the eastern end. Engraving by James Basire after John Carter, reproduced from *Vetusta Monumenta* (London, 1784), vol. II, plate 36

The upper section of the funerary monument is supported on buttressed piers. It consists of a two-tiered arcade of serried blind lights placed behind the gables each of four cinquefoiled arches – that is, with the lower part of each arch formed of five small arcs – with a further two arches on the two lost bays at the east end. On either side of the central arch above the effigy are two pendants with an ogee crocketed gable over each arch (fig. 4.6). Both pendants, and the columns at the east and west ends of the tomb chest, support pinnacles which extend into the upper section of the arcade and into the cornice, where they conclude with carvings of small figures. These small figures are from the restoration of 1867, and in one case the figure has been replaced with a fancy leaf design. The pinnacles are probably from the restoration also. All four arches are richly crocketed and extend up

4.6. The funerary monument of Rahere (detail of arcade)

into the cornice to form foliated finials. The arcade behind the pinnacles and arches is in two tiers with the upper storey containing the paint of an earlier restoration. It is possible that the arcade was originally painted, although there is no evidence of this in the sources. A cornice runs at the top of the arcade, above which is a detailed cresting with reversed trefoils. This design is closely associated to the fine craftsmanship employed on the tomb of Simon Sudbury at Canterbury.

The funerary monuments for Sudbury and Rahere typify late fourteenth century Perpendicular style and there seems little doubt that they are both products of the workshop of Henry Yevele, master mason, who is known to have been a major designer of tombs at this time.[25] Other works by Yevele include the tombs for Richard II and Queen Anne and also that for Simon Langham in Westminster Abbey; both were constructed during the 1390s. Sir Bernard Brocas, chamberlain to Queen Anne, died in 1395 and was accorded burial in the chapel of St Edmund in the Abbey. His restored and heavily repainted tomb, also datable to the 1390s, contains a canopied arcade and cornice closely comparable to

25 *ODNB* entry online by Christopher Wilson, accessed 27 November 2021. On Yevele and tomb design see also: Christopher Wilson, 'The Medieval Monuments', in *A History of Canterbury Cathedral*, ed. Patrick Collinson, Nigel Ramsay and Margaret Sparks (Oxford: Oxford University Press, 1995), pp. 451-510 (pp. 471-72) and plate 102; John Harvey, *English Mediaeval Architects: A Biographical Dictionary Down to 1550* (Gloucester: Alan Sutton, 1987 edn), pp. 358-66.

the monument for Rahere. There is no documentary evidence linking Yevele to the design and construction of Rahere's tomb, but the case for his involvement is strong. It is, moreover, notable that Roger Walden, treasurer of England between 1395 and 1398, and members of his family were living in the priory close during the 1390s and into the early years of the fifteenth century. Walden and Yevele would have moved in the same courtly circles, and it seems likely that Walden was patron of Rahere's retrospective funerary monument.[26]

The surviving contract for the construction of Richard II's tomb at Westminster Abbey reveals that different craftsmen were involved in the production of different sections of the composition.[27] We can be certain of the influence, if not the involvement, of Henry Yevele in the arcade above Rahere's tomb, but it is less clear who was responsible for the effigy of the founder. Rahere is shown recumbent, his hands held together in prayer, and resting on a stone slab at the top of the tomb chest (fig. 4.7). His head is tonsured and he wears the habit of the Augustinian order. The outer garment, the *cappa nigra*, or canon's cope, is fastened at his throat – although there is no sign of any clasp or morse which would have held it together – and flows freely to his feet. The hood has been rolled back and forms a pillow at the base of his neck, underneath which is a tasselled cushion. Under the cope is the almuce – a cape made of, or lined with, fur – of which only the upper part is visible on either side of Rahere's hands. There are two stole-like strips of fur which flow down to his knees. The next layer of clothing is the surplice, or *super pellicium*, now painted black, which descends to the founder's feet as far as the lower end of the cope. It is in carefully engraved folds over each arm. Only the tight sleeves of the cassock (*pellicium*) can be seen, each with two buttons, where his arms are drawn back, and

4.7. Detail of the habit of Rahere, drawing by Christopher Webb, reproduced from E.A. Webb, *The Records of St Bartholomew's Priory and of the Church and Parish of St Bartholomew the Great, West Smithfield*, 2 vols. (Oxford, 1921), vol. I, p. 72

26 A conclusion reached in Varnam, *Church as Sacred Space*, p. 71, but based on her argument that Walden was the translator of 'The Book of the Foundation'.
27 Sally Badham and Sophie Oosterwijk, '"Cest Endenture Fait Parentre": English Tomb Contracts of the Long Fourteenth Century', in *Monumental Industry: The Production of Tomb Monuments in England and Wales in the Long Fourteenth Century*, ed. Sally Badham and Sophie Oosterwijk (Donington: Shaun Tyas, 2010), pp. 187–236 (pp. 200–16).

4.8. The 'bedesmen' on either side of Rahere's tomb
(credit: Christian Steer)

his hands brought together in prayer. At the feet of the effigy appear to be two woollen shoes peeping out from underneath the surplice.

The effigy for Prior Rahere is flanked on either side by two small figures, carved from the same block of Reigate stone as the effigy. They have been variously described as 'puppet canons' and 'bedesmen' and are remarkable, not least for their out-of-proportion hands (fig. 4.8). The two figures are shown on the north and south side of Rahere's right and left knee respectively with hoods drawn over their heads. They each hold a bookrest, on each of which is a copy of the Bible. In 1921 it was noted that the text was written on parchment or paper and attached to the stone book.[28] Today this is gone, but it was copied and reveals that the words were identical on both books and that they were taken from the book of Isaiah in the Vulgate:

Consolabitur ergo Dominus Sion et consolabitur omnes ruinas eius et ponet desertum eius quasi delitias et solitudinem eius quasi hortum domini. Gaudium et laetitia invenietur in ea, gratiarum actio et vox laudis.

('For the Lord shall comfort Zion: He will comfort all her waste places: and He will make her wilderness like Eden, and her desert like the garden of the Lord; joy and gladness shall be found therein, thanksgiving and the voice of melody').[29]

Laetabitur deserta et invia, et exultabit solitudo, et florebit quasi lilium.

('The wilderness and the solitary place shall be glad for them; and the desert shall rejoice and blossom as the lily').[30]

28 Webb, *Records*, I, pp. 52–53, 72; cf. Jessica Barker, 'A Book-Bound Voice: Liturgical Books and the Commemoration of the Dead', in *The Medieval Book as Object, Idea and Symbol: Proceedings of the 2019 Harlaxton Symposium*, ed. Julian Luxford, Harlaxton Medieval Studies, 31 (Donington: Shaun Tyas, 2021), pp. 200–23.
29 Isaiah 51:3.
30 Isaiah 35:1.

The text recalls the conditions Rahere apparently found when he established the priory and hospital at Smithfield, as recorded in the *Book of the Foundation* compiled in the late twelfth century. This was translated into Middle English at about the same time as Rahere's tomb was constructed, and considered to be part of the overarching renewal programme underway around 1400.[31] Whoever commissioned the texts on the monument was familiar with the original account of the foundation and sought to bring 'text and tomb' together. It is not known whether these inscriptions were read aloud or by whom; the most likely occasions would be either the anniversary of the foundation or perhaps the feast of St Bartholomew on 24 August. But if they were intended to promote the sanctity of the church and to reflect the holiness of the priory, they may have been recited regularly as part of the daily round of liturgical celebrations.

The fourth figure on Rahere's tomb is to be found at his feet: a winged angel, crowned and draped in a green gown, who rises from a cloud (fig. 4.9). The angel holds a shield with the arms of the priory, *Gules, two lions passant guardant, in chief two crowns Or*.

4.9. The angel at the feet of Rahere facing towards him (credit: Christian Steer)

The carving of the angel is less sophisticated than that of Rahere or the bedesmen who flank him on. It also seems out of proportion when compared to the overall composition of the funerary monument. It is tempting to suggest that it was a later addition, although the disproportionately large hands may suggest that it was produced by the same craftsmen who provided the two bedesmen.

Rahere's effigy is set on a Purbeck marble slab upon a tomb chest with four quatrefoiled panels. Each panel contain a coat of arms (fig. 4.10). These have been repainted during past restoration programmes and the identity of one of the shields is now uncertain. The shield directly beneath Rahere's head is of St George, *Argent, a cross gules*; next to this are the arms of the priory, *Gules, two lions passant guardant, in chief two crowns Or*; followed by the king's arms, *Azure, three fleurs-de-lis Or quartering gules, three lions passant gardant Or*. A drawing of the monument published in *The Gentleman's Magazine* in October 1767 shows that the shield containing the royal arms was, at that time, blank, and that the priory arms were in the third not the second panel (fig. 4.11). The fourth panel, *Gules, a bend between two martlets Or*, is a puzzle because these were not the arms for either Roger Walden, active in the reconstruction of the priory at the turn of the fifteenth century, or the prior, John Eyton

31 Varnam, *Church as Sacred* Space, pp. 71–72; Webb, *Records*, I, pp. 51–52. See also the chapter by Christine M. Fox in this volume.

4.10. Tomb chest of Rahere

alias Repyngdon, who was in office at the time. Edward Webb suggested these were retrospective and that this shield was reblazoned for Sir Stephen Slaney, Lord Mayor of London, in 1595 (*Gules, a bend between three martlets Or*), who was a noted benefactor to the church.[32] It is unclear what was originally painted on to the fourth shield, and it may be that different arms were applied at different times in the tomb's history. It is odd that the entry for Rahere's tomb in the herald's account has been crossed out; perhaps a later hand removed the entry on the basis that the heraldry had worn away and was no longer identifiable. This might explain the later commissions and appropriation of Slaney's arms.

What we see today is much restored, but it is still eye-catching and a tribute to the outstanding craftsmanship of sculptors of late medieval London. The prior and brethren, possibly with the guiding hand of Roger Walden, set out to commission the best that money could buy from the workshop of Henry Yevele, the king's master mason and the foremost architect of the late fourteenth century. The funerary monument for Rahere has undergone centuries of change and, on occasion, turmoil, and yet it remains a masterpiece of medieval funerary art.

3. WALDEN'S MORTUARY CHAPEL

Roger Walden, treasurer of England between 1395 and 1398, briefly archbishop of Canterbury between 1397 and 1399, and – at the time of his death on 11 January 1406 – bishop of London, was for a time a resident in the priory close. He had lived an eventful life, but his downfall, following the deposition of Richard II in 1399, was swift. He retired

32 Webb, *Records*, I, p. 75. These arms do not appear in the *Dictionary of British Arms: Medieval Ordinary*, ed. Hubert Chesshyre, Thomas Woodcock, Janet Graham, Ian Grant and Sarah Flower, 4 vols. (London: Society of Antiquaries, 1992–2014), and the author has so far been unable to clarify the identity of these arms.

4.11. Funerary monument of Rahere. Priory Church of St Bartholomew the Great, West Smithfield by Hulett. London Picture Archive ref 318513 (© London Metropolitan Archives, City of London)

to St Bartholomew's, where he had evidently already taken a special interest in the revival of the priory's fortunes.[33]

The bishop came from Walden, now Saffron Walden (Essex), where he was born shortly before the Black Death. His critics mocked him as the illiterate son of a butcher, but this was nothing more than propaganda by those jealous of Walden's success. His mother evidently died young, for his father remarried Isabelle, with whom he had a second son, John. John Walden was joint keeper of Portchester Castle (Hants.) with his half-brother between 1397 and 1399, and would become an esquire of the body of Richard II. Later he served Middlesex as MP and died in 1417. He married twice, first to Joan Lovetoft, who was dead by 1397, and secondly to Idonea, widow of John Rote, skinner and alderman of London, who died in 1426.[34] John Walden had two daughters, Idonea and Isabelle, both of whom appear to have predeceased their father; they may even have been dead by the time their uncle Roger Walden drew up his own will on New Year's Eve 1405, as he failed to refer to either of them.

Roger Walden had entered royal service as a clerk in 1371 when he was presented to the rectory of St Helier, Jersey, and it was in the Channel Islands that he became a capable administrator as their deputy warden. His meteoric ascent began in 1387 when he became archdeacon of Winchester and, three years later, dean of St Martin-le-Grand, London. Appointment to five rectories and six prebends swiftly followed. He was treasurer of Calais from 1387 as well as captain of the march of Calais and, by 1393, he was proctor for Thomas Brantingham, bishop of Exeter. In the same year, Walden was appointed king's secretary and, two years later, he became dean of York and keeper of Portchester castle. Richard II's high regard for Walden led to his appointment as Treasurer of England. As a consequence of the king's falling out with the Arundel family – including Thomas,

33 *ODNB* entry online by R.G. Davies, accessed 27 November 2021. See above.
34 *The History of Parliament: The House of Commons 1386–1421*, ed. J.S. Roskell, Linda Clark and Carole Rawcliffe, 4 vols. (Stroud: Alan Sutton, 1992), IV, pp. 740–42. Their wills: Appendix II, wills 53 and 56.

archbishop of Canterbury – in 1397, Roger Walden found himself elevated to the archbishopric of Canterbury – an office he fulfilled diligently until his removal following Henry of Bolingbroke's usurpation of 1399. Walden was allowed to live in comfort at Westminster Abbey, but he became embroiled in the failed 'Epiphany Plot' of 1400, led by the earls of Huntingdon and Kent, who intended to kill Henry IV and restore their half-brother, King Richard II, to the throne. They were betrayed and Walden was committed to the Tower of London. Although he was found guilty, he was freed and retired to his residence in the priory close at St Bartholomew's. Here he was able to live quietly. His fall from grace was dramatic: Walden was no longer at the heart of government, nor was he employed in the service of the Church. He was to spend four years in retirement in a form of 'political exile' at Smithfield. During this time, Walden presumably played an active role in the liturgical celebrations at the priory and involved himself in their affairs. He returned to episcopal life on his elevation to the bishopric of London on 10 December 1404. He was taken ill about a year later and he hurriedly arranged his will while at Much Hadham (Herts.). He died on 11 January 1406.

It was around the time Walden became king's secretary in 1393 that he began his patronage of St Bartholomew's priory. He financed the construction of a new chapel, to the north of Rahere's tomb, dedicated to All Saints but generally known as 'Walden's chapel'. By the mid-1390s it was sufficiently built and hallowed to accept the remains of the dead. Here John Newport, an esquire living in the nearby parish of St Botolph Aldersgate, who died in 1396, requested burial 'in the chapel of the venerable Lord Roger Walden, Treasurer of England', which reveals Walden's patronage.[35] Newport was probably a member of his household, as both Walden and his brother John witnessed his will and were appointed as overseers. Members of the Walden family were also entombed in All Saints' chapel, and it was here that the bishop originally intended his own grave to be. Roger Walden sealed his will on 31 December 1405.[36] He was dying, and yet he had a number of detailed instructions to set down. It was, inevitably, a time of contemplation – particularly so given the ups and downs Walden had experienced. The preamble to his will reflects these troubled times and says (in translation):

In the name of the most holy Trinity, Father, Son and Holy Spirit, amen. I Roger Walden, by God's grace appointed as bishop of London albeit unworthy, knowing and aware that the course of human life while being completely wrecked on the billowy sea of this world is repeatedly battered by storms and tempests, and in that exile to which it is deservedly consigned for the good of its native land is ever exposed to lamentation and toil; nor is there an end to its wretchedness until the hopeful exile from his homeland leaves the pitiable lodging of the flesh and returns to that place from which he came, where he hopes to enjoy a homeland after exile, joy after grief and rest after toil; and because it is needful for those moving towards that end first to make provision for their household, according to the Lord's command to Ezekiel before he died; therefore do I, while I am granted by the Lord healthy soundness of reason and memory, set down, arrange and make my testament regarding my goods in the manner which follows.

35 Appendix II, will 42.
36 Appendix II, will 45.

It is reflective of a dying man's state of mind as the final hour approached, touching on the stresses he had experienced in the service of both Church and Crown. Walden, unusually, did not leave his soul into the care of God, the Virgin Mary and the celestial host, but instead commended it to Jesus Christ, his Saviour, through whose mercy he would 'dwell in heavenly repose, after the wretchedness of toil, in the company of celestial citizens'. Walden went on to provide instructions about his place of burial:

I bequeath my body after it has quit this light to be handed over for canonical burial either in the cathedral church of St Paul's London or in the new chapel which I have had newly built in the conventual church of the canons of St Bartholomew's by Smithfield according to the decision and ordaining of my most reverend lord and father in Christ, Thomas by God's grace archbishop of Canterbury who raised me downtrodden by men and in the dust to the heights of the bishopric of London.[37]

Thomas Arundel was to decide whether the newly installed bishop of London should be buried amongst his predecessors in St Paul's Cathedral or in the new chapel which Walden himself had constructed in the Priory of St Bartholomew.

Roger Walden did not refer to any pre-existing funerary monument either at St Paul's or at St Bartholomew's (few testators provided such instructions, as they had often already organized their own memorial or provided instructions to friends and family), nor did he leave any instruction for one to be made following his death. There is no record of a tomb at the cathedral, nor does the herald's account of St Bartholomew's mention Walden's tomb. A tomb was, however, installed at the priory, because it was noted by John Stow in 1598.[38] This is the earliest reference to such a tomb, but Stow does not provide a description, nor does he copy down an inscription. It is thanks to John Weever that we know of Walden's inscription, written on a brass plate, which read:

Hic iacet Rogerus de Walden Episcopus Londinens[is] qui cum in utraque fortuna plurimu[m] laboravit ex hac vita migravit, 2 die Novem. an dom. 1406.

Vir cultor verus Domini, iacet intra Rogerus
Walden: Fortuna cui nunquam steterat una.
Nunc requiem tumuli Deus omnipotens dedit illi.
Gaudet et in celis plaudet ubi quisque fidelis.

(Here lies Roger Walden, bishop of London, who after toiling much in good and bad fortune, departed this life on the 2nd day of November 1406.

A man, a true servant of the Lord, lies below, Roger Walden, for whom there never was a single fortune; now Almighty God has granted him the repose of the tomb. May he rejoice and sing in the heavens where all the faithful are).[39]

37 Appendix II, will 45.
38 *Survey of London*, ed. Kingsford, II, p. 27.
39 Weever, *Ancient Funeral Monuments*, pp. 434–35. Weever misread the date of death on the inscription.

The text refers to Walden's ups and downs of fortune and this suggests the bishop's influence in the composition of his inscription, which is also reflected in the preamble to his will. It is likely that he composed the epitaph himself.

The existence of the tomb and the inscription at the Priory of St Bartholomew's have been taken as evidence that Walden was buried within his chapel on the north side of the sanctuary. This is not the case, for the bishop's remains were, in fact, in Old St Paul's Cathedral, where he was interred amongst his predecessors as bishops of London. An eye-witness, John Prophete, clerk of the Privy Seal and dean of Hereford, noted Walden's burial in the cathedral on 14 January 1406.[40] The monument at St Bartholomew's, therefore, was a cenotaph, which represented Walden's intended burial and commemoration within the priory church. But he was aware that this might no longer have been possible because of an established tradition whereby the bishops of London were buried in the city's cathedral amongst their predecessors. Walden was, in effect, 'chancing it' by making his own burial arrangements. His decision to leave the location of his grave in the hands of the archbishop of Canterbury might suggest a level of indecisiveness, but it was also an astute political move – for who could question Arundel's authority as the foremost churchman of England?

Six graves are recorded in Walden's chapel,[41] which was almost a private mortuary chapel for his family and household. As well as housing Walden's cenotaph and the remains of his retainer John Newport, it also contained the bishop's brother John, who died in 1417; John's mother-in-law Joan Lovetoft; John's second wife Idonea, who died in 1426; and the bishop's kinsman, also named John Walden, a clerk.[42] Both the bishop's brother John and his wife Idonea requested burial within Walden's chapel – and it is from Idonea's will that we learn that it was also known as All Saints' chapel – but neither John nor Idonea Walden mention any funerary monument, nor was one noted by the herald eighty or so years later. Yet, since the herald also omitted the epitaph for Roger Walden, he may not have inspected the memorials within this private space. This may explain why the herald also omitted from his account the tomb of Walter Sherington, who died in 1448. Sherington was fabulously wealthy; at the time of his death, he owned property in Kent and Middlesex and had an iron coffer deposited at St Paul's containing £3,233, almost all of which was in gold.[43] Sherington was a king's clerk and a capable administrator who rose in the service of Church and state. He left a number of bequests to the churches at Romney (Kent) and also a legacy for the repair of the local highways, which suggests he was born there. His early years are unknown, but in 1407 he was appointed to the prebend of Givendale, in the diocese of York, and he held a number of prebends, including at Lincoln Cathedral and St Paul's, London, until his death in 1448. He was chancellor of the duchy of Lancaster from 1431 and, by the time he came to draw up his will in January 1447, he and his household lived in the priory close at St Bartholomew's. Sherington, as a canon of St Paul's, was instrumental in establishing the library at the cathedral, where he also founded a perpetual chantry in his

40 BL, London, Harley MS 431, f. 97v, and cited in Webb, *Records*, I, pp. 188–89.
41 It was also known as the parish chapel: Webb, *Records*, II, pp. 97–99.
42 Appendix II, wills 42, 43, 44, 53 and 56.
43 Over £2M at today's rate.

memory.[44] Yet in spite of his connections to St Paul's, it was in Walden's chapel that he was to be buried: it is possible he was a member of Walden's household in his youth. Sherington left detailed instruction for his funerary monument:

And my wreched body to be beried in Waldons chapelle w[i]t[h]in the priorie of saint Bartilmeu on the northside of the auter in a tombe of marbil [the]re to be made adioinyng to the wale on the northside aforesaid of the height of two poulesfete for men to knele and lene upon the same tombe for to here masse atte said auter.[45]

This charming, yet blatant, use of a monument as a prop during the celebration of Mass is unusual. It is the only known reference to a tomb upon which weary or infirm worshippers could lean during the liturgy. The physical contact between the worshipper during the Mass and Sherington's tomb chest was clearly important, and provided a living link between the dead body under the tomb, the memorial itself and the worshipper.[46] Sherington would have had a raised tomb chest of 2 ft (60 cm) in height, which folk could kneel and lean upon, set hard against the north wall of the chapel and close to the altar. It is no surprise that he should commission a tomb over his grave. It almost certainly would have included an effigy on the top of the slab, with an inscription, probably a monumental brass similar to those commissioned by other canons at St Paul's.[47] It is unlikely that Sherington would have been granted permission for a raised tomb at the cathedral, where, as in cathedrals elsewhere, such memorials were rare especially for clergy below the rank of bishop. St Bartholomew's allowed Sherington to have a grander tomb than would have been the case in St Paul's.

Walden's chapel was intended to contain the earthly remains of its founder, Roger Walden. His elevation to the bishopric of London complicated his commemorative programme and he handed over responsibility to Thomas Arundel, archbishop of Canterbury. It was Arundel who decided that Walden should be buried amongst the bodies of past bishops of London in the cathedral of St Paul's. Yet, although Walden's bones lay elsewhere, his memory lived on through the brass he had set up in his chapel. The slightly maudlin inscription, written by Walden, was still extant in the early decades of the seventeenth century. Members of the bishop's family and his household chose the chapel as their final resting place. The remains of Walter Sherington were, however, 'the cuckoo in the nest', as there is no obvious link between him and Walden, other than their joint association with St Paul's Cathedral. The instructions given by Sherington for his brass, and the specific direction about the height of the raised tomb and its purpose during the Mass, provide a

44 M.H. Rousseau, *Saving the Souls of Medieval London: Perpetual Chantries at St Paul's Cathedral, c.1200–1548* (Farnham: Ashgate Publishing Limited, 2011), pp. 36, 44–46, 57–58, 64, 74, 114, 187; Nigel Ramsay, 'The Library and Archives to 1897', in *St Paul's: The Cathedral Church of London 604–2004*, ed. Derek Keene, Arthur Burns and Andrew Saint (New Haven and London: Yale University Press, 2004), pp. 413–29 (pp. 415–17).
45 Appendix II, will 77.
46 Sherington's tomb is also notable for the instructions given about its height 'of two poulesfete' a now obsolete unit of measurement. It was equivalent to the length of the foot of the figure of archbishop Æthelgar carved on to the base of a column in old St Paul's cathedral (*OED*). See also Philip Grierson, *English Linear Measures. An Essay in Origins* (Reading: University of Reading, 1972), pp. 17–19.
47 Christian Steer, 'The Canons of St Paul's and their Brasses', *Transactions of the Monumental Brass Society*, 19:3 (2016), pp. 213–34. It was rare for a canon of St Paul's to be commemorated by a raised tomb.

remarkable example of the practical and spiritual use of funerary monuments. At face value it helped weary worshippers, but it also served as a conduit between the living and the dead during the solemnity of the liturgy.

4. THE REMAINS OF THE DEAD: 1400–1538

At the dawn of the fifteenth century there were at least nine funerary monuments set close to the graves of those whom they commemorated: Rahere, Hugh de Hendon, Simon de Papnei, the unidentified lady, Sir Thomas Bacon, John de Carleton, John Malwayn, Thomas de Watford, and John Royston, with that for Roger Walden under construction. There were undoubtedly others from the fourteenth century, and they may have been among those noted by the herald in 1505 on which the inscription was illegible. A further 21 memorials have been identified from the fifteenth century and another two from the first decade of the sixteenth century (Table 2).

TABLE 2 The medieval funerary monuments from the former Priory of St Bartholomew, Smithfield, London. This is based on the herald's account of c.1505, testamentary evidence, *Ancient Funeral Monuments* by John Weever (London, 1631), and archaeological discoveries. The table is arranged in chronological order but with those of 'n.d.' (no date) at the end.

Number	Date of death	Name	Occupation/Status
1	1143x45	Rahere	Prior
2	1295	Hugh de Hendon	Prior
3	c. 1300	Simon de Papnei	Canon?
4	c. 1320-30	unknown lady	
5	1336	Sir Thomas Bacon	Knight
6	1361	John de Carleton	Prior
7	1378	John Malwayn	Esquire
8	1382	Thomas de Watford	Prior
9	1387	John Royston	Esquire
10	c. 1400	Robert Willoughby	A son of Sir Robert Willoughby [Lord Willoughby de Eresby?]
11	1406	Roger Walden	Bishop of London *
12	1409	Thomas Stanlo	Londoner
13	1415	Richard Bankes, and wife Margaret, daughter of William de la Rivar	Baron of the Exchequer
14	1415 (after)	John de Watford	Prior
15	1419x20	Richard Brigge alias Lancaster, and wife Katherine (d. 1436)	Lancaster herald
16	1432	John Morys	Londoner
17	1432	William Thirwall	Esquire

18	1448	Walter Sherington	King's clerk, chancellor of the duchy of Lancaster, canon
19	1450s	Agnes daughter of John Truthall, esquire, of Laughton (Lincs.)	Gentleman
20	c. 1452	John Golding	King's carpenter
21	1458	Gilbert Haltoft	Baron of the Exchequer
22	1459	John Louthe	Gentleman
23	1462	John Ludlowe, and wife Alice	Londoner
24	1474	John Durham, and wife Elizabeth (d. 1477)	Baron of the Exchequer
25	1476	William Scarlett	Esquire
26	1476 (after)	Eleanor, widow of Sir Hugh Fenne (d. 1476) of Herringby, Norfolk, and mother of Margaret, Lady Bergavenny	Knight
27	1478	Robert Threlkeld	Gentleman
28	1480	Thomas Thorold	Gentleman
29	1480	William Essex	Esquire
30	1492x1502	John Wanton or Warton, and wife Elizabeth, daughter of William Scot, esquire	Gentleman
31	1496x1504	Alice wife of Richard Bulstrode, gentleman of Cookham (Berks.) and M.P., heiress of Richard Knyfe of Chalvey (Bucks.)	Gentleman
32	1504	Edward Hungerford	Esquire
33	1508	John Clerke	Gentleman
34	n.d.	Elizabeth wife of Sir William Elington	Knight
35	n.d.	Anne wife of Sir William Fitlyng	Knight
36	n.d.	Filone Gray	
37	n.d.	Elizabeth wife of John Gynor	Gentleman
38	n.d.	Joan daugther of Richard Slade, esquire	Esquire
39	n.d.	Joan daughter of William Smith, esquire	Esquire
40	n.d.	John Underhill	
41	n.d.	Hugh Waltar	Gentleman
42	n.d.	Hugh Williams	

* the funerary monument to Roger Walden, bishop of London, was a cenotaph.

The herald's account is an invaluable source for the lost memorials of the priory church (figs. 4.12a–b). But it is the surviving probate registers for the City of London, and those from the ecclesiastical courts, that reveal a little more about others who were also commemorated at the priory and where they were buried. Occasionally these wills provide a description of the memorial that was to mark the grave and, in five instances, reveal a memorial which went unnoticed in the heraldic account. The earliest recorded request for burial in the priory church of St Bartholomew was by William de Erthyngton, who was staying in the hostel in the close at the time of his death in 1343.[48] He was one of fourteen known testators of the fourteenth century who asked to be buried at the priory. There were many more requests for burial in the century that followed – some 49 examples have been found – and this reflects better surviving testamentary evidence. In the early decades of the sixteenth century a further seventeen testators asked to be buried in the priory. The wills reveal that it was those of gentry stock, rather than Londoners, for whom the priory of St Bartholomew became a popular and prestigious place of burial.[49] One notable example was the herald Richard Brigge, alias Lancaster King of Arms, who died about 1419. He and his wife Katherine, who died seventeen years later, leased a tenement in the priory precinct and were buried under their 'stone' before the high altar of St Bartholomew's. Their estates were in Bedfordshire, Herefordshire and Lincolnshire. They were not Londoners but 'parishioners' of the priory.[50] There were others of gentry status also resident within the close: Richard Bankes, baron of the Exchequer, for example, was buried next to his wife Margaret inside the church, where their memorial stone was placed, in 1415; almost sixty years later, another judge, John Durham (d. 1474), and his wife Elizabeth (d. 1477) were tenants of the priory and both requested burial at the entrance to the chapel of St John the Evangelist at St Bartholomew's.[51] They were remembered by a funerary monument, although the exact design is unknown. Shortly before his death, Durham had witnessed the will of William Scarlett, esquire, of West Wratting (Cambs.), who left instruction that he was to be buried in the place he had already chosen at Hertford Priory.[52] Scarlett died suddenly in 1476 when in London and instead of being taken to the Benedictines of Hertford he was instead laid to rest in the priory church. His grave was marked by a commemorative stone that was noted by the herald thirty years later.

Richard Bankes and John Durham were lawyers, and we find other members of their profession choosing the priory for their burial. Gilbert Haltoft was another baron of the

48 Appendix II, will 14.
49 A similar popularity amongst the gentry has been noted at the hospital of St Bartholomew immediately opposite the priory: Caroline M. Barron, 'The People of the Parish: The Close of St Bartholomew's Hospital in Fifteenth-Century London', in *The Urban Church in Late Medieval England. Essays in Honour of Clive Burgess: Proceedings of the 2017 Harlaxton Symposium*, ed. David Harry and Christian Steer, Harlaxton Medieval Studies, 29 (Donington: Shaun Tyas, 2019), pp. 353–79.
50 Appendix II, wills 52 and 68; on Richard Brigge alias Lancaster King of Arms see H. S. London, *The Life of William Bruges the first Garter King of Arms*, Harleian Society 111 and 112 (London, 1970), pp. 1–8. I am grateful to Nigel Ramsay for this reference.
51 Appendix II, wills 92 and 95; on John Durham see: J. H. Baker, *The Men of Court 1440 to 1550: A Prosopography of the Inns of Court and Chancery and the Courts of Law*, Selden Society Supplementary Series, 18, 2 vols. (London, 2012), I, pp. 614–15.
52 Appendix II, will 94.

4.12a, b. College of Arms MS C.G.Y. 647, fols. 40v–41r (reproduced by permission of the Kings, Heralds and Pursuivants of Arms)

Exchequer who died in London. He came from Outwell (Norfolk), where his wife Margaret is commemorated by an inscription brass, and had estates throughout Norfolk, but in his will he simply left his burial 'where it will please God'.[53] He perhaps died when staying in the priory close; his memorial was later noted by the anonymous herald. Other 'gentlemen' were also commemorated in the church: the herald noted the memorials for Robert Threlkeld, probably of Beddington (Surrey), who died in 1478, and Thomas Thorold, who died two years later. Threlkeld is the only testator who asked to be buried before the image of St Blaise. Thomas Thorold, a lawyer of Lincoln's Inn, and attorney to Queen Elizabeth Woodville, requested burial alongside his first wife in the church of St Bartholomew's 'that is to wite under the marble stoon which I have do leid ther[e] redy where the body of Johan my ffirst wyffe lieth buryed'.[54] Their grave was probably marked by a monumental brass with figures of them both, an inscription and heraldry, all of which had been organized by Thorold following Joan's earlier death. It seems clear that the priory became a resting place for the

53 Appendix II, will 88; on Gilbert Haltoft see Baker, *Men of Court 1440 to 1550*, I, p. 809.
54 Appendix II, will 97; on Thomas Thorold see Baker, *Men of Court 1440 to 1550*, II, pp. 1525–26.

'middling sort' during the fifteenth century, who found it a convenient place to stay when visiting Westminster or the Inns of Court, or attending Parliament or the royal court.

Burial in the priory church remained popular up to the Dissolution. There were at least seventeen burials at the priory between 1500 and 1539. At least half of them were for gentry. One notable example is John Clerke, a lawyer who died in 1508, and in his will directed that should he die in London he was to be buried before the image of St Ursula in the 'parish chapel' of St Bartholomew's (Walden's chapel). Clerke had something of a 'monuments addiction' and he went to some lengths to provide four gravestones for those to whom he was beholden, probably as their executor, at Dudley (Worcs.), Glatton (Hunts.) and Walthamstow (Essex). He also set down careful instructions for his own memorial at St Bartholomew's:

and it is my will that my grave be cov[er]ed and made playne of marble the same to have a remembrance of myn[e] auctorite passed and of the day of my departing of this life w[i]t[h] a request of prayer for my soule as myn[e] executo[r]s shall seme reasonable to be done.

Clerke's memorial seems to have been completely incised on to the marble with reference to his status, date of death and a request for prayer. His request for 'myn[e] auctorite' to be included in the text indicates his status as a man of law who had previously served as auditor of the duchy of Lancaster and as baron of the Exchequer from 1504. He was probably the lawyer of the same name who served as a Justice of the Peace for Essex from 1495 until his death.[55]

The written evidence provides a tantalizing glimpse of the lost commemorative landscape at St Bartholomew's. Whatever brasses and slabs once carpeted the nave would have been swept away when it was destroyed in 1543, and others were lost during the centuries which followed. Hints of lost brasses appear in accounts of the church: in 1802, for example, it was remarked that 'under the organ gallery are many broken slabs, on which there have been brass plates'.[56] These fragments have disappeared although two other indents – the outline or imprint of a lost brass – were noted in 1987. In the walk of the east cloister, set into modern paving, is a fragment of yellow Purbeck marble with the worn indents of the lower part of a figure of a lady or, perhaps, an ecclesiastic, set above a foot inscription (fig. 4.13). The second indent for a lost inscription brass is on the font, and it has been suggested that this commemorated the donor of the fifteenth-century font (fig. 4.14).[57] This may be true, but it is notable that John Golding, described as carpenter, who lived in the close and died about 1452, asked to be buried near the font, under the marble stone which he had already ordained.[58] Burial close to the font not only completed the life cycle but attracted the attention of others when present at future christenings. It would seem surprising for

55 Appendix II, will 110; on John Clerke see: Baker, *Men of Court 1440 to 1550*, I, p. 479.
56 James Peller Malcolm, *Londinium Redivivum*, 4 vols. (London: J. Nichols and Son, 1802–07), I, p. 294 (correcting Webb who mistakenly gave p. 244 as the reference).
57 Jerome Bertram, 'London Notes (I): Gleanings from the City Churchyards', *Transactions of the Monumental Brass Society*, 14:2 (1987), pp. 143–50.
58 Appendix II, will 81.

4.13. Indent for lady or ecclesiastic (credit: Jerome Bertram, reproduced with permission of the Monumental Brass Society)

a carpenter to enjoy such an exalted location for his grave, but Golding was the King's Carpenter and commanded a certain status. He was appointed to this position in July 1426 at an annual salary of £20 plus a new robe every year. He is thought to have been involved in the design of the roof at Eton College chapel.[59] He was certainly no ordinary carpenter, and it is possible that the indent for the lost inscription on the font marks the site of Golding's grave. Only two other testators are known to have requested burial near the font: Richard Ryder, who in 1455 asked to be buried behind the font, and Richard Bellamy, who died in 1539 and who requested burial between the font and the image of Christ.[60] Neither left instruction for any memorial and in the case of Bellamy that would have been most unlikely given that the priory was surrendered soon after his death.

The priory of St Bartholomew attracted the remains of some prestigious gentlefolk during the fifteenth and early sixteenth centuries. Few of those buried there were Londoners. Several seem to have been priory tenants, such as Richard and Katherine Brigge, resident in the close, for whom the priory church was their *de facto* parish church. Brasses and incised slabs were usually set near their graves and the evidence of the probate registers indicates a little about what memorials testators wanted and, more importantly, the trust they placed in their executors. Only two indents remain in the church, the last survivors of what was once, on the eve of the Dissolution, a much richer and fuller commemorative landscape.

5. CONCLUSION

The Priory of St Bartholomew contained at least 42 medieval funerary monuments. The majority were for men and women who were not Londoners, but either rented tenements in the precinct or made the most of the priory's hospitality and stayed with the canons when in town. The priory church was a *de facto* parish church for these gentlefolk. They were the middling sort who could easily afford a memorial stone over their grave, but they also died away from home and away from friends and family who would attend the grave and pray for their souls. These visitors to London were dependent on the prayers of the canons and of strangers.

The construction of the Walden chapel as a mortuary chapel is an example of a single, wealthy donor who lived in the precinct and constructed sacred space for his remains and those of his family and household. The chapel was evidently intended to house the remains of the founder, Roger Walden, who had retired to the priory after he was deprived of the archbishopric of Canterbury in 1399. The wording of his will suggests a pessimistic outlook

59 Harvey, *English Mediaeval Architects*, p. 121.
60 Appendix II, wills 86 (Ryder) and 126 (Bellamy).

4.14. Indent for inscription, on 15th-century font
(credit: Christian Steer)

on life and on his fall from grace, and is mirrored by the epitaph on his tomb. But his elevation to the see of London in 1404 threw his commemorative plans into disarray, with a tomb already set up and waiting for him at the priory but an expectation that his bones would join those of his predecessors as bishop of London in the cathedral. His decision to have Thomas Arundel, the archbishop of Canterbury, decide on the matter demonstrates Walden's astute – and pragmatic – nature. Ultimately he was buried at St Paul's, but his cenotaph at St Bartholomew's formed the centrepiece of a family chapel where the remains of his family and household would rest alongside his brass in the years which followed. Walden's chapel was sufficiently prestigious to attract the attention of Walter Sherington, who set out to join the Walden household in death as he once might have done in life. His determination, set down explicitly in his will, that those attending Mass in the chapel would deliberately kneel before and against his raised tomb is remarkable. It was about audience, and maintaining a physical presence with the living through contact with the tomb.

The funerary monument for Rahere remains the *pièce de resistance* in the church. It has fulfilled its purpose not only to honour him, but also to attract pilgrims and visitors. It is a fine example of medieval craftsmanship, testimony to the determination of the prior and brethren, and perhaps also Roger Walden, to celebrate the founder. In creating the tomb they chose the best that money could buy, and in doing so they ensured that Rahere would be commemorated in style. It is a fitting memorial to a remarkable man whose vision, guidance and leadership established the priory and hospital of St Bartholomew some nine hundred years ago.

In poch'ia ṡi Sep

Copia cartaꝝ hospitalis ſñ

Vrbis ⁊ tn̄ n̄is iuꝑtiꝰ ſn̄

Sciant p̄sentes ⁊ futuri qđ ego n
cessi et hac carta mea confirmaui
illam meam ṫram sup quam ē
Edith ꝥ uxor sua sederunt. Qu
Bardi ligni pannaꝝ ⁊ ṫram te
ram de Suuetſiesteld ante cruce ip̄
in sanctitudine usus mei ⁊ usus
ditate de eisdem usu tenendam ill
meis in ſrodo ⁊ ſicantate sit quiete ⁊ fruabil' redd inde annati u
ponu sepulc̄o ⁊ exactione ⁊ printis reb; Reddendo ad iiii tumnos anny
octab' Paschie et vo denaꝝ ĩfra octab' ſī Johīs Baptē ⁊ vo denaꝝ ĩfra o
iuxta octauam dieꝝ post diem Natal' Dn̄ce ſieḋ nq̃ ego Anch uel
uius de hospitari p̄uocatu' nostrū nq̃ heḋs suos ⁊ p̄dict tra ea
qnem aſm hominē uel ſeruam istiu' hospitaud Ego eram Anch ⁊ h
zare ⁊ acquietare p̄dict tram p̄dicto Roberto ⁊ hedib; suis cōtra omes ſ
annuatim ut dixim' p̄ſoſuendis ſi ŭo R̃ostris forte noſuerit aſi
Ego Anch ero minimor ⁊ tra illa de viii denaꝝ qñ aſiqns aſius ꝥ
tacōe ⁊ carte mee cōfirmatione dedit in p̄dict Robt in Gersuiam i
ſfabro Willīo ſfabro Thoma cementario Willīo ſe Comiser
de maiui kenelbardo ſingni pannaꝝ Robt p̄mentario Ric̄o
de Alsford Steph de Barra ⁊ ali̊ ꝑlus

Sciant presentes ⁊ futuri qđ ego Anch de Valernis con
mea confirmaui Remero carpētaꝝ ṫram meam
genisdc tenendam de me ⁊ hedib; meis sibi ⁊ hediḃ;
quiete fruabil' Reddendo ĩe iiii uñ hedib; meis annuatim p̄ omi

St Bartholomew's Hospital to the Reformation

EUAN ROGER

THE EARLY YEARS

From the hospital's earliest days, its relationship with its sister foundation was an uneasy one. Rahere, as has already been discussed in this volume, was the founder of both the priory and hospital of St Bartholomew's, and thus served as both prior and master of his two foundations alike. After his death in 1143, however (and possibly a few years previously), the leadership of the two houses was split between two individuals, the prior, Thomas of Osyth, and Hagno the clerk, who it appears had worked in the hospital from an early date. The hospital was initially under the care and control of the priory, a situation which must have proved difficult, as in the years between 1170 and 1175 the two institutions came to an agreement about their structure and organization in which the hospital was allowed to receive gifts and bequests in its own right, and to manage these itself. Furthermore, the brothers of the hospital were granted the right to choose their next master, and they could accept orphans, the poor sick and outcasts at their own recognizance.[1] This was an important first step in a gradual process of independence, which would take centuries to resolve.

The earliest masters of the hospital remain obscure, beyond a list of names recorded in the hospital centuries later, but originally took the title of 'proctor', indicating that the hospital was subordinate to the prior and priory (although the title 'master' also features occasionally) (fig. 5.2).[2] As such, the first proctors of the hospital primarily dealt in practical measures such as sourcing food and gifts to care for the poor sick who came to St Bartholomew's, rather than the oversight and management of the house. As the hospital began to accumulate its own property holdings, gifts and bequests after 1175 (with the first grants arriving that same year), it was perhaps inevitable that disagreements would arise between the two institutions. As the hospital had previously not been able to hold any property in its own right, it was not only new grants that might provoke debate, but the existing buildings of the hospital precinct, including the hospital chapel. Following the election of Alan Presbyter in 1182, the hospital increasingly began to push for further independence in what appears to have been a concerted and organized campaign in the papal Curia that would last some fifteen years.

1 See also Christine Fox's chapter in this book.
2 *List of Masters*, SBHB/HC/2/1, ff. 68–69.

5.1. Detail of a leaf from the Hospital cartulary, a book of copies of charters, deeds and other documents relating to the medieval St Bartholomew's Hospital, SBHB/HC/2-1, f. 94r

The result was a compromise between the two institutions under which the hospital was allowed a degree of independence, but under strict supervision from the priory. It was not to alienate lands or rents without first seeking the permission of the bishop of London and the priory, nor provide perpetual allowances of food or clothes without the same, and the hospital's financial accounts were to be audited twice a year to ensure regularity. The proctor was to be chosen from the brethren of the hospital (if a suitable candidate was available, otherwise an external figure could be appointed), not the priory, and was to be elected by both the canons of the priory and the brothers of the hospital, and removed by the same if necessary. All of the brothers and sisters of the hospital, and indeed the proctor, were required to swear obedience to the prior and priory in chapter, and were to receive their habits at the same time, while also agreeing to certain obligations at key feast dates in the priory's liturgical calendar.

The 1197 arrangement was limited in its parameters, offering the hospital a circumscribed level of independence under strict oversight, and it soon became clear that concerns remained on both sides, alongside the potential for the dispute to flare up. In 1223, such a situation arose around the election of a new proctor. The priory, as later arrangements make clear, appears to have attempted to veto the hospital's choice in the election, and the two sides could not come to an agreement. In order to try and resolve the matter, a temporary appointment was made by the Crown of a Templar by the name of Maurice, who was to be warden of the hospital while the dispute was referred to the bishop of London for consideration.[3] New measures were put in place by Bishop Eustace stating that the prior was not to veto the choice of an elected proctor whom the hospital brothers agreed upon, but rather to refer the decision to the chapter of St Paul's Cathedral for resolution if he disagreed with their choice.

Minor, but symbolic, measures such as the decision that the brothers and sisters of the hospital should receive their habits in the hospital church rather than the priory, and an easing of the hospital's feast day obligations within the priory, were welcome positives for the hospital. For the priory, the measures were also welcome, as they limited the hospital's clearly increasing aspirations for independence and restricted its opportunity for local competition. A cemetery for which the hospital had requested papal approval was refused, as was the possibility of a bell tower, any more than two bells, and an altar or image of St Bartholomew, while the hospital had to wait for the priory to ring its bells at Easter before they could do the same. The 1223-24 arrangements appear to have been effective, at least in the short term, with a new proctor elected shortly after in 1224, and over the course of the next century the status quo between the two institutions remained, as the hospital began to develop its property portfolio considerably.

Much of the hospital's property in London and across the kingdom (notably in Middlesex and Essex) was granted to the hospital through bequests and gifts by around the mid-thirteenth century, although large bequests of land for commemoration continued into the fourteenth and fifteenth centuries. It is clear, however, that at the start of the

3 *Patent Rolls of the Reign of Henry III, 1216-25* (London: His Majesty's Stationery Office, 1901), p. 371; The National Archives (hereafter TNA), C 66/29, m. 4.

fourteenth century all was not well within St Bartholomew's Hospital. The hospital at this time, despite the new grants and bequests, was still largely reliant on alms and regular collections around the city, and had been exempted from the payment of taxes by both Edward I and Edward II on account of their poverty. Visitations by the bishop of London in 1316 and 1318, however, indicate that some of this poverty was of their own making, highlighting mismanagement at St Bartholomew's Hospital. Various masters, it appears, had been neglecting the hospital's primary purpose – the care of the sick and poor – and instead granting an excessive number of corrodies (pensions) within the hospital. The hospital buildings, including the infirmary, had also been neglected and needed repairs, while an injunction stating that the community were not to go drinking in the city without special licence probably indicates that certain individuals had been doing just that. A few years later, a master who had procured his election unlawfully had to be deposed.

The number of brothers and sisters also had to be regulated at this time, so that the work of the hospital could be carried on effectively (indicating that perhaps it had not been previously). There were to be seven brothers – of whom five were to be priests – and four sisters, and their clothing was to be regulated. Furthermore, the accounts of the hospital were to be produced in duplicate, so that the master (as he was now named) of the hospital and the brethren could both receive a copy, thus ensuring the openness of the hospital's accounting process. Concerns around interactions between the brothers and sisters of the hospital also appear in the visitation records. A doorkeeper of good standing was to be appointed to keep unwanted visitors out of the sisters' quarters without leave of the master (although this would not guard against a future relationship developing between Master Richard Sutton and one of the sisters in 1376). If there were concerns within the hospital itself at this time, relations with the priory appear to have calmed, at least in the short term. It would not last. With the death of Master Stephen of Maydenhethe in c. 1371/73, the relationship would deteriorate once again, probably relating to the election of Stephen's successor, with the matter once again being referred to the ecclesiastical officials of the city for resolution.[4]

NEW ARRANGEMENTS BETWEEN THE HOSPITAL AND PRIORY

After years of disputes and discontent between the hospital and priory, a new arrangement was drawn up in 1373 regulating relationships between the two neighbouring institutions.[5] Produced by Simon Sudbury, bishop of London, after consultation with both parties, the arrangement provided the hospital with a new, limited form of independence. The brothers of the hospital community could elect their own master, but only with the leave of the prior, who was then to present him to the bishop of London for approval. The master was either to be in priestly orders, or an individual who could be ordained quickly, and was

[4] Stephen's final recorded mention in the hospital records was in 1371, but the list of masters compiled in the hospital cartulary states that he died in June 1373. However, for many of the early masters, the dates are muddled in this list: SBHB/HC/2/1, *List of Masters*.

[5] The hospital's own copy of the agreement was recorded in the hospital cartulary: St Bartholomew's Hospital Archives, SBHB/HC/2/1, ff. 60–62.

required to swear a (newly reformulated) oath of fealty and obedience to the prior and convent. The newly elected master could appoint the brothers and sisters of the hospital without permission, although all new appointees had to swear the same oaths of fealty and obedience within three days of their appointment. Within the hospital precinct, the master was now fully responsible for the oversight of behaviour (although he was allowed to ask the prior for assistance if needed), and the administration of the hospital's properties and grants.

Such regulations were not widely different from previous ordinances, and the question of elections would remain contentious in the future. The 1373 arrangements did, however, resolve some of the hospital's key concerns dating back to the 1170s and 1180s. The hospital's property portfolio remained split from that of the priory, and the administration of these holdings was expanded. The prior did not need to be consulted in any grants of property, and could no longer use the hospital seal. A bell-tower, which had previously been denied, was now allowed, as were additional bells to be housed within it, and the hospital no longer had to wait for the priory to ring their bells first on Easter Sunday. Of primary importance, however, was the consecration of a hospital cemetery for all those dying within the bounds of the hospital precinct and for others, as long as they did not die within the priory precinct or the parish of St Sepulchre and were not parishioners of the same parish. The provision of a cemetery, bells and a bell-tower were of vital importance in attracting patronage, gifts and bequests for any institution, particularly relating to the commemoration of the dead, while also making the hospital more self-reliant with a greater sense of identity. The establishment of firm boundaries between the priory, hospital and parish of St Sepulchre points to the early stages of the hospital precinct forming a distinct geographical and spiritual community, resembling – if not replicating – the spiritual setting of the local parish.

If the 1373 settlement favoured the first steps in the hospital's independence, it also freed the priory of some of their historic obligations. The hospital was no longer to receive the regular food allowance that had previously been provided to them by the priory, while the master of the hospital was required to keep the hospital maintained for the care of the sick. Interestingly, this part of the arrangements does not seem to have been relayed to some of the hospital community, as a few years later three brothers and one of the sisters there complained that they had been deprived of the food owed to them by the prior (with the collusion of the master of the hospital), despite the fact that such a provision was no longer binding. Both the hospital and priory could also only receive gifts, alms and goods intended for their own use, and any erroneously received goods were to be passed to the intended recipients instead. The hospital also retained some of the previous obligations imposed on them – they were banned from having an image of St Bartholomew in their church, and were required to provide offerings in the priory church on his feast day.

The 1373 ordinances represented a balance between the hospital's independence, its right to manage its own affairs, and indeed the possibility of competition between the two institutions on one hand and the priory's historic claims and royal charters on the other. The matter was not, however, at an end, with lingering concerns continuing into the fifteenth century, particularly around the election of the hospital's masters. Since the bishop of

London's injunctions of 1223/24, the election of a new master to the hospital required the leave of the prior, but he was not supposed to veto candidates if they had been unanimously chosen by the brethren. If a disagreement occurred, the election was instead supposed to be referred to the Dean and Chapter of St Paul's for resolution. It is clear from the list of masters compiled in the hospital's fifteenth-century cartulary, however, that elections were not a simple process. The election of a successor after the death of Master Thomas Lackenham in late August 1412 caused the dispute between hospital and priory to resurface once again. The prior, John Watford, refused to hand over the hospital's common seal and other goods, and sought to delay the election of a new master against the terms of the 1373 settlement.[6] The resulting squabble would continue for the next ten months, as Prior John sought to present his case to the ecclesiastical courts, while the brethren of the hospital pursued him through the king and the royal courts. After a judgement on the matter by the royal justices, and several royal summons, Robert Newton was eventually elected as master on 13 June 1413 by the bishop of London.

The procedure utilized by Prior John (and perhaps his predecessors) was seemingly to delay the process of presenting a newly elected master to the bishop of London, so with Newton's retirement on 31 May 1415 – with the events of 1412-13 fresh in their minds – the brethren seem to have attempted to forestall any further problems by appointing the bishop of London to oversee the election. It was a shrewd move; the new master, John Bury, elected 'by way of compromise' (*per viam compromissam*), was installed early in July 1413, with minimal delay to the hospital's business.[7] A few years later, in 1420, the matter of delayed elections was finally resolved with a new settlement from Richard Clifford, the bishop of London, confirming Sudbury's ordinances, but adding that on account of the fact that 'on several occasions the prior had delayed to present the elected master without just cause', the presentation of each new hospital master to the bishop was to take place immediately after his election.[8] The agreement of 1420 appears to have settled the main dispute between hospital and priory, although occasional squabbles would continue to break out over the next thirty years, as both sides attempted to consolidate the decisions, confirmations and rights they had secured over the previous centuries.[9] A final confirmation of relations – confirming the long history of the dispute – was resolved in 1453, after yet another round of arbitration had been needed in the 1440s.[10]

If relations between the hospital and priory could often be tense, this was not always the case. On at least one occasion we find evidence of individuals moving from one institution to the other. John Venyse and John Elys, who both entered minor orders at the hospital in 1414, appeared as members of the priory community in a lawsuit of 1445 – Venyse as sub-prior and Elys as a canon. In the absence of detailed information about the individual brothers and sisters of the hospital, and the toponyms which were favoured by those

6 SBHB/HC/2/1, ff. 62-63.
7 *Ibid., List of Masters*, f. 68-69.
8 A further stipulation limited the requirements on the brethren to attend the St Bartholomew's day procession in the priory, as they had often been delayed unduly in doing so, although an offering of wax was still required.
9 SBHB/HC/2/1, ff. 63-64.
10 *Ibid.*, ff.64-73.

5.3. Agreement between the brethren of the Hospital and the prior and convent of the Priory for the provision of 'holsom water', TNA, SC 8/121/6034A

entering the church, it is impossible to say whether such moves were commonplace. Alongside the movement of individuals, we see evidence of more enterprising interactions between the two houses in the fifteenth century, particularly under the mastership of John Wakeryng (1423–66). In 1433, for example, the two houses came to a mutually beneficial agreement over the supply of water in the area (fig. 5.3).[11] The priory's water supply – which was piped in from Islington – had recently become damaged and needed to be repaired, but the priory were unable to afford the cost of the necessary repairs. Instead, Wakeryng stepped in and offered to cover the cost of the works, on the basis that the hospital would be allowed to siphon off half the water for their precinct (for a payment), with the fresh water channelled to a well within the close. Any future repairs were to be paid for by both parties. As a consequence, the priory's pipes were fixed, and they received an annual fee from the hospital and financial support for further repairs. The hospital received a new long-term source of fresh water, which simultaneously improved living standards in the precinct and supported their role of helping the sick poor (a lack of fresh water which had led to increased sickness within the hospital having been a key motive in the agreement). The repair and extension of the pipes also contributed to the charitable work of both houses, as in future years the hospital's residents themselves contributed further funds towards the project in order to extend the supply further, providing a source of fresh water to those incarcerated at Newgate and Ludgate prisons.

RESTORATION AND REBUILDING OF THE HOSPITAL ESTATE

While the repair of the water supply clearly had an impact on the two sister foundations, it also benefited the local community who lived there, and acted as an attraction to those who might consider renting tenements within the hospital precinct, whether a member of the hospital 'staff' or not. In London, St Bartholomew's held tenements across the city, spread across nearly sixty parishes. In the hospital's surviving rental of London properties, compiled at Easter 1456, they fell into two distinct categories: those within the hospital precinct and those elsewhere in the city. Across several of the properties that formed part of the hospital's portfolio we find similar examples of improvement works taking place during Wakeryng's time as master – particularly in the area around Smithfield and the precinct – a clear policy intended to make St Bartholomew's an attractive and desirable place to live.

11 TNA, SC 8/121/6034A; SC 8/121/6034B; C 66/434, m. 3; *Calendar of Patent Rolls*, 1429-36, pp. 296–97.

The rental, compiled by a hospital brother named John Cok, not only records details of property rental values and tenants, but of improvements, expansions, consolidations and diversification of these properties – often with personal remarks in the margins – alongside histories of a property's tenants. Where the tenants of the precinct had undertaken restoration of their properties (presumably at their own expense), Cok took care to note this, such as the restoration undertaken by James Surynden:

A dwelling in the close next to the Chapel of St Andrew, lately held by Robert Newton and afterwards by James Surynden who rebuilt two rooms above the said chapel and who did many more good things, now inhabited by Thomas Grannt.[12]

Alongside restorations, new building works were also approved and encouraged, as in the case of the Portealeyns, who developed a large tenement in the north of the hospital precinct:

A large tenement and garden formerly held by William Markeby, afterwards by Richard Shipley who carried out much building, now granted to Thomas Portealeyn and Alice his wife who built in stone a kitchen, rooms and other pleasing items, and who improved it very much.[13]

Several other such entries are found throughout the hospital rental, and are in stark comparison to a brewery in St Ethelburga within Bishopsgate, Le Lampe on the Hoop, which had apparently been mismanaged by its tenant, James Brampton, described as being a 'counterfeit gentleman and never thrifty'.[14] Throughout the entries, it is clear that the hospital's officials paid close attention to their properties and businesses, and were happy to make changes in order to boost the attractiveness of the hospital and its surrounding area, drawing wealthy individuals to live, work and potentially to invest in the local area. A large tenement on the west side of Smithfield next to The Elms, for example, called Le Greyhound on the Hoop, which had been donated to St Bartholomew's as part of William Arundel's 1326 grant to the hospital, had been run as a brewery during the tenancy of one Richard Rowdon. After Rowdon's death, however, Wakeryng stepped in and not only converted the brewery into a bakery, but also attempted to ensure that the new bakery would be successful, by renting it to 'Stephen Paul, baker, then the most famous baker in London', as recorded by Cok in the rental.[15] Bequests could also be manipulated to ensure that the hospital 'advertised' to prospective benefactors as well. One of Wakeryng's first acts as master, for example, was to try to secure the legacy of his predecessor, Master John White. White had been named as one of the executors of the wealthy mercer Richard Whittington (d. 1423), receiving both a payment for his work and a bequest of 100s. for the poor of the hospital, to be distributed at White's discretion. Securing this gift, however, had been complicated by the former master's death, and Wakeryng had to recover items and sums

12 SBHB/HC/2/1, f. 7v.
13 *Ibid.*, f. 8.
14 *Ibid.*, f. 36v.
15 *Ibid.*, f. 9.

of money from both Whittington's and White's executors, including a cross with a gilded foot, three large (and valuable) books and various other goods. He was also eventually able to recover from Whittington's executors an annual quit-rent of 20s. for a tenement in Le Ryole, which had been 'for many years in arrears'.[16]

The question of how Whittington's bequest was to be spent, however, was one that now came into question. Simply giving money to the poor, as was seemingly intended, was one option, but a time-limited one: it would only last until the money was distributed. Instead, Wakeryng managed to convince the executors to invest the money instead, through the construction of a huge new south gate for the hospital. The gate would display Whittington's coat of arms, acting as a sign of the hospital's connection with the deceased Londoner and as a sign of patronage for the hospital, while an expensive window was to be installed within the hospital church, at a huge cost of £64 for the gate and £44 for the window. This move both advertised the hospital and its patron to the outside world, and by the inclusion of a window with images of charitable works also offered the dual assurance that Whittington's generosity to the poor would be remembered and that his soul would be prayed for in perpetuity – an inviting prospect for others seeking salvation.

This was a clear and deliberate policy of gentrification, intended both to ensure a steady income stream from someone like a famous baker, who was likely to be successful, and also to draw prominent individuals towards to the area. Through this policy of expansion, diversification and improvement (both by Wakeryng's initiative, and by that of those around him such as Cok, and of his own tenants) the hospital was able to ensure a firm financial footing at a time when other religious institutions around the country were struggling. It was also a policy designed to ensure that buildings did not become dilapidated, expanding the hospital's portfolio where possible, and diversifying the types of properties involved, notably breweries and bakeries. Changing the use of buildings from strictly residential to more lucrative business premises, including shops and offices, was a means of generating further rental income, and seems to have been a key hospital strategy in the mid-fifteenth century. Such a policy of diversification and consolidation of property was not unique at this point, but the rental account makes it quite clear that Wakeryng, Cok and the hospital management more broadly paid close attention to the possibilities of such action in order to attract business and bequests from wealthy benefactors.

Property redevelopment was not the only means of attracting the attention and interest of wealthy and connected tenants, however. The hospital had a school from at least the mid-fifteenth century, if not before. In 1440 Robert Warner had granted the hospital land for the teaching of four boys to officiate in the church, and a few years later, at his death in 1444, one of the hospital chaplains, John Stafford, made a bequest to the hospital of 33s 4d for the teaching of boys in grammar and song.[17] Within the course of a decade, the school had become established, and had been able to attract the employment of one John Reynolds, a master of the ancient grammar school at St Paul's in the 1430s, but who, in his will of 1459, described himself as 'master of scholars of the hospital of the Holy Cross

16 Ibid., SBHB/HC/2/1, *List of Masters*.
17 London Metropolitan Archives (herafter LMA), CLA/023/DW/01/175.

5.4. A document mentioning 'John Barkeby, master of the school of
St Bartholomew's Hospital London', TNA, CP 40/848, rot. 265

and St Bartholomew'.[18] A new master, John Barkeby, likewise appears in the records as schoolmaster in 1473, and as 'teacher of grammar in the schools within the hospital of St Bartholomew, Smithfield' in 1476, possibly indicating the presence of multiple educational foundations (fig. 5.4).[19]

The school had a dual benefit both of education (including that of children whose mothers found themselves in Newgate prison) and of improving the spiritual provisions that the hospital could provide, while also encouraging further gifts and benefactions. In the same year as Barkeby was recorded as teacher of grammar, the will of Beatrice Lurchon bequeathed 2nd to 'every child of the grammar school [...] of the hospital of Saint Bartholomew' who helped to escort her body for burial at St Thomas of Acre.[20] Other members of the hospital community pursued their educational and intellectual enterprises further. One John Bokyngham *alias* Clerk, one of the brothers of the hospital, is known to have gained papal authorization to leave the hospital for up to seven years in order to attend university and study theology, possibly in Italy.[21] He had returned by the time of the 1456 rental, in which he was recorded in his old age, holding a tenement in the area of the hospital known as 'Paradise'. He may have brought a fine Bolognese bible back with him, later attributed to John Cok, which formed part of the hospital's common library. In a further attempt to secure an 'intellectual' reputation at Bart's (and to emulate St Paul's Cathedral), we also see attempts to copy the St Paul's bookselling tradition (on Paternoster Row) by trying to attract similar figures to Duck Lane, on the east side of the hospital precinct, and to encourage 'bookish' types such as John Shirley, a well-known medieval bookseller and copyist who rented a tenement in the precinct and was buried in the hospital church with a now-lost brass and epigraph.

RESIDENTS OF THE HOSPITAL PRECINCT

It is during Wakeryng's mastership – thanks to the 1456 rental – that we find the clearest view of the types of individuals who were attracted to live within the hospital's precinct and vicinity. Forty-six entries (some containing multiple properties) were recorded within

18 LMA, DL/C/B/004/MS09171/005, f. 270v.
19 TNA, CP 40/848, rot 265.
20 LMA, DL/C/B/004/MS09171/6, f. 188.
21 *Calendar of Entries in the Papal Registers Relating to Great Britain and Ireland: Papal Letters* (hereafter CPL) (London: HMSO, 1971), v. 604.

the hospital precinct, with more than two hundred further entries across the Smithfield area and across London, presenting a snapshot of an educated, wealthy and professional group of individuals living within an exclusive gated community.[22] Prominent among the residents of St Bartholomew's Hospital in the fifteenth century was a group of lawyers, civic and royal officials, who both lived and worked in the hospital precinct. The lawyer Robert Danvers (recorder of London and a Justice of the Common Pleas), rented a large – and newly rebuilt – tenement with a garden, in the north-east corner of the precinct, for an annual rent of 66s 8d and a garden elsewhere in the precinct for which he paid an additional 4s. Of particular interest, however, is that Danvers also rented out two shops annexed to his tenement for the use of his clerks in 'Paradise', indicating that this area of the precinct was also a space in which litigants might conduct legal business. A further large tenement with a garden, that of the Portealeyns discussed previously, was noted as being formerly held by William Markeby and Richard Shipley. Both men had been filacers in the royal law court of the Common Pleas, as well as being Alice Portealeyn's first and second husbands. Thomas Luyt, another filacer – this time from the court of King's Bench – was recorded as a resident of the hospital precinct in 1488. He stated in his will that he wished to be buried in the chapel of St Katherine.[23] Yet another large tenement in the precinct recorded in the 1456 rental had previously been held by John Barton, another recorder of London, and was now held by Thomas Burgoyn, the under-sheriff of London. Elsewhere in the hospital we find William Cleve, clerk of the king's works, William Swyrinden and William Marchalle, Chancery clerks, and Richard Sturgeon, a clerk of the Crown, as well as a shop in Paradise held by the exchequer clerk Thomas Gyvendale.

The extent to which their tenements – and those of other influential residents within the hospital close – acted as places of business as well as homes is often unclear, but the concentration of like-minded individuals within the precinct points to a distinct legal and administrative identity at St Bartholomew's in the fifteenth century. Such connections built on previous connections with the royal law courts – during the fourteenth century common law writs were sometimes stored in the priory, for example – and developed these further through the improvement of the buildings and facilities, as well as fostering a sense of community. This legal identity seems to have endured: by the seventeenth century, the hospital precinct was home to representatives from both the court of Common Pleas and the Star Chamber. This was a location where attorneys could be consulted, and mesne process conducted, as is evidenced from the fight between two lawyers and neighbours, Thomas Cotton (of Gray's Inn and the Star Chamber) and Francis Delman (of Thavie's Inn and an attorney of Common Pleas), over the hanging of a laundry line in the hospital close in November 1605.[24] The cultivation of a legal identity at St Bartholomew's brought two advantages to Wakeryng and the hospital: not only were such individuals likely to be of relative wealth and (in theory at least) good standing, they could also be utilized in the

22 The rental can be found in the hospital cartulary: SBHB/HC/2/1, ff. 7–38. References here are to the rental unless otherwise specified.
23 TNA, PROB 11/8/285.
24 TNA, STAC 8/126/10; STAC 8/93/8.

numerous legal disputes which plagued any late medieval institution, as well as any future confrontations with the priory. Thomas Burgoyn would act in such a fashion in the 1440s arbitration mentioned previously, and we find them regularly employed when the hospital has disputes or disagreements, through both their connections with hospital officials and their stake as tenants.

A further group can be established among the residents of St Bartholomew's hospital – wealthy widows. Joan Astley, nurse to Henry VI in his childhood, resided over the hospital's Smithfield gate after her husband's death and held a small garden in the south-west of the precinct. Her daughter, Margaret Malefant, was also commemorated in the hospital church, having sought the sanctuary of her mother (and potentially the security of the hospital precinct) after the death of her husband in 1438. Joan Clinton, widow of Thomas Clinton, was recorded as residing in the hospital at the time of the rental, some forty years after the death of her husband, with a large tenement to the north of the precinct, with a garden and four shops facing on to Smithfield. In her will of 1457 Joan requested that she be buried in 'my new Church of the Hospital of West Smithfield, London', possibly indicating that she had contributed to the fabric of the hospital church.[25] We have already encountered Alice Domenyk-Markby-Shipley-Portealeyn, who was widowed twice during her time at the hospital alone, and would be commemorated in the hospital church alongside her first two husbands. Elsewhere among the residents we find Isabel Langford, Joan Morpath, Joan Thurysley and Joan Newmarchye, all described as widows, one further unnamed widow, and two women – Elizabeth Mollislee and Alice Knyghtle – who were not named as widows in the rental but whose husbands had died in the previous decades. Such women might find security and contemplation in the sanctuary of St Bartholomew's, away from the dangers to which wealthy widows might be subjected on account of their status, seeking community, commemoration and friendship among the tenements and gardens of the precinct.

We get a fleeting glimpse of the hospital staff at this time, beyond the deeds of the master and his main scribe, John Cok. Cok was a man who – as we have already seen – often took the opportunity to impose his own views and opinions in the hospital's cartulary. His promotion of his master, John Wakeryng – whose 'wondrous wisdom and extraordinary discretion' he described in a list of the hospital's masters – is striking throughout the cartulary, as are the mentions of his shaking hands and old age in the occasional marginal notes that appear alongside his entries.[26] As well as the practical grants, deeds and privileges which comprise the bulk of the cartulary, we also find a copy of the annals of the kings of England – in which Cok has inserted himself into the annals of history by stating that he was present at the coronation of Henry V, and that it was a very rainy day – alongside numerous sketches of humans and animals (fig. 5.5).[27] Less is known about his colleagues within the hospital. William Kybbeworthe, John Stafford and Robert Fossard were all recorded in the rental as hospital chaplains, ministering to the spiritual needs of those resident at St

25 Harley MS 4028, f. 125; *Testamenta Vetusta*, ed. N.H. Nicolas (London, 1826), p. 284.
26 SBHB/HC/2/1, *List of Masters*.
27 Cok's Annals of the Kings of England is found in the cartulary: SBHB/HC/2/1, f. 647v. It has been edited in Roger, 'Blackberd's Treasure', pp. 105-07.

5.5. One of John Cok's doodles in the Hospital cartulary, SBHB/HC/2/1

Bartholomew's, while Robert Forster appears in the previous decades. Emma Churbury, one of the hospital's sisters, had invested in the rebuilding of shops in the precinct, which alone brought a combined income of £2 for the use of the sisters, while William Symond, one of the brothers, was also involved in rebuilding two dwellings in the south of the precinct. Other sources of income for the care provided in the hospital came from bequests, such as that of James Surynden, a London mercer, who made bequests to the sick languishing in the hospital for a month after his death, to be distributed by hospital's sisters.[28] It is clear that Wakeryng and his staff – particularly Robert Fossard – were not afraid to solicit deathbed bequests from the residents of the precinct. Both figures regularly appear as executors and witnesses of wills and administrations within the close, as well as receiving bequests themselves, and appear to have encouraged the members of the community to remember the hospital and its good works in their final days and hours.

Bequests and commemoration in the hospital church not only served as a source of income for the hospital and the sick poor within it, but also to develop further the sense of community which Wakeryng was clearly attempting to 'cultivate' (in the words of Anne Sutton's analysis of the fifteenth-century hospital) among its residents. Relationships can be seen between both the residents and the members of the hospital community. The 1448 will of Robert Fossard, one of the hospital chaplains, for example, was witnessed by John Shirley, who was described in the will (alongside his second wife Margaret) as Fossard's 'good and

28 TNA, PROB 11/3/468.

5.6. Thomas Luyt's will, TNA PROB 11/8/285

best betrusted friends [...] in whom I have most trust of any living creature'.[29] Furthermore, the evidence from some of the wills made by the community indicate that, while (prior to the Reformation) the precinct technically sat outside the traditional system of parishes that regulated everyday spiritual life in England, its members acted as if the hospital was its own parish. In his will of 1488, for example, Thomas Luyt described the chapel of St Katherine, virgin and martyr, as being within the 'parish church of the holy cross called St Bartholomew spitell in West Smithfield of London' (fig. 5.6).[30] Likewise the testament of Robert Vynce, a pastry-cook who lived in the hospital close with his wife Joan in 1456, refers to the altar of 'the parish church within the hospital of St Bartholomew'.[31] This form of language was not limited to bequests and probates; in 1465 a suit brought before the court of Common Pleas between John Hewek and Beatrice Lurchon describes an offence in question taking place 'in the parish of St Cross next to the hospital of St Bartholomew in West Smithfield (*in parochia sancte crucis iuxta hospitalem sancti Bartolomi in Westsmythfeld*)'.[32] By promoting a 'parish' community in this way, the hospital was able to secure a source of commemoration, which might serve to encourage further commemorative acts, and also brought the hospital a revenue source of tithes, chantries, burials and oblations in the long as well as the short term. Indeed, by the sixteenth century, the pseudo 'parish' had become yet further established, in part thanks to Wakeryng's efforts. In 1522, a Chancery petition by the then master Richard Smyth refers to the 'parish clerkship', to which one Richard Flecher had been promised appointment (although not without problems – hence the

29 LMA, DL/C/B/004/MS09171/5, f. 4.
30 TNA, PROB 11/8/285.
31 LMA, DL/C/B/004/MS09171/5, f. 165; SBHB/HC/2/1, ff. 8, 460–63.
32 Lurchon was a resident of the hospital precinct, while Hewek was the relation of another resident. The accusation was related to the retention of goods for safekeeping: TNA, CP 40/816, rot. 342.

master's need to petition the Chancellor).[33] The value of such a position to the community is clear: the master had entered into an obligation of £20 with Flecher in promise of his appointment, handing over valuable goods including two gold and sapphire rings, goblets and other plate, plus a cash sum of £4.

LIFE AFTER JOHN WAKERYNG

John Wakeryng ceased to be master on 16 November 1466, after over forty years' service.[34] Two years later, from 1468, when he would have been 76, the name of John Cok also disappears from the hospital's records. Whether Wakeryng died or simply decided to retire is unclear, although the enthusiastic description of his character and tenure in Cok's list of masters may indicate the former, serving as a form of posthumous commemoration. He was succeeded by John Needham, bachelor of canon and civil law, elected 'by way of the Holy Spirit' a few weeks later and installed on 17 December 1466.[35] After Wakeryng's extended period as master (longer than any other master in the hospital's history) – assisted by his equally long-standing accomplice Cok – the hospital had been able to take a long-term view and invest for the future. It now reverted to a series of relatively short-lived masterships. With the loss of Cok and his exceptional attention to the hospital's properties, tenants and records, it also becomes more difficult to view the hospital's activities with real detail. That St Bartholomew's continued to attract commemoration and wealthy tenants is clear from the bequest of Thomas Luyt noted above, and there is no need to suppose that the community established over the course of Henry VI's reign would disband, but short-term leadership clearly proved difficult for the hospital. Needham served for only three years before he died in 1470 and was buried in the hospital church. William Knyght, his successor, also lasted only three years as master before he himself died on 15 July 1473. He was followed by John Barton, who was named as master in May 1485 – although it is not clear when he was elected or installed – and lasted until 1487 when he died. Under the later fifteenth-century masters, the hospital appears to have continued to defend its rights and liberties, while also pursuing debts and rents due. During Barton's time as master the hospital petitioned the Chancellor in a dispute with the civic officials who had tried to make an arrest within the hospital precinct. The petition, dated to the period 1475–85, claims that Richard Whytyngdon, sergeant of London, had tried to arrest one William Alcock in the hospital church, without jurisdiction, and when the master had tried to stop him, Whytyngdon had arrested him, placed him in the counter at Breadstreet and sued an action of trespass against him.[36]

Barton's successor, Thomas Crewker, elected in 1487, appears to have followed a similar approach to his predecessors, pursuing arrears of rents and securing pious bequests for the hospital, such as the £3 bequeathed to the sisters of the hospital (among other gifts) in

33 TNA, C 1/566/15.
34 SBHB/HC/2/1, *List of Masters*.
35 *Ibid*.
36 TNA, C 1/60/181.

the will of Anna Whetnall in 1493.[37] Anna's will was witnessed by the master and Richard Wanton, one of the brothers of St Bartholomew's, among other spiritual figures of London. Crewker appears to have been a litigious master. In a parliamentary petition dating from early in his tenure, Crewker was accused of (wrongly) pursuing a carpenter by the name of Richard Smith across multiple courts in order to avoid paying historic debts owed to him by the hospital, which dated from the time of Barton's mastership.[38] He also clashed with an attorney of the Guildhall – who it is tempting to suggest may have been a resident of the hospital close, given the legal culture already discussed – by the name of Richard Lilburne. Lilburne, it was claimed in 1485, had attacked the master, his servants and his brother William Crewker, wounding him almost to the point of death, while Thomas had been forced to flee.[39] The matter was brought before the Star Chamber, where Richard claimed to have acted in self-defence, but could produce no evidence to support his claim. Instead, over the course of the next twelve years, the dispute between the two men dragged on and on. Lilburne first used his position as an attorney to allege a claim of trespass by Crewker in the London courts, in response to which Crewker petitioned both the Chancellor and the Star Chamber once again in pursuit of justice. Such legal manoeuvring was not uncommon given the overlapping legal jurisdictions of late medieval London, but demonstrates a willingness to pursue both the master's and the hospital's interests. As in Barton's tenure, questions around the hospital's jurisdiction also appeared towards the end of the century. A petition from 1493–1500, for example, claimed that two officers of the civic officials had stormed into the hospital precinct with five or six others and arrested one of the brothers, Roger Heine – described as being sixty years old, in 'extreme sickness' and greatly debilitated – without due cause (and with an alleged beating to accompany his arrest).[40] Heine was placed in the counter at Poultry and refused bail, forcing his master to pursue his cause before the Chancellor.

Crewker died in 1510 and was succeeded as master by Robert Bayley.[41] Following Bayley's death in 1516, however, the hospital appears to have pursued a new policy regarding the election of masters, which suggests that the difficult election battles of the fourteenth and early fifteenth century were a long way in the past. Having sought the licence of the prior of St Bartholomew's to elect a new master, as was usual, the assembled brethren agreed to pursue a new form of election and appoint the Chancellor, Cardinal Thomas Wolsey, to select a new master on their behalf. In the first instance he selected one of the hospital's own brothers, Robert Smyth, but, when he was once again called to nominate a new master after Smyth's death in 1525, he selected an external candidate, Alexander Colyns, for the first time. The brethren's decision to delegate the authority was clearly a move to try and curry political favour for the house, particularly in 1525 at a time when Wolsey was beginning to instigate reforms in religious houses around the country, dissolving approximately

37 TNA, PROB 11/9/398. Moore, II, 114-5.
38 TNA, SC 8/345/E1336.
39 TNA, C 1/192/43; STAC 2/3/59.
40 TNA, C 1/194/18.
41 Details of the later fifteenth- and early sixteenth-century appointments which are discussed here can be found in the Bishop of London's registers, fully cited in the VCH history of St Bartholomew's Hospital.

5.7. June 1528 letter to Wolsey encouraging him to nominate 'Master Wylson' to the mastership of the Hospital. TNA, SP 1/48, stamped folio 101

thirty houses and using the income for new foundations. To earlier masters and brethren of the hospital, however, the decision to delegate responsibility for such a crucial decision would have been anathema. Colyns had previously been the prior of Daventry since 1515, but the priory was one of Wolsey's targets for reform, and had formally been dissolved on 16 February 1525, a few days before Smyth's death. The election at St Bartholomew's provided him the perfect opportunity to find the former prior a new position, and one with a greater annual income than his former house. Despite being an external candidate, there is no evidence that Colyns neglected the hospital; he appears to have been a master committed to preserving the hospital's lands and privileges as previous masters had done, and appears in property disputes throughout his short tenure as master until his death in 1528.[42] The danger of the position of master becoming a potential sinecure for up-and-coming religious figures was, however, real, as would become clear with Colyns's successor.

With a new election required after Colyns's death on 15 January 1528, Wolsey and the king clearly expected to be offered the nomination, and indeed had already identified a

42 See TNA, C 1/485/21 for an example relating to the hospital's property in 'Duckets', in Tottenham, Middlesex.

possible candidate in the form of a royal chaplain 'Master Wylson' (fig. 5.7). A letter written to Wolsey on 6 June states that:

His highness would that your grace should use all the means that you can, to the intent to bring the dispensation thereof into your grace's hands, so that his highness and you should put him [Wylson] or some other good man there.[43]

The brethren had other plans, however, and instead offered the nomination to the bishop of London, Cuthbert Tunstall, who appointed Edward Staple to the mastership *in commendam* (essentially master in name, but with limited responsibilities over the day-to-day running of the house). Staple had been a royal chaplain, and had been appointed as a canon of the collegiate church of Tamworth in March of that year. He was not, however, likely to have been a particularly active master of the hospital, given that he was appointed as bishop of Meath in Ireland the following year, holding the two positions simultaneously. As a bishop in Ireland, Staple took a prominent role in the governance of the country and clearly had little time to manage the hospital's affairs as vigorously as his predecessors had done, and the hospital began to accrue significant debts. He resigned his position as master on 1 July 1532 to spend much of the rest of his life on Irish affairs.

With Staple's resignation, the brothers now delegated the appointment of the master once again, this time to a senior ecclesiastical judge, Richard Gwent, Dean of the Arches and Master of the Prerogative Court of Canterbury. Machinations, it seems, had begun several months before Staple's resignation, with his successor having gained a papal bull authorizing him to take up the position of master should it become available, and hold this alongside his existing benefices, as early as February 1532. The final pre-Reformation master of St Bartholomew's – once again appointed *in commendam* – was John Brereton, a royal chaplain and canon of St Paul's and St Stephen's College at Westminster, appointed on 26 September 1532 (having received a royal pardon in August for procuring his papal bull earlier in the year).[44] Brereton, who first took up a position of keeper of the hospital before his election, complained that the hospital had been left in considerable debt by its former masters (particularly Staple), that several buildings had become derelict, and that reform was needed to ensure the correction of governance within the hospital, in wording reflecting that of the papal bull.[45] Indeed, this may have been one of the factors behind his appointment, as his other benefices provided a steady income without a need to rely on hospital finances, which might be needed urgently in repair works. At this time, as recorded in Brereton's papal bull, the hospital consisted of a master and eight brothers, as well as four sisters. To his credit, Brereton clearly attempted to institute reform within the church; legal disputes over debts accrued by previous masters can be found among the petitions and pleas of the royal courts.[46] He also attempted to restrict the provision of hospital supplies

43 TNA, SP 1/48 stamped folio 101.
44 TNA, C 66/660, m. 32.
45 TNA, C 1/724/28-29.
46 TNA, C 1/887/28; C 1/732/58.

he deemed unnecessary or over-supplied. In one petition he was recorded as trying to cancel provision of wax and tapers for the hospital church (with the supplier allegedly providing too many unordered supplies), for which he found himself arrested for debt.[47] In another he complained about the price and quantity of beer which had been delivered.[48] Whether or not Brereton was successful in his endeavours remains unclear. In any case, the tumult of the Reformation was about to engulf the hospital, and threaten its future survival.

REFORMATION AND RE-FOUNDATION

Brereton, and three brothers of the hospital – John Chewny, Richard Lemyng and Thomas Hyclyng – acknowledged the royal supremacy on 25 June 1534.[49] That so few of the brothers signed the acknowledgement – five brothers (including Chewny and Hyclyng) had been present at Brereton's election two years earlier, with three noted as absent – may indicate problems around the retention and recruitment of staff during hard times rather than any inherent sense of conservatism at the hospital. The following year, the hospital's estates were valued – as part of the country-wide survey of church possessions known as the *Valor Ecclesiasticus* – at £371 13s 2d, placing St Bartholomew's as the third wealthiest hospital in London, behind Henry VII's new hospital, the Savoy and St Mary Spital outside Bishopsgate, who held estates worth over £500 and £470 respectively. The hospital was dissolved and handed over to the Crown over the following years, although the buildings were not destroyed and some inmates continued to be cared for out of alms. Without the financial support built up over generations, and without the institutional structures to maintain and support the sick poor, however, there was little that could be done.

Yet the importance and influence of St Bartholomew's hospital, and the patronage networks which had been so carefully promoted, managed and advertised by masters such as Wakeryng, ensured that the hospital remained at the forefront of civic minds. A civic petition of 1538 requested that the hospitals of St Mary Bethlem, St Bartholomew and St Thomas be placed under the care and control of the City of London and its officials, (alongside other dissolved churches including those of the Friars) for the aid and comfort of the poor, sick and infirm.[50] These re-founded hospitals (as requested in the petition) were to include physicians, surgeons and apothecaries, who were to provide care 'frankly and freely' and were to receive their salaries from the hospital for their services. At first, the Crown did nothing, but in 1544 it was decided that the hospital should be re-founded along semi-religious lines, with a master, a priest and four chaplains – who were to fulfil the roles of vice-master, curate, hospitaller and visitor of the prisoners at Newgate – as well as a contingent of sisters to provide care, rather than the medical professionals the City had requested.[51] Income was to be provided from rentals within the hospital precinct alone (the king retained the rest of the dissolved house's lands), and, with the appointment

47 TNA, C 1/725/47.
48 TNA, C 1/948/47.
49 TNA, E 25/81.
50 British Library, Cotton Cleopatra E/IV, f. 263.
51 TNA, C 66/763, m. 1.

of royal favourites to the hospital staff, the initial re-foundation appears to have been a complete failure, ultimately lasting for just over two years. The Londoners complained that the buildings had been ravaged of much of their furniture, leaving little infrastructure to care for the sick, and the hospital's income was drastically inferior to that of the previous century.

In December 1546, following a comprehensive survey of the remaining hospital's possessions between May and October, the citizens and civic officials of London on one hand and the Crown on the other agreed on the terms of a new re-establishment of the hospital with new governance arrangements which represented the structures of a 'modern' hospital.[52] The valuation of the hospital close itself is interesting in that it records Thomas Hyclyng – one of the brothers who had elected Brereton and signed the acknowledgement of royal supremacy – continued to hold a tenement and garden in the precinct, having been appointed as vice-master in 1544.[53] He had clearly remained at the hospital through the tumultuous years of the previous decade, a thread tying together the old and new institutions. Other historical highlights can also be identified in the valuation, including the Olyfaunt (Elephant) – a tenement in Smithfield on the corner of Hosier Lane – and the brewery known as the Hart's Horn – situated on the south-west corner of the hospital precinct, and which was still being described as a brewery in 1546 – that had been recorded by John Cok a century earlier.[54] The break with the Catholic Church in Rome does not seem to have had an impact on the name of historic properties. The tavern known as 'Cardinal's Hat' by the church of St Sepulchre (also known as 'The tavern at Cardinal's Hat') remained active and was worth an annual quit rent of 37s, almost exactly the same rate it had been assessed at by Cok in 1456.[55] The valuation also sheds light on the hospital at this time, illustrating the need for re-foundation and new financial investments.

While we get glimpses of the hospital in its prime from the valuation, among the 'stuff remaining in the custody of the sisters' – such as two hangings of green say, with images of the Holy Ghost and the Virgin Mary upon them, or the painted hangings and imagery in the 'new parlour in the garden' – almost all are described as old or damaged (fig. 5.8).[56] The 35 beds in the hospital's 'inner rooms' (which were separated into male and female areas) were described as 'barely furnished and for the most part little or nothing thereupon', as were the beds in the 'out room where poor men do resort'. In the vestry, however, and among the possessions of the brothers more generally, we find finer goods, such as 'the best cope, quartered with crimson velvet and blue, with lyons of gold and fleur-de-lys', which was worth 40s. alone, as well as chalices, crosses and several other copes. Processionals, journals, manuals and mass books residing in the choir were also valued, alongside a legend written on paper, candlesticks, linen and a large desk. In the hall we find tables, and a coffer in 'the

52 The hospital's record of the new arrangements are SBHB/HC/1/2001 and SBHB/HC/1/2002, while the Crown's copy of documents can be found in TNA, C 82/860-1; C 66/798, m. 37d and C 47/7/3/5-6.
53 SBHB/HC/3.
54 SBHB/HC/2/1, ff. 8-10; SBHB/HC/3 m. 5-10. The Olyfaunt on the hoop was situated on the approximate site of the Barts Pathology Museum today.
55 SBHB/HC/2/1, f. 12v; SBHB/HC/3 m. 5-10.
56 SBHB/HC/3 m. 16-17.

5.8. Hospital valuation listing the 'stuff remaining in the custody of the sisters', 1546. SBHB/HC/3 m. 17

reading place', and in the buttery and kitchen a selection of plates, pots and candlesticks. The sum total of the brethren's goods came to £22 6s 9d. If the hospital had received new investment as part of its first re-foundation, it is clear where the brothers' priorities had been, although the depth of the challenge faced by the hospital in dealing with infectious disease is also highlighted. A memorandum at the bottom of the sister's entries states that the hospital was extremely lacking in bedsheets, because they 'have been occupied in burying the poor that hath been buried there', having died at St Bartholomew's.

The newly re-founded hospital was to have paid medical, surgical and nursing staff, as well as lay administrators and support staff, and was underpinned by new royal endowments (many of them from the nearby dissolved site of the Greyfriars), worth approximately

500 marks annually (£333 6s 8d), a sum which the civic officials were required to match.[57] Rebuilding works and re-provisioning of the furniture and implements required to deliver care were undertaken by the Londoners, new bequests were made, and the hospital church was officially designated as a parish, the parish of 'Little St Bartholomew in West Smithfield'. The City was to supply lodging, food, clothing and necessities for 100 poor men and women in the hospital, and a matron and twelve women to attend to them, as well as a person learned in the science of physic and another with sufficient knowledge in surgery. Eight beadles were appointed 'to bring to the said late hospital, hereafter to be called the House of the Poor, such poor, sick, aged, and impotent people as shall be found going abroad in the City of London and the suburbs of the same'. Oversight was provided by a panel of twelve governors, four of whom were to be aldermen of the City, chosen by the Lord Mayor and appointed to hold office for two years, with half the panel retiring each year to be replaced by new appointees, ensuring that the governance of the hospital did not stagnate.

The new establishment placed medical and surgical care at the forefront of the hospital's activities. This is not to say that the poor and needy were neglected – provisions were made in the re-foundation charter to care for the poor, while a visitor of Newgate prison was also now appointed – but the new St Bartholomew's was now, and would remain, at the forefront of medical thinking for centuries to come. It was an institution that the City of London could be proud of – a note on the back of the documents which confirmed the new arrangements describe St Bartholomew's as the 'spital of London' – a well-ordered and well-governed institution which was a match for any hospital in England or Europe.[58] The first 400 years of the hospital's existence had not always been easy. Disputes around its independence, its liberties and its finances have persisted throughout the story of St Bartholomew's Hospital. The determination of masters such as Wakeryng and the support of his administrators like Cok, however, had cultivated a community and a connection with the City of London which could not be broken, even by events as tumultuous as the Reformation. The new foundation of 1547 was one of which Wakeryng, and all the hospital's masters of the past centuries, could be proud.

57 SBHB/HC/1/2001; SBHB/HC/1/2002; TNA, C 82/860-1; C 66/798, m. 37d.
58 TNA, C 82/861.

EARLY MODERN

Rich L.d Chancelor.

Dissolution and Reformation at St Bartholomew's Priory and Hospital

NICK HOLDER

THE ENGLISH REFORMATION is the neat label applied to a half-century of religious change in Tudor England. With hindsight, the destination is clear: a largely Protestant England with an independent Anglican Church. But for those experiencing the events, these were unpredictable and tumultuous years. During the 1530s, Henry VIII and his advisors had pushed many reforms on to English people – reforms that reflected Henry's own religious tastes: 'no' to papal supervision, pilgrimage and relics; 'yes' to Catholic liturgy and ritual. As the 1530s progressed, another aspect of Henry's religious views was becoming clear; influenced by the Catholic reformer Erasmus, Henry was turning against monks and monasteries. By 1539, the Dissolution of the Monasteries was well underway, and only a few institutions would ultimately survive, as reformed cathedrals.

The king had several senior officials to put his religious ideas into practice, including his Archbishop of Canterbury Thomas Cranmer and his Principal Secretary Thomas Cromwell (both rather more sympathetic to Protestantism than they dared reveal to Henry). But when the Lincolnshire rebels rose up in 1536 against the religious changes – including the first closures of monasteries – their protest ballad listed the names of *three* men: 'Crim, Cram and Rich'. Crim was Cromwell, Cram was Cranmer and Rich was Richard Rich, chancellor of the Court of Augmentations (fig. 6.1). His court was the government 'department' administering the monastic closures and Rich was, therefore, one of the architects of the Dissolution of the Monasteries. He was soon to be the owner of St Bartholomew's Priory.[1]

THE CANONS AND RESIDENTS IN 1539

The morning of Sunday 26 October 1539 – the day after Prior Robert Fuller surrendered the 400-year-old institution to the Crown – must have been a strange one for the canons of St Bartholomew's. Prior Robert, his sub-prior Robert Glasyer and their twelve canons would have to seek new jobs and new places to live – a daunting prospect, no doubt. The task was, however, made easier by a financial agreement signed that Sunday with officers of

1 Eamon Duffy, *The Stripping of the Altars: Traditional Religion in England, c.1400–c.1580* (New Haven and London: Yale University Press, 2005), chapters 11–17; Diarmaid MacCulloch, *Thomas Cromwell: A Life* (London: Allen Lane, 2018), pp. 202, 310, 320–22, 391.

6.1. Richard Rich by Hans Holbein the Younger, c.1532–43, black and coloured chalks, and pen and ink. Royal Collection Trust (© His Majesty King Charles III 2022)

the administrative Court of Augmentations: the sub-prior and his twelve canons were to receive annual pensions of between £5 and £15.[2]

Prior Fuller's pension took a little longer to arrange, but it was definitely worth the wait. He was granted for life the rental income of most of the priory's estates in London, Middlesex, Essex and Hertfordshire (the freehold of which now belonged to the Crown), amounting to about £880 a year, plus another £200 from his landholdings as former abbot of Waltham. This seems an extraordinarily generous settlement – the annual income was more than many aristocrats enjoyed – and it was far beyond the sums awarded to other priors and abbots in the wake of the Dissolution (the prior of St Mary Bishopsgate was to receive £80 a year, for example, and the abbot of St Mary Graces £67). Was this Cromwell and Henry's reward to Fuller for his co-operation and assistance with the Dissolution, including, with the 1535 monastic tax commission, the *Valor Ecclesiasticus*?[3]

Most of the canons found other work in the Church: Henry George became vicar of nearby St Sepulchre, while George Chapman left to be parson of Bushey (Herts.). The other canons are harder to trace, and may have made a living as chantry priests, performing sponsored masses for the souls of the dead, until the ever-changing Reformation closed down that option in the late 1540s.[4]

For the one or two hundred residents of the close, rather less changed that Sunday. They had a new landlord – the Crown – but their rents, rights and obligations as tenants or lessors remained the same. They soon had a visit from the Crown's rent collector, Hugh ap Harry, who collected the year's rents of about £66 from the 53 tenements in the close.[5]

THE PARISH OF ST BARTHOLOMEW-THE-GREAT FROM 1539

In 1539 the residents of the priory tenements became parishioners of a new parish. Before the closure of the priory, the residents had had the use of a parochial chapel, dedicated to All Saints and situated on the north side of the monastic church, and a small burial ground just beyond. The site of the priory had originally formed the north-western quarter of the parish of St Botolph Aldersgate and the priory duly paid St Botolph an annual payment of 20s. to compensate for the loss of parochial income. But to complicate matters, the western part of the priory precinct was in another parish, St Sepulchre. Given that the priory had long held the patronage of St Sepulchre, appointing its vicar and receiving a share of the parish tithes and fees, the links between the priory and St Sepulchre had grown stronger than those between the priory and St Botolph. There were disputes between the parishioners of St Sepulchre and the prior of St Bartholomew, but these were perfectly normal negotiations between a parish and its patron over income.[6]

2 *Letters and Papers*, xiv(2), no. 391; Webb, *Records*, I, p. 255.
3 *Letters and Papers*, xv, no. 393 [Waltham Abbey], xvi, no. 1500 (p. 716) [St Bartholomew]; *The Religious Houses of London and Middlesex*, ed. C.M. Barron and M. Davies (London: University of London, 2007), pp. 78, 162. Ex-prior Fuller's St Bartholomew's pension has been calculated by correlating the list of rents and other income granted to him with the corresponding entries in Webb's 'Possessions of the monastery' chapters (I, pp. 258–59, 321–77). For more information on Prior Fuller and the *Valor Ecclesiasicus*, see Christine Fox's chapter in this book.
4 The National Archives [TNA], E 321/44/54 [George]; C 1/1341/14 [Chapman].
5 TNA, SC 12/27/18.
6 Webb, *Records*, II, pp. 98–99 [All Saints]; II, pp. 199–200 [St Botolph]; I, pp. 19, 77–78, 101, 140, 202 [St Sepulchre].

By the fifteenth century, the lay residents of the adjacent hospital were beginning to think of themselves as living in a separate parish (which would later be St Bartholomew-the-Less). A little later, the residents of St Bartholomew's close, in the main priory precinct, were thinking along the same lines (their parish would later be St Bartholomew-the-Great). In 1523, Thomas Pokeapart wrote his will and described himself as 'of the *parish* of St Bartholomew'; previous residents writing their wills had used the formula 'of the close of St Bartholomew'.[7] In 1531, the bishop of London had recognized this increasingly separate parochial status when he declared that the vicar of St Sepulchre was not to claim any tithes or fees from the St Bartholomew's residents. The vicar was probably not very happy with this arrangement and his successor was still claiming, twenty years after the Dissolution, that the residents of St Bartholomew should be paying their share of parish taxes.[8]

By 1539 this parochial enclave was not quite a fully formed parish. There was certainly no presumption at the Dissolution that any of the plate or furniture of the main priory church should go to the parish chapel. Although five bells remained in the bell tower of the parish chapel (and were later moved to the seventeenth-century tower, where they remain), six other priory bells were bought by St Sepulchre. The last prior, Robert Fuller, barely mentioned the new parish in his will of 1540, asking to be buried in and bequeathing money to St Sepulchre instead.[9]

In the early 1540s a dozen higher-ranking residents of the close were working behind the scenes to create a formal parish structure for St Bartholomew. In May 1544 the Crown sold most of the priory precinct to Richard Rich, a package that included the patronage of the parochial chapel. But, because the parish had no longstanding tradition or history, the Crown grant had to assert its identity with some force: St Bartholomew was, the 1544 grant insisted, 'universally held used and accepted as a parish', and 'a parish in itself distinct and separate from other parishes' which had a parish priest who 'administered and solemnized in the same manner and form as in parish churches within this realm of England'. Later that month Richard Rich signed a memorandum formally creating the new parish and endowing it with seven properties in the former precinct, which would provide rental income for the rector. The monastic precinct finally became a formal parish and the parochial chaplain John Deane became its first rector, with Thomas Burgoyne and Stephen Fyndley his assistant priests. This important agreement was witnessed by twelve parishioners – residents of the close – including Sir Rowland Hill (a London alderman), Richard and Thomas Tyrrell, Richard Modye esquire, Hugh ap Harry (the parish rent collector), William Glascock and Robert Corbett.[10]

The Crown grant of May 1544 fixed the Latin name of the new parish church as 'St Bartholomew the Apostle the Great in West Smithfield' (*Ecclesia parochialis Sancti Bartholomei Apostoli Magni in West Smythfeild*). Although the Latin adjective *magnus*, 'great', appears to be

7 See Appendix II for wills.
8 Webb, *Records*, I, pp. 232–3; II, p. 302; Caroline Barron, 'The People of the Parish: the Close of St Bartholomew's Hospital in Fifteenth-Century London', in David Harry and Christian Steer (eds), *The Urban Church in Late Medieval England: Essays in honour of Clive Burgess*, Harlaxton Medieval Studies, 29, pp. 353–79.
9 Webb, *Records*, I, pp. 259–61, 541; II, pp. 112–15.
10 Webb, *Records*, I, pp. 273, 518–21; I, p. 266 [Fyndley]; I, pp. 270, 516 [1544 Crown grant].

agreeing with the masculine saint rather than the feminine church, this is probably a traditional form of the name, with *magni* originally describing the 'great priory' (as opposed to the 'lesser hospital'). The church and parish were initially known in English as Great Saint Bartholomew's, with the altered word order of St Bartholomew the Great becoming more common in the seventeenth century.[11]

The parish must quickly have acquired a strong identity. Unlike much of London, it did not have the overlapping boundaries and competing structures of parish and ward. As a medieval monastic precinct St Bartholomew's had been a 'liberty', sandwiched between the City wards of Farringdon Without and Aldersgate. Now the parish would have to manage many of the tasks traditionally carried out by wards, including the supervisory roles of beadle and constable, the legal role of inquestman, and the cleansing role of scavengers. The parish only became part of Farringdon Without in the nineteenth century.[12]

CHANGES TO THE PRIORY CHURCH AND PARISH CHAPEL IN THE 1540S

Richard Rich, acting first as tenant and later as principal landowner, started demolishing and adapting parts of the priory church in the early 1540s. John Bochard's will, written in June 1542, implies that the physical changes were already underway that year: he bequeathed £6 13s 4d 'towardes the bildyng of [the church]'. The Court of Augmentations (which collected the rent from the residents of the former priory) contributed at least £160 to the works in 1543. The parishioner and Augmentations rent-collector Hugh ap Harry supervised the demolition of six of the ten bays of the priory nave, leaving, however, the eastern bay (next to the crossing) and the three westernmost bays (fronting on to West Smithfield). He closed these newly separate buildings with brick and stone walls. The demolition work was certainly complete by April 1544, when Rich was buying the former priory, but the church conversion was not yet finished. The medieval parish chapel on the north side of the priory's ambulatory and choir was also demolished at this time.[13]

The new parish church probably had two parts: the old priory choir (with the crossing and the additional un-demolished bay) became the parish nave, and the former Lady chapel served as Rector John Deane's chancel at the east end (Map 3). The walled yard formed by the demolition of the six bays of the priory nave became the new parish churchyard; the parish priest John Bochard was probably the first to be buried here in May 1543, a long way from his native Lancashire.

11 Webb, *Records*, I, p. 148 [medieval form of name]; I, p. 516 [Latin name of parish in Crown grant], I, p. 543 ['Great Saint Barthilmews', in will of Dorothy Paver, 1548]; TNA, PROB 11/98/352; Webb, *Records*, I, p. 552 ['Sainte Barthlomewes the great neare West Smithfeild', in will of William Neale, 1601].
12 Webb, *Records*, II, 199-200, 395-97; F. F. Foster, *The Politics of Stability: A Portrait of the Rulers in Elizabethan London* (London: Royal Historical Society, 1977), pp. 29-33.
13 TNA, PROB 11/29/374 [Bochard will, written 1542, proved 1543]; Webb, *Records*, I, pp. 264-73, 502-18 [April 1544 particulars for grant and May 1544 grant to Rich]; I, p. 262 [Hugh ap Harry works]; II, plate XIV plan facing p. 3.

RICHARD RICH

We have already met Sir Richard Rich in his role as chancellor of the Court of Augmentations.[14] By 1540, Rich was also a member of Parliament for Essex, and a member of the king's Privy Council. Like many of Henry's senior servants, Rich used his job and status to secure a new house. As Chancellor of the Court of Augmentations, Rich had his pick of the newly suppressed monasteries, choosing Leez (or Leighs) Priory in Essex to be his country mansion and St Bartholomew's for his London townhouse. By February 1540 Rich was signing letters at St Bartholomew's and in October he invited Sir Thomas Arundel and his wife to stay in his new home.[15]

In 1544, Rich and the Privy Council were looking for ways to raise cash for Henry's expensive wars with France and Scotland. Rich – in his Court of Augmentations role – duly responded by beginning the great sell-off of the monasteries, most of which had been initially retained as long-term Crown assets. In about March that year Sir Richard Rich, the wealthy private citizen, applied to his own Court to buy the former London priory. The Court surveyor valued the built-up core of the St Bartholomew's precinct as worth £6 annual rent (clearly an underestimate). He then added in the other income streams of the ex-priory, including the rented tenements and the income of the fair, took off some outgoings (most of which were short-term) and calculated a net annual rental value. He then multiplied this rental value by nine, giving a total sale price of £1064 11s 3d – a large sum, but a very good deal for a nine-acre central London property asset with nearly £140 of annual income. The surveyor's calculations were duly signed off by officers of the Court of Augmentations – including the Chancellor![16]

Rich seems to have selected the eastern half of the built-up core of the former priory as the main part of his mansion. He had the prior's house with its adjacent garden with, to the west and south, wings arranged in a double courtyard (Map 3). These included the old chapter house and infirmary ranges, the latter with a kitchen wing and small chapel. Rich thus acquired a ready-made courtyard-mansion – the fashionable new Tudor plan-form – without the tiresome need for architects and builders. By choosing this half of the former precinct (rather than the main cloister to the west), Rich's new Tudor mansion and garden were set back from the bustle of Smithfield and could be accessed by secluded gates to the north and south.

Rich demonstrated a remarkable talent for political survival and adaptation, albeit at a cost to his posthumous reputation. Holding his nerve in the mid-1540s after falling out with Henry, Rich was made Baron Rich and Lord Chancellor by Protector Somerset after the accession of the young Edward VI in 1547. He survived the execution of Somerset by

14 See Christine Fox's chapter in this book.
15 P. R. N. Carter, 'Rich, Richard, First Baron Rich (1496/7–1567)', *ODNB*; M. E. Coyle and A. D. K. Hawkyard, 'Rich, Richard (1496/97–1567), of West Smithfield, Mdx., Rochford and Leighs, Essex', *History of Parliament* (London: History of Parliament Trust, 1982), online edn, <http://www.histparl.ac.uk/volume/1509-1558/member/rich-richard-149697-1567>, accessed 10 March 2022; *Letters and Papers*, xv, no. 210; xvi, no. 128 [Rich at St Bartholomew's in 1540].
16 Webb, *Records*, I, pp. 264–73, 502–18 [particulars for grant].

the earl of Warwick in 1552, declared his support for the young Lady Jane Grey in June 1553 and promptly switched his loyalty to Mary Tudor after Edward's death in July.

Rich was probably a traditional Catholic at heart (although with a certain flexibility of belief) and he seems to have reached a deal with Queen Mary to ensure his political survival. He had to return most of his St Bartholomew's estate to the Crown in December 1555 – including the newly adapted parish church and the former priory cloister – and did not receive any rebate on the £1064 he had earlier paid for the site. Rich kept his long and slightly irregular eastern range – the old prior's house, the adjacent house to the south-east (the former infirmarer's house) and the kitchen and chapel. He also kept the gardens on the eastern side of his buildings (Map 4). This was still a respectable townhouse even if it now lacked cross-ranges and courtyards.[17]

Meanwhile, Queen Mary had a plan for the rest of this London monastery.

THE DOMINICAN FRIARS AT ST BARTHOLOMEW'S, 1556–59

Queen Mary arrived in London on 3 August 1553, a fortnight after the deposition of Lady Jane Grey and nearly a month after the death of her half-brother Edward VI. She began to undo the largely unwelcomed Protestant reforms of her predecessor, bolstered by her marriage to the Catholic Philip of Spain in July 1554 and the return of Cardinal Reginald Pole from exile in November. She reunited the English Church with Rome and brought back traditional liturgy and worship. However, her father's Dissolution of the Monasteries could not be undone quite so quickly – too many powerful people had bought and re-developed these religious houses and were not in any hurry to hand them back to the Church with an apology. Mary and Pole therefore began the slow process of endowing and re-founding monastic houses, beginning in the south-east of England. In 1555, Franciscan friars returned to Greenwich and Carthusians arrived in Sheen; the following year saw the return of Benedictine monks to Westminster Abbey. Mary also arranged for the return of some female religious in 1557, when Dominican nuns travelled to Kings Langley and the Bridgettines returned to Syon Abbey. Mary's brief five year-reign, however, only allowed her to re-found six monastic houses.[18]

The sixth of Mary's monasteries was the Dominican friary at St Bartholomew's.[19] The original friary (at the eponymous Blackfriars in London) had been closed in November 1538, a year before the closure of the Augustinian priory of St Bartholomew. By the mid-1550s it was much easier to re-found a religious order with a strong Continental organization, such as the friars or Benedictine monks, compared to the decentralized order of Augustinian canons, whose every priory had been a largely independent institution. So Mary, presumably with some involvement of Richard Rich, asked the English Dominican friar William

17 Webb, *Records*, I, pp. 277–9, 521–3 [Rich's grant to the Crown].
18 David Knowles, *The Religious Orders in England*, 3 vols. (Cambridge: Cambridge University Press, 1948–59), III, pp. 438–40; C. S. Knighton, 'Westminster Abbey Restored', in Eamon Duffy and David Loades (eds), *The Church of Mary Tudor* (Aldershot: Ashgate, 2006), pp. 77–123.
19 The account of Mary's refoundation of the Dominican friary at St Bartholomew's is largely based on Nick Holder, *The Friaries of Medieval London: From Foundation to Dissolution*, Studies in the History of Medieval Religion, 46 (Woodbridge: Boydell, 2017), pp. 57–65.

6.2. The north side of the church fronting Cloth Fair (photograph 2022)

Peryn to set up the new friary. He recruited perhaps a dozen friars, including exiled English and Continental friars from the Low Countries and Spain. The Londoner Charles Wriothesley recorded in his chronicle: 'This yeare at Easter [5 April 1556] the churche of Great St Bartlemewes, in Smythfeilde, was sett up with black friers; Fryer Perwyn beinge head thereof'.[20]

Prior Peryn now had the difficult task of re-establishing his house of friars while negotiating with his powerful neighbour Richard Rich and managing the expectations of his parishioners, who had only been given their enlarged parish church a decade earlier. He must have begun work to change the nave of the parish church back into a monastic choir, which, of course, it had been until the changes of the 1540s (Map 4). Three bequests to the new friary from parishioners gave him a little money to invest in these works: Richard Bartlett, for example, bequeathed £6 to the friars in his 1557 will. Prior Peryn re-opened the doorway between the east range of the cloister and the monastic choir (actually the easternmost bay of the nave, now forming part of the friary church), allowing the friars to walk from the refectory and chapter house to the choir, just as their Augustinian predecessors had done. The friars could sleep in the old dormitory above the east range of the cloister, but

20 Charles Wriothesley, *A Chronicle of England During the Reigns of the Tudors, from A.D. 1485 to 1559*, ed. W.D. Hamilton, Camden Society, new series, 11, 20 (2 vols., 1875), II, p. 134.

6.3. 16th-century window in north wall (photograph 2022)

Prior Peryn needed a separate apartment, given that Rich had the old Augustinian prior's house. The evidence of a survey of 1616 suggests that Peryn converted the chapter house into a two-storey building, quite possibly using the inserted upper storey as his accommodation. We can also note that some of the brickwork in the north wall of the surviving church (where it fronts on to modern Cloth Fair) may date from the 1550s, for example a brick window of two lights with four-centred Tudor arches (figs. 6.2, 6.3). This may have been built during Prior Peryn's tenure to make good the north side of his choir after the earlier demolition of the medieval parish chapel.[21]

The other change that Peryn was able to make in his brief spell at St Bartholomew's was a new front door. The Augustinian canons had their main West Smithfield gate on the north side of the nave, but since the 1540s this had been the parish gate, giving access to the parish church and churchyard. The friars therefore needed a new gate to the south-west of the parish church to lead into their precinct. The gate survives today with its thirteenth-century ground floor and late-sixteenth-century upper floors (fig. 6.4). Two strands of evidence suggest that some fabric of the mid-1550s may be preserved inside. In a court case of 1596 concerning modifications to the gatehouse the building was described as 'certayne chambers or roomes one over another *auncyently edified* builded and standing over and upon the same gate on an arche of stone'. During renovation work in 1915 it was noted that many timbers were not in their original setting, suggesting that an earlier timber frame had been partly dismantled and re-modelled in the 1590s.[22]

21 Holder, *Friaries*, p. 63; Webb, *Records*, I, pp. 282, 544–45; II, pp. 141, 144–45, plate 49; II, plate LX plan facing p. 120 ['cupboard' marked on plan in position of Tudor window].
22 Webb, *Records*, II, pp. 67–70; TNA, C 2/Eliz/D9/54, m. 10.

6.4. The 13th-century south-west aisle door with Tudor-era gatehouse above (photograph 2022)

All the evidence suggests that the Dominican friars quickly reintegrated themselves into the spiritual life of London. Parishioners of St Bartholomew's made bequests to the house and the friars took up their traditional roles of preaching and hearing confession. They were also specialists in the traditional Catholic *post mortem* ceremonies, participating in funeral processions, commemorative masses and anniversary funeral services held on the one-month and one-year anniversaries of the original funeral.

We can, perhaps, imagine Prior Peryn looking eastwards from his new flat above the chapter house, meeting the gaze of his neighbour Richard Rich looking westwards from his mansion, the two men separated by the forty-foot-wide infirmary garden. Had Peryn helped Rich to ease his conscience with this monastic refoundation? There was certainly plenty to trouble that conscience: Rich had betrayed Thomas More in 1535 and Thomas Cromwell in 1540, both men going to the executioner as a result. And it might have been

145

Rich rather than Cromwell who had originally developed the scheme to close England's monasteries.[23]

CHANGES TO THE PRIORY CHURCH IN THE 1550S

With the establishment of the Dominican friary in 1556, life for the parishioners of St Bartholomew's changed once again. John Deane remained rector, but the patronage of the parish, including the advowson (the right to appoint a new rector), passed from Richard Rich to the Dominican prior. The friars reclaimed their choir and so the parishioners lost their nave. They now had to squeeze into their chancel, the former Lady chapel (Map 4). When parishioner Richard Bartlett wrote his will in January 1557, he bequeathed £1 'towardes the makynge of the churche wall' and a further sum 'towardes the makynge of a Soller in the parish church'. The rector did not receive the money until Bartlett's death in May the following year, but it seems likely that Bartlett had identified works that were urgently needed, or which were taking place at the time. The new church wall might have been to separate the friars' choir from the shortened parish church; the 'soller in the parish church' sounds like an upper storey, perhaps a rood screen and loft separating the rejigged nave and chancel.[24]

The parishioners probably had the use of other ex-monastic spaces, including the westernmost bays of the old nave facing on to West Smithfield. We can guess that they converted these into tenements to provide rental income for the rector and parish, perhaps carrying out the works in tandem with Prior Peryn's works to create a friary gatehouse. By the seventeenth century, one of these houses was known as the Coach, a coachman's shop rather than an inn. The West Smithfield gatehouse is, therefore, the surviving third of a once-larger building, an unusual thirteenth-cum-sixteenth-century row of London houses.[25]

The former north transept may have been part of the friars' church, but it could equally have formed part of the parishioners' portion. By the 1550s, the building must have seemed rather awkwardly placed; parishioners needed access around the north side of the friary church in order to move between West Smithfield, their new burial ground (the demolished nave) and the new parish church (the former Lady chapel): see map 4. It is likely that the north transept was demolished or adapted at this time to facilitate this access.[26]

THE CLOSURE OF THE FRIARY IN 1559

Prior William Peryn died in 1558 and was replaced by Richard Hargrave. However, with the death of Queen Mary and Archbishop Pole on the same day in November that year, the fate of the re-founded Dominican friary – and of re-founded Catholic England – was thrown into confusion. Mary's sister Elizabeth began to reform the English Church once again, creating a Protestant Church of England that shared many features with the Reformed Church

23 For Rich as original instigator of the Dissolution, rather than Cromwell, see MacCulloch, *Cromwell*, pp. 202, 310, 320–22.
24 TNA, PROB 11/40/280; Webb, *Records*, I, pp. 282, 544–45.
25 Webb, *Records*, II, p. 242 and plate LXXXII map facing p. 199.
26 Webb (*Records*, II, p. 50) assumes the north transept was demolished c. 1544.

of her brother Edward VI, but which also allowed the traditional trappings of liturgy and church decoration favoured by her father Henry VIII.

In March 1559, the London friars received a letter from Rome confirming the election of Prior Hargrave. The timing was not good; this was just when Elizabeth's Act of Uniformity was progressing through Parliament – an act that reintroduced the Protestant *Book of Common Prayer*. Friar John of Vilagrassa (a Spanish friar at the London priory) nervously handed in the pope's letter to the privy council. Prior Hargrave went into hiding and left the country, later explaining to the head of his Order: 'I went into exile – my life was in grave danger'. When the friary was finally closed on 13 July 1559, just three friars and a novice remained, presumably all English and intending to remain in the country.[27]

With the closure of the friary and the re-establishment of a (largely) Protestant Church of England, Richard Rich and the parishioners of St Bartholomew's played another round of their metaphorical game of musical chairs. In 1560, Richard Rich bought the friary precinct for the second time, paying £153 8s 3d – rather more than the £54 he had paid for the (larger) Augustinian precinct in 1544. The parishioners of St Bartholomew's got their nave (the priory choir) back, but lost their chancel (the former Lady chapel) to Rich.[28] The subsequent changes to the parish church and Rich's mansion are discussed in Steven Brindle's chapter in this book.

FROM MONASTIC TO CIVIC HOSPITAL

St Bartholomew's Hospital was one of a wide range of London religious houses offering spiritual and physical care, including hospitals, almshouses, hostels and schools.[29] By the late 1530s, as increasing numbers of monastic houses were being surrendered, these traditional institutions of monastic charity and hospitality faced an uncertain future. Wealthy City merchants – acting in both a private and a civic capacity – had long been involved in the administration of London's religious hospitals, so in 1538 the London mayor Sir Richard Gresham asked the king if the City could take over the running of three London monastic hospitals and five monastic churches: St Bartholomew's, St Mary Bishopsgate and St Thomas, as well as the abbey of St Mary Graces and the four friaries. The request was, at this point, unsuccessful; in October 1539, St Bartholomew's Hospital was closed with the priory.[30]

It is not clear to what degree the hospital functioned for the next four or five years; the king's description of the hospital in 1544 as 'vacant and altogether destitute of a master and all fellows or brethren' may be an exaggeration. In June of that year Henry re-founded the

27 'io fui discacciato, e fui in gran pericolo della vita': G. M. Pio, *Delle Vite de gli Huomini Illustri de S. Domenico* (Bologna: G. B. Bellagamba, 1607), p. 379; *The Diary of Henry Machyn: Citizen and Merchant-Taylor of London, from A.D. 1550 to A.D. 1563*, ed. J.G. Nichols, Camden Society, old series, 42 (1848), p. 204.
28 For the cost calculations see Holder, *Friaries*, p. 60, based on Webb, *Records*, I, pp. 277–79, 286–88, 521–26. See also the 'Acte to annexe to the Crowne certayne Religious Howses and Monasteries and to refourme certayne Abuses in Chantreis', clause 16: *The Statutes of the Realm: From original records, etc. (1101–1713)*, ed. A. Luders and others, 11 vols. (London, 1810–28), IV, pp. 397–400.
29 See Euan Roger's chapter in this book.
30 *Memoranda, References, and Documents Relating to the Royal Hospitals of the City of London* (London: City of London Corporation, 1836), Appendix I, pp. 1–2; Webb, *Records*, I, p. 275.

6.4. Sir Rowland Hill by an unknown artist, c. 1540–60, oil on panel (© Museum of London)

hospital, appointing the royal chaplain William Turges as the first of its new masters. Over the next decade the City authorities, the bishop of London and two successive kings made arrangements for the future of this and six other London hospitals.[31]

In 1552, the City established a committee to administer the London hospitals, defining three categories of need: 'poor by impotency' (orphans, the aged and those with long-term illness or disability), 'poor by casualty' (the sick and wounded) and 'thriftless poor' (a pejorative category including vagabonds and prostitutes). Christ's Hospital on the site of the former Greyfriars priory was to serve the first category, particularly orphans; St Bartholomew's and St Thomas's were to serve the second category of ill Londoners; and

31 *Royal Hospitals of the City of London*, Appendix II, p. 5.

the newly established Bridewell was to deal with the third group, functioning as England's first workhouse. To this list must be added St Mary Bethlehem, which – caring for the mentally ill – did not quite fit into the City's three categories. With St Katherine's Hospital and, a little later, the Savoy (both originally royal foundations), there were now seven civic hospitals, of which St Bartholomew's was the oldest.[32]

It is worth noting here the role of several London mayors and merchants in securing the futures of these hospitals. Men like Richard Gresham (mentioned above), his son Thomas Gresham and the St Bartholomew's resident Sir Rowland Hill (fig. 6.4) moved in high-ranking circles and had personal experience of Continental social reform movements in European mercantile cities such as Bruges. Hill, in between running his international cloth business and acting in senior roles in the Mercers' Company, served on the City's hospitals committee for several years in the 1550s.[33]

St Bartholomew's Hospital and the other late medieval London hospitals were, from the late fifteenth century, increasingly providing medical care as well as the traditional social and spiritual care offered by monastic institutions. Apothecaries, bloodletters, physicians and even surgeons were working at or visiting these institutions, and the 1544 re-foundation of St Bartholomew's Hospital certainly encouraged this transition towards fuller medical care. The later history of the hospital is not discussed in detail in the present volume.[34]

CONCLUSION

The canons, residents and inmates of St Bartholomew's Priory and Hospital experienced two extraordinary decades of change and uncertainty between 1539 and 1559. Prior Fuller enjoyed his generous pension for less than a year, dying in September 1540. The other Augustinian canons quietly dispersed after four centuries of monastic ritual, seeking other work in the English Church. Dominican friars briefly re-established a monastic house at St Bartholomew's in the 1550s, with several then leaving the country in 1559, including Prior Hargrave. After an uncertain five years, the hospital rose again, now a civic rather than a monastic institution. By 1559 the residents of the close had become a fully formed parish, and they set to work restoring their parish church. And that great political survivor Baron Richard Rich could adjust to life under the new Protestant queen, secure in his London townhouse, which was newly restored as a great Tudor mansion with courtyards and gardens.

32 J. Stow, *Survey of London*, 1633 edn (with contributions by Anthony Munday and Nicholas Bourn), pp. 342–45; online edn accessible via 'Map of Early Modern London', <https://mapoflondon.uvic.ca/>, accessed 19 March 2022.

33 Paul Slack, 'Hospitals, workhouses and the relief of the poor in Early Modern London', in A. Cunningham and O. P. Grell (eds), *Health Care and Poor Relief in Protestant Europe 1500–1700* (London: Routledge, 1997), pp. 229–46 (pp. 229–33); Ian Archer, 'Hill, Sir Rowland (c.1495–1561), merchant and local politician', *ODNB*.

34 For more on the later history of the hospital, see: Carole Rawcliffe, 'The hospitals of Later Medieval London', *Medical History*, 28 (1984), pp. 1–21 (pp. 7–8); Chriz Harward *et al.*, *Spitalfields: The medieval priory and hospital of St Mary Spital*, MOLA Monograph, 59 (London: Museum of London Archaeology, 2019), pp. 164–74; *Royal Hospitals of the City of London*, p. 11; Moore, *Hospital*, II, pp. 149–886 [later history of the hospital]. Like the priory, St Bartholomew's Hospital celebrates its 900th anniversary with a new volume: Ann Robey (ed.), *St Bartholomew's Hospital: 900 Years*.

COACH & HORSES
DEVONSHIRE
WHITBREAD
ENTIRE

The Long Decline, c. 1559–1864

STEVEN BRINDLE

FOR OVER FOUR CENTURIES, St Bartholomew's had evolved as a monastic precinct on the edge of the City – a self-governing enclave dedicated to the religious life and to serving the people of London through its hospital, as its founder Rahere had intended. It had a substantial lay population, including the servants of the priory and the hospital and probably several other households, as well as the hospital's inmates. However, the precinct was 'extra-parochial', that is, outside the jurisdiction of the diocese of London. In effect it formed its own parish, and the friars employed chaplains who provided the normal round of parish services for inhabitants in the Walden chapel, on the north side of the choir.[1] This distinctive, enclosed place was rudely broken open by the events of the 1540s and 1550s. The priory buildings were divided up and adapted for new purposes, and the precinct became a parish with a rector, part of the diocese of London. However, it continued to be a 'liberty' – a self-governing enclave in terms of civil administration and justice, outside the jurisdiction of the Sheriff of Middlesex.

The three centuries covered by this chapter witnessed the evolution of St Bartholomew's as an unusual parochial church, serving a parish which was large by City standards, though small in comparison with the adjacent suburban parishes like St John, Clerkenwell. The parish was diverse, with some wealthy inhabitants and a wide range of activities, including the hospital, the meat market and the famous annual Bartholomew Fair. From an architectural point of view, this period represents a prolonged low point or nadir, between the destruction of much of the church in the 1540s and its restoration in the later nineteenth century.

THE PRIORY BUILDINGS AND THEIR SETTING IN THE SIXTEENTH CENTURY

The priory was re-sold to its previous owner, Richard, Lord Rich on 19 February 1559, for the modest sum of £298 9s 4d. The last friars left on 13 July. The choir of the monastic church was brought back into use as the parish church. Around it there was a confused scene of partial demolition, adaptation, patching-up and new building. North of the church,

1 For more on Walden's chapel, see Christian Steer's chapter in this book.

7.1. Wood engraving of the gateway in a ruinous state by J. Brown, c. 1850. Wellcome Collection

7.2. Detail of Faithorne and Newcourt's 1658 map of London
showing Smithfield and buildings along the new Cloth Fair (in red).
Reprinted from _Maps of Old London_ ed. by Geraldine
Edith Mitton (London: Adam and Charles Black, 1908)

reaching to Long Lane, was the broad open space on which the Bartholomew Fair had been held. The north transept of the monastic church had been demolished and a blank wall built in the crossing arch. In the later sixteenth century, the Rich family developed the area to the north: a new street, Cloth Fair, was laid out running from east to west, crossing the site of the north transept, with building plots to either side. As the name suggests, the street represented the remaining space available to the fair. The third Lord Rich wanted to continue to profit from the fair, while simultaneously benefiting from the property development; some of the lease agreements for the new houses came with provisions that the ground floors should be reserved for commercial use.[2] By the time Faithorne and Newcourt's map appeared in 1658, Cloth Fair was lined on both sides with buildings (fig. 7.2).

To the north of the priory church was the fifteenth-century Walden chapel. Its function as the parochial chapel had been definitively moved into the choir and by 1598, when Stow published his *Survey of London*, it had been demolished.[3] Newman's Row, a row of houses facing on to Cloth Fair, was built on its site. To the south of the choir, the fine prior's lodging built by Prior Bolton in the early 1500s had been taken over by Richard Rich as his residence in 1544. The house included the north triforium gallery with its superb oriel window, used as the prior's pew, from which he and his household had watched services in the choir. The house had a good-sized garden to its east, enclosed to the north by the Lady

2 Webb, *Records*, I, p. 311; II, p. 311.
3 Stow, *Survey*, p. 338.

chapel. After 1559, the house was extended by the addition and conversion of the former Lady chapel. This needed to be linked to it: the south triforium gallery formed part of the link, and to complete it the upper part of the ambulatory behind the high altar, above the 'purgatory chamber', was also taken from the church. This created a 'flying freehold' situation above the east end of the church, which persisted for over three centuries, and was not finally reversed until 1886.[4] The south triforium arches were blocked up around this time, to make a division between the house and the church. The north triforium gallery was taken into the residence as well, and its arches also blocked. The gallery formed a long room with a brick north wall and a little tower at its east end; it is possible that the wall and tower date from before the Suppression.[5] In the seventeenth century, the north triforium became the parish schoolroom.

The Lady chapel was converted to domestic use as part of the house, with a floor inserted and the windows remodelled. Richard, first Lord Rich, continued to use this as his London residence, but it is not clear whether any of his descendants did. Around 1595, the Lady chapel was detached to form a separate house, together with the north triforium gallery, which was let to Sir Percival Hart of Lullingstone Castle. Initially it formed a two-storey house with a hall below, stairs and a chamber floor above. Successive alterations in the seventeenth and eighteenth centuries rendered it quite unrecognizable, as described below. The south transept remained standing, though in 1539 the lead had been stripped from its roof, and it had fallen into ruin. As on the north side, the south crossing arch was filled with a brick wall. The ruined transept became part of the churchyard.

To the west, the changes of 1539–59 had been even more sweeping. The medieval nave had been demolished, except for its easternmost bay adjacent to the crossing, c. 1544. Rich had a new west front for the church built. Otherwise, the only parts of the nave to remain standing were the south aisle wall, together with the southern of the three portals on the original west front. The area of the nave became the newly formed parish's burial ground. By 1559, the monastic church had been brutally truncated, with a total disregard for its architecture. The Lady chapel, transepts and nave had been cropped from it, the triforium galleries detached and colonized. The surviving choir was reduced to a rectilinear box. This has to be understood in the context of an age when hundreds of monastic churches, including most of the ones in and around London, were totally destroyed. In several English towns, monastic churches were retained for parochial use after the Suppression. There were a few places, like Beverly in Yorkshire or Malvern in Worcestershire, where the whole church survived. There were others, like Bridlington Priory in Yorkshire and Malmesbury in Wiltshire, where the nave survived, reflecting its parochial use prior to the Suppression, and the monastic choir was demolished. St Bartholomew's was unusual in the way in which it was sliced up and hemmed in with secular buildings, while remaining in parochial use.

4 See Evan McWilliams's chapter in this book for details.
5 The brickwork and the mullioned windows which form the outer side of the north triforium, and the adjacent tower, could date from before or after 1539, to judge from their appearance, and there does not appear to be documentary evidence for the date of this alteration.

What of the conventual buildings? In 1559-60 Lord Rich recovered the church and most of the main monastic buildings which were listed in the grant, including the cloister, old kitchen, frater, chapter house, library, dormitory and six houses in the close that were attached to the rectory as the main glebe endowment.[6]

The monastic cloister was surrounded by ranges on its west, south and east sides, in the conventional way. The west range housed the guest house and cellarer's quarters. This seems to have been sold off early, and probably demolished, for it is not named in the later sale documents. Rich regained possession of the cloister and the other ranges in 1559-60. The cloister itself and the south range, with the frater, parlour and kitchen, were sold to Sir Walter Mildmay, an eminent Elizabethan courtier and landowner, who formed a large residence there. It passed via his daughter Mary to her husband, Francis Fane, earl of Westmorland, and the Westmorlands lived there into the mid-seventeenth century. The east range, with the monastic dorter on its first floor, was likewise sold by Rich and became another substantial house, owned by Sir Philip Scudamore. In the early seventeenth century this was occupied by Edward Nevill, Lord Abergavenny, as Lady Scudamore's tenant.

To the east of this was the former prior's house, occupied by Rich himself from 1544 to his death in 1567. To the south, the house was abutted by the infirmary range, which extended eastwards, forming one side of another courtyard. This formed a further large house, occupied in the early seventeenth century by Sir Henry Cary, first Viscount Falkland. Thus in the late sixteenth and early seventeenth centuries, the priory area had a number of wealthy and eminent inhabitants.

ST BARTHOLOMEW'S AS A PARISH CHURCH, 1559-1605

When Richard Rich surrendered the property to the Crown in 1555 he had retained the prior's lodging as his own residence, and he resided there periodically throughout the Marian re-occupation of 1555-59.[7] In 1559, Rich was around 63 years old. He had survived the political twists and turns of the three previous reigns, retaining the bulk of his estates throughout. The skills and character traits that this required were not agreeable ones, and Rich has retained a reputation for treachery, double-dealing, perjury and hypocrisy that has few equals in English history.[8] He may have retained a residual loyalty to the old religion: during Queen Mary's reign he had supported the persecution and burning of Protestants. He had founded a chaplaincy at Felsted church, on his Essex estates, with provision for the singing of masses and ringing of bells, which also suggests old-style preferences.[9]

Next to Rich, the most important figure in this transitional period in St Bartholomew's history was its first rector, Dr John Deane, sometimes given the courtesy title of Sir John. He was a Cheshire man, from a yeoman family in Davenham near Northwich in Cheshire.[10]

6 Webb, *Records*, 1, pp. 285-89, 523-26.
7 P.R.N. Carter, 'Rich, Richard, First Baron Rich (1496/7-1567)', *ODNB*; M.E. Coyle, 'Sir Richard Rich, First Baron Rich (1496-1567): A Political Biography' (unpublished PhD thesis, Harvard University, 1967).
8 Webb, *Records*, 1, pp. 289-96; Carter; Coyle, pp. 4-13.
9 Coyle, pp. 218-19.
10 Marjorie Cox and L.A. Hopkins, *A History of Sir John Deane's Grammar School, Northwich, 1557-1908* (Manchester: Manchester University Press, 1975), pp. 9-26.

Little is known of his early life or education, but he must have acquired connections, for in 1539 he was appointed chaplain of the parochial chapel at St Bartholomew's. Deane was already in post when the priory was sold to Rich in 1544. Rich, as the patron of the newly formed parish, appointed Deane as the first rector in 1544 with a stipend of £11 per year.

Deane must have adhered strictly to the Edwardian, Protestant settlement, for in 1551 he was given another living at Carlton-cum-Dalby in Lincolnshire, worth £5 6s 8d a year, and for a number of years he was also rector of Coulsdon in Surrey, worth another £22 a year. However, he seems to have remained in residence at St Bartholomew's throughout the turbulent 1540s and 1550s. Despite his humble origins, Deane acquired significant means, which he used to acquire estates in Cheshire from chantries suppressed under the Edwardian act. He was unmarried and celibate, which doubtless helped him survive the change of regime under Queen Mary. In 1557 he used his property to found a grammar school for poor boys at Witton, near his home town of Davenham; his portrait appears in its founding statute, in an academic gown with a fur tippet, a scarf and a doctor's cap. Sir John Deane's Grammar School still exists today.[11]

Deane, like Rich, was a survivor. He saw the Dominican friary at St Bartholomew's come and go, and was in post as rector when the priory was sold back to Rich in 1559. The parish church presumably moved back to the Walden chapel in 1555-59, and then returned to the monastic choir. However, it was not long before Deane and the parish had to fend off a mortal threat to their church from an unexpected quarter. On 3 June 1561, the spire of St Paul's Cathedral was struck by lightning and destroyed; it was the tallest spire in England, said to be 490 feet high and made of lead and timber, rising from the stone crossing-tower.[12] Faced with this catastrophe, Edmund Grindal, bishop of London, cast around for the means to rebuild it. In 1563 his eye lit on St Bartholomew's, and on 3 July he wrote to the Secretary of State, Sir William Cecil:

St Bartholomew's church, adjoining nigh to my Lord Riches house, is in decay and so encreaseth dayley; it hath an heavy coat off lead, which would do very Goode service for the mother church of Powles. [...] I have obtained my L Riches good will, and if I could obtain my Lord Chief Justice the Kings Bench and Sir Walter Mildmay's assent, I would not doubt to have the assent also of the whole parish. [...] Now remaynewth only this scruplle. How shall the parish be provided of a church. That is thus answered. There is an house adjoining which was the Fratrie, as they termed, a very fair and large house, and indeed already, if it were not purged, lacked nothing but the name of a church. If we might have the good lead, we would compound with my Lord Rich for converting the said Fratrie into a church.[13]

It is striking that Rich apparently did not object; maybe he saw one last opportunity to profit from his purchase of St Bartholomew's. Cecil's reply is not recorded; maybe Catlyn and Mildmay did object, but at any rate the bishop's request was not granted, and

11 Cox and Hopkins, pp. 10-11.
12 Derek Keene, Arthur Burns and Andrew Saint, *St. Paul's: The Cathedral Church of London, 604-2004* (New Haven: Yale University Press, 2004), pp. 51, 171-73.
13 British Library, Lansdowne MS 6/55, quoted in Webb, *Records*, II, pp. 303-04. Mr Justice Catlyn and Sir Walter were also influential parishioners.

St Bartholomew's was saved from final destruction. Rector Deane died in 1565. His will directed that he be buried in 'Sir Walter Myldmaye's Chappell within the Quire of greate Saynte Bartillmews where I have allredie made my grave'.[14]

Richard Rich was still alive, and it was presumably he who appointed one Ralph Watson to be Deane's successor as rector – his last intervention in St Bartholomew's history. Nothing seems to be known of Watson, who was only in post until 1569. It must have been Robert, the second Lord Rich (d. 1581) who appointed the third rector, Robert Binks, in post from 1570–79. He too has left little historical record. During his rectorship the church was refurbished, with the floor levelled up and repaved, pews repaired, new seats added, and money spent on the bell-wheels and ropes. Around the same time an inventory of the church's goods was made, which survives with the earliest surviving churchwarden's accounts, for 1574–78. The plate consisted of just two communion cups. There were a few vestments of velvet, a couple of copes, table cloths, and just three books, including an old Bible, 'one great book', and 'one old service book for the minister'.[15] The services at St Bartholomew's in the late sixteenth century were evidently dignified, and carried out by priests who were robed, not black-clad.

The next rectors, James Stancliffe (1580–81) and John Pratt (1582–86), left little mark on history. David Dee, the rector from 1587 to 1605, seems to have made the wrong kind of impression. He engaged in lawsuits with the tenants of the six glebe houses that furnished his stipend. One of the defendants, Ann Lupton, referred to the rector's 'troublesome disposition'. The defendants began to lobby for his removal, and eventually Dee was deprived of his parish by the Lord Chancellor in 1605.[16]

On the death of Robert, second Lord Rich, in 1581 his son Robert, third Lord Rich and first Earl of Warwick (1559–1619), succeeded to his estates. He continued the family's drive to profit by developing the precinct, as noted above. Around 1612, the third Lord gave the property in St Bartholomew's together with the advowson to his younger son Henry, on the occasion of his marriage to Isabel, daughter and heiress to Sir Walter Cope of Cope House, Kensington. Henry took up residence in this magnificent mansion and became a leading figure at the Stuart court, being created Baron Kensington in 1623 and Earl of Holland in 1624. Cope House was renamed Holland House.[17]

Henry Rich never resided at St Bartholomew's, but in 1616 a detailed survey was made of his property there, which shows that the former prior's lodging was then occupied by a Mr Arthur Jarvais. Around 1630 it was bought by another great courtier, Lionel Cranfield, first Earl of Middlesex, and subsequently known as Middlesex House. Edward, Lord Abergavenny was residing in the former dorter range to the east of the cloister, while the house in the former infirmary was occupied by Sir Henry Cary, first Viscount Falkland.

14 Webb, *Records*, II, p. 545.
15 London Metropolitan Archives [hereafter LMA], P69/BAT3/B/013/MS20779. Reproduced in Webb, *Records*, II, p. 308.
16 Webb, *Records*, II, pp. 310–11.
17 R. Malcolm Smuts, 'Rich, Henry, First Earl of Holland (1590–1649)', *ODNB*.

THOMAS WESTFIELD, RECTOR 1605-44,
AND ST BARTHOLOMEW'S DURING THE CIVIL WAR

By the time Henry Rich inherited the family's property at St Bartholomew's, the church had a new rector. After the contentious David Dee was ousted as rector in 1605, he was replaced by one of St Bartholomew's most distinguished incumbents, Thomas Westfield. Westfield was from Ely, of a humble background, and was educated at Jesus College, Cambridge, where he was a fellow until 1603, later becoming a doctor of divinity at both Oxford and Cambridge.[18] Westfield became chaplain to Robert, third Baron Rich, who appointed him rector of St Bartholomew's in 1605. Westfield's career prospered; he was given the rectory of Hornsey (1635-37), the archdeaconry of St Alban's, the presidency of Sion College, and finally the bishopric of Bristol in 1642. Westfield was a pluralist, but nevertheless he was highly regarded by both his parishioners and his superiors. Westfield was appointed to an ecclesiastical commission for appointments in 1633, and preached at St Paul's Cathedral in 1641 – further signs of official approval.[19]

Dr Westfield's rectorship was a time of development for the church and parish. In 1616, a parish school was established in the early sixteenth-century brick building above the north choir aisle. In the later sixteenth century this had become part of the house in the former Lady chapel, belonging to Sir Percival Hart. His lease fell in c. 1616. Henry Rich detached the north triforium from the house, and gave a lease of it to the parish. The schoolmaster lived in the tower-like building at the east end, while the gallery over three bays of the triforium became the schoolhouse. The space occupied by the schoolroom is still there, and the north wall retains its three-light windows and fireplace. The Norman triforium arches overlooking the choir had been blocked, separating off the schoolroom. These were re-opened during the Webb restoration, so the space is once more a triforium gallery. Generations of the parish's boys were educated in this narrow room. Today the Tudor brick façade looks picturesque from Cloth Fair, but then it was hidden behind Newman's Row. To the north, in fact, the church must have been more or less invisible from Cloth Fair.

Dr Westfield's tenure also saw the first major amelioration of the church since the Reformation. The enhancements made in St Bartholomew's in his time suggest Laudian sympathies. In 1624, an organ was installed in the church, on a gallery over the west end. The east end was remodelled with a 'railed altar' of the kind favoured by Bishop Laud, and with a magnificent retable, with arched panels for the ten commandments flanked by columns, which broke forward with obelisk finials above, and the royal arms in between (fig. 7.3).[20] Its appearance is known from eighteenth-century engravings, and it survived until 1828. At the same time a new tower was built to house the church's peal of five bells. These had been cast in the time of Prior Bolton as part of a suite of eleven, six for the priory and five for the parish. The historian John Stow tells us that the six priory bells were housed in a bell-tower, which stood until the demolitions of c. 1544. The bells were then sold to the parish of St Sepulchre. The parish church retained its five bells, which hung in what Stow

18 Webb, *Records*, II, pp. 313-21.
19 J. Sears McGee, 'Westfield, Thomas, Bishop of Bristol (1573-1644)', *ODNB*.
20 Webb, *Records*, II, pp. 19-20. The arms were apparently those of Charles I.

7.3. St Bartholomew the Great by Thomas Hosmer Shepherd, 1821
(© London Metropolitan Archives, City of London)

described as a 'steeple', probably a timber bell-cote to the north of the choir. The 'steeple' had recently been repaired when he published his book in 1598.[21]

In 1628 the bells were moved to a new brick tower, built over what had been the easternmost bay of the nave's south aisle, and thus abutting the south transept. This was done at the initiative of a parishioner, Sir Henry Martyn. He organized a subscription for it, contributing £50 himself.[22] The tower measures 19 feet by 24 and 74 feet high, plain and simple, built of a red-brown brick. The five bells bell still hang in the tower (fig. 7.4), and bear inscriptions in Gothic script:

1. *Sancte Bartholomeo Ora Pro Nobis.* 22" diameter
2. *Sancta Katerina Ora pro Nobis.* 24" diameter
3. *Sancta Anna Ora pro Nobis.* 26½" diameter
4. *Sancte Iohannes Baptiste Ora Pro Nobis.* 29" diameter
5. *Sancte Petre Ora Pro Nobis.* 31" diameter.

One curious point is that the bell dedicated to St Bartholomew should be the smallest one, the treble bell. The bells also bear the initials *TB*, probably for Thomas Bullisdon, a bell-founder of Aldgate, active c. 1500–20. St Bartholomew's bells are a unique survival: it is the only church in England with more than four pre-Reformation bells. A sixth bell, the Sanctus bell, seems to have survived the suppression, and was hung in a little cupola on top of the tower; this was re-cast in 1814 as the striking bell for the new church clock that was installed in the tower at that time.[23] The parish was prosperous, and in 1637 major repairs costing £698 were carried out to it.[24] There were several officers, and a table of fees to be paid to the rector, churchwardens, clerk, sexton, searchers and bearers was set out in 1635.[25]

As the political situation deteriorated in 1640–41, Dr Westfield was vulnerable as a supporter of the king and court in a predominantly Puritan city. He was abused in the streets, and in 1642 he fled to the king's camp. King Charles made him bishop of Bristol on 26 April 1642. Westfield installed a Mr Edward Pealle as minister at St Bartholomew's; Pealle was buried in the church in November 1643, and succeeded by a Mr Henry Scudder. Dr Westfield was deprived of his income from Bristol by the Parliamentarians, but it was restored out of respect for his upright character. He compromised with Parliament, being present at an assembly held at Westminster for the re-organization of the Church in 1643. Dr Westfield died on 25 June 1644, and was buried in the choir of Bristol Cathedral.[26]

St Bartholomew's was raided by Puritans in 1644, who removed and burnt the rails that Westfield had erected around the altar.[27] A new rector, John Garrett, was presented by the Earl of Holland as patron. Little seems to be known of him; very few parochial events

21 Stow, *Survey of London*, p. 338; Webb, *Records*, II, p. 120.
22 Webb, *Records*, II, pp. 535–36.
23 Webb, *Records*, II, pp. 112–15.
24 *Calendar of State Papers* 1628/9, 406, 29.
25 Lambeth Palace Library, Miscellaneous Charters, VII, no. 75. Reprinted in: Webb, *Records*, II, pp. 329, 559.
26 Webb, *Records*, II, pp. 320–21; 'Westfield, Thomas', *ODNB*.
27 Webb, *Records*, II, pp. 316, 321.

7.4. The bells as presently hung in the bell tower (photograph 2019, credit: Paul Norman)

are recorded for the years 1644–55.[28] The goods of parishioners regarded by Parliament as 'malignant' were sequestered, including those of the patron, Lord Holland. Indeed, Holland was a prominent Royalist victim of the war: he took up arms again in the king's cause in the Second Civil War, was captured, and executed on 9 March 1649.[29]

When the rector John Garrett died in 1655, his successor Ralph Harrison was presented to the living by Isabella, dowager Countess of Holland, not long before her own death in August of that year. Harrison was presumably a Presbyterian or Independent, but on the restoration of Charles II he conformed to the Church of England, and he was formally instituted as rector by William Juxon (1582–1663), the recently reinstated bishop of London, on 25 August 1660.[30]

ST BARTHOLOMEW'S AS A PARISH CHURCH, C. 1660–1790

In the later seventeenth century Smithfield was a prosperous part of the City, and St Bartholomew's was refurbished and adorned by its parishioners. Ralph Harrison, the rector, died in 1663. He was replaced by Anthony Burgess, who was presented by the patron, Robert, second Earl of Holland and Baron Kensington. Burgess was evidently a young man, for he had only graduated from St John's College, Cambridge, in 1662. He was in post as rector until 1707, but may not have been there for much of the time. He very rarely signed the Minute Books, even at the Easter vestry meetings. It seems likely that regular worship was conducted by curates.[31]

28 Webb, *Records*, II, pp. 321–22.
29 'Rich, Henry, First Earl of Holland', *ODNB*.
30 Webb, *Records*, II, pp. 322–24.
31 Webb, *Records*, II, pp. 324–31.

London was afflicted by the Great Plague in 1665, which reached its height in the summer. In the parish that year were recorded 244 deaths: 139 in August, 86 in September, 11 in October, 7 in November, and just one in December. About a quarter of the parish's population had died. However, the parish was spared destruction by fire a year later. The Great Fire was stopped at Pie Corner on Giltspur Street; the place was marked by a gilded figure of a fat boy, emblem of gluttony, for the fire had started at Pudding Lane and ended on Pie Corner. The neighbouring parish church of Christ Church, Newgate Street had been destroyed in the fire, and the Blue Coat boys from there were provided for at St Bartholomew's; they attended school there until 1672, and again between 1680 and 1683.[32]

The Churchwardens' Minute Books survive from the later seventeenth century, and provide many insights into the life and workings of the parish.[33] The church was probably in disrepair after the Commonwealth years, and in May 1662 a rate of £400 was levied to pay for repairs.[34] The bells were rung regularly; in December 1687, the vestry resolved that John Chapford was to have 30 shillings per annum to maintain and repair them. In 1689, the church was robbed, with the vestry door broken open, and the altar plate and other items stolen. The losses were swiftly made good by the parish, Rector Burgess himself giving a silver-gilt cup and cover engraved with his name and arms.[35]

By the 1690s the church was filling up with box pews, which were for the better-off householders in the parish. Periodically, the minutes have references to pews being allocated or re-allocated: on 28 September 1697, for example, Mr Sandys and his family were moved out of the pew where Mr Rowley sat and a Mr Hilbert placed there, to give the Sandys family a more suitable place.[36] By this time, the choir had been a parish church for over 150 years. Repairs must have been due, and in 1704 the churchwardens ordered the east window to be repaired in stone, suggesting that the fifteenth-century tracery was still *in situ*.[37] It is not known when it was replaced with twin arched windows. A new font was bought in February 1712, though in April the vestry ordered the old one to be set up again.[38] The porch at the north-west corner was rebuilt in 1713. The main porch from the churchyard was rebuilt in 1715, and the east church door remade, with a 'shell' over it.[39]

On 5 April 1715 the churchwardens ordered that a 'Conoble organ' be set up in the church, 'providing it be approved on by a master of music whom the churchwardens shall appoint'.[40] This was built by Johan Knoppell, presumably a German immigrant, who had worked with the organ-builder Bernard Smith. On 7 December 1715 a Mr Vannallson was engaged as the organist, for £18 a year.[41] In 1720, the organ was ordered to be enlarged or

32 Webb, *Records*, II, p. 327. This connection may explain the presence of a painting of a Blue Coat boy presently hanging in the south vestry. For more on this painting, see Jeremy Haselock's note in this book on the lesser paintings held by the priory church.
33 LMA P69/BAT3/B/001/03990, vols. I–VI [hereafter Vestry minutes].
34 Vestry minutes, I, p. 6, 20 May 1662.
35 Vestry minutes, I, p. 472. The account of the robbery is at the end of this volume, not in date sequence.
36 Vestry minutes, I, p. 241.
37 Vestry minutes, I, p. 349, 5 February 1704.
38 Vestry minutes, II, pp. 30, 31.
39 Vestry minutes, II, pp. 58, 74.
40 Vestry minutes, II, p. 77, 5 April 1715. Mr Conoble was give £20 in part-payment in July: Ibid., 83.
41 Vestry minutes, II, p. 87, 7 December 1715.

7.5. Hand-coloured engraving of the west prospect of St Bartholomew the Great by William Henry Toms, after Robert West, 1737 (© Alamy)

replaced. Eventually the latter course was decided on, and in 1731 a new organ was built by Richard Bridge of Clerkenwell.[42]

John Pountney, rector from 1707 to 1719, was succeeded by the Reverend Thomas Spateman. There were numerous repairs to the church in Mr Spateman's time. By this time there were problems with the church roof, which in 1737 was surveyed and pronounced to be badly decayed. It was resolved that a full year's worth of the parish rates should go towards the cost: the rate yielded £325, and the rector added another £20.[43] The earliest detailed view of the church that we have was made in 1737, showing the west front from the churchyard. The west wall, built by Rich in 1544, had one large window divided into lights with three mullions and a transom, with the main entrance below it (fig. 7.5).

42 Webb, *Records*, II, pp. 410–11, 502–03. For more on these organs, see Nicholas Riddle's chapter in this book.
43 Vestry minutes, III, pp. 100, 101, 138.

7.6. Aquatint of the church of St Bartholomew the Great, interior view showing the organ gallery, c. 1740. Wellcome Collection

We do not have any late seventeenth- or eighteenth-century views of the interior, but early nineteenth-century engravings show us what St Bartholomew's looked like in the Georgian age (figs. 7.3 and 7.6). The walls were whitewashed. The triforium arcades were blocked, but the arches were visible. The low-pitched medieval roof, repaired in 1737, remained *in situ*. At some point, the fifteenth-century east window was taken down and the wall rebuilt with a pair of large, arched windows. At the west end of the church was the gallery, set up in 1624, on which an organ had been rebuilt in 1724, and again in 1731.

The large west window was visible behind the organ pipes (fig. 7.6). The gallery extended around the north side of the crossing, occupied by the parish schools.

Much of the interior was filled with box-pews with high sides and doors. Pews were allotted by vote of the vestry. A note in the Minute Books of 1827 explained what the parish custom was, as pews 25, 29, 32, 34, 35 and 36 were vacant:

According to the ancient custom to appropriate such pews as have always been reserved for the most respectable inhabitants to the use of the head of the family during his or her residence in this parish, on such person making such an offering for the use of the poor as shall be satisfactory to the vestry, and such pews always to be declared vacant on the death or removal of such.[44]

Status and money mattered a great deal in Georgian England. Nevertheless, there were stirrings of popular enthusiasm and deep religious commitment amongst working-class and middle-class people. John Wesley, the charismatic clergyman and founder of Methodism, preached at St Bartholomew's in 1747, attracting great crowds.

THE CHURCH IN ITS SETTING, C. 1660–1830

In the Middle Ages, St Bartholomew's Priory had been a place apart – a hushed, secluded place behind its precinct walls. After the Suppression those walls were torn down, and by the mid-seventeenth century the parish was as densely packed with streets and houses as anywhere in the City of London. As Ogilby and Morgan's map of 1677 shows, the church was closely hemmed in on all sides, except for the churchyard to its west, on the site of the former nave (fig. 7.7). The yard had filled up with graves. To the south it was enclosed by the original south aisle wall. In the eighteenth century an alehouse called the Flying Horse, which probably took its name from the Mildmay coat of arms, was built on the north part of the cloister. Around 1756 it changed its name to the Coach and Horses.

The hubbub of the city pressed in on the church. In 1686, the churchwardens ordered that the churchyard 'be railed with palisades, walles, and gates on both sides, and next the Ingeion house'. The latter housed the parish fire-engine.[45] Visitors to the churchyard would have been presented with another aspect of parish life – the maintenance of law and order and deterrence of petty crime. The parish was still a liberty, outside the jurisdiction of the Sheriff of Middlesex, and must have had its own serjeants. It had its own cage and lock-up, near the gate from Smithfield. The parish stocks were on the south side of the churchyard on the way to the main door, where the parishioners would have seen anyone put in them. There were stocks and a whipping-post in the churchyard, testifying to the persistence of medieval ways of dealing with minor offenders. This carried on well into the Georgian age: in 1754-55 the churchwardens ordered a replacement set of stocks to be fixed in 'the most convenient place [...] without delay'.[46] This was in the same place, in the churchyard by the wall of the Coach and Horses.

44 Vestry minutes, IV, pp. 606–08, has a long consideration of the allocation of pews.
45 Vestry minutes, I, p. 120.
46 Vestry minutes, III, pp. 321, 329.

7.7. Detail from Ogilby and Morgan's map of 1677 showing the buildings encircling St Bartholomew's (© Trustees of the British Museum)

In 1705, the school and schoolhouse on the north side of the choir were let to Mr Charles Smith, curate of the parish and presumably the schoolmaster, for £14 a year.[47] Elsewhere, the houses were crowded up close to the church walls, and the church would have been invisible from Cloth Fair. To the east there was the former Lady chapel, though this too was hidden from Cloth Fair by the houses on its south side. In the seventeenth century this had been a large residence, but by the early eighteenth century it was divided into three houses, numbered 40, 41 and 42 Bartholomew Close, owned by the brothers Thomas and John James, letter-founders. Their foundry occupied a further house abutting the east end of the former chapel.[48] In 1726, a young journeyman printer, Benjamin Franklin, was working there for a printer, Samuel Palmer. He recorded in his autobiography:

I immediately got engaged at Palmer's, at that time a noted printer in Bartholomew Close, with whom I continued nearly a year [....] I was employed at Palmers on the second edition of Woolaston's Religion of Nature.[49]

At some point in the eighteenth century the roof was removed, the walls raised, and another storey added. Nineteenth-century views of it show a three-storey building. The only original features visible are the buttresses, the original windows having been blocked or adapted and replaced with sash windows of various shapes and sizes. It was unrecognizable as a medieval religious building (fig. 7.8).

47 Vestry minutes, I, p. 369. School, p. 1705.
48 Webb, *Records*, II, pp. 74–90.
49 Benjamin Franklin, *The Autobiography of Benjamin Franklin* (Minneapolis: Voyageur Press, 2016), p. 101.

7.8. Sketch of the former Lady chapel in use as a fringe factory,
view from Bartholomew Close, September 1886 (© Museum of London)

As we have seen, the monastic buildings had been divided into a number of large houses, which until the Civil War had eminent owners and occupants. In the later seventeenth century, the aristocratic families moved away and the houses were divided up and went down in the world in the same kind of way as the Lady chapel. Two fine plans of the priory buildings, made in 1791 and 1821, give us a clear and detailed picture of their state at the time.[50]

To the south, the former prior's lodging, known as Middlesex House, still stood, divided into a number of residences. The gallery in the south triforium, which had formed part of the house, was occupied by a Non-conformist meeting house by 1705. Close by it, and also abutting the quire to the south, the medieval sacristy was still standing. This was a finely detailed thirteenth-century building, as the Society of Antiquaries noted in 1784 in *Vetusta Monumenta*. At the time it was in use as a carpenter's shop, where 'till within a few years, were the 12 apostles or saints painted on the walls'.[51] In 1809, the sacristy (then being used as a hop-store) was described in more detail by the celebrated antiquary and writer John Carter in the *Gentleman's Magazine*:

50 British Library, Crace, Portfolio VIII, 98, 11-13-370 is a hand-drawn survey plan dated 1791; VIII 99, 11-13-371 is a printed plan of the same area, dated 1821. Neither document is signed.
51 *Vetusta Monumenta* (London, 1784), II, explanation of plates 36 and 37, p. 8.

A magnificent chapel on the side of the quire. The windows on the east and south sides have lost their arched heads; the columns and architraves [...] remain, they are very delicate and beautiful. The upper part of the chapel is destroyed.[52]

The south transept, separated from the church by a wall in the crossing arch, remained a ruined shell, used as an extension to the burial-ground. At some point it must have been sold by the parish. John Carter drew it in 1781: his drawing shows that the clerestory stage had been taken down. To the east, a timber structure rose above the former sacristy. Beyond the south wall, the top of the former chapter house was visible (fig. 7.9).

7.9. Sketch of the ruined south transept by John Carter, 1781. Wellcome Collection

ST BARTHOLOMEW'S, C. 1790–1865: THE ROAD TO RESTORATION

In 1790 the architect Thomas Hardwick (1752–1829) was commissioned to survey the church; he was paid £45 for the survey and supervising the repairs.[53] Hardwick was a pupil of Sir William Chambers, who had toured Italy and designed buildings in the Neoclassical style of the age, but he showed real scholarly interest in St Bartholomew's, making the first measured drawings of the church and part of the monastic buildings, which are now in the collection of the Society of Antiquaries of London.[54] Hardwick examined and reported on the state of the church, which was sufficiently alarming as to prompt calls for demolition.[55] Hardwick returned to make a further report in 1812; further repairs were carried out, and the interior was whitewashed. Hardwick's surveys and intervention probably saved the building, and might have heralded the first steps towards restoration, but no more money was available.[56] Beyond the church, the monastic buildings continued to be eroded. John Carter returned to St Bartholomew's in 1809 and reported that the

52 *Gentleman's Magazine*, 79 (March 1809), pp. 226–28, 327–28.
53 Vestry minutes, IV, p. 10, 7 March 1791; Howard Colvin, *A Biographical Dictionary of British Architects, 1600–1840*, 4th ed (New Haven: Yale University Press, 2008), pp. 480–82.
54 Society of Antiquaries' Library, Red Portfolio, London, A-B, 12-16. The plan in the British Library, Crace Portfolio VIII, dated 1791 (n. 51), was probably made by Hardwick as well.
55 Vestry minutes, IV, pp. 8–21;
56 Vestry minutes, IV, pp. 276, 278.

7.10. Etching of the east range of the St Bartholomew's Priory cloister in use as a stable by J. Storer, 1804. Wellcome Collection

south cloister range had recently been destroyed, and that the east cloister was in use as a stable (fig. 7.10).⁵⁷

One significant enhancement was made to the church in the early nineteenth century: in 1815 a clock was installed in the tower, costing the substantial sum of £159 5s. It was a striking clock, and the only bell available was the old late-medieval 'Sanctus' bell, weighing 104 lb, which was not large enough. This was exchanged for a new bell, weighing 3 cwt, 2 stone and 22 lbs, made by Thomas Mears of Whitechapel at a cost of £31 9s 6d. The clock was probably made by Thwaites & Reed, a firm of clock-makers established in 1740; they offered to wind the clock and keep it in repair for £7 7s per annum.⁵⁸

The Rich family had held the advowson of the parish since Richard Rich bought the priory and precinct in 1544. The last male heir of the direct line, Edward Henry Rich, ninth Baron Rich, seventh Earl of Warwick and fourth Earl of Holland, died in 1759. His ultimate heiress was Elizabeth, daughter of the fifth Earl of Warwick, who married William Edwardes, a Welsh landowner and MP. His son William was created Baron Kensington, one

57 *Gentleman's Magazine*, 79 (March 1809), pp. 226–28.
58 Vestry minutes, IV, pp. 344–45, 1 February 1815. The firm of Thwaites & Reed still exists.

of the Rich family's former titles. His son, William, the second Lord Kensington, sold the advowson of St Bartholomew's in 1818, bringing the family's association with the church to an end.[59] It was no loss to the parish: the early generations had squeezed all the money they could from the property, and since then they had been lacklustre patrons. There does not seem to be one recorded episode of the family making a significant contribution to the fabric of the church or the life of the parish, beyond appointing the incumbents.

By the early nineteenth century there was widespread interest in medieval monuments, and had the parish been richer St Bartholomew's might have benefited from this revival of interest. However, the area had gone down in the world in the late Georgian age. Smithfield and Clerkenwell, like the City of London itself, were being abandoned by prosperous middle-class residents. Victorian views of the area look like scenes from Dickens's novels, with sixteenth- and seventeenth-century buildings sliding into decay.

The church had limited resources, but a first attempt at restoring it to a more medieval appearance was carried out in 1828, when £800 was spent on removing the elaborate seventeenth-century retable and wainscoting, and replacing them with Norman-style blind arcading, formed in Roman cement.[60] Its appearance is recorded in an engraving by R.W. Billings of 1837 (fig. 7.11). There is no retable, and the sanctuary is dominated by a pair of large pulpits, which says something about the Low Church style of churchmanship and liturgy being practised at St Bartholomew's at the time.

This was not the most architecturally distinguished of restorations, but it doubtless reflected the limited resources available. The church's situation shortly got much worse: in May 1830, a serious fire broke out in the buildings adjoining it to the south. It began in the former chapter house, which was occupied by a Non-conformist meeting-place known as the Bartholomew Chapel (fig. 7.2). The buildings to the south of the choir, including the sacristy and Middlesex House (the former prior's lodging) were burnt out, as was the other Non-conformist meeting house in the south triforium. The church suffered serious damage, and was narrowly saved from being gutted. However, the parish were uninsured, and £1,000 had to be borrowed to meet the repair costs.[61]

Outside the church a good deal of monastic fabric, in buildings in private ownership, was lost in the aftermath of the fire. Middlesex House was demolished, as was the ruined south transept. The sacristy, which as Carter noted had retained fine medieval stonework and painted sculptures, was also demolished. This revealed the south side of the choir, which was in poor condition, but only the most basic repairs could be carried out, and the burnt triforium roof was replaced by a temporary structure. Charles Knight published a view of the area in 1842, when the site of the chapterhouse and Middlesex House were lying waste.[62]

In 1842 a row of small houses, Cockerill's Buildings, was built on the site of the south transept. Two more houses, Pope's Cottages, were built on the site of the sacristy, hiding the scarred south side of the building. Not until 1914 was the sacristy site bought, and Pope's

59 Webb, *Records*, II, pp. 294–95.
60 Webb, *Records*, II, p. 20.
61 Vestry minutes, V, pp. 50–51, 55. See also Jeremy Haselock's chapter in this book.
62 Charles Knight, *London* (London, 1842), II, p. 42.

7.11. Engraving of the interior view of St Bartholomew the Great by Robert William Billings, 1837. Wellcome Collection

Cottages demolished. As a result, the Webb restoration never reached this side of the church. Three bays on the south side of the choir, between the transept and the south-east chapel, are still as they were repaired c. 1831, with twelfth-century stonework calcined by the fire, and crude repairs in brick and Roman cement (fig. 7.12).

Despite the rising interest in the priory, the loss of medieval fabric continued. The fine vaulting over the east range of the cloister, which had been drawn by a number of artists, collapsed in 1833. The owner of the building rebuilt it as a house, and encroached on the west wall of the south transept: a chimney and fireplace were built, resting on it. When the church recovered the transept in 1891, the west wall was still a party wall, and they had to leave the fireplace and chimney *in situ*, supported on a girder. This accounts for the shape of the chimney and fireplace, in stock brick, still being visible on the west side of the transept. In 1856 the City of London served a notice on the owners of the former Coach and Horses, the inn that had occupied the north side of the former cloister, declaring it to be a dangerous structure. The inn was demolished, taking the surviving south wall of the medieval nave with it.[63]

The mid-nineteenth century saw a number of medieval cathedrals being restored, to designs by Sir George Gilbert Scott, including Ely (from 1847), Gloucester (1852) and Coventry, Hereford, Lichfield and Peterborough (all in 1855). A Restoration Committee for St Bartholomew's was formed, probably influenced by these developments, at a meeting chaired by the rector, Mr Abbiss, on 24 July 1855. The committee had eminent members, including the Dean of St Paul's and Alexander Beresford Hope, a wealthy Tractarian and enthusiast for church architecture. In 1857, the committee commissioned William Slater (1819–1872), an architect who had been chief assistant to the well-known church architect

63 Vestry minutes, v, p. 479, 9 May 1856.

7.12. Photograph of the south side of St Bartholomew the Great showing the 1831 repairs as they presently appear (photograph 2022)

R.C. Carpenter and taken over his practice, to produce a design for restoration. Slater made a design, but no action was taken at the time.[64]

The restoration campaign was dormant for a few years, and was revived in 1863. In that year an eminent antiquary and writer, John Henry Parker (1806–1884), was asked to make a detailed study of the church. He gave a lecture on its history and architecture on 13 July 1863, which was published as a basis for a fundraising campaign.[65] Around the same time, the Restoration Committee commissioned William Slater (1819–1872) and a second architect, Thomas Hayter Lewis (1818–1898), to carry out a thorough survey of the church and make recommendations. Hayter Lewis and Slater were not partners: the former had been an assistant to Sir William Tite, and became Professor of Architecture at University College London in 1864. Their report, delivered in April 1863, presented a detailed picture of the state of the church, and the prospects for restoration. As they noted, any major progress depended on the parish being able to buy various neighbouring properties.[66]

64 Webb, *Records*, II, p. 380 notes that a plan by Slater was then in the parish safe, as plan 26. It is not clear if this still exists. No other documentation for this episode has yet been found. See also Jeremy Haselock's chapter in this book.
65 Documents generated by the Restoration Committee are in LMA, P69/BAT3/033/MS20794/001, Bundle 2.
66 Report on the state to the church to the Rev'd J. Abbiss, by T. Hayter Lewis and W. Slater; Vestry minutes, VI, p. 479. See also Evan McWilliams's chapter in this book.

Hayter Lewis and Slater's report started with the east end. The houses in the former Lady chapel were occupied by a fringe factory owned by Messrs Stanborough and Graves, including the space above the east ambulatory. The adjacent north triforium was in the parish's hands, still in use as the schoolroom and in relatively good condition, though with its arches blocked. The site of the north transept, though, was another story. The building had been demolished in the 1540s. Part of the site was occupied by 8–9 Cloth Fair. Another house belonged to the parish, having been left to it by Lady Saye and Sele to support the almshouses. The rear premises were occupied by a blacksmith's shop, whose forge directly abutted the wall which blocked the north crossing-arch, and presented a fire risk to the church.

The site of the south transept was occupied by houses, and could not be rebuilt without encroaching on other properties built after the 1830 fire. 'Very fine remains' of the east cloister walk had survived until 1833–34, when the vaults collapsed, and the surviving walls were built into another row of houses, as we have seen. Close by, the south nave wall had survived, built into the Coach and Horses, until it was demolished as recently as 1856. Elsewhere, portions of the prior's house remained standing. Part of the south range, the refectory and its crypt, were visibly built into houses in Middlesex Passage.

Hayter Lewis and Slater concluded with a long list of recommendations, including 'exposing the nave', re-roofing the church and restoring the triforium. They also compiled a shorter list of works to be done first, costed at £4,000. This was clearly too much for the parish to contemplate, for in May 1864 the architects returned with a revised report, and a shorter list of immediate works costed at £1,800.[67] This included removing earth from within the church to lower the floor (which had been raised in the 1570s) to the medieval level, revealing the column bases. They also suggested removing built-up earth from the outside, making steps down into the church, putting in drainage, hot-water heating, removing memorial tablets that had been cut into medieval mouldings, and revealing the mouldings of the south transept arch. Fundraising began in earnest, with donations of £1,050 (a thousand guineas) from the architect Sir William Tite, Hayter Lewis's former employer, who was the committee chairman, and from Joseph Boord and Rector Abbiss. £210 came from the City Corporation, and £105 from the Governors of St Bartholomew's Hospital.

In 1865, work began. The basic works listed above were presumably undertaken, and one major work of restoration was attempted at the east end. This involved reinstating the two central columns of the original Norman apse and the arches that they supported, which had been removed during the late medieval alterations to the choir. Doing this involved taking down the lower part of the east wall, behind the altar. The problem was that, while the wall and the area behind it belonged to the church at ground-floor level, the area above at triforium level was part of the premises occupied by the fringe-makers in the former Lady chapel, which formed a 'flying freehold' over the east end of the church, as we have noted. However, the parish could not afford to re-purchase the property. To reinstate the Norman apse while supporting the 'flying freehold' and the east wall above, two iron columns and a cast-iron girder were installed. The columns and girder framed the restored apse

67 Vestry minutes, VI, pp. 724–25, 11 May 1864.

at ground floor level, with the blank party wall rising above, and the two arched windows rising above that.

It all looked very odd, but there is an explanation for the thinking behind this in a letter of 14 March 1864 from Hayter Lewis and Slater to the Vestry. First, they set out the alternatives: to do nothing, or to restore the east end to a square plan, as it had been in 'Perpendicular times'. This, they said, was rendered problematic by the lack of evidence for the design of the original east window. The Norman design, by contrast, could be worked out with some confidence from the surviving fabric. Nevertheless, it is difficult to avoid thinking that they – and the parish – regarded the original Norman design as a higher priority. The architects acknowledged that, given the ownership situation, this third option would produce an awkward result:

The lower part of the present east wall might be removed, and the upper part of it carried on an arch or girder, and the apse completed so far as the triforium floor, leaving the room overhanging, to shew clearly the reason for the work being incomplete. We believe that public opinion, when the question was thus prominently brought forward, would prove so strong as to lead to some means being found for completing the good work, as you are now so zealously trying to do.[68]

This is what was done (see fig. 10.2, p. 229). Clearly the church agreed with the architects' assessment, that it would represent a firm commitment to restoration, but the result would look so awkward that – paradoxically – it would help with fundraising. However, for the time being these works had absorbed the available funds, and the 'room overhanging' still belonged to someone else – the last of Richard Rich's legacies to St Bartholomew's. On 16 August 1867, the *Christian Times* reported that £4,000 had been spent, and the Restoration Fund was almost £1,500 in debt. A great effort, they said, was being made to raise more.

St Bartholomew the Great, the oldest parish church in the City of London, had somehow survived the Suppression, rapacious owners, Bishop Grindal, Puritan ideologues, the Great Fire, decaying roof-timbers, botched repairs, bad neighbours, and another fire in 1830. It was much loved by its parishioners, and by many others. In the next generation, that love would bear fruit in a most remarkable restoration.

68 Vestry minutes, VI, p. 726, letter from Hayter Lewis and Slater, 14 March 1864.

VIRTVTE NON VI

MORS NOBIS LVCRVM.
HIC IACET GVALTERVS MILDMAY MILES, ET MARIA VXOR EIVS,
IPSE OBIIT VLTIMO DIE MAII 1589.
HAEC DECIMO SEXTO MARTII 1576.
RELIQVERVNT DVOS FILIOS, ET TRES FILIAS.
FVNDAVIT COLLEGIVM EMANVELIS CANTABRIGIAE.
MORTVVS CANCELLARIVS ET SVBTHESAVRARIVS SCACCARII,
ET REGIAE MAIESTATI A CONSILIIS.

The Early Modern Funerary Monuments at St Bartholomew the Great

JON BAYLISS

THE STARTING POINT FOR ANY RESEARCH into the early modern monuments of St Bartholomew the Great must be the account by E.A. Webb in the second volume of *The Records of St. Bartholomew's Priory and of the Church and Parish of St. Bartholomew the Great, West Smithfield* of both the monuments themselves and the biographical material associated with them. Since Webb's time the study of early modern funeral monuments as a whole has advanced considerably, but there is so much that can never be known. While Webb wrote of every monument in the church right up to the time at which he was writing, the intention here is to cover the early modern period by including sculpted memorials to those dying before 1715. Webb provided transcripts of the inscriptions, translations from Latin where appropriate, and descriptions of heraldry; the reader is referred to his book for those details.[1] He also used wills to provided biographical details as well as the records of the parish. The loss of the parish registers covering the period before 1616 meant that he was sometimes unable to establish why some who were apparently not parishioners were nevertheless buried in the church. Webb on occasion identified alabaster as marble, although the monuments in question were made before Italian marble was widely available to sculptors.

The mixture of those commemorated in the church changed as time went on, from one of the foremost Elizabethan politicians at the end of the sixteenth century, through civil servants, doctors and lawyers in the first half of the seventeenth, and then through to some who had moved away returning to the parish church in which they had worshipped as children and young adults to be buried and commemorated in the later Stuart period. It was not unusual for wills to request burial in parishes in which the testators no longer lived, but such requests relied on executors to carry them out. The changes reflect the movement of people from the city to the new suburbs over this period. By the end of the sixteenth century there was already development in the area just north of St Bartholomew's. John Stow's *Survey of London*, published in 1598, reported 'many fair houses built, and lodgings for Gentlemen' in the area of Clerkenwell around the Charterhouse.[2] As the seventeenth century progressed, other areas to the west and north-west of the city were developed – Covent Garden in the 1630s, Lincoln's Inn Fields in the 1640s and the parishes of St Giles-in-the-Fields and St Martin-in-the-Fields throughout the first half of the century. The Great Fire of London in

1 Webb, *Records*, II, pp. 449–85.
2 Stow, *Survey*, II, p. 163.

8.1. Monument to Sir Walter Mildmay

1666 gave considerable impetus to the move of those citizens who could afford to leave and live somewhere more fashionable.[3]

THE SCULPTORS OF THE PARISH OF ST BARTHOLOMEW THE GREAT

The last third of the sixteenth century saw the arrival in England of a number of Netherlandish sculptors bringing new ideas with them and at first supplanting English craftsmen. The earlier immigrants chose to settle in Southwark, outside the control of the City of London, but later ones began to settle in liberties within the City itself, where the authorities did not hold sway.[4] Two of them later moved into the parish of St Bartholomew the Great. John Colt, who came over from Arras (then part of the southern Netherlands) around 1585, was living in the liberty of St Martin-le-Grand in 1595, but lived in the parish of St Bartholomew the Great for the greater part of his life. He was buried there in 1637. His brother Maximilian had joined him in 1595 and quickly moved to St Bartholomew's, living there for at least forty years and burying his daughter Abigail in the church.[5]

On 4 March 1604/05, Maximilian contracted to make the monument of Elizabeth I in Westminster Abbey. He completed it just over two years later, then immediately contracted for the monument of Princess Sophia, also in the Abbey. This was completed in December 1607. He moved on to that of Princess Mary, likewise in the Abbey, and finished it in December 1608. As a result of these commissions he petitioned for an official position and was rewarded in July 1608 by the award of the new post of Master Carver to the King. This led both to work for the Crown and to monumental work for leading courtiers. He worked extensively at Hatfield House, Hertfordshire, and the monument he made in 1614–18 for Robert Cecil, Earl of Salisbury in the church there is the outstanding example of his work. Maximillian was still working in 1641, when he received a final payment for the monument of Sir Lewis Mansel at Margam Abbey, Glamorgan, which – although a fine piece of work – demonstrates how conservative his style had become. He must have died during the Civil War or the Commonwealth. John Colt was paid in 1618–19 for the monument of the young Sir John Cavendish at Chesham, Buckinghamshire, and may be the author of two monuments in churches in Lincolnshire known to be by 'Mr Colte' but long attributed to his brother.

John Colt's son, another John, apparently lived his entire life in the parish of St Bartholomew's, petitioning to replace his uncle as Master Carver to the king after the Restoration in 1660. Hubert le Sueur, a French bronze sculptor, was been sent for by Charles I and arrived in London in 1626, settling in Bartholomew Close in 1630. He had returned to France by 1643 but in the interim he had employed the younger John Colt

3 Timothy Mowl and Brian Earnshaw, *Architecture without Kings: The Rise of Puritan Classicism under Cromwell* (Manchester: Manchester University Press, 1995) and Elizabeth McKellar, *The Birth of Modern London* (Manchester: Manchester University Press, 2021) cover the development of the new suburbs from the 1630s onwards.
4 For biographical details and discussion of sculptors' work, see: Adam White, 'A Biographical Dictionary of London Tomb Sculptors c. 1560–c. 1660', *The Volume of the Walpole Society*, 61 (1999), pp. 1–162; Adam White, 'A Biographical Dictionary Of London Tomb Sculptors c. 1560–c. 1660: Addenda And Corrigenda', *The Volume of the Walpole Society*, 71 (2009), pp. 325–55.
5 Webb, *Records*, II, pp. 280–81.

as an assistant. The latter signed a monument at Toppesfield, Essex, in the 1630s and was employed on a sculptural project at the Charterhouse in Clerkenwell in 1635-36 from which the fine figures of Moses and Aaron survive.[6]

MATERIALS AND DESIGN

In the latter part of the sixteenth century, sculptors catering for the middle and top end of their market used alabaster from the East Midlands, a dense and pure black limestone – often termed 'touch' – from Tournai in Belgium, and a red Belgian limestone called Rance after the location of the best quarry. Both the latter two are often termed marbles, and alabaster is often mistaken for marble. Early in the seventeenth century, pure white Italian marble from Carrara was used for the monuments erected in Westminster Abbey for Elizabeth I and Mary, Queen of Scots, which resulted in demand from richer patrons for its use. Alabaster remained the first choice for most, only gradually being supplanted over the course of the century as demand for Carrara marble spread down the social scale.

The design of late sixteenth- and early seventeenth-century monuments in England generally followed the lead set by Netherlandish artists, especially Cornelis Floris, whose monuments were in demand all over northern Europe. In addition Floris published a number of designs for monuments in 1557. He was an early exponent of the strapwork – decoration that looks like cut leather straps – that was extensively used all over northern Europe. As the seventeenth century progressed, strapwork became fleshier and less delicate in appearance. By the time of the earliest post-Reformation monuments in St Bartholomew's, Roman capital scripts had supplanted medieval blackletter.

Designs for monuments were agreed between the patron and the sculptor. The patrons could be the subjects of the monument, making sure that they were commemorated while they still lived – perhaps after the death of their husbands or wives – or the subjects' executors or overseers, whether husbands, wives, children or trusted third parties. The lettering and layout of inscriptions was as much part of the design as the rest of the monument, and the wording of the inscription was sometimes the work of professional writers and poets. In the case of the monuments in St Bartholomew's, there was no shortage of sculptors available in the parish, the rest of the city, or the new suburbs to the west from which to choose. In some cases, the patrons may have already been personally acquainted with the sculptors they chose. This would be especially true for those who lived in the parish and knew the members of the Colt family. Unlike almost all other city churches that survived the Great Fire of 1666, St Bartholomew's has no early modern monumental brasses. This may be because the Colts, who did not make them, were able to supply low-cost alternatives.

THE MONUMENTS

1. Percival Smalpace (d. 1558) and Agnes Smalpace (d. 1588)

The tablet commemorating Percival and Agnes Smalpace was erected after Agnes's death in 1588, Percival having died nearly thirty years before (fig. 8.2). The couple probably lived in

6 Webb, *Records*, II, pp. 281–82.

the parish in the house in Bartholomew Close that had belonged to Agnes's first husband Thomas Bill, physician to Henry VIII. Dr Bill had made his will on 1 June 1551 and it was proved 23 February 1552/53, leaving the house to Agnes for the rest of her life and then to his daughter Margaret.[7] Percival was a clerk of the Board of Green Cloth, a body that audited the accounts of the Royal Household and arranged royal travel.[8]

The monument is made of alabaster darkened by smoke over the centuries. It has a black Belgian marble panel that encompasses the inscription and incised figures of the pair as corpses lying naked on a rush mat. Another black marble panel has a further inscription. Alabaster busts of the pair, showing Percival with three chains on his chest and a beard covering part of his ruff (much larger than those worn at the time of his death in 1558) and Agnes in a cap and large ruff. Either side of the busts are pilasters with Ionic capitals under which cords depend from rings. Ribbons curve sinuously from the rings and clusters of fruit are interspersed with symbols of mortality such as a skull, an hourglass and a pick and spade. The arms of Smalpace now sit atop a Whiting monument – a switch presumably made after the restoration of the Smalpace monument by a descendant in 1897. The broken scrolls now on top of the Smalpace monument probably originally belonged to the Whiting monument but the central feature was probably once sat on top of the Smalpace as one of a pair.[9] The shape between them probably represents an oil lamp.

8.2. Monument to Percival and Agnes Smalpace

The monument is of an unusual format, but one that strongly suggests Gillis de Witte as its author.[10] A number of other monuments attributed to him have incised figures com-

7 TNA PROB 11/35/80.
8 Webb, *Records*, II, pp. 449–51.
9 Such pairs are found on tablets attributed to the same sculptor at Wrotham, West Malling and Cranbook, all in Kent.
10 Sally Badham and Jon Bayliss, 'The Smalpace Monument at St Bartholomew the Great, London, Re-Examined', *Church Monuments*, 20 (2006), pp. 81–93.

parable to this work at St Bartholomew, the closest parallel being that in the church of St John the Baptist, Margate, Kent, where the semi-recumbent figure of Henry Crispe, died 1588, is depicted below the inscription on a black marble panel in the same manner as the Smalpace figures. Gillis de Witte had fled to London from Bruges in 1585 after the failure of the Protestant Reformation there. He was described as a 'marbeller' in 1593 while living in Blackfriars, a London liberty. He was employed at Cobham Hall in Kent to make chimney-pieces, several of which remain and demonstrate his ability to carve black Belgian marble.[11]

2. Sir Walter Mildmay (d. 1589) and Mary Mildmay (d. 1576)

Sir Walter Mildmay's is the largest monument in the church, and appropriately it commemorates the most important individual buried here at this period (figs. 8.1 and 8.3).[12] He was born in 1520 or 1521, the fifth son of a Chelmsford mercer. He spent about two years at Cambridge in the late 1530s, but did not take a degree. He was appointed a clerk at the Court of Augmentations in 1540. The court had been established in 1536 to deal with the properties and revenues of the monastic establishments dissolved by Henry VIII at the Reformation. During the 1540s he developed a reputation as a hard-working fiscal expert. In 1545, he was elected a Member of Parliament. By the end of the year was one of the three main officers in the Court of Augmentations, and the following year was a member of a commission planning its forthcoming reorganization. In 1546 he had married Mary, sister of Sir Francis Walsingham. The same year he was admitted to Gray's Inn. Early in 1547, Mildmay was knighted by Edward VI. He was made a justice of peace for Essex later that year. In April 1548, he and Robert Kellwey were tasked with deciding the fate of the assets of the chantries that had been surveyed prior to their abolition. Mildmay's inclination, shown by his support for the re-foundation of Chelmsford grammar school, was to favour their use for education.

Despite his Protestant views, his financial expertise saw him remain an important official under Mary I. Within three months of Elizabeth I's accession, he was appointed Chancellor of the Exchequer. He was to play a major role in reforming the Exchequer so that it functioned more efficiently. In the 1570s and 1580s he was working closely with William Cecil, Lord Burghley, and together they handled the difficult issue of the presence in England of Mary, Queen of Scots. Mildmay was careful to take only his very large annual salary of £500 as chancellor during his time in this post. Mildmay's lasting legacy of the period was the founding of Emmanuel College, Cambridge, in 1584.[13]

Sir Walter died at his house in Smithfield on 31 May 1589. In his will he made extensive bequests of a charitable nature and asked for 'a decent tombe withe as meane a charge as conveniently may be'.[14] The monument may perhaps be seen as a compromise between those wishes and the more extravagant taste of his eldest son Anthony, overseer of his will, who was himself later commemorated at Apethorpe, Northamptonshire, the estate

11 Adam White, 'Tomb Sculptors', pp. 141-44.
12 Webb, *Records*, II, pp. 451-56.
13 L.L. Ford, 'Mildmay, Sir Walter (1520/21-1589)', *ODNB*.
14 Webb, *Records*, I, pp. 548-50.

8.3. Detail of the Mildmay monument

acquired by Sir Walter. Unlike most large standing monuments of the day, Sir Walter's has no effigies, but otherwise the materials – alabaster, Rance, and black marble – are typical of the time, as is the design. While the Apethorpe monument, one of the largest in an English parish church, is evidently the work of Maximilian Colt, Sir Walter's is anonymous.[15]

3. Elizabeth Scudamore (d. 1593) and Sir Philip Scudamore (d. 1611)

Although this small alabaster monument commemorates both husband and wife, only Elizabeth is buried here (fig. 8.4). She had three daughters by her previous marriage to Henry Coddenham, Auditor of the Mint, who also lived in the parish, but none by Philip.[16]

Sir Philip Scudamore, who was admitted to Lincoln's Inn in 1564, served as churchwarden of St Bartholomew's from 1574 to 1578. In 1576, he paid for his brother-in-law Quintayne Jones's burial in the church and for the ringing of the bells at the funeral service. He gave around fifty books to Sir Thomas Bodley's new library in Oxford in 1600. He was knighted by James I in 1603 and separated from his second wife, Ruth, between July 1606 and May 1609, when he received a licence to travel abroad. He had no intention of

15 Adam White, 'Tomb Sculptors', p. 31.
16 Webb, *Records*, II, pp. 270, 456–57. Coddenham had left eight hundred pounds to each daughter on her marriage in his will of 1569.

returning. He died in 1611 and was buried in Antwerp as a Roman Catholic. Ruth, to whom he left leases of property in the parish of Great St Bartholomew, lived in the parish for a time after their separation.[17]

Elizabeth Scudamore's youngest daughter Elizabeth married twice, becoming Lady Saye and Sele by her second marriage, and was a parishioner, contributing to the rebuilding of the tower in 1628 and founding almshouses in the early 1630s.[18] It was probably she who had the monument to her mother and stepfather set up.

This simple monument has an ornamented frame of alabaster around a black marble inscription panel with a heraldic achievement in a circular surround above and a black marble 'jewel' below. The Scudamore arms appear alone, suggesting that Elizabeth Jones did not come from an armigerous family.

8.4. Monument to Elizabeth and Sir Philip Scudamore

4. Sir Robert Chamberlayne (d. 1615)

Elizabeth Scudamore's eldest daughter Alice Coddenham was Sir Robert's mother through her marriage to Robert Chamberlayne of Shirburn, Oxfordshire. Sir Robert was also a cousin of Philip Scudamore through Scudamore's mother, Sybil Chamberlayne, and was left freehold property in Bartholomew Close by Philip. The Chamberlaynes were a prominent Catholic family in Oxfordshire. Sir Robert had been knighted at the coronation of James I. In 1610, he received permission to travel abroad for three years, renewed for a further two in 1613. While in Spain he visited his kinswoman Jane Dormer, Duchess of Feria – a former lady-in-waiting of Mary I – who urged him to 'stand strong and firm in the Catholic faith'.[19] He also visited the Holy Land among other places. He never married. Given the circumstances of his disappearance while travelling between Tripoli and Cyprus in 1615, it is likely that a number of years elapsed before his death was confirmed and the monument was set up by a sorrowing but anonymous friend (fig. 8.5).[20]

17 TNA PROB 11/117/471.
18 Webb, *Records*, II, pp. 244, 535, 568–69.
19 Alan Davidson, 'Roman Catholicism in Oxfordshire from the Late Elizabethan Period to the Civil War, (1580–1640)' (unpublished PhD thesis, University of Bristol, 1970), pp. 113–14.
20 Webb, *Records*, II, pp. 457–59.

8.5. Monument to Sir Robert Chamberlayne

8.6. Monument to Elizabeth Freshwater

It seems likely that Sir Robert Chamberlayne's monument was made by one of the Colt brothers.[21] A number of similar monuments survive, with dates of death from 1606 to 1631, with differing detail. They all have standing figures of angels holding curtains open to reveal figures within a semi-circular alcove of those commemorated. Most have ceilings of scallop-shell design. But it is clear that the design was employed by various sculptors; a version by Nicholas Stone was executed in 1626 to commemorate Bridget, Lady Knatchbull, at Mersham in Kent. The small figure of Sir Robert is depicted kneeling, but not before a prayer desk as on most other monuments of this design, although there is plenty of room for one.

5. Elizabeth Freshwater (d. 1617)

Elizabeth Freshwater was the second wife of Thomas Freshwater, a lawyer who was a younger son. He had started his legal studies at Clifford's Inn before transferring to Lincoln's Inn in 1590. His first wife was Elizabeth, daughter of John Mounds of Romford, Essex. His second marriage to Elizabeth, daughter of John Orme, was also a second marriage for her.

21 Simon Bradley and Nikolaus Pevsner, *London: The City Churches*, The Buildings of England (New Haven: Yale University Press, 2002), p. 24.

In 1609, at the age of eighteen, she had been married to Thomas Thelwall, a 36-year-old lawyer of Staple Inn, in Great St Bartholomew's. He died shortly thereafter. His will was proved in November 1609, naming Elizabeth and John Orme among his executors. Thomas Freshwater was older than Thelwall, but still outlived Elizabeth by a considerable margin. A monument erected at Heybridge, Essex, to him and his third wife Sarah after his death in 1638 gives his age as 76.[22]

Elizabeth Freshwater's monument (fig. 8.6), erected after her death at the age of 26 in 1617, was described by Nikolaus Pevsner as 'a remarkable piece' on account of its precocious use of what he terms as 'scrolly volutes and halves of pilasters' that prefigure their widespread adoption in the mid-century.[23] The monument to John Huxley, died 1627, at Edmonton, Middlesex, also has them and has been attributed to Maximilian Colt. As Thomas Freshwater married Sarah Clipper, widow, on 10 December 1618, it is unlikely that the commissioning and erection of Elizabeth Freshwater's monument was much delayed beyond her death. Elizabeth's parents John and Mary Orme both died within months of their daughter's death and their dates are given in the inscription. However, the whole inscription has been recut in sans serif lettering (unknown in the seventeenth century), so it is impossible to tell if the latter details were added later.

Elizabeth's brother Nicholas Orme, who died on 4 February 1628/29 at the age of 28, is commemorated by a black marble ledger slab in the south aisle. He was called to the bar at Lincoln's Inn in 1623. The slab was provided by Thomas Gundrey, whose son Nicholas was later buried beneath it in 1675. Thomas Gundrey had married Nicholas Orme's sister Mary in 1618. The slab was probably engraved by one of the Colt brothers. A slab commemorating Abigail, the fifteen-year-old daughter of Maximilian Colt, who died in March 1629/30, was formerly close by.

6. Dr Francis Anthony (d. 1623)

Francis Anthony was born in 1550, the eldest son of Derrick Anthony, a goldsmith who was chief graver to the Mint from 1552 until he died in 1599. He was educated at Cambridge. After his father's death he attempted to support himself by practicing medicine but ran afoul of the regulations of the College of Physicians, appearing before them six times between 1602 and 1606. He was banned from practice after being found inadequate but ignored the ban and was imprisoned three times. In 1608 he was made a Doctor of Medicine at Pembroke College, where his second son, John, commenced his own studies. Thereafter the College of Physicians discussed Anthony seventeen times in fourteen years but took no effective action against him.[24]

While his earlier bouts with the College led to reduced circumstances for him and his large family (ten children with his first two wives before 1609), the growing popularity of a potion he made for which he claimed very wide powers and the patronage of powerful families changed his fortune. *Aurum potabile* (drinkable gold) was made from gold

22 Webb, *Records*, II, pp. 459–60.
23 Bradley and Pevsner, p. 68.
24 Webb, *Records*, II, pp. 283–85.

8.7. Monument to Dr Francis Anthony 8.8. Monument to Anthony Lowe

and mercury. The unsympathetic College of Physicians arranged a trial of it in 1609, after which both sides claimed vindication. Anthony published a book in 1610 asserting his view, the registrar of the College published a rebuttal in 1611, and Anthony responded with a further publication – this time in English as well as Latin – in defence.[25]

The failure of the potion to save either Sir Thomas Overbury in 1613 or Francis Manners, heir to the earl of Rutland, in 1618/99 from death did not dent its popularity. Anthony's two books were published as a single volume in 1618 with an endorsement by James I on the title page. Anthony lived in his own house in Cloth Fair and leased an estate at Barnes, bought shares in the Virginia Company in 1617, and left a £300 dowry for his youngest daughter in his will.[26] He died on 26 May 1623.

Francis Anthony's alabaster monument was set up by his son John, whose own death was later added (fig. 8.7). As might be expected from a son following the same profession and using the same potion, the verse epitaph has nothing but admiration although it does admit that 'poisnous envye' sought to detract from his praise.[27] The incised design that occupies

25 F.V. White, 'Anthony, Francis (1550–1623)', *ODNB*.
26 TNA PROB 11/141/687.
27 Webb, *Records*, II, pp. 460–61.

the top of the inscription panel, three pillars supporting a ring of fifteen roses, seems unparalleled elsewhere and is referred to in the verse:

RELIGION, VERTVE, & THY SKIL DID RAISE
A THREEFOLD PILLAR TO THY LASTING FAME

7. Anthony Lowe (d. 1641)

Anthony Lowe was christened on 22 June 1576 at Lindridge, Worcestershire, the third son of Henry Lowe. He was admitted to the Inner Temple in 1590 and was made a bencher there in 1603. He married Mary Hammond of Debden, Essex, in the late 1590s. In 1628, he was one of those who contributed to the rebuilding of the tower of St Bartholomew.[28] He died on 29 April 1641, leaving a son and three daughters.

His widow Mary erected his monument (fig. 8.8). It is a smoke-darkened alabaster tablet topped by a broken segmental canopy incorporating a cartouche with the arms of Lowe framed by a pair of curved branches. The inscription, in Latin, is placed in a decorated frame with a lugged architrave. The apron has a central skull in a draped cloth. As a parishioner, it is likely that Mary Lowe chose one of the Colts to make her husband's tablet; some features of the monument are consistent with what is known of their work.

8. James Rivers (d. 1641)

James Rivers was a great-grandson of the grocer Sir John Rivers, Lord Mayor in 1573. James's uncle William Rivers was also a grocer, living in the ward of Farringdon Without in 1634. In 1636 Maximilian Colt brought a Chancery court case against William Rivers, his wife Elizabeth and son Edward.[29] James Rivers was an Oxford graduate, awarded his BA by Corpus Christi College in 1620. Why he was in the parish of St Bartholomew at the time of his death 8 June 1641 is not clear, but he had been elected to Parliament for Lewes in 1640 and as a leading Puritan member had reason to be close to Westminster at this critical juncture. The opening session of the Long Parliament had taken place only the day before his death.[30]

The wall monument commemorating James Rivers has been identified as the work of William Wright of Charing Cross (fig. 8.9).[31] It is closely related to the monument of Sir Thomas Richardson, who died the following year and was memorialized at Honingham, Norfolk, and to that of Sir John Francklyn, died 1647/48, whose monument is at Willesden in Greater London. All three monuments have the lion-head corbels so characteristic of Wright's work. They also have very exaggerated steep swan-neck pediments. Both the Richardson and Francklyn monuments emphasize the contemporary taste for contrasting black and white, using white Carrara marble and black Belgian marble, whereas for Rivers

28 Webb, *Records*, II, pp. 461, 535.
29 TNA C 3/399/103.
30 For more information, see the entry for his brother (also an MP) in M.W. Helms and B.M. Crook, 'Rivers, Nizel (1614–95), of Offham, Hamsey, Suss.', in *The History of Parliament: The House of Commons 1660-1690*, ed. B.D. Henning, 3 vols. (Woodbridge, Suffolk: Boydell & Brewer, 1983).
31 Adam White, 'Tomb Sculptors', pp. 149–50.

8.9. Monument to James Rivers

the main contrast in colour is between the black columns and the lighter colour of the rest of the monument, making it a rather less striking example. The small monument to Elizabeth, Lady Richardson in St Botolph Aldersgate is a cut-down version of the same design, but with an inscription panel very similar to that of Rivers.

The inscription of Rivers's monument has been re-lettered with some of the older text showing through, demonstrating that the original layout and spacing has been altered (fig. 8.10).[32] The capital script used by Wright had a few distinctive characteristics that have not been preserved by this reworking. James Rivers's wife Charity appears as a kneeling daughter on her parents' monument at Isfield, Sussex (c. 1631). The sculptor chosen to erect the monument at Isfield was evidently also William Wright.

32 Webb, *Records*, II, pp. 461–62.

8.10. Detail of inscription on the Rivers monument

9. Dr Edward Cooke (d. 1652)

In contrast to Francis Anthony, Edward Cooke had a family background in medicine. His father was an apothecary, as were his brothers John and Robert. He had been born in 1613 in St Dionis Backchurch and studied at Sidney Sussex College, Cambridge, from 1631 until 1638, gaining successively BA and MA degrees before continuing his studies at Leiden and Padua, where he became an MD in 1643–44.[33] He married Mary, daughter of Timothy Wade, at St Helen's Bishopsgate in 1645 and evidently lived in that parish for some years afterward, as his son Edward was christened there in 1647. At his death in 1652, he was survived by two sons, Edward and Robert.[34] He had various properties in London, Essex and Lincolnshire – the last made over to him by his father-in-law at the time of his marriage.[35] He also had two parts in the Bills of Ireland, a parliamentary scheme to distribute Irish lands to those who contributed. His widow remarried, and at the time of her second husband's death in 1670 she and her son Robert Cooke were still living.

Edward Cooke's tablet has a half-effigy under an arch with a large keystone (fig. 8.11). He is shown with a book in his hands – a type of monument favoured for scholars. The Latin inscription refers to his philosophical learning as well as his status as a man of medicine. Above the arch is a shield with the arms of Cooke placed centrally in the swan-necked

[33] J.A. Venn, *Alumni Cantabrigienses*, 4 vols (Cambridge: Cambridge University Press, 1922), I, p. 383.
[34] TNA PROB 11/224/545.
[35] TNA PROB 11/224/348.

pediment. Below is the inscription panel with the arms of Cooke impaling Wade beneath. Those of Cooke have a mark of cadency indicating he was a fourth son. The inscription ends with four lines of verse that are very much of their time, with a distinct feeling of the work of Francis Quarles – who had, however, died eight years before.

Vnsluce yo^r briny floods, what² can yee keepe
Yo^r eyes from teares, & see the marble weepe
Burst out for shame: or if yee find noe vent
For teares, yet stay, and see the stones relent

The propensity of stone to 'weep' in certain atmospheric conditions within unheated churches is best observed on black marble, and Webb records that 'before the hot-water pipes were placed below drops would often be seen condensed upon it'.[36] On Cooke's monument only the pilasters either side of his figure are of black marble, the rest being alabaster. Mary Cooke appears to have found a sculptor from elsewhere in London to produce the monument. It has been suggested, not particularly convincingly, that this was Thomas Burman.[37]

8.11. Monument to Dr Edward Cooke

10. Ellis Yonge (d. 1659)

Ellis Yonge's small but well-cut alabaster tablet is today on the wall beneath that of James Rivers (fig. 8.12). Yonge was a deputy to the King's Remembrancer of the court of the Exchequer, working to record taxes, paid and unpaid.[38] In 1637 he is recorded paying arrears of ship money from various counties on behalf of the Remembrancer, Sir Thomas Fanshawe, to the Treasurer of the Navy. In 1651 Parliament ordered that he was to execute the office of Remembrancer after the then-ailing incumbent died.[39] He did not officially become Remembrancer when that happened in 1652; there was a six-year gap before the next one was appointed. Yonge thus remained a 'secondary' until his own death in 1659.

36 Webb, *Records*, II, p. 463.
37 Bradley and Pevsner, p. 203. Fisher's attribution to Burman is rejected in Adam White, 'Tomb Sculptors', p. 15.
38 Webb, *Records*, II, p. 464.
39 *Journals of the House of Commons*, 6 (1803), p. 603.

His will, made verbally, records only monetary bequests, largely to his brother Richard and others with the same surname.[40] That of his widow Anne, then living at Hornsey, requests burial in St Bartholomew's 'as neare to my deare husband as conveniently it may be'.[41] However, her burial took place at Hornsey. No surviving child is mentioned in either will. She had been baptized Anne Osborne in 1610 and married Ellis Yonge before 1634. She was 'cousin Young' to Lady Anne Fanshawe (sister-in-law to Sir Thomas the Remembrancer), who lodged with her in Chancery Lane in the early to mid-1650s.

8.12. Monument to Ellis Yonge

11. John Millett (d. 1660)

John Millett was born and lived much of his life in the parish and his body was brought back to be buried with his parents and siblings. At the time of his death, he was living in Wandsworth and had had a successful maritime career. He held leases of two houses in West Smithfield, one of them occupied by William Crosfield, merchant tailor. He and his family were resident in the parish until the mid-1640s, if not later.[42] His will was witnessed by John Whiting, emphasizing his ongoing connection with the parish.[43] Nothing is known of his early career, but by 1641 he already had his own ship, the 350-ton *Aleppo Merchant*.[44] A John Millett had witnessed the will of Charles Purser, master of the *Aleppo Merchant* in September 1639, and was presumably 'my mate Millett', who received a minor bequest.[45] Over the next dozen years Millett made at least three voyages in the ship, bringing back valuable cargoes from the East Indies, particularly from Surat in India. In 1647, he was elected a Freeman of the East India Company. By 1654 his son Nicholas had taken his place as master of the *Aleppo Merchant*.[46] With the company's agreement, John Millett built a new ship in 1660 – the *Loyal Merchant* – but by the time of its first voyage he was already dead.[47] His wife Judith died in 1662 and willed to be buried beside her husband.

40 TNA PROB 11/302/3.
41 TNA PROB 11/315/12.
42 Webb, *Records*, II, pp. 464–65.
43 TNA PROB 11/303/79.
44 *A Calendar of the Court Minutes, Etc. of the East India Company, 1644–1649*, ed. Ethel Bruce Sainsbury and William Foster (Oxford: Clarendon Press, 1912), III, p. 230.
45 TNA PROB 11/183/443.
46 Peter Mundy, *The Travels of Peter Mundy in Europe and Asia, 1608–1667*, ed. Richard Carnac Temple (London: Hakluyt Society, 1936), V, pp. 26, 44.
47 John S. Amery, *Devon & Cornwall Notes & Queries* (J.G. Commin, 1964), XXIX, pp. 266, 269.

8.13. Monument to John Millett

8.14. Monument to Thomas Roycroft

John Millett had requested a 'broad stone to be layed over with an epitaph ingraven thereon', but has an alabaster tablet on the wall with an eighteen-line verse epitaph and pilasters either side with navigational instruments hanging from rings and intertwined with ribbons with a globe beneath (fig. 8.13).[48] Above is a shield with the arms of Millett while a short Latin inscription on the apron gives his age, 59, and date of death, 12 December 1660. The lettering on this and the epitaph suggests that the tablet was made in the workshop of Edward Marshall of Pink's Alley, off Fetter Lane, which runs north from Fleet Street through Holborn.

12. Thomas Roycroft (d. 1677)

Thomas Roycroft was born in 1621 and was apprenticed to a printer in 1637. He became a Freeman of the Stationers Company in 1647, rising eventually to become Master of that company in 1675. He was City Printer in 1677 and the king's printer in oriental languages. In 1668 he was operating two presses in Bartholomew Close. He had moved to the parish by 1666, having previously been in St Giles Cripplegate from around 1650 and probably

48 TNA PROB 11/303/79.

in St Botolph Aldersgate before that. As the printer of the Polyglot Bible, to which the Latin inscription on his monument refers, and many other works, he was highly regarded. In 1653, during the Commonwealth, it seems he had married Elizabeth Wood at Bull Lane independent chapel in Stepney, but at St Bartholomew's he was signing the minutes of the vestry meetings from 1666. His son Samuel, his only surviving male child, grew up to be a printer too, becoming a Freeman of the Stationers Company in 1677, the year of his father's death.[49] Thomas's wife Elizabeth died the following year and asked to be buried near him. She also ordered 'a ffaire Grave stone to be laid over my Grave'. This has now disappeared, but referred to her husband as Lieutenant Colonel Roycroft, reflecting his role in the City militia. When her will was proved, it referred to her as late of St Giles Cripplegate.[50]

Thomas's monument is a large alabaster tablet with a black marble inscription and side columns (fig. 8.14). While the overall design is a fairly standard one for the period, two features stand out: the spines of six books on the apron and the manner in which the inscription is treated. The monument was set up by Samuel, and it is worth asking whether he was responsible for designing both the lettering with its use of various fonts and the layout of the inscription.

13. John Whiting (d. 1681) and Margaret Whiting (d. 1680)

Comparatively little information survives about John Whiting and his wife Margaret. The house in which John Whiting, citizen and draper of Long Lane, lived in 1666 had seven hearths – more than any other individual in the parish – although Cloth Fair was counted collectively at 69 hearths. In the 1660s and 1670s he signed the vestry minute books alongside Thomas Roycroft.[51] In 1671, John Whiting joined James Dacres and other parishioners in a legal action against their landlord, the earl of Holland.[52] The inscription on the couple's monument tells us that they 'lived lovingly together in Holy Wedlock for 40 years and upward' (fig. 8.15). The couplet that ends the inscription,

Shee first deceas'd, Hee for a little Try'd
To live without her, likd it not and dy'd,

is a variation of that credited to Sir Henry Wotton (1624), found on a number of monuments of couples whose deaths were not long separated.

Of their twelve children, only three survived. Their son John erected the monument. What we see today is distorted by the fact that all the heraldry on the top of the tablet belongs to the Smalpace monument. The shields and strapwork were presumably removed during restoration of the other monument in 1895 and not replaced correctly. There is a single shield of arms with Whiting heraldry on the apron of the Whiting tablet above the centremost of three festoons of fruit and flowers. It has been repainted. Although insufficient

49 Webb, *Records*, II, pp. 287-88, 465-66.
50 TNA PROB 11/358/197.
51 Webb, *Records*, II, pp. 466-68.
52 TNA C 10/475/88.

8.15. Monument to John and Margaret Whiting

traces remained a hundred years ago to show exactly what the original blazoning was, those carved on his son's monument provided the answer.[53]

14. John Kellond (d. 1685)

John Kellond was the second son of John Kellond of Paynesford, Devon, and his wife Bridget Fownes. The inscription notes that he is buried near his uncle, Thomas Fownes, esquire. Thomas had married Hester, daughter of Sir Nicholas Crispe, a wealthy merchant.[54] The Fownes lived in the parish of St Bartholomew the Great for 40 years. Thomas requested burial by the pew where he sat.[55]

John is commemorated by a tablet in the form of a cartouche (fig. 8.16). The heraldry and inscriptions are enclosed in fleshy strapwork, itself surrounded by drapery from folds of which peep cherubs' heads at either side. A third cherub's head acts as a corbel at the base of the tablet. The well-lettered Latin inscription notes that John, aged nineteen at the time of his death, was buried near his uncle. It seems entirely possible that John was living with his aunt at the time of his death.

15. James Master (d. 1702), Ann Master (d. 1705/6) and Streynsham Master (d. 1724)

James Master was the son and heir of Richard Master and Ann, daughter of Sir James Oxenden of Wingham, Kent. He was born 22 October 1627 and admitted to Gray's Inn on 8 February 1647/48, having previously attended Queen's College, Cambridge. He was called to the bar on 7 February 1654/55 and pursued a career as a barrister from then on, only marrying in 1667. His wife Joyce was the daughter of Christopher Turnor, a Baron of the Exchequer. The first seven of their fourteen children were christened in St Andrew's, Holborn, and the final seven at St Bartholomew's.[56] Joyce died on a visit to one of her daughters, also named Joyce, who had married Thomas Pocock, rector of St John the Baptist, Danbury, Essex, of which James Master was patron. Pocock made a note in the back of the parish register there: '20th May 1728 A monument was erected for Mrs Joyce Master. Mr Carpenter at Hyde Park

53 Webb, *Records*, II, p. 467.
54 Webb, *Records*, II, pp. 468–69.
55 TNA PROB 11/362/422.
56 Webb, *Records*, II, pp. 469–71

8.16. Monument to John Kellond

Corner made this and another for James Master Esq set up in ye church of St Bartholomew ye Great in West Smithfield, London'.[57]

Andrew Carpenter was one of the major London sculptors at the time, but the two monuments for the Master family are minor works. They are of very similar form, but not quite identical. That in St Bartholomew is of what was known in England as 'Sicilian marble' – grey with darker flecks (fig. 8.17).[58] It commemorates James, his mother Ann, who died in January 1705/06, and his only surviving son, Streynsham, who died in 1724.[59] Streynsham was born in the parish but is buried elsewhere. He had a successful naval career serving under his brother-in-law, Lord Torrington, but died shortly after settling down and marrying. It seems likely that his three surviving sisters and their husbands arranged for the erection of both monuments. Thomas Pocock had served with Lord Torrington as a naval chaplain.

57 Parish Church of St John Baptist, Danbury: Church Register 1673–1759.
58 It was actually from Carrara in Tuscany, but was not of the better-known pure white type.
59 J. K. Laughton and Stuart Handley, 'Master, Streynsham (1681–1724)', *ODNB*.

8.17. Monument to James, Ann, and Streynsham Master

8.18. Monument to John and Mary Whiting

16. John Whiting (d. 1704) and Mary Whiting (d. 1727)

Mr John Whiting, gentleman, had previously set up a monument commemorating his parents that celebrated their forty years of marriage in the parish (fig. 8.18). He died in the Tower of London, where he had been employed in the Ordnance Office at £75 a year until 1702/03. As he gave the Tower as his address in his will of 1702, it seems likely that he retained a home there. That he kept closely in touch with his old parish is shown by his gift of one of two communion cups given in 1689 to replace two that had been stolen. It was noted then that he had been born in the parish, but all references to him in the 1680s and 1690s give his address as the Tower of London. Like his father, he was a member of the Drapers Company, but presumably by patrimony rather than training in his case. He apparently had no surviving children.[60]

In his will he set out arrangements for a charity to take effect after the death of his wife whereby his lands, houses and estate in Navestock, Essex, were to pass to the 'Minister Churchwardens and Overseers of the Poore of the parish of great St Bartholomewes' to pay for the 'learning and instructing of twenty poore children borne in the said Parish to learne to read English untill they can read the English Bible and be instructed in the

60 Webb, *Records*, II, pp. 471–73.

Catachisme' and willed the 'said number be filled up from time to time forever'.[61] His property in East Greenwich was to pass after Mary Whiting's death to three nephews and a kinsman, William Reeve, son of Hampden Reeve, but his property in Hampton Wick he willed to 'my welbeloved wife Mary her heires and assignes forever', suggesting that John had married a widow with offspring. John's messuage, tenement and garden in London Street, East Greenwich, was to pass at Mary's death to his nephew John Bowell, who shared his surname with Hampden Reeve's wife Margaret (married in November 1693). His property at Rainford in Essex was willed directly to the governors and master of the 'Blewcoat Hospitall'. Other bequests were of money.

17. Henry Tulse (d. 1705)

Henry Tulse was the younger son of Henry Tulse of Lymington, Hampshire, who in his will (proved in 1702) left him £800 to be paid when he was 21, as well as £40 a year for maintenance and education.[62] Young Henry had been apprenticed to William Crosfield, woollen draper, of St Bartholomew the Great and would have attended services at the parish church during that time – probably for the seven years that most apprenticeships took.[63] Once his apprenticeship had finished, his father's money enabled him to set up as a draper himself, based at Hornsey. He did not live long to enjoy his new status, dying at the age of 24 in August 1705. His will named Samuel Youngs of St Bartholomew the Less, draper, as his executor and William Crosfield as overseer.[64] His burial was to be at the direction of Youngs. His monument is very much of its time, with a grotesque face set between two large volutes on the apron and a shield of the Tulse arms set in a fleshy strapwork cartouche over the inscription panel (fig. 8.19).

LATER MONUMENTS

Of the later monuments, two are of particular note. William Phillips Taylor, who died at the age of 22 in 1829, is commemorated by a tablet signed by Mullane of New Road, St Pancras. Of Carrara marble on a black marble background, it has some good detail. It is the sole representative in the church of the type of tablet that was so ubiquitous in the City churches, often signed by New Road sculptors. Mullane also signed the tablet commemorating Frances Belcher, died 1830, in St Martin Ludgate, with which Taylor's shares a number of similarities. A grandson of the patron of St Bartholomew's William Phillips, who had died the previous year, Taylor had also recently lost his father, who died in Canada in 1826. His mother Elizabeth had the tablet set up.[65]

The Lady chapel contains the imposing tablet that acts as the cenotaph of Sir Borradaile Savory, Bart., rector during the restoration that rescued the church from the parlous state to which it had declined over the centuries and contributed so much to its current appearance

61 TNA PROB 11/479/54.
62 TNA PROB 11/457/261.
63 Webb calls this 'a flimsy reason' for his being commemorated at St Bartholomew's: Webb, *Records*, II, p. 473.
64 TNA PROB 11/484/111.
65 Webb, *Records*, II, pp. 475–76.

8.19. Monument to Henry Tulse

and condition.[66] It was erected by parishioners and friends after his death in 1906 and is an interpretation of the Baroque style with a curved broken pediment with the centre of the fascia recessed to take the Savory arms in an oval surround. The sans-serif inscription is in a frame decorated with an egg-and-dart border, and winged figures holding swords before them stand either side. The whole tablet is set in a lugged frame (see fig. 9.5). Savory was buried at Stoke Poges, where he is commemorated in the churchyard.[67]

66 For a history of Sir Borradaile's tenure as rector, see Jeremy Haselock's chapter in this book.
67 Webb, *Records*, II, pp. 481–83.

MODERN

St Bartholomew the Great in the Nineteenth and Twentieth Centuries

JEREMY HASELOCK

THE STORY OF ST BARTHOLOMEW THE GREAT in the modern era is of restoration and revitalization, deeply rooted in the church's ancient history. The men – and they were nearly all men – who presided or took the chair at committees or drew up schemes or laid new stones were conscious of the need to honour the past. Their immediate predecessors, especially during the Reformation, had not felt the same obligation. Their successors in the twentieth century would follow the Victorians' lead, cherishing their inheritance and preserving it for the future. The heroes of this story are the Webb family – Sir Aston Webb and his sons Maurice and Philip – who oversaw the great restoration from the 1860s onwards. Their endeavours meant that damage wrought by bombs in both world wars did not seal the fate of the church, as it would so many others in London. Because of their foresight, the structure they bequeathed to the next generation was sound enough, and valued enough, to be protected.

The history of the church's restoration is told in detail elsewhere in this volume.[1] This chapter tells the parallel story of St Bartholomew's the parish church, through the colourful characters that held the cure of souls. It is thanks to another of the Webbs – E.A. (Alfred) Webb, Sir Aston's brother – that we know so much about the life of the nineteenth-century parish. His magisterial collation of the church's records is the primary source for this chapter, which also seeks to place the parish in context, describing very briefly the life of the church and its relationship with the City from the Napoleonic wars to the twentieth century. What emerges is a picture of a parish that, much like its church building, stood immovable and seemingly undisturbed by the dramas unfolding around it. The medieval walls of the priory church protected it from the encroachment of modernity, scorning falling bombs and, more impressively, dwindling adherence to the Established Church. It is tempting to attribute its longevity as a place of worship – its great feat of survival – to a stubbornness and a determination that proclaims: 'Rejoice evermore. Prove all things; hold fast that which is good.'[2] It was the actions of good men – guided, if only implicitly, by Rahere's vision that there should be in Smithfield a house of God preserved 'unspotted

The author and editor would like to thank Daryl J. Oliver for her valuable research assistance on this chapter, and Charles Pitt for his helpful preliminary work.

1 See the chapter by Evan McWilliams in this book.
2 1 Thessalonians, 5:16, 21.

9.1. Painting of St Bartholomew's Priory by John Crowther, 1880
(© London Metropolitan Archives, City of London)

for ever and ever' – that saved the almost derelict priory for our generation.[3] The church we enjoy today stands only because people gave their whole lives to its service.

At the start of the reign of Queen Victoria, English church life was varied and complex. The parish church and its priest did far more than minister to its immediate flock, having legal, administrative and financial responsibilities throughout social life. Eighty-five percent of marriages, for example, were solemnized by a Church of England minister.[4] Because the Established Church touched upon so many different aspects of people's lives – even if they were not regular worshippers – it had to pay attention to their behaviour and activities and to be closely involved with the governance of English society. Ignoring many examples of devoted parish clergy selflessly serving their flock, the early nineteenth-century Church has been caricatured as 'white-chokered, immoral, wine-swilling, degraded clergy backed by debauched aristocrats and degraded wives and daughters'.[5] Consequently, Methodism in particular caught the imagination of many people, especially those who gained wealth and status from the Industrial Revolution. Migration and a population boom in the major industrial cities fuelled the Sunday schools and community-driven Methodist enterprise. Along with Methodists, other Non-conformists, including Quakers and Unitarians, were often the leading lights of the great Christian causes of the age – the abolition of the slave trade, prison reform, strict moral codes and temperance. All of these brought opprobrium or pressure or both on those parts of the Established Church that seemed by comparison indifferent either to evangelical mission or to righting historic injustices.

From 1833 and John Keble's landmark assize sermon 'National Apostasy', the Church of England was re-energized by the emergence of the Oxford Movement. What initially began as concern for the reforming Whig government's encroachments on the Church of Ireland evolved into a campaign to restore to the Church its ancient spirituality, liturgy and ritual.[6] While John Henry Newman, one of the movement's early leaders and spokesmen, initially saw Anglicanism and Roman Catholicism as compatible, his first inspiration was the English Church of the seventeenth-century Caroline divines rather than the nineteenth-century Church of Rome. Newman's conversion to Roman Catholicism in 1845 was a huge blow, but other articulate advocates for the return of the Church of England to its historic faith and liturgy demonstrated that the Oxford Movement was, at its heart, never a campaign to bring England into the sphere of Rome. Its legacy was to have a huge influence on the Church of England and the Anglican Communion, creating a powerful Anglo-Catholic movement which, although much diminished in today's Church, remains key to the identity of St Bartholomew's as a worshipping community.

For two reasons, St Bartholomew's in this period seems like an unbending tree in a storm. First, its own antiquity meant that the dramatic changes in society during this period had

[3] Moore, *Foundation*, p. 8.
[4] See Jeremy Morris, *A People's Church*, (London: Profile Books, 2022) p. 300ff for more on Victorian Church statistics.
[5] Eugenio Biagini, *Liberty, Retrenchment and Reform: Popular Liberalism in the Age of Gladstone, 1860–1880* (Cambridge: Cambridge University Press, 2004), p. 245.
[6] Recent scholarship on the Oxford Movement is best encapsulated in *The Oxford Handbook of the Oxford Movement* ed. Stewart Brown, Peter Nockles and James Pereiro (Oxford: Oxford University Press, 2017).

less material impact on the parish; unlike in the aftermath of the Blitz, the City of London was not knocked down and rebuilt in the nineteenth century and its inhabitants did not experience the Industrial Revolution in the same way as in the north. Secondly, the City of London was itself an island of autonomy, operating under medieval rights and laws that exempted it from the drive for municipal government in other big cities.[7] The history of St Bartholomew's in this period is appropriately parochial – focused, inevitably, on the challenges of keeping alive and open a church founded in the twelfth century. Where the life of the parish chimes with the age is in the gradual diminution of the Vestry – a predecessor of what is now the Parochial Church Council (PCC) – as an arm of the state. At the start of the century, a parish priest and his church wardens were responsible for the poor, for schooling, for maintaining streets and signage, and for other civic functions. By the start of the twentieth century, nearly all of these functions had been subsumed into the secular state.[8]

The advowson or right of presentation to the rectory of St Bartholomew the Great was acquired by Richard Rich along with the choicest parts of the monastic property at the dissolution of the priory.[9] It passed by direct descent through his family, the earls of Holland, and then via the female line to the Edwardes family, barons of Kensington. William Edwardes, the second baron, sadly lacking any interest in the long family connection with St Bartholomew's, sold the advowson to a Mr William Phillips, who was looking for a living for his brother-in-law. The new patron had married a Miss Abbiss, whose brother John Abbiss was at Oxford preparing for ordination. After first securing an agreement that he would resign after five years, Phillips presented John Richards Roberts to the benefice in 1814. Phillips's son, an honorary canon of Winchester and possibly influenced by the Oxford Movement, inherited the advowson, and presented the next two rectors, William Panckridge in 1884 and Borradaile Savory in 1887. In turn, his son, Frederick Abbiss Phillips, inherited the advowson, and presented, in 1907, William Fitzgerald Gambier Sandwith. In 1908, the patronage devolved jointly on Phillips's widow, Mrs Bowen-Buscarlet, and her son, Noel Phillips, who appointed Edwin Sidney Savage in 1929. Ultimately, the patronage was passed to the Dean and Canons of Westminster Abbey, who hold it today. Perhaps the best way to chronicle the many and varied changes to parochial life at St Bartholomew the Great in the nineteenth and twentieth centuries is to see them through the eyes of this succession of rectors from the arrival of John Abbiss in 1819 to the retirement of Newell Wallbank in 1979.

THE REVEREND JOHN ABBISS, RECTOR 1819–84

In 1819, John Abbiss replaced John Roberts as the rector at St Bartholomew's. His predecessor had, by the agreement mentioned above, served a short term of five years; Rector Abbiss remained in post until his death sixty-four years later. He presided over the church for two thirds of the nineteenth century, arriving four years after the Battle of Waterloo and dying just as Edison's electric lighting was becoming fashionable. Abbiss grew up in

7 Stephen Inwood, *A History of London* (London: Macmillan, 1998).
8 See Morris, op. cit., ch. 17, for more on this century-long transformation.
9 See the chapters by Christine Fox and Nick Holder in this book.

Wandsworth and was educated at Winchester College and Trinity College, Oxford, where he was a fine classical scholar and a student of ecclesiastical law. He was made deacon in Salisbury Cathedral in September 1815, at about the same time that Napoleon boarded a ship for his final exile in St Helena. Four years later, and aged only twenty-six, Abbiss was instituted as Rector of St Bartholomew the Great by the bishop of London. Before ordination Abbiss travelled widely in Europe; as he grew older, he was known to recall these travels in conversation.[10]

Through his connection with his brother-in-law, who, as we have seen, purchased the advowson with the intention of presenting him to the living, Abbiss was familiar with St Bartholomew's before he became rector; he had taken several funerals, a christening and a wedding, and had preached in the run-up to his arrival. His first sermon as rector was a week after his institution on 13 August 1819; he would preach every Sunday for the next 54 years. He was proprietorial about his pulpit, once forbidding Prince Albert's chaplain, J.B. Lightfoot, from preaching the annual sermon in aid of the parish's schools. While Rector Abbiss was known on occasion to allow family members to preach, on the big state occasions he trusted only his own voice; six months into his tenure he preached on the death of George III.[11] He took a similar approach to administration, chairing all clergy and parish meetings – though with due modesty he declined all votes of thanks to the chair, as he held the position by right. The parish clerk at the time of his death, W.H. Jackson, wrote that he was 'an autocratic gentleman of the old style, who never gave his parishioners more than two fingers to shake'.[12]

Abbiss was short – only five foot three – but strongly built and invariably bewigged.[13] He liked to use classical allusions in his sermons, even if they went over the heads of the congregation. We read that he was clubbable – and often at his club in the Strand. Fond of children, polite to women and antagonistic to men, he would talk in a whisper but declaim in a roar. He was 'a man of strong will and grit' and chaired meetings with 'granite-like methods', though he would relax once the business was through, sharing anecdotes of his Winchester and Oxford days. Beyond church he was a sportsman, enjoying shooting and boxing. He could clearly endure pain: in old age he had his cataracts removed without anaesthetic.[14]

From his notebooks it is clear that early in his ministry Abbiss set out to establish his rights as rector over the fabric of the church and oversaw a constant flow of minor works as well as the major restoration under the Webbs. The rector and parish were conscious of their history and in 1823 the church marked the 700th anniversary of the founding of the priory and the hospital with a dinner on Maundy Thursday. Their attitude to the fabric was not, however, steeped in heritage. Historic furnishings were replaced in the 1820s and in 1840 the brass chandeliers sold to make way for gas lighting. Piecemeal repairs were made

10 Webb, *Records*, II, p. 373.
11 Webb, *Records*, II, p. 374.
12 Webb, *Records*, II, p. 530.
13 The clerical wig, almost ubiquitous in the eighteenth century, went out of fashion in the 1830s as King William IV disliked them. Rector Abbiss would have seemed quaint indeed if he continued wearing one into the 1880s: William Gibson, '"Pious Decorum": Clerical Wigs in the Eighteenth-Century Church of England', *Anglican and Episcopal History*, 65.2 (1996), pp. 145–61.
14 Webb, *Records*, II, pp. 530–31.

9.2. Line engraving with etching of the Bartholomew Chapel, looking west, c. 1822. Wellcome Collection

to the roof and elsewhere in the building.[15] Then, in 1830, what has been described as 'the Great Fire' caused more fundamental damage that in time would lead to the need for the major works undertaken by Aston Webb.

The fire started in a timber store below what was known as Bartholomew Chapel, which occupied the remains of the monastic chapter house next to the south cloister (fig. 9.2). From there it spread down the south side of the building, burning through the south triforium and Prior Bolton's gallery. The south side was damaged and unsafe, and the church was forced to close for six months. The Vestry appointed a committee to save the church, which first insured the building for £1,500 and borrowed £1,000 for the repairs. The south wall was shored up and repairs made to the vestry room.[16] The committee tried to buy the land outside the church between the south transept and the south chapel from Lord Kensington, but he struggled to prove he held the title to the land. The committee therefore refused his offer to sell it for £100 as a burial ground. Webb notes that the committee's decision was an error; in 1853, Parliament restricted new burials in metropolitan areas and the need for more burial space in cramped churchyards like that of St Bartholomew's went unanswered. Had the 1830 Restoration Committee bought the land, however dubious Lord Kensington's claim on it, they would have been able to prevent houses being built there instead.[17] In 1846, the south wall was faced with brick and cement and permission

15 Webb, *Records*, II, pp. 376–77.
16 Webb, *Records*, II, p. 377.
17 Webb, *Records*, II, p. 378.

9.3. Front cover of the Lewis and Slater report on the church's condition and proposed repairs, 1863. St Bartholomew's church archives

was granted to a builder, Joseph Cockerill, to erect a small row of houses up against it – these would be known as Cockerill's Buildings. At the same time another builder, Mr Pope, erected the cottages named for him along the south wall of the choir.[18]

By 1860 it was clear more work was required. The Vestry appointed the architect Hayter Lewis, who in turn approached William Slater, who had previously worked on the maintenance of the fabric of St Bartholomew's. Slater is remembered for his work with the better-known R.C. Carpenter, restoring very many churches in the Midlands in the 1860s and 1870s. Lewis and Slater presented their survey to the Vestry in 1863, noting that the floor level was two-and-a-half feet higher than it had been and that the apse could and should be rebuilt (fig. 9.3). The north triforium had been largely rebuilt in the seventeenth century and was now a school room, while the south triforium had been almost entirely

18 Webb, *Records*, II, p. 379.

lost to the fire. The south transept could be replaced. They put their proposals to a general meeting of the parish, chaired by the rector, which accepted them; a new committee would be formed to oversee these new works under the chairmanship of William Cubitt, also chairman of St Bartholomew's Hospital. Cubitt was a partner in the building firm established by his famous elder brother Thomas Cubitt, who had made his name and his fortune developing the elegant streets and squares of Belgravia and Pimlico. Cubitt's committee launched a fundraising appeal and the rector set an admirable example, pledging 200 guineas.[19] A contemporary account shows that the rector and committee were perhaps too reticent in approaching charitable bodies, let alone the general public, for funds; *The Morning Post* lauded the idea of restoration, but continued:

A most respectable committee, headed by the rector, the Rev. J. Abbiss, M.A., have undertaken to collect subscriptions for the work; but their proceedings, so far, do not seem to have taken a very practical direction. They appear to have addressed the public generally upon the wants of the church and to have waited patiently for a reply which has never come. Instead of this general appeal, and this handing over, as it were, of the remainder of their work to Providence to complete, they would probably be more successful if they were to make direct and earnest appeals to individual bodies and special interests.[20]

The newspaper then elaborated at length upon the most likely of these, including the Lord Mayor and Corporation, the livery companies, City banks, archaeological societies, the descendants of those buried in the church, Londoners resident abroad, etc. – implying that none of these had yet been approached for contributions.[21] Abbiss, though a careful and zealous rector, was apparently no fundraising strategist, nor were the earliest members of the restoration committee.

Fifty-four years after his arrival, and a decade before he died, Rector Abbiss started to weaken in old age. In December 1873 he gave his last sermon, though he continued to attend services. In 1877 he was well enough to join the parish in beating the bounds on Ascension Day – a tradition that fell into abeyance until it was revived in 2019 – and there followed a parish dinner in Anderton's Hotel.[22] Abbiss remained generous to the end, giving £100 to improve the church heating in 1882. He last attended a Vestry meeting in November that year. It was said that he often anticipated his death, saying that 'when I die, they will have nothing to do but to bury me', implying that his affairs were in order. Surprisingly, however, he died intestate and his nephew inherited what was left of Rector Abbiss's long life, lived almost entirely at St Bartholomew the Great.[23]

19 Webb, *Records*, II, pp. 379–83.
20 'Restoration of St Bartholomew's Church, Smithfield', *The Morning Post*, 29 September 1864, p. 6.
21 The City Corporation eventually contributed £210; see Steven Brindle's chapter in this book.
22 Webb, *Records*, II, p. 403.
23 Webb, *Records*, II, pp. 403–04, 531.

THE VESTRY

Today the term 'vestry' more usually applies to a room, but for most of the life of the church after the Reformation it also referred to the assembly of parishioners who, with the incumbent and church wardens, took the key decisions in the running of the church and the parish. It was composed of people of both sexes who were rated for the relief of the poor in the parish, whether resident there or not, and the owners of rated properties.[24] It was in some respects the prototype of today's Parochial Church Council (PCC), though the members were not elected. Unlike today, decisions of the Vestry had a direct material impact on parishioners' lives. It had, in effect, tax-raising powers – the parish rate – and in establishing eligibility for the Poor Law its rulings could make the difference between someone receiving financial assistance or not. Consequently, people and parliaments alike took interest in the work of the Vestry and in their powers and processes. In 1716, Parliament rejected attempts to reform the way vestries worked, including how they selected their members. Parishioners at St Bartholomew's included keen reformers, and in 1720 there was an attempted coup by Joshua Lock and John Darby. They advertised a rogue meeting on Easter Day and appointed church wardens while the select Vestry met and appointed theirs. With one church warden in common, each group championed their own man for the second slot, and St Bartholomew's was in danger of imitating the popes and anti-popes of the fifteenth century. The 'rightful' Vestry brought a libel action against Lock and Darby, and the ecclesiastical court found in favour of the plaintiffs. When the dispute ended, with the help of the Lord Mayor, it had cost the parish £100. Lock and Darby seem to have been the exception, however; Webb records that the elected members of the Vestry were normally exemplary at St Bartholomew's and a model of honest administration.[25]

One final curiosity of this group of civic-minded parishioners was their encounter with London's greatest novelist of the era – not that they noticed. In 1830 their usual meeting to assess eligibility for the poor rate was gate-crashed by rowdy parishioners, presumably keen to be included in the charitable distribution. Before a judge the charge of riot brought against the intruders was upheld and one of the ringleaders was fined £20. The notes of the case were written up by a young court reporter, Charles Dickens.[26]

In 1868 the balance of power between laypeople and clergy was materially altered by the Compulsory Church Rate Abolition Act. This had consequences for all parish churches, not least St Bartholomew the Great, as it shifted the power firmly away from the Vestry. In 1848 the Corporation of London took on the wider responsibilities of the Vestry as the operating unit of local government. This reduced to almost nothing the functions of the Vestry in the wider community – as Webb notes: 'owing to its civil duties having been taken away, its meetings are very poorly attended'.[27] At the same time as the erosion of the traditional powers of church as the focal point in a parish began, the unique privileges enjoyed

24 Kenneth MacMorren and Timothy Briden, *Handbook for Churchwardens and Parochial Church Councillors* (London: Bloomsbury, 2010) p. 167, n. 2.
25 Webb, *Records*, II, pp. 391–93.
26 Webb, *Records*, II, p. 393.
27 Webb, *Records*, II, pp. 394–95.

by this royal foundation also began to ebb away. Henry I's charter of 1123 stated that St Bartholomew's 'shall be free from every subjection and earthly service and power so that as any church in the whole of England is amply free this church also shall be free'.[28] Later charters would confirm this, under Henry II, c. 1173, and Henry VII in 1489. The details of Henry VIII's grants to Richard Rich are covered in detail in Christine Fox's and Nick Holder's chapters in this volume; Rich's grandson obtained clear details – an exemplification – from Elizabeth I in 1583. Fortunately for historians of St Bartholomew's, the rights and privileges of the parish were added to the minutes of a meeting in 1825.[29] We know the rights Rector Abbiss's church possessed when he arrived and can see how they were gradually diminished over his tenure by changes in legislation.

The annotations to the Vestry minutes set out that until the reign of James I, St Bartholomew's was not subject to the authority of the City of London. This gave the parishioners certain freedoms, as well as disenfranchising them from nominating councilmen, although they could vote in elections. Traders could trade without taking up freedom of the City – a source of tension amongst some trades, even after the City Companies ceased to have effective powers. Parishioners were also exempt from jury service. A sign of the Corporation's frustration with the exercise of these medieval privileges was its withholding of the parishes' share of money for the poor.[30] However, as the nineteenth century wore on, the privileges peculiar to a twelfth-century priory were one by one removed and the lives of the parishioners of St Bartholomew's became regulated in just the same way as any other Londoner.

From the time Elizabeth I introduced the first Poor Laws in 1601 to as late as 1907, the church wardens were responsible for provision for the poor of the parish. In the seventeenth century the numbers were small – for example, in 1681 the poor pensioners numbered four men, two women, eight widows and eight children. For adults the stigma was visible – recipients had to wear a badge. The hated workhouse was also a form of welfare, and in 1707 the parish was obliged, after a court battle, to contribute to the Corporation of London's workhouse. There was briefly a parish workhouse between 1737 and 1741 just off Little Britain, but the Vestry preferred to appoint and pay individuals to care for the poor of the parish. In 1822, the Vestry supported moves to close the London workhouse and instead to focus energies on finding work for the poor. The 1832 Reform Act and the 1834 Poor Law centralized the workhouses under new Unions of Parishes and removed responsibilities for the poor from the church wardens.[31] Their interest in the welfare of the poor of the parish did not abate, however. In 1846 the City of London opted out of the Public Baths and Washhouses Act, and the Vestry's efforts to establish a joint public washhouse with the adjoining parish of St Sepulchre's were rejected by the courts, so that the poor of the parish were deprived of basic sanitation.[32] In 1909, the Royal Commission on the Poor Laws and Relief of Distress laid the foundations for the welfare state as established by the Liberal government under

28 See Christine Fox's chapter in this book.
29 Webb, *Records*, II, pp. 395–99.
30 Webb, *Records*, II, p. 399.
31 Webb, *Records*, II, pp. 401–02.
32 Webb, *Records*, II, p. 402.

H.H. Asquith and David Lloyd-George. Amongst their reforms was the City of London (Union of Parishes) Act, 1907, which on 1 April 1908 removed the last aspects of Poor Law provision from the church wardens at St Bartholomew's. By this Act, the hundred and more City parishes were extinguished as separate rating authorities, and the City was constituted as one civil parish with one set of overseers, while the parochial boundaries became areas merely for ecclesiastical convenience. The City thereby became the sole authority for rating, valuation and Parliamentary registration. All rates levied within the City boundaries were now to be collected and administered under the Corporation authority.[33]

THE REVEREND WILLIAM PANCKRIDGE, RECTOR 1884–87

Rector Abbiss's successor, William Panckridge, would serve for just three years. He arrived in January 1884 after serving as Vicar of St Matthew's, City Road. He had been educated at Jesus College, Cambridge, before ordination in London in 1865. His career was a mixture of teaching in schools and serving as a parish priest. Although his tenure was brief, he is credited with reviving parish life after a period of decline in the last years of his aged predecessor. His innovations included establishing a working men's club, a boys' club and a Sunday school. He paid from his own pocket for a surpliced choir and an organist. Surpliced choirs were still relatively uncommon outside of cathedrals and collegiate foundations at this time, and the establishment of one at St Bartholomew's is perhaps indicative of the influence of Tractarian churchmanship.[34] Further evidence of where Panckridge's sympathies lay can be seen in his association with the Reverend H.B. Bromby, a friend from university days, who came to work with him for a year. After working in other London parishes, Bromby became vicar of All Saints', Clifton, in Bristol, a famous centre of Anglo-Catholic worship.[35]

Much of Panckridge's time was taken up with the next phase of the restoration of the fabric of the church. The members' list of the new Restoration Committee reads like a 'Who's Who' of the Church of England and included the archbishop of Canterbury, the bishop of London, the deans of St Paul's, Windsor and Exeter, and many more. On 4 June 1884, Sir Aston Webb was appointed architect to the committee.[36] Panckridge oversaw the earliest phases of this major undertaking and on St Andrew's Day (30 November) 1886 he presided over the opening ceremony of the new Lady chapel at the east end of the church. The occasion was marked by a lunch in the Great Hall of St Bartholomew's Hospital, where the remarkable medic and churchman Sir James Paget gave the speech.[37] Paget was one of the medical giants of the age and his industry and genius enabled great advances in the understanding of pathology. He was friends with Thomas Huxley and Charles Darwin, and saw no contradiction between the growing understanding of science and his own Christian

33 Webb, *Records*, II, p. 445.
34 For more on this choir and the Tractarian influence on worship at St Bartholomew's, see the chapter by Nicholas Riddle in this book.
35 Webb, *Records*, II, p. 406.
36 Webb, *Records*, II, p. 408.
37 Webb, *Records*, II, p. 412.

faith.[38] Sadly for Panckridge, this was all the progress of the great restoration he would enjoy. He fell ill in February 1887 and died the following June; he was buried in Highgate Cemetery, and memorialized in a choir screen at St Bartholomew's.[39]

THE REVEREND SIR BORRADAILE SAVORY, BART., RECTOR 1887–1906

Savory, a Cambridge graduate from Trinity College, was ordained in 1880 and came to St Bartholomew's from a curacy at St George's, Hanover Square. His father had been a surgeon at St Bartholomew's Hospital. The new rector was also a chaplain to the Order of St John of Jerusalem (the royal order of chivalry which founded St John's Ambulance Corps), the Royal Army Medical Corps volunteers, and the Freemasons.[40]

Sir Borradaile inherited various unfinished works initiated by his late predecessor, including the new organ and the rebuilding of the parochial schools. He and his wife personally subsidized the fund for a new school building with club rooms below it.[41] Meanwhile, Webb's restoration continued apace until, in 1893, the Vestry was ready to invite the Prince of Wales, the future Edward VII, to attend the opening ceremony of the restored transept. The plans for the royal visit took up a great deal of time, and the archbishop of Canterbury impressed on the rector that the Prince of Wales might sit anywhere in the church – even the sanctuary – but suggested a raised dais with special chairs. His Royal Highness was having none of it. His private secretary responded to the suggestion with 'I am sure the Prince would not like that: in fact he always tells me that when he is in church he likes to feel that he is like anyone else'.[42] When the great day came round, the Palace informed the rector that the Princess of Wales would be accompanying her husband. Earlier that year their eldest son, Prince Albert, Duke of Clarence had died after a short illness, plunging his mother into a deep grief, and this would be her first public appearance in nearly six months. Also in the royal party were the future King George V, then Duke of York, Princess Maud, the future queen consort of Norway, and their sister Princess Victoria.

Perhaps unaware he was a baronet, *The Sketch* reported: 'The Rev. Borradaile Savory, the popular and energetic Rector of St Bartholomew the Great, West Smithfield [...] is to be congratulated on the admirable restoration of his church, which is, perhaps, the most interesting ecclesiastical building in London. Since Mr Savory's appointment, some years ago, he has worked most zealously to secure a reverend and artistic restoration of his grand old church, and the function last week, which was attended by royalty, was a fitting crown to his remarkable efforts.'[43] There were further celebrations in 1897, at which the bishop of London presided, to mark the completion of the restoration of the Lady chapel.[44]

38 Herbert Schlossberg, *Conflict and Crisis in the Religious Life of Late Victorian England* (New Brunswick, NJ: Transaction Publishers, 2009), p. 46.
39 Webb, *Records*, II, pp. 412–13.
40 Webb, *Records*, II, p. 413.
41 Webb, *Records*, II, pp. 414–15.
42 Webb, *Records*, II, pp. 423–24 (quote p. 423).
43 *The Sketch*, 14 June 1893.
44 Webb, *Records*, II, p. 427.

The presence of the great and good at the various celebrations may give the modern reader a false impression of prosperity; in reality, the parish during Sir Borradaile's tenure was a rough, deprived area plagued by the problems of poverty and ignorance (fig. 9.4). The English industrialist and social reformer Charles Booth interviewed the rector as part of his 'Inquiry into the Life and Labour of the People in London', a survey of working-class life undertaken between 1886 and 1903. Booth's original survey notebook containing the notes of the interview survives, painting a fascinating and sobering picture of the parish of St Bartholomew the Great in 1898.[45]

9.4. Photograph of Cloth Fair looking along the north side of the church, 1877 (© Museum of London)

The parish had a slowly decreasing nighttime population of about 1,800 inhabitants, comprised mostly of the poor working class, including porters and the lower-paid workers of Smithfield Market. It was exceptionally well-provided with pubs – 32 in all – and the parishioners tended to drink to excess in order to forget the difficulty of their lives, much to the teetotaller Sir Borradaile's distress. Fortunately, the rector was able to report that he knew of no brothels (euphemistically termed 'bad houses') in the parish; women mostly worked honest jobs for their livings, unmarried cohabitation was very rare, and what little prostitution occurred was by way of 'supplementary earnings'.

The staff of the priory church included three clergymen (Sir Borradaile and his assistant priests C. Albert Smith and L. Savill), ten Sunday School teachers, a verger, beadle, mission worker and six district visitors (two of which were paid). The rector reported 120 attendees at the three Sunday morning services, a great many of whom came from outside the parish, 'attracted by the fame of the church'. Evensong averaged 200 attendees, mostly parishioners. Around 150 children attended the Sunday afternoon children's service with catechesis, which Sir Borradaile thought 'very poor', though many other children attended the parish day-schools and received religious instruction there. The parish spent £248 per annum on charity in addition to what Sir Borradaile himself gave; 'if anyone wanted anything, they got it', he told Booth. Though looked down upon by the standards of Victorian philanthropy for doing so, the rector gave financial assistance to those who were out of work, showing great concern for the difficulties his parishioners faced.

45 London School of Economics, notebooks of Charles Booth, 'Church of England District 1 [The City]', BOOTH/B/246, pp. 74–89; digitized at: <https://booth.lse.ac.uk/notebooks/b246>.

Most fascinating, perhaps, is Sir Borradaile's account of the services, which portrays a continued moderate Tractarian influence. Booth writes:

The services at the church are high, although moderate, and Sir B. thinks that the people would like it "more so". He says that for people with little brightness in their lives and who are uneducated, anything of this kind is enjoyed. Thus, whenever there is anything out of the way it at once constitutes an attraction. Level of ritual is a "childish desire", and Sir B. looks at the question from the point of view of one who is willing to give the people what they like up to the point that will not do them harm.[46]

Though deprived, the parish was a lively one – there were separate Bible study classes for women and men, guilds for boys and girls, a men's club, a mothers' meeting, a boys' choir, and of course the Church of England Temperance Society, amongst many others. Several of these clubs had been started by Panckridge; Savory continued them, and also continued to pay for the surpliced choir, in 1898 numbering six men and eighteen boys.

9.5. Monument to Sir Borradaile Savory (rector 1887–1906) in the Lady chapel (photograph 2022)

Despite his wealth, education, and connections, Sir Borradaile genuinely seems to have enjoyed living out his calling in an impoverished London parish. Booth describes him as

a man of perhaps 35 to 40, big, clean-shaven, well-groomed. He seems to be a man of simple and enthusiastic nature, who enjoyed his life, and would do his best to see that other people did the same. He is apparently rich, and last year spent nearly £850 in the parish. He is not particularly clever, I suppose, but is none the less a good fellow for that.*
** The rector makes it a rule never to <u>deliver</u> a gift himself.*[47]

In short, in 1898 the parish of St Bartholomew the Great was as deprived as any East End parish, and had in Sir Borradaile one of those energetic, wealthy, reform-minded Victorian catholic priests whose unselfconscious benevolence and faithful living out of God's calling amongst the poor and needy has justly won them fame.

In March 1906 the Restoration Committee agreed to install electric lighting in the church. Sir Borradaile would not live to see the lights installed; in June 1906 he became

46 LSE BOOTH/B/246, p. 83.
47 LSE BOOTH/B/246, p. 83.

ill, and died in September of that year. It was said that he died with many friends and no enemies. In his memory new communion rails were installed, a stone plaque recording the restoration work carried out during his incumbency and that of his two predecessors was placed in the west porch, and a fine memorial tablet was fixed to the north wall of the Lady chapel (fig. 9.5). These were dedicated in May 1908 by Cosmo Gordon Lang, at that time bishop of Stepney.[48]

THE REVEREND WILLIAM FITZGERALD GAMBIER SANDWITH, RECTOR 1907–29

William Sandwith, the twentieth rector since the suppression of the priory, was born in India, where his father had served with the Indian Civil Service. He was Queen's Scholar at Westminster and graduated BA at Christ Church, Oxford, in 1884. By the time he was presented to the living of St Bartholomew's, he had served curacies at St Margaret's, Westminster, and Enville in Staffordshire, and incumbencies in Norfolk and south London.[49] He came to a now well-established London landmark church, with the Aston Webb restoration complete and a liturgical tradition established. A guidebook published in the second year of his incumbency listed the daily services and gives evidence of the moderate Tractarian tradition being maintained:

Sundays:	8.15 am	Holy Communion
	11.00 am	Mattins
	11.45 am	Holy Communion (choral) and sermon
	4.00 pm	Children's service and catechizing
	7.00 pm	Evensong and sermon
Saints' Days:	8.15 am	Holy Communion
	11.00 am	Mattins
	8.30 pm	Evensong and sermon
Weekdays:	11.00 am	Mattins
	4.00 pm	Evensong[50]

Sandwith's main tasks beyond the pastoral care of his parish would be to oversee the acquisition of surrounding land as old buildings were demolished and new ones erected, and to secure the setting of the church within the crowded townscape. He was a great fundraiser for special projects unconnected with the fabric of the church, notably the repair of the organ, which in 1919 was reported to be in such a bad condition as to be unfit for the musical services of the church.[51] He undertook to raise what he could by means of lectures on the history and architecture of the church illustrated by lantern slides.

48 Webb, *Records*, II, pp. 431, 434–37.
49 Webb, *Records*, II, p. 436.
50 G. Worley, *The Priory Church of St Bartholomew the Great, Smithfield* (London: George Bell and Sons, 1908), p. 30.
51 For more on the organ, see Nicholas Riddle's chapter in this book.

During the interval between the death of the previous rector and Sandwith's institution, the churchyard was overshadowed by a tall building erected at its west end, looking on to Smithfield. The building works placed the Tudor gateway in considerable danger, requiring it to be underpinned, but under Aston Webb's supervision this was accomplished without difficulty.[52] For many years it had been an objective to obtain the house over this important gate and to remove the shop front which encroached upon it and hid part of the medieval porch. This gateway was alienated from the church at the time of the suppression, when Sir Richard Rich sold the rooms over it but retained the arched doorway as the gateway to his property.[53] Once the owners of the house and shop had been persuaded to sell, an appeal separate from the Restoration Fund was set up in November 1908 to acquire the building and restore it carefully.[54] The demolition of the shop front exposed part of the south side of the arch, and also a fragment of a mural arcade. On the east side of the arch an Early English base and capital to a vaulting shaft of the first bay of the south aisle were uncovered and are still exposed to view.[55]

9.6. Photograph of buildings in Bartholomew Close damaged by the 8 September 1915 Zeppelin raid. Wellcome Collection

About the same time, on 18 December 1908, the Vestry decided to allow the City Corporation to encourage access to the churchyard and cease payments to the night watchmen whose surveillance had safeguarded the property, in return for a payment of £1,500. Of this, £646 was devoted to defraying the balance of the cost of the gatehouse and its repairs. The remainder was invested in the names of trustees, and the interest, together with the rents of the rooms over the gate, continue to this day to provide a sum for keeping the gate and gatehouse in repair, and also for other purely parochial purposes, when there is a balance available.

The Great War played a crucial role in restoring the gatehouse to its Elizabethan appearance: on 8 September 1915 a Zeppelin raid damaged what appeared to be a brick frontage covering the gatehouse (fig. 9.6). Restoration work undertaken by Aston Webb revealed the gatehouse to be a half-timbered building, dating from the year 1595, later covered in front with tiles resembling bricks to give the structure an eighteenth-century look. The wood to which the laths holding these tiles were fastened had once belonged to the church,

52 Webb, *Records*, II, p. 437.
53 For more on Rich and the gatehouse, see Nick Holder's chapter in this book.
54 Webb, *Records*, II, pp. 437–38.
55 *Westminster Gazette*, 21 March 1910, p. 6.

9.7. Architectural remains unearthed during the excavation of the cloister and churchyard, presently stored in the south triforium (photograph 2022)

including what was identified as the top rail of a screen, which was put on view in what then remained of the cloisters. The restoration was completed by summer 1916.[56] In 1917, when a stone tablet commemorating the dead of the Great War was placed on the south side of the gateway, a controversy erupted over its inclusion of a crucifix.[57]

Much time and energy was spent at this time in buying up freeholds of leasehold properties possessed by the church and extending, where possible, the area around the building to prevent encroachment and unsightly development. At the same time excavations were carried out revealing the dimensions of the first Lady chapel and the remains of the walls of the south chapel, disclosing the fact that the chapel had two apses, confirming the strong debt Rahere's building owed to Norwich Cathedral.[58] Later excavations on the north side revealed a block of masonry which indicated that the north chapel also had an eastern apse like that of the south chapel.

Further excavations relating to the construction of a warehouse to the south east of the church revealed the remains of the chapter house, the slype, the prior's house and other monastic buildings. At the west end of the chapter house the great arched entrance from the cloister was discovered, with the usual arched opening on either side.[59] In the centre

56 'Smithfield Gateway: An Elizabethan house near St Bartholomew's', *Westminster Gazette*, 4 August 1916, p. 8.
57 *Daily Mirror*, 20 November 1917.
58 *The Shoreditch Observer*, 11 June 1915, p. 3.
59 *Belfast Evening Telegraph*, 9 July 1912, p. 6.

of the floor was found a stone coffin, supposed to be that of Prior Thomas; also twelfth-, thirteenth- and fifteenth-century work from the chapter house, bosses from the cloister, a kneeling figure of a canon carved on what had been the left arm of the prior's chair in the chapter house (see fig. 3.16 above), and many interesting fragments which are presently stored in racks in the south triforium (fig. 9.7).

The old boys' school-house on the north side was repaired and made available for parish use and a choir vestry built upon the foundations of the south chapel so as to retain the plan of the chapel and to expose to view what remained of its walls. The corresponding room on the north side was converted for the use of the clergy. These were dedicated on 9 June 1915 by Dr Winnington-Ingram, bishop of London, in the presence of the Lord Mayor and Sheriffs.[60] When Cloth Fair was widened it exposed the north side of the church, and the demolition of the Elizabethan houses at 6-9 Cloth Fair in 1915 uncovered another bay in the nave and a thirteenth-century window. Work continued to reacquire what remained of the cloister. The east cloister had been destroyed fire in 1830, and its remains were demolished around 1886 to make way for new stables. The bays adjoining the church were purchased in 1904 and, where possible, the vaulting was re-erected. The west doors which had been removed in 1893 were found to fit the porch into the cloister.[61]

The church took possession of the remaining bays of the east cloister in 1922 and the Restoration Committee mooted plans to rebuild the three missing bays, in the teeth of opposition from the Society for the Preservation of Ancient Buildings. Their secretary was clear that rebuilding the cloisters was 'conjectural' and would be of no historic artistic value, proof he thought that 'this generation likes make believe buildings'.[62] Nevertheless, the project went ahead under the supervision of the Webbs and in 1928 Princess Mary, daughter of George V, attended a special service to mark the opening of the completed east range of the cloister.[63]

THE REVEREND EDWIN SIDNEY SAVAGE, RECTOR 1929-44

Born in Port Elizabeth South Africa in 1862, Savage was educated at New College in Eastbourne, University College, London, and Magdalen College, Oxford. In 1889 he married secondly Sibil Farrar, a daughter of Frederick Farrar, dean of Canterbury (1895-1903), a staunch supporter of Charles Darwin and the author of *Eric, or Little by Little*, one of the most popular boys' books in mid-Victorian Britain. Savage had been rector of Hexham from 1898 to 1919, during which time he oversaw the rebuilding of the abbey church and became an honorary canon of Newcastle Cathedral. He distinguished himself during the First World War as Chief Commissioner of YMCA in the Mediterranean, serving with 21 ships, and was much decorated for services in relief of the civilian population of Serbia.

In the parish, Savage took an interest in the work of Smithfield Market and the livery companies based in the area, and became chaplain to the Butchers' Company. His

60 Webb, *Records*, II, p. 441.
61 Webb, *Records*, II, pp. 443-44.
62 See chapter by Evan McWilliams in this book.
63 *East London Observer*, 1 September 1928.

> **From**
> **The Priory Church of St. Bartholomew the Great.**
>
> ## AN URGENT S.O.S.
>
> is still the signal to those who love and prize St. Bartholomew's Priory Church, and rightly regard it as a national possession
>
> SCAFFOLDING ERECTED FOR REPAIRS TO ROOF.
> *From the drawing by Hanslip Fletcher by courtesy of "The Sunday Times."*
>
> "So when great strangers roam our streets
> There many a sight to see
> Of power and pomp—yet Rahere's tomb
> Excels their majesty:
> And when the spirit of Christ doth move
> The hearts of rich and poor,
> Men tell of the Jester who opened first
> That never-closed door."
>
> (*From* "The Ballad of Rahere the Jester,"
> by L. G. REDMOND-HOWARD.)
>
> ". . . . in 'Rahere' we have a figure who should be as dear to England as Joan of Arc is to France—if we could only realise the vastness of the tradition which he left behind and which has become part of the national character—I mean charity."
>
> (*From the Preface to the above Ballad.*)

9.8. Title page of Canon Savage's fundraising appeal, 1930.
St Bartholomew's church archives

experience at Hexham Abbey made him an able and committed custodian of the fabric of St Bartholomew's as restoration work came to an end and the area around the church was finally consolidated. In 1931 the Restoration Committee was wound up. For nearly sixty years its efforts had dominated church life and this had taken its toll – restoration fatigue had set in and the parish felt that, as the building was now sound, the committee's work was done. Those who given so much to the programme all died around this time: Alfred Webb on 23 July 1929 and Sir Aston on 21 August 1930.[64] They had quite literally saved the church from the ravages of age and their work to restore, rather than to rebuild – to preserve for the next generation that which had been founded to last for generations to come – remains at the heart of the church's mission today.

Nevertheless, works remained to be done in order to improve the church. Rector Savage preached an impassioned sermon on 9 February 1930, saying:

I have a definite duty to perform. It is my privilege and burdensome responsibility to be the successor of rectors who have given of their best, at no little cost to health and strength, in conserving and restoring the Church. The names of rectors Sandwith, Savory, Panckridge, and others, are writ large and indelibly

64 Aston Webb obituary, *The New York Times*, 22 August 1930, p. 11.

9.9. Photograph of *The Acts of Rahere* performed by candle-light in the priory church, 1929. *The Sphere* magazine

on the walls of this ancient building. After the inglorious spell of indifference, neglect and vandalism of Georgian and Victorian days, the Church now raises our thoughts, as it was ever meant to do, from the meanness of this material world to the duty of man to his God. The Church to-day is resonant with thanks to those to whom it owes its re-awakening. It is our part to see that, not only there is no reaction to the appalling lethargy of those decadent days, but that it is vocal with all good things to-day.

This sermon called for the installation of electric lighting (which still had not been completed despite the Restoration Committee having approved it in 1906), the erection of a new pulpit in a place where the acoustics of the church would allow the preacher to be heard properly, the insertion of panels into the choir screen to reduce drafts, fitting up the rooms over the gatehouse to make them habitable, the erection of a memorial to E. A. Webb in the form of a clergy vestry, and the settlement of £900 of debt unpaid for work on the cloister.[65]

Rector Savage's deep love of St Bartholomew the Great is evident in every line of the sermon, and in his introduction to the appeal booklet issued shortly thereafter (fig. 9.8). Such obvious affection was powerfully persuasive in itself, but the church also took other expedients to raise the money needed for the works. Performances of *The Acts of Rahere*, a pageant play written by Miss E. Werge-Oram (a pseudonym combining the names of Evelyn Werge Thomas and her companion Eanne Oram) had begun in 1929 (fig. 9.9); Savage thanks the author in the introduction to his fundraising appeal.[66]

[65] The Rev'd Canon E. Sidney Savage, 'Rahere Yesterday and Today, and His Priory Church of St Bartholomew, Founded in 1123: Its chequered story and an appeal' (London: 1930). The money for the pulpit of Savage's day, a Roman-style ambo located to the east of the stone screen separating the north transept and the choir, underneath the place now occupied by the Chamberlayne monument, had been given by Charlotte Hart, late sextoness of the parish: Webb, *Records*, II, pp. 419, 421. There was no soundboard above this pulpit, and Canon Savage notes that parishioners were unable to hear distinctly when any sermon was preached from it.

[66] 'Pageant Drama Acted in Church', *Daily Mirror*, 18 November 1929, p. 23.

With the church now closer in appearance to its medieval foundation that at any time since the Reformation, it provided the ideal setting for celebrating the life of its founder. On 19 October 1931 there took place the first of many performances of *Rahere*, a new pageant play written by Jean Scott-Rogers and directed by John Wyse, who had previously played Rahere in Werge-Oram's production. The celebrated illustrator Charles Pears produced a poster advertising the new play for the London Underground (fig. 9.10).

Scott-Rogers's pageant told the story of Rahere and his vision in Rome, bringing the audience back to the very stones that would be his foundation. St Bartholomew's was to be, in the words of the play, 'The Wonderful Monument of Stone' which has come down to us through the centuries, 'a perpetual inspiration and joy'. The finale was a moment of silence as the actor playing Rahere contemplated the founder's tomb lit by a solitary candle in his hand. These performances aimed to raise funds for urgent repairs to the roof, which had been invaded by death-watch beetle.[67]

9.10. Advertising poster for *Rahere* by Charles Pears, 1931 (© TfL from the London Transport Museum collection)

In 1932, painted panels highlighting incidents in the pageant and telling the story of the foundation of the monastic community and the hospital, painted by Frank Beresford, were inserted into the wooden choir screen at the west end of the church (see fig. 12.6 below).[68] These formed part of the programme of improvements that Rector Savage had outlined in his sermon of appeal two years previously. Electric lighting and a new pulpit were also installed, and the gatehouse made habitable as a residence for the rector. On 11 July 1932, the Lord Mayor unveiled the choir panels and opened the newly restored gatehouse, and the president of the Royal Academy unveiled a memorial tablet to Aston Webb (see fig. 10.10).[69] Thus the church was prepared for the next phase of its life through the dedication of its rector and the generosity of its friends.

In 1944, Canon Savage retired to Bexhill, where he had long owned property. He died on 26 October 1947, aged 85, and was remembered with a memorial service at St Bartholomew's on 7 November 1947, at which Dr Newell Wallbank, Savage's successor as rector, presided. Savage's obituary in the *Times* praised 'his warm vitality and personal magnetism' and the

67 *The British Journal of Nursing*, November 1931, p. 303.
68 For more on these panels, see the chapter by Peter Delaney in this book.
69 *Daily Mirror*, 12 July 1932, p. 21.

way that the 'musical quality of the services' at St Bartholomew's during his tenure 'gave worthy expression to the beauty of worship and prayer'.[70]

ST BARTHOLOMEW'S DURING THE SECOND WORLD WAR

The City of London was a principal target of German bombers throughout the Blitz, from its beginning on 7 September 1940. There followed 57 days of continuous night attacks. In consequence of the Blitz, the Great's late-medieval bells – along with those of St Bartholomew the Less and St Andrew Undershaft – were removed to Cleeve Abbey in Somerset for safekeeping.[71] They were only returned to the tower in 1953.[72]

To the enormous credit of the City's authorities, daily life went on throughout, despite the devastation the bombing caused. Even while the bombing was extended to other cities, London continued to be bombed into 1941, with raids nearly destroying the Mansion House and the Bank of England in January 1941. On 10 May, the Luftwaffe launched the most intense raid of the Blitz, killing nearly 1,500 people and destroying 11,000 homes. Nearby Butchers' Hall was hit by a V1 flying bomb on 31 July 1944; miraculously no one was killed. On 8 March 1945, as the war was nearing its close, Smithfield was hit again by a devasting V2 rocket attack. 110 people were killed and a further 123 seriously injured.

In token of what would be mythologized as the 'Blitz Spirit', St Bartholomew the Great continued to host weddings throughout the war. Newell Wallbank, Savage's godson and curate and later his successor, married there in January 1942. His wife, Phyllis, later recalled the devastation around the church: 'It was war time and the City had received terrible devastation by fire and by high explosives. Dear St Bartholomew's was still standing in spite of all the buildings in Little Britain and around the church having been reduced to rubble […] we decided it was too dangerous with air raids to keep people around in London, so we had no reception but went straight to Paddington station to spend our honeymoon in Devon.'[73] On 19 April 1941 Andrew Cavendish and Deborah Mitford, the future Duke and Duchess of Devonshire, were married in the church. Their reception went ahead in at the bride's family's London home in Rutland Gate despite the windows having been blown out by an air raid the night before.[74]

St Bartholomew's survived the London Blitz, as it had the Great Fire and the First World War. Canon Savage continued actively serving the parish almost to the end of the war, retiring in 1944 aged 83. His curate Newell Wallbank, who was frightened of heights, and others saved the church by kicking incendiary bombs from the roof as they fell around them. Unlike so many churches in the City – and unlike many of the buildings immediately surrounding it – St Bartholomew the Great emerged from the Second World War relatively unscathed, thanks to the heroism and perseverance of its clergy and congregation.

70 Notices in *The Times*, 28 October 1947, p. 1; 31 October 1947, p. 1. Obituary in *The Times*, 3 November 1947, p. 7.
71 *The Sphere*, 13 September 1947, pp. 18–19.
72 *Coventry Evening Telegraph*, 10 December 1953, p. 13.
73 *St Bartholomew the Great: Sixty-Five Years of Weddings* (London, n.d.).
74 'Mitford Wedding in London', *Press and Journal*, 15 April 1941, p. 2.

9.11. Photograph of Rector Wallbank distributing hot-cross buns at the Butterworth Charity on Good Friday, c. 1956, St Bartholomew's church archives

THE REVEREND DR NEWELL EDDIUS WALLBANK, RECTOR 1944-79

Newell Wallbank was born in Hexham; his father was organist and choirmaster at Hexham Abbey. Educated at Bloxham School and Queen's College, Cambridge, he won the University scholarship and took his BA and Mus. Bac. degrees at the age of nineteen. Three years later he obtained his Mus. D. from Trinity College, Dublin, and was thought to be the youngest holder of that degree in Europe at the time.[75] He arrived in 1939 as a curate and spent the entirety of his ministry at St Bartholomew's, retiring in 1979 after 35 years as rector. For most of the second half of the twentieth century he and his wife Phyllis were an energetic and beloved presence in the parish (fig. 9.11).

Music and education were at the heart of the parish during their tenure.[76] Mrs Wallbank founded England's first all-age Montessori school in the sitting room of the gatehouse rectory in 1948. At its inception, the Gatehouse School had eight pupils and operated on a shoestring budget; Dr Wallbank's stipend was modest, so Mrs Wallbank acquired her Montessori materials second-hand and the children sat on inexpensive bathroom stools which she had stripped of their cork and painted. At the end of each day, the learning materials and stools were cleared away, and the schoolroom once again became the rectory sitting room. Within a few years the fame of the school had spread without the need for advertising (it accepted students of all backgrounds and abilities, including the profoundly

75 *Newcastle Journal and North Mail*, 18 November 1944, p. 2.
76 For more on music at the church under Newell Wallbank, see Nicholas Riddle's chapter in this book.

9.12. Photograph of children from the Gatehouse School doing their lessons in the churchyard, 1951 (TopFoto)

disabled, and helped them achieve remarkable success), and with it the number of pupils had grown. The school began to occupy the cloister and – on fine days – the churchyard (fig. 9.12), where the children did their lessons, ate lunch, and napped among the gravestones. By the early 1960s, the number of students had grown beyond the capacity of the church to accommodate, and the school moved into premises first in Clerkenwell and later in Bethnal Green.[77]

The Wallbanks had a famous neighbour, the poet John Betjeman, who lived just across Cloth Fair from the church. A reporter described Betjeman's answer to a question about his churchmanship thus:

Although I'm High, I don't mind Low. I don't even mind Middle Stump. That one – he pointed across the road to St Bartholomew the Great – is Middle Stump. Would you like to see it, before I go off to the dentist?[78]

Affected insouciance aside, in Betjeman's estimation the services at St Bartholomew's in Dr Wallbank's time could still be described much as they had been in Sir Borradaile's – high, but moderate. 'Middle stump' or not, St Bartholomew's continued to attract the great and the good. On 10 November 1951, Queen Elizabeth the Queen Mother (then simply Queen

77 'Phyllis Wallbank, educationalist who founded Britain's first all-age Montessori school', *The Telegraph*, 27 April 2020.
78 *Sunday Dispatch*, 26 October 1958, p. 2.

221

Elizabeth) and her daughter Princess Margaret, later Countess of Snowdon, attended the wedding of her niece, Mary Bowes-Lyon, to Lieutenant Timothy Colman RN.[79] On 15 September 1964, a memorial service for the novelist Ian Fleming, creator of James Bond, was attended by intelligence agents and newspapermen in approximately equal numbers.[80]

The Wallbanks retired to Dorney, near Windsor, in 1979. Dr Wallbank continued to take services at Eton College, and Mrs Wallbank to help dyslexic students there. In 1984, Mrs Wallbank founded the London Run Charitable Trust, which works to support rough sleepers. In 1996, she was honoured with both an MBE and the Roman Catholic Benemerenti Medal for her work with the homeless. She continued to lecture on education well into her eighties. Newell Wallbank died in St Bartholomew's in March 1996 during a memorial evensong for one of the directors of music who had served alongside him.[81] At the time of his death, the Wallbanks had been happily married for 54 years. Phyllis Wallbank died on 9 April 2020.[82]

THE CHAPEL OF THE SOCIETY OF KNIGHTS BACHELOR

In March 1961, the council of the Imperial Society of Knights Bachelor met at Butchers' Hall, their deliberations preceded by a visit to St Bartholomew the Great.[83] For some years the Society had been looking for a suitable church in which to locate a chapel for its use, without any great success until the archdeacon of London, Oswin Gibbs-Smith, suggested St Bartholomew's. Their reconnaissance confirmed them in their view that the priory church, with its powerful atmosphere of a bygone age of chivalry, would be an admirable venue for their corporate services. Rector Wallbank was amenable, encouraging even, perhaps because the suggestion been made that he should become chaplain to the Society, and offered them the space at the east end of the south aisle as a shrine and focus for their presence. 'He envisaged a register of all members of the Imperial Society in the form of a book resting on a prie-dieu at the side of the altar [...] and would prefer a crucifix to a cross on the altar.' Lord Mottistone of Seely and Paget architects, whose offices were in nearby Cloth Fair, was chosen to design the small chapel, but in January 1963 he unexpectedly died before any progress could be made. The following five years were filled with protracted discussions as to how this small space, variously described as a 'wayside shrine' and a 'small alcove' should be furnished, but by the early months of 1968 the chapel boasted a dossal curtain, altar candlesticks and a cross by Leslie Gordon Durbin – the silversmith of choice for many an institution – a crimson, Laudian altar frontal with the lapel badge of the Society, stainless steel altar rails and a panel of stained glass depicting the Knights Bachelor badge in the window behind.

79 *The Sketch*, 21 November 1951.
80 *Belfast Telegraph*, 16 September 1964, p. 2.
81 For more on Rector Wallbank's death and on music at the church during his tenure as rector, see the chapter by Nicholas Riddle in this book.
82 Phyllis Wallbank obituary, *The Times*, 1 May 2020.
83 The author is indebted to the Reverend Dr Peter Galloway for this information, which is published in his *The History of the Imperial Society of Knights Bachelor* (London: Spink & Son Ltd, 2021), pp. 247ff.

The much-anticipated service of dedication took place on 10 July, conducted by the bishop of London, Robert Stopford (1961–73), in the presence of Queen Elizabeth II and the Duke of Edinburgh. Sir Arthur Bliss, Master of the Queen's Music, composed an anthem for the service to words taken from Psalm 15 and a trumpet fanfare which was sounded to mark the arrival of Her Majesty. Dr Wallbank, now confirmed as the Society's chaplain, was very content with the splendour of the occasion. It inaugurated a tradition of an annual service that continues to this day – but no longer at St Bartholomew's, as the Society, having decided that a larger chapel was required, left the priory church in 2005. Only the stained-glass roundel and the altar rails remain to mark where the chivalric shrine once stood.

THE REVEREND ARTHUR WILLIAM STAWELL BROWN, RECTOR 1979–91

At some stage in Newell Wallbank's incumbency, the advowson of St Bartholomew the Great was transferred to the Dean and Canons of Westminster Abbey, perhaps in an attempt to safeguard the Prayer Book Catholic tradition it shared with the Abbey at the time. Arthur Brown was appointed rector by the Abbey in 1979 and served the parish for twelve years until 1991. Trained at Cuddesdon Theological College, he had started his ordained ministry as vicar of St Alban's, Portsea, a parish with an established moderate Anglo-Catholic tradition. From 1981 to 1991, to provide himself with adequate accommodation, he combined his role as rector of St Bartholomew's with that of St Sepulchre Without Newgate, where, as a bachelor, he could live comfortably in the attached watchhouse, and which in the 1980s did not have regular Sunday services. Parishioners recall an immaculately turned-out figure who would travel all over London on his tricycle sporting a black suit and homburg in the winter and a linen jacket and panama hat in the summer months. Services were conducted in accordance with the Book of Common Prayer, with not much enthusiasm for the contemporary language Alternative Service Book which appeared in 1980. He went on to spend the last three years of his ministry as chaplain to Holy Trinity, Madeira. He died in 2020 aged 94.[84] He was succeeded first by the Reverend David Lawson, from 1991 to 1993, and the Reverend Dr Martin Dudley, from 1995 to 2016, before the present rector, the Reverend Marcus Walker, was instituted in February 2018.

The church building we so value and enjoy today owes its survival to the determination of successive architects, builders, rectors and parishioners. That a 900-year-old building is still standing is a feat of engineering. That it is still true to the vision of its founder is a feat of devotion and commitment. Unlike the wreckers who for personal gain exploited the Reformation and the religious and civil turmoil that followed, the modern custodians of St Bartholomew's restored the building and revived its spiritual life with deep respect for the past and great personal and financial sacrifice. For those worshipping in the church today, the debt of gratitude to the leading lights of the last 150 years is almost as great as that to Prior Rahere himself.

84 *The Church Times*, 6 November 2020.

The 'Great Restoration' of Aston Webb and Sons

EVAN MCWILLIAMS

WHEN THE COMMISSION for the restoration of St Bartholomew the Great came in 1885 to architect Aston Webb (fig. 10.1), it brought great responsibilities, but potentially also great rewards. 'When introduced to the work of restoration at the first meeting of the committee [...] his heart almost failed him. It was his first real work, and, though he had done many larger works since, nothing has since given him the same amount of real anxiety.'[1] Webb's new opportunity was the latest in a series of attempted restorations or rebuildings of the church. In 1790, St Bartholomew the Great had been in danger of complete demolition. A plan concocted 'under the weak pretence that a certain part of the Choir was then in imminent danger of falling' threatened to destroy the ancient gem of Smithfield entirely, until judicious repairs by Thomas Hardwick (1752–1829) saved the day.[2]

In 1857, William Slater (1818/19–1872), one-time chief assistant to R.C. Carpenter (1812–1855), had prepared a design for restoring the church. He intended to reinstate an apsidal eastern termination, and to add stone vaulting over the present church. Nothing came of this proposal.[3] The increasingly decrepit building had to wait until 1863, when the rector, the Reverend John Abbiss, met his churchwardens Joseph Boord and W.H. Jackson, the vestry clerk Thomas Kitt and architects T. Hayter Lewis and William Slater to discuss a new restoration campaign. Lewis (1818–1898) had been invited to be architect for the restoration and was not only distinguished – he was soon to be Professor of Architecture at University College London (1864–81)[4] – but had rebuilt the distilleries for Boord's firm, Boord and Beckwith of Bartholomew Close.[5]

Dr McWilliams and the editor would like to express their profound gratitude to Dr Ian Dungavell, who generously shared the fruits of his research on Aston Webb with us. Dr McWilliams's task has largely been to select and arrange, rather than to extend or improve upon, Dr Dungavell's thorough and meticulous work.

1 *City Press* (12 March 1898).
2 *Gentleman's Magazine*, LXXIX (March 1809), pp. 226–27. Hardwick's drawings of the church are in the library of the Society of Antiquaries, along with drawings by Lewis and Slater, Aston Webb and Maurice Webb. For more information on the Hardwick restoration, see the chapter by Steven Brindle in this book.
3 Webb, *Records*, II, p. 380.
4 J. Mordaunt Crook, 'Architecture and History', *Architectural History*, 27 (1984), p. 555.
5 As a young man, Lewis had worked in the office of Sir William Tite, another member of the committee: *RIBA Journal*, 3rd series, VI (1899), pp. 126–30.

10.1. Sir Aston Webb by Solomon Joseph Solomon, c. 1906, oil on canvas (© National Portrait Gallery, London)

Encouraged by Lewis and Slater's report on the church of 27 May 1863, it was decided to establish a formal Restoration Committee.[6] The assistance of the great and the good was sought and the committee eventually included churchmen, antiquaries, architects and neighbourhood luminaries. William Cubitt MP was chairman, succeeded on his death in late 1863 by William Tite MP (1798-1873).[7] Among the architects and antiquaries were J.W. Butterworth, Benjamin Bond Cabell, Thomas Lott, J.H. Parker, R.N. Phillips, A.J.B. Beresford Hope, president of the Ecclesiological Society, the Reverend John Lewis Petit,[8] C.F. Hayward,[9] Philip Hardwick and P.C. Hardwick,[10] and Edward I'Anson.[11] John Hilditch Evans, uncle of the young Aston Webb, was also a member of the committee As a means of drawing attention to the proposals and soliciting funds, an 'archaeological meeting' was held in the church on 13 July 1863. The Reverend Thomas Hugo gave an account of the monastic establishment, John Henry Parker lectured on the architectural history of the building, and Beresford Hope concluded 'with an exhortation to liberality and of encouragement to the participants in the work'.[12]

By March 1864, sufficient money had been raised to proceed with work necessary to protect the fabric of the building. Several centuries of surrounding development meant that the church was embedded 'about twelve feet below the surface, in the very midst of a crowded throng of tottering inhabitations'.[13] By excavating around the outside of the church to create a dry area and by lowering the floor inside two-and-a-half feet to its original level, not only would drainage be improved and damp alleviated, but the 'ancient fine proportions' of the interior would be restored and the bases of the Norman columns would become visible once again. The interior masonry would be improved by having 'the thick coats of whitewash cleaned (not *tooled*) off',[14] any tablets which 'cut into the ornaments or mouldings of the church' would be removed to the south aisle, and damaged stonework would be repaired as necessary.[15]

Something also had to be done with the east wall of the church, which was crumbling. The Norman apse had been squared off in the fifteenth century, when it was thought

6 Guildhall MS 3993, p. 214. Webb, *Records*, II, p. 382 gives the month as April. The report is reprinted on pages 536-44.
7 Cubitt died 28 October 1863. Brother of the builder Thomas Cubitt, he was Lord Mayor of London (1860-62), Conservative MP for Andover (first elected 1847) and president of St Bartholomew's Hospital. For an obituary see *The Builder*, XXI (1863), pp. 777, 818.
8 Petit was a well-known archaeologist, artist and writer on architecture. For an obituary see *The Builder*, XXVI (1868), p. 926.
9 Hayward (1830-1905) had been assistant to P. and P.C. Hardwick: *The Builder*, LXXXIX (1905), p. 72.
10 Son of Thomas Hardwick, Philip Hardwick (1792-1870) succeeded his father as architect to St Bartholomew's Hospital in 1826. P.C. Hardwick (1822-92) took over in turn as architect in 1856. See Howard Colvin, *A Biographical Dictionary of British Architects 1600-1840* (London: J. Murray, 1978), p. 386; *The Builder*, XXIX (1871), p. 24; LXII (1892), p. 108.
11 Edward I'Anson (1812-1888) was for many years the surveyor to St Bartholomew's Hospital, where he built a new medical school and library. He restored the Dutch Church, Austin Friars, in 1865-66: *The Builder*, LIV (1888), pp. 77-78.
12 *The Builder*, XXI (1863), p. 511. Parker's lecture was reprinted in *Gentlemans' Magazine*, CCXV (October 1863), pp. 391-406.
13 *The Ecclesiologist*, XXV (1864), p. 277.
14 Report by Lewis and Slater, April 1863: Webb, *Records*, II, p. 538.
15 Amended report of the architects, 14 March 1864: Guildhall MS 3993, pp. 260-62.

that Perpendicular windows were inserted and a reredos installed. This in turn had been destroyed early in the seventeenth century, when the existing wall was built. There were, according to Lewis and Slater, three options for the rebuilding. The first was simply to leave the east end as it was. The second was to complete the east end on the square plan as built in the fifteenth century, but this presented problems, as 'no trace remain[ed] to decide whether the East end was finished with one, two, or three windows or what kind of tracery was used', and there was 'nothing to shew that the work proposed to be done in Perpendicular times was actually carried out'. In any case, 'the effect could never be at all equal' to the third option, rebuilding the Norman apse. Since 'no part remains of the Perpendicular work of such importance as that of the Norman church', Lewis and Slater believed that Norman must have priority.[16]

Unfortunately, a building extending from the ancient Lady chapel, then in use as a fringe factory, projected into the church over the apse and prevented any such plan being carried out in its entirety until possession of the freehold could be obtained. The architects' creative solution was to support the overhanging building on a girder and complete the restoration of the apse up to the level of the triforium floor. This inelegant construction would no doubt 'encourage some means being found for completing the good work, as you now, so zealously[,] are trying to do'.[17] It was an unusual and unsightly solution with an uncertain outcome; the Restoration Committee felt it necessary to postpone their decision while proceeding with the other repairs.

An application to the Incorporated Church Building Society for funds to repair and re-seat the church enabled that Society's committee to conclude the 'church is so valuable as an example of early building in London that it requires the most careful treatment and ought to be inspected'.[18] Their inspectors included the foremost church builders and restorers of the day – George Gilbert Scott, G. E. Street, J. L. Pearson, Benjamin Ferrey and Joseph Clarke.[19] They visited in July 1864 and made various recommendations as to the type and location of seats, but their real interest lay in the problem of the east end of the church: 'it is of the utmost importance everything should be done now that can towards effecting the proper restoration of this part of the Church'. That meant following Slater and Lewis's original proposal to reinstate the Norman apse up to triforium level using a girder to support the wall above. Although the existing east wall was 'not without interest', they thought that any traces of its construction could be preserved elsewhere in the church.[20]

The faculty granting permission to undertake these works was obtained in August 1864, and the construction firm of Dove Brothers had almost completed the excavation by November that year. More work was required than originally envisaged: deep graves near some piers had eroded their foundations, which needed underpinning, and repairs were

16 Ibid.; Webb, *Records*, II, pp. 536–44.
17 Guildhall MS 3993, pp. 261–62.
18 Incorporated Church Building Society (ICBS) file 6266, Report of the Committee of Architects, n.d., signed 'G. E. S' and 'J. H. P.'.
19 *The Times* (25 July 1864), p. 8. Joseph Clarke (1819/20–1888) built and restored many churches, working as the diocesan surveyor for Canterbury and Rochester. He was also a consultant architect to the Charity Commissioners: *The Builder*, LIV (1888), pp. 197–98.
20 ICBS file 6266, Report of the Committee of Architects, n.d.

required to walls, arches and columns. A second contract was made with Dove Brothers for this work in January 1865.[21] In spite of the parishioners' complaints that the church had been closed since the end of July 1864, contracts for additional works were also let in August 1865 and May 1866.[22]

In December 1866, although the work was mostly complete, instructions still had not been given for the tiling of the chancel or the final form of the seats.[23] By May 1867, the clerestory windows had been filled with tracery, new windows had been added at the east and west ends of the south aisles in place of former doorways, and a plain porch was constructed at the west end.[24] The church was eventually reopened by the bishop of London on 29 March 1868, but *The Builder* noted that visitors to the restored church might feel disappointed, as 'only those who know how much money an old building can absorb will believe that 6,000*l* have already been spent upon it'. Moreover, the iron girder arrangement at the east end was 'wretchedly ugly'.[25] The architects, in reply, pointed out that this arrangement had been sanctioned by the ICBS, and attempted to turn necessity into a virtue, by admitting 'there is, perhaps, less to be seen than in many other cases, as it has been our greatest care throughout to leave every portion of old work so far as possible untouched'.[26] Their overriding concern had been to preserve the church as an historical document, which included restoring a Perpendicular window 'because there were decided traces of an old one having existed, and we thought it better to preserve the history of changes in the church'.[27] Of course, it did not include retaining any traces of the detested eighteenth century, which could be happily expunged from the church's history as 'modern' (fig. 10.2).

The continuing difficulty of raising money for the work and their failure to acquire properties formerly part of the main fabric of the church seems to have sapped the committee's enthusiasm for further restoration. At the meeting of 27 May 1868, Joseph Boord – treasurer, church warden and one of the largest contributors to the restoration fund – resigned after a disagreement with Rector Abbiss.[28] It was over the relatively minor matter of heating and lighting the church, and was not even recorded in the minutes, but it was enough to bring that phase of restoration to a close.[29]

Despite the diligence of the 1863 Restoration Committee there remained much work to be completed: secular activities in long-since partitioned parts of the building interfered with the services, creating a noise nuisance and a fire hazard. The north transept was occupied by a blacksmith's forge; the triforium housed the parochial boys' school; the site of the chapter house was the girls' and infants' schools. Worst of all, the altar was still overhung by the fringe factory, which constituted 'a DESECRATION, great DISFIGUREMENT,

21 *The Times* (24 January 1865), p. 9.
22 Webb, *Records*, II, pp. 386–87. The works included restoration of side chapels and the straightening of the north aisle wall back to Perpendicular: *The Times* (8 January 1866), p. 12; *The Times* (17 January 1866), p. 12.
23 Guildhall MS 3993, pp. 346–47.
24 *The Times* (28 May 1867), p. 12.
25 *The Builder*, XXVI (1868), p. 249.
26 *The Builder*, XXVI (1868), p. 284.
27 William Tite to Editor, *The Times* (29 January 1866), p. 6.
28 Webb, *Records*, II, p. 387.
29 Guildhall MS 3993, p. 357.

INTERIOR OF ST. BARTHOLOMEW-THE-GREAT.

10.2. St Bartholomew's Priory, London: interior looking east, showing the girder arrangement. Wood engraving by A. H.W., 1868. Wellcome Collection

and IMMINENT DANGER to the whole Church from FIRE'.[30] Luckily for Aston Webb, who saw value in the ancient but still-scarred fabric, there was a long history of family involvement with the church. Just around the corner was Bartholomew Close, where John Evans, Webb's maternal grandfather, had lived since 1822,[31] and where the headquarters of Evans & Lescher, a family firm, had been since 1842.[32] Webb's own parents were married in

30 'Proposed Restoration of the Ancient Priory Church of St Bartholomew the Great, West Smithfield EC', 1885 (printed pamphlet, in ICBS file 8979)
31 Guildhall MS 4032 records John Evans at 57 Long Lane from midsummer 1824, at 63 Bartholomew Close from midsummer 1833, and at 60 Bartholomew Close from Christmas 1841.
32 A.E. Smeeton, *The Story of Evans Medical 1809-1959* (London: Evans Medical Supplies, 1959).

the church in November 1844.[33] Many of his relatives had not only been regular worshippers but also active participants in church committees: his uncle John Hilditch Evans was a church warden and sub-treasurer to the first Restoration Committee in 1863;[34] another uncle, Worthington Evans, was to sit on the 1885 Restoration Committee.[35]

In 1881, the Vestry of the neighbouring parish of St Botolph Aldersgate considered devoting some of its money to restore the structure of St Bartholomew the Great: 'The present condition of the church is simply a disgrace to the City [....] Something ought to be done to preserve the remains of this fine Norman structure, which is actually crumbling into decay, and to remove the hideous erections that abut upon and disfigure it.'[36] In 1882 it was clear that the tower was badly in need of repair and repointing, and that the roof was in a 'sad condition'.[37] However, by this time the Reverend John Abbiss, rector since 1819, was in his early nineties. He had last preached a sermon in December 1873, and his work since then had been performed by curates in charge.[38] It was not a climate favourable to the laborious task of restoration. Abbiss's death on 8 July 1883 therefore came as a rejuvenation for the parish. The patron of St Bartholomew's, the Reverend Frederick Parr Phillips, was Abbiss's nephew, and had no doubt felt reluctant to interfere to any great extent in his aged uncle's affairs, although he was keen to see the church restored. *The Builder*, too, thought that it was an excellent opportunity to renew efforts towards the restoration of the church.[39]

William Panckridge, the new rector, was instituted on 24 January 1884. At the ceremony, Phillips offered £1000 towards a restoration fund, clearly attempting to set the agenda for his new appointee.[40] In April 1884, Panckridge chose as his churchwarden Edward Alfred Webb (1850–1929), Aston's younger brother. Alfred was a partner in the firm of Evans, Lescher & Webb, whose London offices just around the corner Aston Webb had designed. Panckridge made a propitious choice, for Alfred was not only a competent administrator and a devout member of the congregation, he was also a polymath: he had taken several medals of the Pharmaceutical Society, was a fellow of the Linnaean Society and, more importantly, was an antiquary. He was deeply interested in the history of St Bartholomew's. His book, *The Records of St Bartholomew's Priory and of the Church and Parish of St Bartholomew the Great, West Smithfield* is a comprehensive history of the church from its earliest days, and includes an authoritative account of its restoration. Alfred, already living in an Aston Webb house and working in an Aston Webb office building, would have recognized the potential for his brother's involvement in the scheme.

Panckridge moved more slowly than Phillips might have liked. It was down to Phillips to suggest in September 1884 that a consultative committee should be formed to investigate the

33 Guildhall MS 6779/7, p. 95.
34 Guildhall MS 3993, p. 357; Webb, *Records*, II, p. 387.
35 Webb, *Records*, II, p. 545.
36 *The Builder*, XL (1881), p. 490.
37 *The Builder*, XLIII (1882), p. 638.
38 Webb, *Records*, II, pp. 373–75.
39 *The Builder*, XLV (1883), p. 743. See also the chapter by Jeremy Haselock in this book.
40 W. Panckridge to Thackeray Turner, 21 February 1884, SPAB.

acquisition of property which once been part of the church.[41] Clearly, if this restoration was to get any further than its predecessor, some of the alienated properties had to be reclaimed. At the first meeting of the consultative committee on 15 September 1884 the potential of the Webb brothers' collaboration was evident. Alfred reported that the blacksmith's forge on the site of the north transept at 10 Cloth Fair was owned by a Mr Debenham, who was 'not desirous but not unwilling' to sell it to the committee for £1250. Moreover, the tenants of the fringe factory on the site of the Lady chapel were vacating at Christmas, which might allow its purchase from the freeholder, Frederick Hindley of Hindley & Son.[42] Two of the major obstacles to the restoration no longer seemed insurmountable.

Since Aston Webb had conducted these preliminary enquiries, he was invited to be present at the next committee meeting on 11 October 1884. By this time, not only had Aston gained Debenham's agreement to part with 10 Cloth Fair, but Debenham had also offered a discount of £125 on the price, which was to be considered as his personal donation to the restoration fund. However, this would count for little if they could not purchase the fringe factory which overhung the altar. Aston's trump card was that he frequently did business with the owner, Frederick Hindley. With that promising piece of news before the committee, Aston was thanked for his help and invited to become a member.[43]

Hindley was prepared to sell, but convincing him to do so at a reasonable price was no easy matter. He had heard that some great improvements were planned in the area, and he wanted £8000 for the fringe factory site. Aston Webb's valuation was for £6150, considering that ancient lights would restrict any new building to two floors, that the local authorities would probably want the frontage set back to give greater width to the street, and that the market for such properties was currently depressed.[44] The committee offered £5500. Hindley would not consider it, nor would he agree to sell separately the portion overhanging the church. Yet the committee knew that no restoration could be successful without the acquisition of this property, and so finally a refusal at £6500 was agreed in March 1885.[45]

There remained, however, the vital problem of raising cash. A new Restoration Committee was formed, and an appeal launched. Canon Edmund Venables, precentor of Lincoln, for whom J.L. Pearson had worked on Lincoln Cathedral, wrote a long letter to *The Times*, describing the history and present state of St Bartholomew's and asking for support.[46] Yet there was still no plan for the restoration, and no architect had been appointed to superintend it. As Rector Panckridge wrote in March 1885, 'We have not thought much about the Restoration, and certainly have taken no step in that direction. Mr Aston Webb, my Churchwarden's brother, has been asked to give a report, but if a Restoration Committee is appointed they will of course select their own architect'.[47] The choice of architect would be a very sensitive matter.

41 Guildhall MS 3993, pp. 346–47.
42 Guildhall MS 3993, pp. 362–63.
43 Guildhall MS 3993, pp. 364–66.
44 Guildhall MS 3993, p. 373.
45 Guildhall MS 3993, pp. 376–81.
46 *The Times* (9 April 1885), p. 4.
47 Panckridge to Powell, 18 March 1885. SPAB.

Although Webb had a strong claim to be considered on account of his successful negotiations for the fringe factory and the blacksmith's forge, he was hardly an experienced church restorer. His sole achievement in that field was the restoration of St Helen's, Worcester (1879), which had involved extensive rebuilding and was no model for the present work.[48] He had built a couple of churches, neither of them in London, and several houses, but his largest works had been commercial ones, most notably the Evans, Lescher & Webb building at 60 Bartholomew Close. Through his competition entries for the new Admiralty and War Offices (1884) he had become more widely known, and his presidency of the Architectural Association (1881–82) was evidence of the esteem of his contemporaries. Ultimately, it was his long family connection with the parish that counted strongly in his favour. Panckridge also favoured Webb for the job. Phillips, however, was still smarting from the criticism he had suffered as a result of Ford and Hesketh's destructive restoration of his own church at Stoke d'Abernon in 1866, and wanted the reassurance of a more established church architect.[49] Panckridge delicately raised with Alfred the suggestion that Aston work in association with 'some man like Pearson'.[50] There is no record of Aston's response to the proposal, but subsequent events show that he was able to resist it.

In the meantime, the Webb brothers team was proving its worth. Subscriptions to the restoration fund were forthcoming from the extended family, and Aston provided advice on who should and should not be approached for their help: 'Ruskin I should certainly not write to, he will only be very abusive. "Restoration" is a perfect red rag to him,' he wrote to Alfred.[51] When support did not materialise as quickly as it was needed, Aston was also instrumental in negotiating with Hindley for an extension of time on the refusal of the fringe factory, which was granted until 15 May 1885.[52] At the same time, he was preparing his report on the required works.

There is no doubt that Phillips, the patron, wanted to see the apse completed as Lewis and Slater had planned in 1863-68. In February 1885, he offered to pay for the part of the fringe factory which projected into the church and directed that the £1500 he had donated so far should be spent on the restoration of the chancel or apse.[53] The Society for the Protection of Ancient Buildings (SPAB) had made clear their ideas on the subject much earlier. In October 1884, Thackeray Turner had written to the rector and church wardens on behalf of the Society. In its view, the overwhelming need was to secure the church from the danger of fire by purchasing adjacent properties, and to acquire such remains of the original

48 *The Builder*, xxxvii (1879), p. 468; *Building News*, xxxvii (1879), p. 122.
49 Ian Nairn and Nikolaus Pevsner, The Buildings of England: Surrey, 2nd revised (London: Penguin, 1971), p. 456, describes it as 'Possibly the classic example of bad restoration, the worst even in Surrey'. Panckridge wrote to Alfred Webb, 29 January 1885, that the criticism Phillips received on restoring his own church some time ago made him 'both savage and anxious' and 'really afraid of public opinion' (Guildhall MS 20,794/1). However, Ian Dungavell found no contemporary comment in the *Athenaeum*, *The Builder*, *Building News*, *Church Builder*, *Ecclesiologist* or the *Times*.
50 Panckridge to E.A. Webb, 29 January 1885: Guildhall MS 20,794/1.
51 Aston Webb to E.A. Webb, 31 March 1885: Guildhall MS 20,794/1. Contributions came from many members of the Webb and Evans families, and a disproportionate number of subscribers came from Chislehurst, where Alfred lived. See Guildhall MS 20,792 for a list.
52 Guildhall MS 3993, pp. 391, 393.
53 Guildhall MS 3993, p. 378.

buildings as still existed in the vicinity. Its opinion was also formed on two other points: the old houses clustered around the church must not be demolished (fig. 10.3), and the temporary apse arrangement as installed by Lewis and Slater should remain. The SPAB was decidedly conservative: Morris's 1877 manifesto had pleaded for protection rather than restoration, and 'to resist all tampering with either the fabric or ornament of the building as it stands'.[54] So even if the houses crowding around the church were not all themselves medieval, at least they represented a typical medieval arrangement, and formed a picturesque veil to the makeshift architecture of the fragmentary church.

10.3. Houses crowding around the Poor's Churchyard, 1877 (© Museum of London)

It was better, according to the SPAB, not to perpetuate the errors already made during the 1863–68 restoration. Seeking to rebuild the Norman apse neglected 'the very obvious alterations that had been made to it in the 13th and 14th centuries', and, as similar changes had been made at Norwich, Canterbury and Gloucester, no further destruction of this work should be permitted. But what should be done with the unsightly iron girders? The SPAB advised masking them with oak panelling of clearly modern design. Most importantly, 'in any new work to be done the idea of imitating or restoring the ancient work of the building [should] be altogether abandoned [...] so the genuine old work for which the church is prized shall not be confused with modern work of similar form'.[55]

Webb took this letter seriously, although he knew they would always be at loggerheads with the SPAB about the completion of the apse.[56] Panckridge was not keen to 'begin touching the fabric'; he was more interested in removing the boys' school from the north triforium than in rebuilding the east end. Although he did not object to the proposal, he confided to Mr Powell of the SPAB that, if he succeeded in building new schools, he would 'think [he] had done enough in the brick & mortar line leaving it to another incumbent to undertake the responsibility of restoring the church'.[57] Ultimately, it was the patron, Canon Phillips, who set the restoration agenda.

54 May Morris, *William Morris: Artist, Writer, Socialist* (Oxford: 1936), I, pp. 109-12, quoted in Wim Denslagen, *Architectural Restoration in Western Europe: Controversy and Continuity* (Amsterdam: Architectura & Natura Press, 1994), p. 71.
55 Thackeray Turner to rector and church wardens, 8 October 1884: Guildhall MS 20,794/1.
56 Aston Webb to E.A. Webb, 31 Mar 1885: Guildhall MS 20,794/1.
57 Rector Panckridge to Mr Powell, 18 March 1885. SPAB.

In April 1885, a SPAB sympathizer wrote anonymously to the *Athenaeum* to oppose any plan to restore the church beyond the removal of the encroaching buildings. The correspondent thought that, though a fringe factory overhanging the altar was 'no doubt indecent', its existence was 'the fault of the "restorers" rather than the fringe makers'. If the 'bogus Norman arcade' had never been erected, there would have been no such indecency in the first place. Canon Venables wrote to defend the plan to reinstate the arcade, and soon the matter was dropped.[58] Webb took the precaution of discussing the proposals with Sir Edmund Lechmere and A. J. B. Beresford Hope.[59] Unsurprisingly, Beresford Hope – who had been a member of the earlier Restoration Committee – approved of the plan to complete the apse and ridiculed the suggestions of the SPAB.[60]

On 4 June 1885, once the negotiations for the properties had been successfully completed, Aston Webb was officially appointed architect to the committee and invited to prepare a scheme for the restoration of the church. By then, the members can have had no doubt about his carefulness, but they were still wary of his inexperience, for they added the condition that the committee was free to 'consult with any recognised leader of the profession on any difficult points that may arise'.[61] Still, it was better this way than working as junior partner to a more prominent architect. In recognition of his previous work, Hayter Lewis was also invited to join the committee.

On 15 December 1885, Webb presented his report and plans to the committee. Firstly, the apse was to be completed. This was a foregone conclusion: Beresford Hope had sanctioned it, Phillips would pay for it, and Venables had written about it in the press. Webb paid lip service to the concerns of the SPAB by insisting that his plans would preserve 'all the present traces of the architectural history of the building': he would be using the jambs (the sole remains) of the large fifteenth-century east window and 'taking out only the modern wall between and turning an arch over these jambs, *thus preserving all indications of the square end*, and forming a sanctuary arch with a straight wall over'. The question was when 'modern' and therefore removable work became 'historical' and inviolable; Webb's 'modern' wall dated from the mid-seventeenth century. There was to be quite a lot of new work: a new roof, new shallow transepts, a new west window and new school buildings. The roof, which was 'without architectural character' and leaked badly, would be replaced with one of oak of a similar pitch. The north and south transepts would be rebuilt in 'a late character', though shallower than their ancient plan, now restricted by rights of light and the cost of land. Webb also proposed a new west window and entrance porch, new seating and furniture, and a new school building which would allow the north triforium to be vacated. Webb was also keen to restore the Lady chapel and crypt beneath: although much cut about, enough remained to restore it 'to a great extent with certainty'.[62]

58 *Athenaeum* (4 April 1885), p. 449; (18 April 1885), p. 513; (9 May 1885), p. 607.
59 Nikolaus Pevsner, 'Scrape and Anti-Scrape', in *The Future of the Past: Attitudes to Conservation, 1174–1974*, ed. Jane Fawcett (New York: Whitney Library of Design, 1976), pp. 35–53 (p. 50).
60 Aston Webb to E. A. Webb, 11 May 1885: Guildhall MS 20,794/1.
61 Guildhall MS 3993, p. 400.
62 Guildhall MS 3993, pp. 407–17; reprinted in Webb, *Records*, II, pp. 545–49.

The plan was approved by the general committee on 26 January 1886, and a faculty granted on 24 March.[63] *The Builder* lent its approval as well, describing the restoration as a 'highly commendable act' which would bring credit to those involved 'if proper care be taken, as we are sure it will be by the influential committee, that the historical, architectural, and archaeological character of the building is not interfered with'.[64] Cautiously, Webb sought the advice of as many authorities as he could: he went over the church with St John Hope, Secretary of the Society of Antiquaries, J.T. Micklethwaite, vice-president of the Archaeological Institute, and a Mr Green, an 'amateur'. A few days before he had done the same thing with 'the shining lights of the S.P.A.B. – Wordall, Thackeray Turner & Philip Webb. To all these gentlemen I explained what I proposed and I believe as a whole they did not disapprove though for preference they would keep the iron columns & put up an oak screen!'.[65]

But the SPAB did disapprove, and wrote to the committee saying so. In a tone guaranteed to cause offence, Thackeray Turner wrote that the plan to rebuild the apse, though 'evidently well meant [...] would be, if carried out, a very great mistake and an enduring cause of regret'. If something *had* to be added, it would be best for the architect not to imitate the existing work, which would confuse history, but to work in his own style even though this would 'suffer seriously from juxtaposition with the ancient'.[66]

The Reverend W. Benham of the executive committee had 'not read a more cheeky document since the Manifesto of the three Tailors of Tooley Street, which began "We the people of England." I think the Rector should be deputed to punch the Secretary's head.'[67] Beresford Hope thought their objections 'thoroughly impractical' and hoped that the 'wise & successful plan of restoration' would continue.[68] The *Saturday Review* recognized that there were differences of opinion on the apse question, but thought it would be 'nothing short of foolish fanaticism to attempt now to undo what was then done [....] Mr Webb's plan preserves all existing traces of the successive alterations to the church, while he invests it with much of the original dignity and beauty of which these alterations have so long deprived it.'[69] Even *John Bull*, though regretting to find itself 'out of harmony with the Society', thought the old arrangement was simply too ugly to retain.[70]

The Builder agreed: 'Looking to all the conditions of the problem we cannot see a better solution of it than that proposed by Mr Webb [...] it can scarcely be contended, in the face of Mr Webb's designs, that we or our posterity will be the loser by the substitution of his nice art for the uncouth barbarisms which it will replace'. In its annual report, the SPAB remained hopeful that 'further representations [...] will lead to the abandonment of the

63 Guildhall MS 3993, p. 429; MS 20,777.
64 *The Builder*, xlix (1885), p. 912.
65 Aston Webb to E.A. Webb, 7 March 1886: Guildhall MS 20,794/1.
66 Thackeray Turner to Restoration Committee, 8 Mar 1886: Guildhall MS 20,794/1.
67 W. Benham to E.A. Webb, 22 April 1886: Guildhall MS 20,794/1.
68 A.J.B. Beresford Hope to Aston Webb, 22 May 1886: Guildhall MS 20,794/1. Panckridge used Beresford Hope's endorsement to defend the scheme in a letter to the *Daily News* (21 May 1886), saying: 'a more learned or consistent exponent of conservative architecture is not to be found'.
69 *Saturday Review* (20 March 1886), p. 401. E.A. Webb records that this article was by Canon Venables, although it is unsigned: Guildhall MS 14,375/1.
70 *John Bull* (8 May 1886).

plan' and urged its members to withhold financial support.[71] Yet *The Builder* found their annual report 'pathetically amusing [...] recounting the few successes of the Society and the numerous snubs they have received'. Considering SPAB objections to this and other restoration projects during the year, it said: 'Is it any wonder that some architects refuse to give any attention or reply to the views of such silly and impossible doctrinaires?'.[72]

With the SPAB almost the only objector to the restoration, work proceeded smoothly and was little commented on in the press. Dove Brothers were once again the lowest tenderers, and the contract was signed on 20 April 1886.[73] Work commenced on 4 May. By the end of October, the first phase of work had been completed. The square east wall had been removed and the upper part was found to contain tracery from what had probably been a large east window, but the great discovery was that the lower part was 'built of the remains of the original Norman Apsidal termination of the East End, thus permanently setting at rest the question of the original completion of the Norman Apse', as Webb triumphantly declared in vindication of his work.[74] Many stones were in perfect condition and retained a great deal of their coloured decoration.

The roofs had been entirely replaced except for the principal beams, which were found to be sound enough for reuse; the apse roof was boarded and moulded ribs added, as after 'partial removal of the scaffold the effect was found to be hardly dignified enough for its position'.[75] Various other works, mainly structural, had been executed, and Webb emphasized in his report that this was carried out *without the removal of a single worked stone from its original position*.[76] A representative of *The Builder* was present at the reopening service on 30 November 1886, and reported that the restored apse 'harmonises thoroughly with the rest of the building, for all its details are derived from corresponding measurements in the extant portions of ancient work'. However, the forge on the site of the north transept still required removal, as 'the unseemly clanging and the frequent vibrations caused by heavy sledges pervaded the whole building' during the service.[77] The SPAB was noticeably silent.

Having acquired the organ from St Stephen Walbrook, the rector wanted to place it and the choir stalls at the west end of the church, and to arrange the seats for the congregation facing each other on the model of a college chapel. This had the additional advantage of solving the problem of the treatment of the west end, which would benefit from being hidden.[78] The question of parish schools also had to be settled. Not only was it a pressing desire of Rector Panckridge to see the accommodation improved, but the existing premises had only been passed by the most recent government inspection on the condition that new premises would soon be built. In March 1886, a school building committee was established, with Panckridge as chairman and E. A. Webb as honorary secretary. In June 1886, Aston

71 Society for the Protection of Ancient Buildings, ninth annual report of the committee (June 1886), p. 38.
72 *The Builder*, L (1886), p. 841.
73 Guildhall MS 20,794/1.
74 Webb, *Records*, II, pp. 549–50.
75 Guildhall MS 3993, p. 459.
76 Webb, *Records*, II, p. 550.
77 *The Builder*, LI (1886), p. 798.
78 Guildhall MS 3993, ff. 439–41. For more on this organ, see Nicholas Riddle's chapter in this book.

ST. BARTHOLOMEW'S, BEFORE THE RESTORATION. ST. BARTHOLOMEW'S, AFTER THE RESTORATION.

104a,b. Contemporary colour engraving of the apse before and after
Webb's restoration. St Bartholomew's church archives

Webb submitted his plans for a new building, south of the Lady chapel, on a portion of the site vacated by the fringe factory.[79] Classrooms were provided over three floors: on the ground floor was the infants' school for 200, above was the girls' school, and above that was the boys' school, each of these to accommodate 120 pupils. An appeal went out in August but funds trickled in rather slowly, perhaps because the good will of potential donors had been exhausted by the appeals for the church itself.

The death of Rector Panckridge on 8 June 1887 was another setback, for he had been one of the major proponents of the scheme. So little had been finalized that in March 1888 the Restoration Committee asked the School Building Committee if their new schools could not be of two rather than three stories in height, so as not to dwarf the adjacent Lady chapel.[80] Webb began a new, reduced design, with the infants' and girls' schools sharing the ground floor, and the boys' above. Tenders were considered by the committee at the end of June and the contract was awarded to Mowlem & Co, which had undercut Dove Brothers'

79 School minutes, 22 March 1886: Guildhall MS 3999/2.
80 Restoration Committee, 9 March 1888 and 15 March 1888: Guildhall MS 3993, ff. 504, 507.

tender by £154.[81] The foundation stone was laid on 5 July 1888 by the duchess of Albany.[82] On finding that the foundations had had to be dug deeper than anticipated, the new rector, Sir Borradaile Savory, paid for the formation of two basement rooms beneath the classrooms, to be used for a boys' club and a men's club.[83] Other minor alterations had to be made to avoid legal action over ancient lights by the owners of adjoining properties.[84] The building was almost complete by the middle of March 1889, but it opened in mid-April without a ceremony 'in consequence of it being impossible to obtain the attendance of any person of note' (fig. 10.5).[85]

Phillips was anxious to get on with the restoration of the church in spite of a £1100 debt on the previous work. In March 1888, he had offered to rebuild the north transept himself to the value of £1000, on the condition that the Lady chapel was re-erected and the schools built. The committee agreed, although the cost far exceeded what they had available – Webb's estimate was £1,400 for the transept and £2,000 for the Lady chapel.[86] Thankfully, help was at hand from the Charity Commissioners: in January 1889, Ewan Christian, their architect, reported on the works necessary at the church and estimated that £8,000 would be required – leaving aside the restoration of the Lady chapel, which he thought should be left to private sponsorship.[87] He agreed with the works recommended by Webb in his report of November 1886, but

10.5. The church of St. Bartholomew the Great and surrounding area; exterior view of the schools rebuilt in 1889. Photograph by Rev. C. F. Fison. Wellcome Collection

81 B.E. Nightingale would have been cheapest had the decision been taken to build in stone and brick, rather than stone and flint. School Building Committee, 27 June 1888: Guildhall MS 3999/2.
82 Order of Service, 5 July 1888: Guildhall MS 14,375/1, f. 95. For an account of the ceremony, see *City Press* (7 July 1888).
83 School Building Committee, 3 August 1888: Guildhall MS 3999/2.
84 School minutes, 19 March 1889: Guildhall MS 20,824, f. 28. Webb made no charge for resolving the disputes over ancient lights, the value of which was estimated at £50 (f. 33). In September 1886 he had charged no fees for his negotiations with Hindley and survey of the fringe factory (Guildhall MS 3993, f. 457). In May 1890, his offer to forego his fee on the Panckridge memorial choir screen amounting to £16 15s was declined by the committee, but a donation of five guineas was accepted: Guildhall MS 3993, f. 570.
85 School Minutes, 19 July 1889: Guildhall MS 20,824, f. 28.
86 Restoration Committee, 9 March 1888: Guildhall MS 3993, ff. 503–04.
87 Webb, *Records*, II, p. 416.

funds would not be available until the scheme had been approved by the government. In the end, it was not passed by the Commons until 9 February 1891.[88]

The south transept was very dilapidated and let in the rain freely, so in March 1890 it was decided to anticipate the Charity Commissioners' grant and start work at once. Some members of the Restoration Committee wanted to rebuild the transept on the ancient plan, but rights of light would have prevented it. Nor would it have been possible to do so with the north south transept, part of which was now a public thoroughfare. Webb favoured a shallow transept. So too did Christian and – in the end – so did the majority of the committee.[89] The restored transept was opened on 14 March 1891 by the bishop of London.[90]

Renewed activity predictably brought more adverse comments from the SPAB. Thackeray Turner told readers of the *Pall Mall Gazette* that money should be spent on acquiring surrounding properties rather than making 'spurious antiquities' by rebuilding.[91] The SPAB annual report described the scheme as 'mischievous', since 'the new windows combine with those in the modern apse to destroy the solemn harmony of Rahere's choir, and the impression received is not, as before, that of a twelfth-century building, with mean but inoffensive additions, but it is almost that of a nineteenth-century edifice containing medieval remains'. The Society did, however, concede that 'laudable care has been taken to preserve the Norman arches and plastering revealed in the construction of the new transept, and that the junction of the old masonry with the new is everywhere apparent to the close observer'.[92]

Webb reported on the further works proposed to the church on 9 February 1891. The work allowed for by the Charity Commissioners included repairs to the tower and west front, the vaulting of the north and south aisles, re-roofing of the south triforium, repairing the old school and house over the north triforium, and building a shallow north transept and a vestry over the west porch. Their grant for this work, including the building of the south transept, was £5,406, whereas Webb estimated it would cost £5,900. Since the window in the new south transept had made the west window unnecessary for lighting the church, it could be built up rather than restored, thus saving £300. Webb proposed two porches in addition to the Commissioners' grant. One would provide an entry into the north transept from Cloth Fair and a room over for the verger. Since this transept was more visible than the south, he proposed to 'treat it a little more ornately and introduce a little ornamental flint and stonework'. The other would be at the west end of the church, with a small vestry over, and similarly decorated. Both were necessary to prevent draughts and would add to the appearance of the exterior. There were sundry other additional works which all together would cost roughly £2,500 in excess of the grant. The committee resolved to accept his plans and estimates for the next phase of the work.[93]

88 Webb, *Records*, II, p. 418. The scheme had to lie on the table of the House of Commons for eight weeks after it reassembled on 8 November 1890, but Sir John Lubbock had privately told E.A. Webb that it would be allowed to pass: Guildhall MS 3993A/1, f. 10.
89 Guildhall MS 3993, pp. 574-75. Webb's plan as approved is pasted in.
90 *The Builder*, LX (1891), p. 235. See also *The Times* (16 March 1891), p. 6; *Daily Graphic* (16 March 1891), p. 9.
91 Thackeray Turner to Editor, *Pall Mall Gazette* (19/20 December 1890).
92 Society for the Protection of Ancient Buildings, fourteenth annual meeting of the Society, June 1891, p. 29.
93 Guildhall MS 3993A/1, pp. 14-18; reprinted in Webb, *Records*, II, p. 551-52.

Most of this was complete by January 1892, except for the construction of the north transept and west porch and the re-casing of the west front. Webb presented designs for this work to the committee in February.[94] There was some discussion about the arcading that replaced the window on the west front, but Webb assured them that it was 'quite in keeping with the other work which he had introduced into the building', and the designs were approved.[95] Views of the new transepts were exhibited at the Royal Academy that year, and illustrated in *The Builder*. Webb noted that they 'caused no disturbance to the old work, but by providing abutments to the central arches add to their stability, and have merely involved the removal of modern walls hurriedly built to keep out the weather after the destruction of the original transepts'.[96] W. S. Frith was commissioned to provide a figure of Rahere, the founder, for the niche over the west porch, and one of St Bartholomew for the north porch.[97] Great ceremony accompanied the opening of the north transept on 5 June 1893 (fig. 10.6). Present were the Prince and Princess of Wales, the Duke of York, Princesses Victoria and Maud, and senior members of the church.[98]

10.6. The restored north transept surrounded by houses (c. 1895), view from Cloth Fair. St Bartholomew's church archives

Webb had wisely left his proposals for the Lady chapel as a postscript to his report of February 1891. It was needed neither for schools nor for the conduct of services, and had no funds provided by the Charity Commissioners towards its restoration. Although then in 'a most wretched and pitiable condition', incapable of repair and likely soon to fall down of its own accord, he thought it could be restored in a 'substantial but simple manner' for £2,800.[99] By November 1892 it was so dilapidated that a heavy fall of snow might bring it down.[100] But the committee preferred to wait until after the work funded by the Charity Commissioners was complete before starting on the Lady chapel.

In April 1894, Webb's proposals were presented to the committee. Since there was not enough money in hand for a complete restoration, Webb suggested that the bay immediately

94 Designs for the proposed west porch and for the proposed refacing dated February 1892 are in British Architectural Library, Drawings Collection, Dove Brothers U9.
95 Restoration Committee, 2 February 1892: Guildhall MS 3993A/1, pp. 50–56. Webb's report is in MS 20,794/1.
96 *The Builder*, LXII (1892), p. 455 (review); LXIII (1892), p. 225 (illustrations).
97 Restoration Committee, 19 July 1892: Guildhall MS 3993A/1, p. 63.
98 *Church Times* (9 June 1893), pp. 618–19.
99 Guildhall MS 3993A/1, pp. 14–19; Webb, *Records*, II, p. 552.
100 Aston Webb to Restoration Committee, 23 November 1892: Guildhall MS 3993A/1, p. 70.

10.7. Exterior view of the apse and the north side of the Lady chapel, under renovation. Photograph by W. F. Taylor. Wellcome Collection

adjoining the apse might be restored, so the Lady chapel would be visible from the church and visitors could see what remained to be done. The alternative was to restore the two easternmost bays of the chapel together with the crypt underneath, which could then be put into service as a mortuary chapel.[101] Only at the end of June did he present the more suitable plan of demolishing the existing buildings and erecting the walls and roof of the Lady chapel and leaving the decoration till later, which was adopted by the committee (fig. 10.7).

Since the walls only survived to sill level, Webb was left with a relatively free hand in the treatment of the elevations. Once again, the appeal emphasized that the new work, 'whilst harmonising with the old, is distinctive'.[102] The committee decided to omit an east window, thinking that it would not look well from the church.[103] By May 1895, the roof was on and the vaulting of the crypt complete. The crypt opened on 29 June 1895. The second stage of work began in December 1896, when Webb's designs for a carved and panelled oak ceiling and a wrought iron screen between the church and Lady chapel were approved.[104] The chapel was opened by the bishop of London on 18 May 1897. Once again, *The Builder*'s response

101 Aston Webb to Restoration Committee, 14 April 1894: Guildhall MS 3993A/1, p. 113.
102 A scheme to complete at once the restoration of the Norman Priory Church of St Bartholomew the Great (1894). Guildhall MS 3993A/1, pp. 115ff.
103 Restoration Committee, 20 Nov 1894. Guildhall MS 3993A/1, 125.
104 Guildhall MS 3993A/1, pp. 152, 191, 202; Webb, *Records*, II, pp. 425–27; *The Builder*, LXVIII (1895), p. 486.

10.8. Testimonial to Sir Aston Webb signed by the Restoration Committee, led by Canon Phillips and Rector Savory, in praise of his restoration of the church

10.9. Memorial plaque in the south vestry commemorating Sir Aston's son Philip Webb, designer of the vestry, killed in the Great War

was favourable: Webb had 'preserved the spirit of the old work, and the harmony of the whole, without condescending to any ridiculous attempt to make his modern rebuilding and repairs look as if they were parts of the original'.[105]

Though Webb's association with the church was to continue, and that of his son Maurice, the restoration of the Lady chapel largely marked the end of over thirty years of concerted work to restore St Bartholomew the Great to its ancient glory. The Restoration Committee praised the 'excellent judgment and feeling of the past' and the 'religious care' with which 'he has welded the old and new into one beautiful and harmonious whole' (fig.10.8).

However, along with small returns to the fabric of the former monastic enclosure, new works continued to be undertaken. The excavations preliminary to the restoration of the Lady chapel had revealed the remains of the walls of the twelfth-century south chapel and its curious double apse similar to the corresponding chapel at Norwich Cathedral.[106] Further investigations indicated that the chapel on the north side also had a double apse on the same plan, confirming the indebtedness to Norwich.[107] In July 1912 it was decided to build clergy and choir vestries on the site of the south chapel, but preliminary demolition of structures on the site revealed so much of the walls of the two apses that plans were changed and only a single vestry, designed by Sir Aston's son Philip Webb, was built on the ancient foundations of the chapel, thereby retaining its interesting footprint and exposing what remained of its walls (fig. 10.9). The clergy were given the room on the site of the north chapel as a vestry.

105 *The Builder*, LXXII (1897), p. 456.
106 *Archaeologia*, LXIV (1913), p. 169.
107 See Stephen Heywood's chapter in this book.

10.10. Memorial plaque on the south wall of the gatehouse commemorating Sir Aston Webb, Edward Alfred Webb, and Frederick Dove

In March 1918 an offer was made to the Restoration Committee to help with the acquisition of the site of the remaining five or six bays of the east walk of the cloister when the lease expired. Funds were difficult to come by while war raged, but in 1918, after the armistice was signed, an appeal raised sufficient funds for the committee to justify proceeding with the purchase, and the site of the cloister was secured in 1922. The entrance to the covered way from the transept and the doors to the chapter house and to the dormitory stair were uncovered when the site was cleared. Despite renewed opposition from the SPAB, five bays were rebuilt and vaulted after the proportions of the surviving three. A subtle change in the design of the reticulated tracery in the window openings marks the transition from surviving medieval fabric, albeit heavily restored, and the modern work. The completed range was opened and dedicated in 1928 in the presence of Princess Mary, daughter of King George V. Two years later, Sir Aston Webb died, his half-century of devoted care for his much-loved building memorialized in a commemorative plaque in the Smithfield gatehouse (fig. 10.10). Surely, however, *si monumentum requires, circumspice*.

ARTS AND MUSIC

Music in the Priory Church

NICHOLAS RIDDLE

These stones that have echoed their praises are holy,
and dear is the ground where their feet have once trod;
yet here they confessed they were strangers and pilgrims,
and still they were seeking the city of God.

This is a verse of the hymn, 'In our day of thanksgiving', much-loved in Anglo-Catholic circles.[1] Singing of 'the saints who before us have found their reward' in the priory church has always seemed especially appropriate. There is a sense of being surrounded by stones soaked in liturgies of praise and thanksgiving performed by many different communities.

Chronicled here is a musical thread that runs – with a few glitches – between the foundation of the Priory in 1123 and today. But first a glance at the present, rather than starting at the beginning. The music used in the church's services today is a mixture of almost all the kinds of liturgical music that have heard in it over the past nine centuries. Today's congregations take this in their stride and do not even notice, but it would have surprised and even shocked generations of devout worshippers in the past.

Choral Eucharist on a Sunday morning now might include three hymns spanning hundreds of years. One might be a metrical adaptation of plainchant with words translated from the original Latin; one might be a nineteenth-century 'warhorse'; one might have words and music from the twentieth century. Alongside these, the choir sings the traditional plainchant Propers in Latin. Up to four of these are sung most Sundays: Introit, Alleluia (or Tract in Lent), Offertory and Communion. Something very similar would have been sung at the same points in the medieval Priory's masses.

Then there is the Ordinary of the Mass, the fixed part of the service: Kyrie, Gloria (apart from in Lent and Advent), Credo, Sanctus, Benedictus and Agnus Dei. This may be sung to settings written in the Renaissance period by composers such as Byrd, Tallis, Palestrina, Victoria or Lassus, or in so-called 'Viennese' settings by Haydn, Mozart or Schubert. Also used are more modern settings, starting with Dvořák and coming right up to today via Puccini, Vaughan Williams, Britten, Howells, Langlais, Dove and many others.

1 Words by W. H. Draper (1855–1933) usually sung to the tune 'St Catherine's Court' by R. Strutt (1848–1927) and found in many hymnbooks, notably *Common Praise*, the new edition (2000) of *Hymns Ancient and Modern*.

11.1 The organ in use as seen from the north transept chapel (Alamy)

A motet is sung either at the Offertory or during the Communion, or both. It might be a Latin motet from the Renaissance or from the period of the English or German Reformations, or anything else up to the present day. A similar range of music from different periods can also be heard at Choral Evensong. While combining music from all these different periods and styles in the same service would be unusual, at least some of this mixing of periods occurs at most of the services.

The repertoire used is therefore very wide – one might also say 'catholic', in the non-denominational sense. This is not the result of some process of accretion. For some seven hundred years, the church took an either/or approach. Latin masses and propers disappeared from use at the suppression of the Priory, replaced eventually by the music of the reformed Church of England. There was also much greater concentration on contemporary works, rather than drawing on a perceived 'canon' of great works from the past. In fact, up until the twentieth century, this was broadly true of all western 'serious' music.

This matters because music and liturgy are part of what knits together the nine centuries of people who have worshipped and prayed in the priory church. It matters that the plainchant that generations of the Priory's canons would find recognizable is used and that a connection is maintained with Church Latin, which still acts as a unifier across the centuries. Most of all, it matters that Catholic Christianity, taking on board all the lessons of the Reformation and Counter-Reformation, is once again active within the walls that were raised for its practice. At every service we hold, this is presented to us afresh in stone, word, liturgy and music.

In the early twelfth century, ecclesiastical music was based extensively on monophonic chant, i.e., music made up of just a single line of melody. We call this 'plainchant' or, with much historical licence, 'Gregorian chant'. Today, musicologists believe that what we have come to know as 'Gregorian chant' was really a process of fusion between many elements over an extended period, but most significantly between Roman and Frankish chants that gradually became the accepted form throughout the western church.[2]

Despite the watery borders on three sides of the country, the idea that English church music developed quite separately from the European mainland is wrong. Depending on the politics at the time, there was a constant and rich cultural interchange, including the interconnected areas of music and liturgy. Church leaders in England sought information on good practice from French monastic houses, with Corbie, Fleury, Cluny and Bec all being important 'consultants' in the pre-Norman period. How the advice was adapted to local use back in England was a voluntary matter.

This changed in 1066 with the arrival of the Normans. William I initially held off from dramatic change in the English Church. While he was securing his rule in the teeth of resistance, taking on the Church as well would have made life unnecessarily difficult. Then, in 1070, everything changed. Papal legates arrived, and, with the king's connivance, deposed Stigand, the 'inherited' archbishop of Canterbury, and replaced him with Lanfranc, formerly prior of Bec and abbot of Saint-Etienne in Normandy . Within a few years, virtually all the important posts had been switched to Norman incumbents. This meant a clearer alignment of liturgical and musical practices. Rahere, former courtier, perhaps a musician, and the founder of

2 See David Hiley, *Western Plainchant: A Handbook* (Oxford: Clarendon Press, 2000).

St Bartholomew's, was part of this Norman establishment. His role as prior and his warm relationship with Henry I both speak strongly to this. It follows that the Priory will have followed the best liturgical and musical practices of the Normans.

'The Book of the Foundation' tells a story that illustrates the importance of singing to the Priory. It concerns the theft of an 'Antiphoner', a necessary volume for the offering of daily worship. Without this crucial book, the canons would have had neither the texts nor any melodic indication. The writer mentions that the Priory at this stage had few books and that the singers depended on this one. They duly report the loss to Prior Rahere. The prior retires to bed. St Bartholomew comes to him in a dream and enquires what is wrong. Rahere explains the loss of the Antiphoner. Bartholomew exhorts him to rise early, mount his horse and ride into the city to the street of Old Jewry (still part of the modern City). There, Rahere is to give the horse its head to go where it will. Wherever it stops, there will be the place to which the book has been taken. Rahere follows the advice, and – by now to nobody's surprise – finds the book, and (as the modern translation has it) 'speaking peaceably with the enemies of peace', takes it back to the Priory. Music is thus restored.[3]

Another story in 'The Book of the Foundation' tells of a severely disabled girl who is miraculously cured as the canons sing the 'hymn of Mary the Most Blessed Mother of God [i.e., the Magnificat], at the incensing of the altars'.[4] 'The Book' also reports the story of a man wrongly imprisoned in chains in a building near the church:

On one sabbath, when, as their custom was, the canons of St Bartholomew's Church were singing Te Deum laudamus before dawn, matins being finished, a peal of bells was rung, and the poor man who was confined in bonds, hearing the joyful sound of the bells and hymns [...] began with devout mind and lamentable voice to call upon St Bartholomew.[5]

The power of music could not be withstood. The man's bonds fell off, and he was able to escape his prison. Most commendably, the man does not pragmatically head for the hills, but instead enters the priory church to render thanks there for his release.

We can suppose that the canons were solely responsible for singing in the early years. By the time the priory had become wealthier, they doubtless began to maintain a choir to enhance their services. There is a reference in the literature to a song school in the hospital, training boys in singing and elementary grammar.[6] Perhaps they sang in the priory church choir. As the Priory became able to afford trained singers, polyphony would have been added to the services, especially for major events. With the development of printing some 120 years before the Priory was surrendered, it became easier for musical works to be disseminated and performed.

There is a tantalizing detail in the election of the last prior before the Suppression, Robert Fuller, which took place on 28 June 1532. It began with a Mass of the Holy Spirit in the

3 Moore, *Foundation*, I.14, p. 64.
4 Moore, *Foundation*, II.1, pp. 80–81.
5 Moore, *Foundation*, II.2, pp. 81–83.
6 See also Euan Roger's chapter in this book.

church. As the community assembled, the canons sang 'Come, Holy Ghost' and 'Lord, who the hearts of the faithful', after which the voting took place. Later that same day, the new prior was proclaimed by the vicar-general before the high altar, upon which, we are told, those assembled sang the 'Te Deum laudamus' solemnly 'with the organ sounding'.[7] Was this a portative instrument that could be moved around, or was it a larger, fixed instrument? The first fixed installation with a recognizable keyboard had been in Halberstadt in Germany in 1361, so, two centuries later, either is possible.[8] Whatever organ was used, it will not have survived the Suppression and the dismantling of large parts of the church. In some places, the new Church of England was actively hostile to organs as a symbol of, and contributor to, Popish practices. Several cathedral churches saw their instruments dismantled. It is anybody's guess what happened to the musicians who sang at the services. The canons received annuities for their enforced retirement.[9] Did the singers get anything? Probably not.

When the Black Friars were established in the priory and church in 1556 under Queen Mary, they resumed the singing of the office, but also had the means to have a choir when needed. The diary of Henry Machyn, citizen and merchant-taylor of London, 1550–63, gives the details of a funeral – Machyn sold funeral trappings and therefore had a professional interest in recording the proceedings – on 20 September 1558. The service was for Lady Cisele Mansfield in the 'blake frers in Smyth-feld, the wyche was sant Bathelmuw' with 'many clarkes syngyng'. Machyn says this was followed the next day by three sung masses – presumably simply chanted, because he also says there were two further 'pryke-songe' masses.[10] 'Pryke' in this case means one or more lines sung around a plainchant melody, in other words a form of polyphonic mass setting. This means there must have been good singers available. The following year, 1559, Queen Mary died and was replaced by Elizabeth I, and the brief tenure of the Black Friars – and whoever sang for them in the priory church – was over.[11]

It is difficult to overstate the sheer confusion that persisted for several years in the English Church. Some things were clear: music written for the 'old church' was tainted; the services for which it had been composed were replaced; the language requirements changed. There was no further use for plainchant: its flowing melismas – stretched-out, multi-note syllables – were stylistically unacceptable in the new dispensation. Still, its flexibility proved open to some adaptation. John Merbecke was a former chorister of St George's Chapel, Windsor, and then also an organist there. He would have been burnt at the stake with the Windsor Martyrs, but was pardoned by the king.[12] In 1550, Merbecke published a *Booke of Common Praier Noted*, based on the first prayer book of Edward VI.[13] It set the English texts of the Ordinary to something like plainchant, but with only one note to each syllable. Modern ears

7 Webb, *Records*, I, pp. 239–40 (quote p. 240).
8 'Organ', in *The Oxford Dictionary of Music*, ed. Michael Kennedy (Oxford: Oxford University Press, 2002).
9 See Christine Fox's chapter in this book.
10 *The Diary of Henry Machyn, Citizen and Merchant-Taylor of London, 1550–1563*, ed. J.G. Nichols, Camden Society o.s. (London, 1848), p. 174.
11 See Nick Holder's chapter in this book.
12 Allan W. Atlas, *Renaissance Music: Music in Western Europe, 1400–1600* (New York: Norton, 1998), p. 546.
13 Merbecke's setting for the Office of the Holy Communion is available in editions by several modern music publishers, including Novello, as well as being available from CPDL (the Choral Public Domain Library) at <https://www.cpdl.org/wiki/index.php/Communion_Service_(John_Merbecke)>.

do not always register this significant difference in expressiveness. At the time of writing, most Sunday mornings, the congregation of the priory church sings Merbecke's setting of the Creed, written just twenty years after the suppression of the Priory.

This was a good time to be a composer. There was a huge requirement for new music. This was partly a practical issue, but there was a more subtle aspect too. In 1381, Richard II had dedicated the country to the Blessed Virgin Mary, in line with the country's informal name, 'Mary's Dowry'.[14] This national devotion to the Mother of God was part of the country's clear Catholic identity. Now it urgently needed a new Protestant identity, and music was co-opted to this end. In place of Latin texts sung to plainchant or in complex polyphony in which the words might not be clear, plain English, simply set, would be the rule. It helped that this also made it easier to produce new musical works quickly.

Inspiration was also drawn from Reformation countries abroad, especially Germany, Switzerland and the Netherlands. During Queen Mary's reign, and especially during her assault on Protestant heretics, many prominent English reformers fled to cities such as Strasbourg, Zürich or Geneva, where they picked up ideas about music in a reformed Church. Luther had set a strong lead from 1523 with the development of 'chorales', which led directly to what we call 'hymns'. He also adapted plainchant into metrical forms or composed completely new melodies. Calvin was inspired by the idea of rendering the psalms singable in the vernacular by making them metrical. The outcome of this was the *Genevan Psalter*. The explicit goal of all these settings was to put the musical praise of God into the mouths of congregations rather than priests and choirs. After Mary's early death, the reformers returned to England armed with many ideas.

Some parts of the country were strict about what music was acceptable. London was more varied, partly because the Queen's influence was more present. She made austere Protestants tut with frustration at her love for a degree of ritual in church and more elaborate choral music.[15] Several London churches maintained choirs, among them St Botolph Aldersgate, St Dunstan in the West, St Mary Woolnoth, and St Mary-at-Hill, where Thomas Tallis had been organist for two years.

There is now a frustrating silence about music in the priory church for a century and a half, from Elizabeth's accession to the early eighteenth century. It is likely that congregational metrical psalms and the gradual development of hymnody, possibly with a small number of singers hired in to keep the singing on track, was all that happened. Henry Machyn alludes in his diary to the 'syngyng of clarkes' at funerals.[16] There may have also been 'clarkes' singing at the priory church, at least for important services.

There is no mention of an organ in the building, certainly during the Puritan period, and even after the Restoration. Samuel Pepys wrote about a trip to Hackney church to sample the unfamiliar experience of hearing an organ accompanying the service. He writes of wishing there were such an instrument at his own church and muses about paying for one if the

14 *The Regal Image of Richard II and the Wilton Diptych*, ed. Dillian Gordon and others (Coventry: Harvey Miller, 1997), p. 24.
15 Jeremy M. Haselock, 'Elizabethan Enigma: Music and Reformation in Sixteenth-Century England', *Faith & Worship, Journal of the Prayer Book Society*, 87 (2020), pp. 43–54.
16 Nichols, pp. 298–302 (passim).

church authorities will take on its maintenance.[17] Meantime, an anonymous pamphlet published in 1698 to counter the acceptance of organs in churches says:

The churches which use them are the Popish churches, the Cathedral churches in England, and some very few parish churches [....] As for my own part, I am of the opinion that it is with organs in the worship of God, as it is with pictures in churches, a distraction and diversion rather than a help to devotion.[18]

Indeed, the writer seems to think that organs played a malign role in Catholicism's alleged derailing of Christianity:

The churches received Latin singing, with organs from Pope Vitalian, and from thence began to say Latin mass, and to set up altars with idolatrous images [....] We must remember that [organs] were introduced in the times of Popish darkness, and I cannot imagine that Protestants should be the more fond of them, because they were introduced by a Pope.[19]

Edward Hatton's *A New View of London*, published in 1708, includes several pages about St Bartholomew the Great. There is much detail about the physical layout of the building, its monuments and epitaphs. He also observes 'Prayers daily at 11, but no Organ'.[20] Doubtless he was right, but in fact this was just ahead of a crucial turning point in the story.

Alfred Webb, a church warden for much of the period in which the priory church was being restored, noted that the Vestry 'at this time was supreme, even in the smallest matters'. On 5 April 1715, its records state that it was 'ordered that a Conoble's organ [...] be brought into the church, provided it be approved on by a Master of Music whom the churchwardens shall appoint'. He states that a Mr Vannallson was then engaged to be the organist.[21] There is confusion here because other sources think he was a Mr Adrian van Helsding.[22] Whichever he was, he only lasted six years.

In 1730, the Vestry decided that the organ was too small for the purpose and resolved either to expand it or replace it.[23] The latter course of action was chosen, and the commission went to a local builder, Richard Bridge of Clerkenwell. The *Daily Journal* of 30 October 1731 advertised the opening of the organ:

On Sunday next, the curious New Organ, made by Mr. Richard Bridge, Organ Maker, in St. John's Clerkenwell, and lately erected in the parish church of St. Bartholomew the Great, near Smithfield, will be opened with an anthem in the morning. The said organ has been play'd on by several of the greatest Masters in Town, and by them allowed to be a very fine Instrument.[24]

17 Samuel Pepys, *The Diary of Samuel Pepys*, entry for Sunday, 21 April 1667.
18 Quoted in W.H. Cummings, 'Organ Accompaniments in England in the Sixteenth and Seventeenth Centuries', *Proceedings of the Musical Association*, 26 (1899), pp. 193-211 (p. 203).
19 Quoted in Cummings, p. 202.
20 Edward Hatton, *A New View of London* (London: R. Chiswell, A. and J. Churchill, 1708), § 2, pp. 141-46 (quote p. 146).
21 Webb, *Records*, II, p. 333.
22 'Helsding, Adrian van', in *Biographical Dictionary of the Organ*, ed. W.B. Henshaw (Bardon Music: online) <https://www.organ-biography.info/index.php?id=Helsding_Adrianvan_18>.
23 Webb, *Records*, II, p. 335.
24 Quoted in: Webb, *Records*, II, p. 336.

The Bridge organ suited the musical needs of the church much better. Apart from some modest additions in 1800, it remained in service until some point in the 1860s. During this period, a further eleven appointments of organists were made. In the middle of this run were two consecutive appointments that clearly went wrong. Thomas Ball was organist for eight years, but simply stopped turning up for services and had to be discharged. After him came John Whitaker, who served for twelve years but is recorded as having been dismissed for inefficiency.[25]

During the time of the first restoration of the priory church between 1863 and 1868, the opportunity was seized to get the organ repaired and cleaned. There is some confusion about whether this was still the Bridge organ, or a second-hand instrument by someone called Russell, or a Russell organ that had been rebuilt by someone called South. Whichever organ it was, it was removed either to Russell's or South's premises. Alas, whichever it was, the builder then died. In the resulting confusion, the organ was sold erroneously as part of the estate, and nobody could find where it had gone. The church received a very modest £40 compensation payment.[26] Tantalizingly, in the *Musical Times and Singing-class Circular* of 1 February, 1864, R.H. South, of 73 Gray's Inn Road, offers for sale an organ 'quite new, and suitable for Library or School' for the sum of £20.

The partly restored church was reopened on 29 March 1868. The money raised had been insufficient to implement anything like the original restoration plan, and it had all been spent. The thought of then having to buy a new organ must have been alarming, with the £40 compensation for the mislaid organ not exactly burning a hole in the Vestry's collective pocket. An exceedingly small organ was purchased, built by Gray & Davidson, whose premises were then in the Euston Road.[27] It was so small its size may just have reflected the scale of the compensation payment. It was installed on the south side of the sanctuary, opposite Prior Rahere's tomb. The rationale may well have been that this emphasized the temporary nature of this inadequate instrument while leaving the site of the old organ ready to receive something more suitable when the time was right. In the end, the organ was in use for eighteen long years.

William Panckridge became rector in 1884. In May 1886, he discovered that St Stephen's Walbrook wanted a new organ and was prepared to sell the existing one to the priory church for £300. The move cost another £125, while building a suitable organ loft was a further £175, for a total cost of £600.[28] The instrument had been built originally by George England, a highly respected builder of the day. In 1872, Hill & Son, one of the greatest English organ builders, undertook a major rebuild of the instrument. Still, something did not please St Stephen's, because, as we have seen, a mere fourteen years later they were prepared to sell it to the priory church. The installation, managed by Hill & Son, was duly undertaken. It was

25 'Ball, Thomas' and 'Whitaker, John', in *Biographical Dictionary of the Organ*, ed. W.B. Henshaw (Bardon Music: online) <https://www.organ-biography.info/index.php?id=Ball_Thomas_18> <https://www.organ-biography.info/index.php?id=Whitaker_John_1776>
26 Webb, *Records*, II, pp. 49, 410, 502.
27 Webb, *Records*, II, p. 502.
28 Webb, *Records*, II, pp. 410–11, 503.

considered an excellent instrument.[29] The 'shock and awe' it will have delivered from the west end of the building must have been quite something after its tiny predecessor at the other end.

Rector Panckridge made a further major contribution to the musical life of the church that was of much wider significance. He was a breath of fresh air for the parish after the 69-year incumbency of his predecessor, Rector Abbiss. He was also a whirlwind of innovation in parish life. Alfred Webb reports that 'he introduced a surpliced choir of men and boys, for the payment of whom and of the organist he made himself responsible'.[30] This is where the modern story of music – and much more – in the priory church really begins.

The first parish church in London to introduce a surpliced choir was the Temple Church, in 1842. The church had been closed for restoration from 1840 to 1842 and the choir came into being when it reopened. In 1843, Dr E. J. Hopkins was appointed organist and set about raising the standards of the choir to among the highest in the country. He wrote:

At that time, there were only three surpliced choirs in London, namely, those at St Paul's Cathedral, Westminster Abbey, and the Chapel Royal, St James's Place [....] [By 1888] the "precedent" set in so renowned a church was speedily and extensively followed, until there are now in London, of surpliced choirs alone, over five hundred.[31]

William Burge, QC, who had played a significant role in the architectural restoration of the Temple Church, authored a book called *On the Choral Service of the Anglo-Catholic Church*.[32] This is interesting, partly because of the use of the term 'Anglo-Catholic'. This was only some ten years after the so-called 'Tractarians' had started to publish the series of *Tracts for the Times* that gave them this name alongside that of 'the Oxford Movement'. Their message was about rediscovering the Catholic heritage of the Church of England in theology and liturgy.[33] The fact is that the movement to introduce surpliced choirs began in Oxford Movement churches, although it later spread well beyond them.

What does this say about the priory church? A postcard of the sanctuary by Arthur C. Payne, the older brother of the military painter Henry Payne, sheds an interesting light on this (fig. 11.2). The angle of the picture is from a little east of the Mildmay tomb, and looks diagonally across the sanctuary, taking in the south-east ambulatory. Between the pillars, it is possible to see the cross on the high altar. There are also evidently six candlesticks with it, an unmistakable sign of an Oxford Movement church. In the ambulatory, a verger has just led a priest from the sanctuary. Aside from a generous red academic hood, he is dressed in a long surplice over his cassock. On his head is a biretta. From details of the painter's active years and the shape of the altar rails in the picture, which were replaced in 1908, we can date

29 Webb, *Records*, II, p. 503.
30 Webb, *Records*, II, p. 405.
31 David Lewer, 'The Temple Choir in 1842', *The Musical Times*, 84.1199 (1943), pp. 14–16 (p. 14).
32 William Burge, *On the Choral Service of the Anglo-Catholic Church* (London: George Bell, 1844).
33 For an overview of the latest scholarship on the Oxford Movement, see: *The Oxford Handbook of the Oxford Movement*, ed. Stewart J. Brown, Peter B. Nockles and James Pereiro, Oxford Handbooks (Oxford: Oxford University Press, 2017). The Tractarians had wider concerns as well. See also S. A. Skinner, *Tractarians and the 'Condition of England': The Social and Political Thought of the Oxford Movement* (Oxford: Clarendon Press, 2004).

11.2. Postcard (c. 1890s) by Arthur C. Payne showing the Oxford Movement influence on St Bartholomew the Great (Image courtesy of Sarah Kelsey)

the picture to sometime between 1880 and 1908. If the priest in the picture is the rector, Panckridge – who took the 'high church' step of introducing the surpliced choir – might fit the bill, impeccably Anglican and impeccably Catholic.

This is no fantasy of the artist. We also have two photographs with clear views of the six candles on the altar, as well as two floor stands and the pre-1908 altar rails. The church also owns another painting made from the same position used by Arthur Payne. In this, a crucifer in full-length alb and sash leads a procession of surpliced choirboys down from the high altar, on which are the six candlesticks. This painting is dated 1901, during the incumbency of Sir Borradaile Savory. A contemporary photograph (taken after 1886, when new marble altar steps were put in, but before 1908, when the altar rails were changed) likewise shows six candles on the altar (fig. 11.3). These clues put it beyond doubt that the priory church was then an Oxford Movement church. If the introduction of the choir under Rector Panckridge points to the church having turned towards the Catholic tradition, it clearly continued so during his successor's incumbency.

In 1919, Mr Stanton Jeffries was appointed organist. He had come from the Royal Chapel in Windsor Great Park and would go on from the priory church after only two years to be director of music at the Marconi Wireless Company, and then a music producer at the BBC.[34] For a time, his assistant organist, whom he inherited from his predecessor, was the Australian William McKie, who would much later become organist and master of the choristers at

34 'Jeffries, Leonard Stanton', in *Biographical Dictionary of the Organ*, ed. W.B. Henshaw (Bardon Music: online) <https://www.organ-biography.info/index.php?id=Jefferies_LeonardS_1896>.

11.3. Photograph (c. 1890s) showing the altar with six candlesticks (Image courtesy of Sarah Kelsey)

Westminster Abbey. There he directed the music for HM Elizabeth II's wedding in 1947, as well as for her coronation in 1953.[35]

In 1921, Anderson Shaw was appointed organist under Rector Sandwith, whose incumbency was marked by the ongoing restoration of the church. During Shaw's thirteen years as organist, the organ went through a substantial rebuild at the hands of Henry Speechly & Son. The project was finished in 1931 and was a significant upgrade.[36] The priory church now had an organ equal to that of many cathedrals. It was a great attraction to first-class musicians and an excellent accompanying instrument. Organ and surpliced choir together gave the feeling of being in the quire of a moderate-sized cathedral. The stage was set for another leap forward in the musical life of the church.

Rector E. Sidney Savage, appointed in 1929, continued the restoration of the building. Anderson Shaw left in 1934, and Savage oversaw the imaginative appointment of Nicholas Choveaux as organist. He was to remain in post until 1949, with a break during the war years when, among other things, he was music adviser for ENSA. He was also an active composer. Organists today still play his 'Three Pieces for Organ'. He is strongly associated with the prolific German composer Sigfrid Karg-Elert, whom he knew personally, and whose profile in the United Kingdom he worked hard and successfully to raise. In 1930, he and two others ran a Karg-Elert music festival at St Lawrence Jewry, which the great man himself attended, Choveaux playing two of the recitals in his presence. Later, he went to work in contemporary music promotion at music publishers Boosey & Hawkes before founding his own concert

[35] 'McKie, Sir William', in *Biographical Dictionary of the Organ*, ed. W.B. Henshaw (Bardon Music: online) <https://www.organ-biography.info/index.php?id=MacKie_William_1901>.

[36] Andrew Morris, 'Music at St Bartholomew-the-Great', *The Musical Times*, 114.1567 (1973), pp. 941-43 (pp. 942-43).

artist agency, which he ran with much success.[37] Musical periodicals of the time contain numerous references to his work at the priory church. There he is, organizing a music festival in the church in 1936, or a series of Sunday six o'clock recitals with performers such as Kathleen Ferrier, Harriet Cohen, Gerald Moore, the Boyd Neel String Orchestra, the choir of St Matthew's Church, Northampton (giving the first London performance of Britten's E major *Te Deum*, written for the centenary of St Mark's Swindon), and so on. Many of these performances were given in place of a sermon.[38]

Until at least the middle of the twentieth century, the music sung by the choir was from the broad Anglican choral tradition. There is a useful reference point for this provided by the anthology *Cathedral Music*, originally started by the composer Maurice Greene (1696-1755) but completed after his death by his pupil, William Boyce (1711-1779). A large part of the repertoire it contains is still in use today, albeit now sung from more modern and reliable editions. A revised edition of *Cathedral Music* came out in the middle of the nineteenth century and was widely adopted by churches that were setting up their surpliced choirs. Further anthologies were to follow, especially the *Church Anthem Book* published in 1933. This was edited by Walford Davies – organist of Temple Church 1898-1923, and in 1933 just retired as organist and director of the choir at St George's Chapel, Windsor – and Henry Ley, Precentor at Eton College. It proved extremely popular with church choirs, and the music library of the priory church is stocked with many well-used copies.

In 1944, at the age of 33, Newell Eddius Wallbank, godson of the previous incumbent, became rector of the priory church and remained in post until retirement. The son of a cathedral organist, he had read music at Cambridge, supplementing his degree with a Mus.B. and then a doctorate from Trinity Dublin. He then trained for the ministry at Ripon College.[39] Throughout his incumbency, his support for the music at the priory church was unquestionable. Despite his immense musical expertise – or perhaps because of it – he was not the sort of rector who second-guessed his director of music. Instead, he offered unstinting support and constant encouragement to greater ambition. His way of steering the music was to make wise appointments and then get out of the way. The first of these was inspired.

Paul Steinitz was a brilliant organist. In his twenties, he was director of music at St Mary's, Ashford, in Kent, while working on his doctorate at the University of London. During this time, he became extremely interested in the music of Johann Sebastian Bach. In 1946, he founded what became the London Bach Society. Despite the name, the choir was not only about Bach. Its first year also included Palestrina's *Missa Brevis* and a 'Stabat Mater' by George Oldroyd, who had been one of Steinitz's teachers.

In 1949, Steinitz became organist and director of music at the priory church. Alongside the usual round of services using the church choir, Steinitz's activities with the London Bach Society quickly impinged upon the musical life of the church. On 22 March 1952 – and it seems extraordinary now that this could be true – the first complete performance in the United

37 'Choveaux, Louis Nicholas', in *Biographical Dictionary of the Organ*, ed. W.B. Henshaw (Bardon Music: online) <https://www.organ-biography.info/index.php?id=Choveaux_Nicholas_1904>
38 Morris, 'Music at St Bartholomew-the-Great', p. 943.
39 For more on Rector Wallbank, see Jeremy Haselock's chapter in this book.

11.4. Memorial in the cloister to music director Paul Steinitz

Kingdom of Bach's *St Matthew Passion* (*Matthäus-Passion*) in German was given in St Bartholomew the Great. It was an enormous success, although not without some controversy. Some people felt it was bad form to use the German language so soon after the Second World War; some felt the loss in understanding of the text was unfortunate; some found it simply too unfamiliar in such a well-loved and well-known work. But it put down a crucial marker. Today, professional performances in Britain are virtually always in German. But in the early 1950s, even Covent Garden was still performing English translations of operas. It is no accident that the motto at the foot of Steinitz's memorial in the priory church's cloister is *Singet dem Herrn ein neues Lied* (Sing to the Lord a new song) (fig. 11.4).

Alongside his duties at the priory church and his role with the London Bach Society, Steinitz was a professor at the Royal Academy of Music from 1945 and taught at Goldsmith's College from 1948 until 1976. His most ambitious project with the London Bach Society was to perform all of Bach's extant cantatas, a huge undertaking. The project began in November 1958 and was completed in December 1987, a few months before Steinitz's death. In 1969, he also formed the Steinitz Bach Players, one of the earliest groups to use period instruments in performance, and significantly influential on the historically informed performance movement which is so familiar today. Many of the performances of the cantatas took place on Sunday evenings at the priory church. This was a remarkable career that took him to many other countries, including two visits to the Thomaskirche in Leipzig in the German Democratic Republic. He contributed greatly to the way that Bach is understood, performed and appreciated in this country.[40] This attracted enormous attention to St Bartholomew the Great. On the one hand, it was reinforced as an important concert venue; on the other, it became known for the outstanding liturgical music sung by its choir.

Up until the Second World War, the church choir had comprised six men, with somewhere around twenty to 24 boys. After the War, it proved difficult to maintain these numbers. The church accepted the inevitable, and instead had a simple adult quartet, one to each part. This was the ensemble that Steinitz inherited. To be able to expand the repertoire, and with the rector's blessing, he added a further quartet. This high-quality octet learnt to perform in the languages in which composers of the past had written their works, including Latin, while the works of many contemporary composers were also performed.

40 Nicholas Anderson, 'Paul Steinitz', *Early Music*, XVI.4 (1988), pp. 621–23.

In 1961 Steinitz left the priory church. Rector Wallbank needed a replacement who would continue the outstanding tradition that had developed. The choice fell on 35-year-old Brian Brockless, a rising star of the London music scene. Brockless had studied organ and composition at the Royal College of Music, where his most influential teacher was Herbert Howells. Later, he studied conducting with Sergiu Celibidache. Two years after becoming director of music at the priory church, he won the conducting prize at the Accademia Musicale in Siena, where his studies with Celibidache had taken place. Orchestral conducting was a major part of his life. He worked with the Royal Philharmonic Orchestra, Northern Sinfonia, the English Chamber Orchestra, Philomusica of London, the London Schubert Orchestra (named for its founder, George Schubert) and numerous others in concerts and broadcasts in many countries around the world. He also spent part of his time as a professor at the Royal Academy of Music as well as lecturing at the University of Surrey and teaching at both Goldsmith's and Morley colleges. As if this were not enough, he was an active composer, with many of his works being brought out by Novello and other music publishers.[41]

One might have thought that this level of busy-ness would preclude doing much as a church director of music. Not so. Building on Steinitz's work with the choir, Brockless expanded their repertoire further backwards in time to take in the full range of Renaissance music. As Steinitz formed the London Bach Society and performed extensively with it in the priory church, so Brockless formed the St Bartholomew Singers in the early 1960s to sing Renaissance music. The concerts often took place in the priory church. So, for example, on 3 January 1964 they sang 'A Programme of Medieval Christmas Music' with the Jaye Consort of Viols and Medieval Instruments, and Guy Oldham at the organ. The repertoire included plainsong propers with motets by Perotin, Binchois, Dunstable, Dufay and others. Then on 23 March 1964 they were to be found performing a programme of plainsong and medieval music for Lent and Passiontide under Brockless's direction. At this point, there is a sense of the wheel turning in some sense full circle. The stones that had echoed to plainchant propers, and just conceivably the music of John Dunstable and his contemporaries, was echoing again to this music. In 1968, the St Bartholomew Singers transformed into Pro Cantione Antiqua, a group that still exists today.

In 1971, Brockless faced up to a significant degree of overwork and decided to leave the priory church. Once again, Rector Wallbank was faced with making an appointment now freighted with expectation. Following a recommendation from Brockless, the lot fell upon 23-year-old Andrew Morris, to whom he had taught keyboard harmony at the Royal Academy of Music. In a neat circularity, Morris had been a Westminster Abbey chorister under Sir William McKie, former assistant organist at the priory church. He also studied conducting, organ and piano at the Royal Academy, going on to the University of London, and then Pembroke College, Cambridge. Taking a cue from his two predecessors, he worked assiduously on both the music in the church's liturgy and the concert life of the church building. The choir made recordings and broadcasts with both the BBC (two Radio 3 Choral Evensongs) and ITV (Midnight Mass in 1973), and recorded with Abbey Records. They focused especially on the repertoire of the sixteenth, early seventeenth and twentieth centuries. This was,

41 Obituary: Brian Brockless, *The Independent*, 28 December 1995.

no doubt, partly a feature of the times. The great warhorse anthems of the Victorian and Edwardian eras were out of fashion. Instead, excitement was focused on either mastering the works of contemporary composers, regardless of the challenges they might contain, or performing much earlier music in an historically appropriate style.

During his time at the priory church, Morris founded the New English Singers – or rather, re-founded, because it had been the name of a group with a lineage going back to early in the twentieth century, but which had not functioned beyond 1955. With them, he conducted many concerts inside and outside London, often with instrumental groups. He also became a professor of Piano and Harmony at the London College of Music. He put on several festivals at the church, including a remarkable one to celebrate the 850th Anniversary of the priory church in 1973. This included a stellar cast: Paul Steinitz (who greatly helped with the whole festival) and his London Bach Society – of course – and the Schutz Choir conducted by Roger Norrington, the Aeolian String Quartet and the King's Singers, all household names among the musically minded public. Four years later came a music festival for the Queen's Silver Jubilee, with performances directed by Morris and his predecessor, Brian Brockless.

In the following years were two St Bartholomew's International Festivals of Twentieth-Century Music. In these, Morris conducted the London premieres of works by Lennox Berkeley, John Tavener and Elizabeth Maconchy. On the organ, he played British premieres of pieces by Augustine Bloch, Pál Károlyi and Miroslav Miletic, as well as the London premiere of Paul Patterson's *Games*.

In 1979, his time at the priory church came to an end when he was appointed director of music at Bedford School, a post he was to hold for 32 years with great distinction, building the school's reputation for music to an extremely high level.[42] Alongside this, he examined for the ABRSM for nearly forty years, as well as supervising tonal and keyboard skills at Cambridge University, and being a visiting professor at Trinity Laban Conservatoire.[43]

Rector Wallbank was due to retire in 1979, so the choice of the next director of music was one of the last major decisions that he had to make before leaving. To the surprise of many people, Brian Brockless declared himself interested in returning, remaining for the following sixteen years. He and Morris used to say that what had happened was reminiscent of John Blow, a seventeenth-century organist at Westminster Abbey, who stepped down in favour of his pupil, Henry Purcell, only to return to the post after Purcell's untimely death in service. The choir, a completely voluntary group of adult singers, continued to be enthusiastic and produced good musical results. BBC Television filmed a series of hymns in the church for a late evening spot on BBC 2. Still, anyone paying attention would have noticed that it was now more difficult to find volunteer singers for a church in the middle of the City of London, probably far away from where they lived. Gradually, the congregation was also beginning to decline in number.

42 Andrew Morris, 'Bedford', in *Music in Independent Schools*, ed. Andrew Morris and Bernarr Rainbow (Woodbridge: The Boydell Press, 2014), pp. 248–56 (pp. xv, 253).

43 'Andrew Morris', *Trinity Laban* <https://www.trinitylaban.ac.uk/study/teaching-staff/andrew-morris/> [accessed 5 August 2022].

On 9 September 1995, Martin Dudley became rector. Brockless was already in poor health, and it was clear that he would soon retire. This created an immediate need to plan for a new appointment. In the end, it was agreed that Brockless would stand down on 18 December. However, his assistant at the time, Simon Niemiński – one of several assistant organists who have gone on to major careers in the church music world – had to take over as acting director of music from the start of December. Very sadly Brockless died on the night of what would have been his last service, had he been well enough to be present (fig. 11.5).

Brockless owed much to Wallbank, who had – as with all his directors of music – been a staunch support throughout. Moreover, Brockless had been his director of music for more than two-thirds of the time he had been rector. A memorial evensong for Brockless was duly arranged to take place on 3 March 1996, and Wallbank was invited to preach. Andrew Morris, former director of music, had been invited to play the organ for the prelude and the first hymn. In a highly unexpected turn of events, soon after the service began, Dr Wallbank collapsed and died. There to commemorate one of his directors of music, the last music he heard was played by another of his appointees. His entire active clerical career from ordination to retirement had been spent at St Bartholomew the Great. Music was a parallel driving force throughout his life, and Evensong can certainly be seen as the most musical of all the services. While it was a terrible blow for his family and those who knew him well, it was clearly also an appropriate way to have made an exit.

11.5. Memorial in the cloister to music director Brian Brockless

For some time, the priory church's liturgy had reverted to 'straight-down-the-middle' Anglicanism. Prayer-book Mattins was the predominant service on a Sunday morning with Prayer-book Choral Evensong in the evening. This was increasingly making the church seem undifferentiated in a City divided between Evangelical and Anglo-Catholic establishments. The priory church congregation had shrunk to the point where many of the main services were being held in the Lady chapel, with only larger services for livery companies, Hospital View Day, or weddings and other such events at the high altar. Something needed to be done. Neither of the two rectors between Wallbank and Dudley succeeded in stemming the draining membership and attendance.

Rector Dudley wrote in 2014: 'One of my first ambitions as the new Rector of Saint Bartholomew the Great in September 1995 was to establish a choir that would deliver a consistently high standard of music every Sunday of the year'. A musically minded clerical friend had advised him to appoint David Trendell as the next director of music. He also asked John Scott, organist of St Paul's Cathedral, about advertising the post. On hearing that Trendell

was being considered, Scott recommended no advertising and to go ahead immediately with the appointment.[44]

Trendell was senior lecturer and director of music at King's College, London. He was especially known for his research into sixteenth-century Spanish polyphony as well as for his love for English Renaissance music, especially the recusant composers such as Byrd and Tallis. The recordings he made with the King's College Choir are outstanding testimony to his gifts as a choral director – beautiful, poised, balanced, elegant and deeply affecting. His interests lay not only in the Renaissance period but also in contemporary music. This was very much in tune with the way that the church repertoire had been developed by his immediate predecessors. While Trendell's name was certainly well known among *aficionados* in church music circles, he was less interested in the wider musical stage than his predecessors. His spiritual life was important to him, and, in Dudley, he encountered a rector who was determined on a major revision of the parish's approach. It proved an effective pairing.

The new rector's vision was for the church to recall its roots in the great Priory of which it had been the spiritual centre, while not forswearing the excellent aspects of its Anglican inheritance. This led to an eclectic mixture of liturgical elements. Mattins disappeared to be replaced by a Sunday morning Solemn Eucharist, with priest, deacon and subdeacon. Six candlesticks appeared once more on the high altar and thuribles were purchased and used with enthusiasm. Choral Evensong was the familiar cathedral service, but with the Marian Antiphon appropriate to the season at the close. Some members of the existing congregation did not appreciate these changes. But what could not be denied was that the congregation had begun to grow appreciably.

The voluntary choir had disbanded when Brian Brockless made his final exit. As part of the agreement that brought Trendell to the church, a professional octet was instead engaged from Sunday to Sunday. The Propers of the Mass were now sung liturgically, rather than as concert items. The Ordinary of the Mass was most often sung to a setting from the Renaissance period, or occasionally a modern setting, but always in Latin. There was a strict rule that the setting should always have been intended for the liturgical season in which it was being used. No settings written for the Epiphany being used for Trinity Sunday! Except in the rarest of circumstances, no choral music was repeated during the year, not even at Evensong. Most hymns were sung only once a year in a seasonal cycle. As a result, the congregation was familiar with much of the hymnal. This meant a very wide repertoire being presented to the congregation, the music reinforcing the message of the season. Liturgy, music and the history of the church visible in its very stones bonded and formed a powerful epoxy and the congregation grew remarkably.

In 2009, Trendell accepted an offer to become director of music at St Mary's, Bourne Street. In 2014, in an immense shock to his friends and colleagues, Trendell suffered a fatal brain haemorrhage at the age of fifty (fig. 11.6).[45] It was a terrible blow for everyone associated with him. By the time he had left for Bourne Street, the music of the priory church had

44 'Organists & Directors of Music', *Great St Bartholomew* <https://www.greatstbarts.com/worship/music-2/directorsofmusic/> [accessed 5 August 2022].
45 Obituary: David Trendell, *The Telegraph*, 23 October 2014.

11.6. Memorial in the cloister to music director David Trendell

been transformed, with the east and west poles cooperating in a liturgical restoration in tune with that of the building. This was suffused with a Catholic spirituality that had tried to burst back into the church's life in its flirtation with the Oxford Movement. Now, it was back to stay.

When Trendell had announced his intention to resign, Rector Dudley felt the solution was staring him in the face. A concert by a still new consort choir called Tenebrae was scheduled to take place in the church on 7 July 2005. The choir had been founded by Nigel Short in 2001 to perform a work he had devised that incorporated a more theatrical approach to using a sacred building to perform music – especially using movement around the space. The concert was to be the world premiere of a piece by Jody Talbot called 'Path of Miracles' – a reference to the famous pilgrimage walk to Santiago de Compostela. On the day of the concert, however, there were terrorist bombings on trains and a bus in London, and the performance had to be postponed for ten days. When it finally took place, the context made an already moving piece yet more profoundly effective. Tenebrae, whose reputation for extraordinary performances was growing dramatically alongside a catalogue of remarkably good recordings, had subsequently returned to the church for further concerts. Now the rector approached Short to become director of music. After some discussion, he agreed. While he had played the organ earlier in life, he did not consider himself an organist but rather a choral director, making him the first such director of music at the priory church.

Short had sung as a countertenor with most major consort choirs, as well as in various great church and cathedral choirs, including Westminster Abbey and Westminster Cathedral. In 1993, this culminated in his joining the King's Singers. He has said he is entirely self-taught as a choral director. This may be so, but, in that case, he was his own excellent student and the composition of the church choir quickly changed to include a number of Tenebrae regulars. The congregation again grew, especially at Choral Evensong, a service that often teeters between liturgy and concert. The fundamental rules of choosing the repertoire remained the same as under Trendell, except that Short added a much stronger interest in the great Anglican repertoire of the nineteenth and early twentieth centuries. This further enriched the mix of choral repertoire.

Towards the end of 2009, the pipe organ in the West gallery finally expired, its airways leaking noisily and producing spurious pitched sounds that made it difficult to sing *a capella* music with the organ switched on. Consultants were brought in to assess its suitability for rebuilding. A major rebuild during 1982–83 influenced by a fashion for updating instruments to be more 'Continental' was felt to have pushed a once fine instrument over the edge. Including its original home in St Stephen's Walbrook, the organ had been in use for almost 250 years. It was the priory church organ for over 120 years, about the same length of time

that the Bridge organ had been in use. The consultants' advice was to replace it completely. The decision was made – reaffirmed in 2021 – to acquire a new pipe organ. In the meantime, a digital organ by Viscount, formerly used by Llandaff Cathedral during the rebuilding of its own organ, has accompanied the services.

Rector Dudley was on sabbatical when the new director of music had to be recruited. The churchwardens and an associate priest interviewed candidates and recommended that the PCC (with the Acting Archdeacon's agreement) should offer the position to Rupert Gough. He accepted. There are echoes of Trendell's tenure in this. Gough is Director of Choral Music and College Organist at Royal Holloway, University of London, a similarly outstanding centre for choral music. He maintains and directs its first-class choir with the added challenge of a membership that significantly changes every year as students graduate and new ones arrive. It is an extraordinary testament to any choral director's skill to produce a consistency of impressive results under such circumstances.

Unsurprisingly, the composition of the priory church choir gradually changed to include alumni of Royal Holloway or those who have worked with Gough in other contexts. This also meant that the average age of the choir members fell. It was precisely this link with younger musicians that was one of the attractive aspects of Gough's appointment. In recent times, the professional octet has been supplemented during term time by a quartet of 'choral scholars' from the College. The difference between eight and twelve singers is a significant enrichment of tone, and the effect has been remarkable. The choir of Royal Holloway has given concert performances in the church from time to time, but also expands the breadth of its singers' experience by undertaking some services each year for the priory church.

The full repertoire built up by Gough's predecessors has continued to be performed, but with the addition now of composers in whom Gough has a special interest. For example, composers from the Baltic states have been well represented in the service music lists, as have many contemporary composers from near and far, among them a growing number of women composers.

At the end of 2016, Dudley left the parish. Replacing him took until February 2018, when Marcus Walker became rector. The congregation, which had been stable for some time, once again started to grow significantly. This was not because the shape of the services had changed in any way. In the first two years, little was altered. Services lasted the same amount of time, the content was almost identical to the past, but growth was noticeable. The church already had a reputation for intelligent preaching. Continuing this was one of the priorities expressed in the PCC's parish profile when looking for a new rector. So was the maintenance of the Anglo-Catholic tradition in the priory church, and the importance of music in its spiritual life.

When the Covid-19 pandemic hit in 2020, the church, along with most others in London, was briefly closed. Some churches shut down their musical establishments to save money. The priory church, however, continued to support its musicians. Initially, the choir recorded their individual voice parts at home and Gough edited them together into performances that were included in the church's newly established online services. Eventually, the choir was able to come together again – carefully socially distanced – to make the recordings more easily (fig. 11.7). The live-streamed services were watched by a widespread congregation from many

countries of the world. Even when restrictions were dropped in many places so that people could go to their own churches, the online numbers barely declined. Live-streaming choral services is now a regular part of the ministry of the priory church.

Looking back over nine hundred years, there are several distinct points where the story takes a new turn. Twenty-eight years ago, the church had declined seriously, and a fresh start was needed. This spurred the creation of the professional choir and the restoration of Anglo-Catholic liturgy and spirituality. These led to a growing congregation, and three outstanding directors of music. Yet this was itself built on the introduction of the surpliced choir in the Oxford Movement years and the acquisition of an excellent organ that drew first-class musicians to work at the church. This would not have happened but for the decision in 1715 to install the first organ since the suppression of the Priory.

11.7. Recording the first-ever medieval Christmas carol service for home streaming during the 2020 Covid-19 pandemic (credit: Marcus Walker)

The story can also be told in the other direction. God inspires Rahere through his apostle Bartholomew to build a remarkable priory that does much good in Smithfield for over four hundred years. Then come the disasters of the two monastic suppressions, the maltreatment of the building, and a musical wasteland. But God still has plans for the priory church and uses music to develop its potential. The restoration of the building to be once again 'the priory church' commences. As it starts to resume its shape, Catholic tradition reignites in the liturgy, and the music is precipitated into substantial development. Eventually, building, music, liturgy, preaching and spirituality come together in a way that connects us closely with the days of the Priory in a renewed church ready to grow and flourish afresh. Many of those who have been responsible for this church throughout the centuries would be surprised to find that the Catholic flame here is now kept alive within the framework of – of all things – the very Church of England that Henry, the destroyer of monastic life, propelled into being for his own purposes. The right question now is, what does God expect next of the priory church?

Sing praise, then, for all who here sought and here found Him,
Whose journey is ended, whose perils are past:
They believed in the light; and its glory is round them,
Where the clouds of earth's sorrow are lifted at last.

The Modern Works of Art in St Bartholomew the Great

PETER DELANEY

UNLIKE ART PLACED IN A MODERN ART GALLERY, where the pieces are displayed to be seen as individual works of art, modern art in St Bartholomew the Great has to hold its own within the majestic and towering architectural spaces built as part of a monastic house for the life of prayer and the worship of Almighty God. St Bartholomew the Great has some very fine examples of the Arts and Crafts movement in iron screens and silver objects for liturgical use, as well as sculptures and paintings from the latter part of the twentieth century placed within the church building. Only the wrought iron screens, the west choir painted panels, the silver liturgical objects and the Lady chapel reredos painting were commissioned to be placed in the present building. The other art has been loaned or donated to be placed somewhere in the present church space; in a way, it has found a home amidst the antiquity of the great monastic building.

This chapter begins with some reflections on the development of Christian art – that, is, of art and architecture designed to serve the church community as it gathered for worship of the God who took human form in the person of Jesus Christ.[1] The very forms that provide the spaces for worship and prayer reflect the desire of mankind to mirror heaven in an earthly New Jerusalem – a medieval title given to the Church of God. The rounded arches of the Romanesque and later the pointed arches of Gothic architecture trace the aspiration of men and women who used all their skill to express their worship of God in words, music, images, sculptures, and all the creativity humankind could employ as part of their journey to God. This has not been an easy journey, as we see from the different stages of the interior of the priory church.

The Christian Church throughout its history has been a great promoter of the arts, and at times one of the chief iconoclasts. From the beginning of its varied history, the Christian community has grappled with the place of image in its life and the danger of graven images which might lead to idolatry. The opening centuries of the church saw intellectual battles over the way God should be represented both in pictorial form and in three-dimensional images. Having emerged from the Jewish ideas of a direct interpretation of the Ten

Modern art is generally understood to be art created or constructed between 1890 and 1970. Contemporary art is most often defined as art made from the 1970s to today. This chapter uses the term 'modern art' to cover both of these periods.

1 A useful introduction to the history of Christian art can be found in Beth Williamson, *Christian Art: A Very Short Introduction* (Oxford: Oxford University Press, 2004).

12.1. *Exquisite Pain* by Damien Hirst, 2006, gilt bronze
(© Damien Hirst and Science Ltd. All rights reserved. DACS 2022)

Commandments with its accompanying fear of the power of the image, Christianity grew into a faith whose very core is based upon the 'Word made Flesh' in the Incarnation of Jesus Christ.

At first, Christians resorted to veiled symbols of recognition – early forms of which included the fish, the lamb, the Greek letters chi rho, and the cross itself – to identify where they met in safety. All these symbols were prevalent from the catacombs in Rome onwards. 'The Good Shepherd' began the attempts to represent Jesus himself based upon scriptural references. After the Emperor Constantine's edict of 313 AD making Christianity the religion of the Roman Empire, symbols and images began to grow in number. This gave rise to new Christian buildings for worship, often based on pagan temple forms, and the emergence of visual representations of the Christian faith.[2]

At first, murals and wall and floor mosaics covered the interiors of churches. These were followed by carvings in stone, and finally by painted and gilded wooden images of the Bible stories and the saints of God.[3] As soon as the Christian community began to develop architecture to house its assemblies for worship, the whole notion of visual symbols and the story of the life of Christ told in pictorial form was at the heart of the message shared by the Christian community. Gatherings of church elders, synods and councils have frequently returned to the questions surrounding the theological arguments associated with what is acceptable as visual image and what is not and why.[4]

The Protestant Reformation swept Europe in the sixteenth century bringing a reformed character to the Church and with it a rejection of much that had become central to worship and belief. There was particular emphasis on the rejection of images and painted aids to worship, statues and textiles. This movement split the Church in the west into factions and included a form of iconoclasm, the destruction of images destroying much great art and architecture. The Roman Catholic church instigated its own reforms, which became known as the Counter-Reformation and set up guidelines for the arts, initiated at the Council of Trent. This gave rise to a blossoming Baroque and Rococo style of art and architecture.[5] In the East, the great Orthodox Church remained unaltered and continued with its tradition of liturgy using icons and other images dominated by Greek and Russian forms, which maintained a formal rejection of three-dimensional images in worship.[6]

The most successful created images to be placed within sacred space are those commissioned to be a part of a particular worship space. In the case of historic architecture, this has often been built over the centuries by the faith it represents. In the case of St Bartholomew the Great, the present architecture is a record of the styles and opinions of those who

2 For a comprehensive treatment of symbology in Christian art, see George Ferguson, *Signs & Symbols in Christian Art* (London: Oxford University Press, 1989).
3 An overview of the latest scholarship on early Christian mosaics, sculpture, painting and other decorative arts can be found in Robin Margaret Jensen and Mark D. Ellison, *The Routledge Handbook of Early Christian Art* (London: Routledge, 2020).
4 Richard Krautheimer, 'Early Christian and Byzantine Architecture', in *The Pelican History of Art* (London: Penguin Books, 1989), chapters 1, 2.
5 *Art and Reform in the Late Renaissance: After Trent*, ed. Jesse Locker (London: Routledge, 2018), pp. 1–18.
6 Robert Taft, 'Icon and Image East and West', in *Icons and the Liturgy, East and West: History, Theology, and Culture*, ed. Nicholas Denysenko (Notre Dame, Indiana: University of Notre Dame Press, 2017), pp. 13–34.

commissioned and built the structure. There is also a shocking element to the present physical church in that it represents also what is left of the physical structure after the religious wars and disagreements which split the wider Church apart.

What is left of the domestic architecture of the monastic church, the cloister and the garth contains Victorian copies as well as original relics of the past.[7] With the destruction of so many original spiritual artefacts we are left with what is comparatively new church art mainly from the twentieth century. We can only imagine what the interior of the church looked like when it was adorned with detailed altarpieces, statues, reliquaries, mural paintings and tapestries. The various restorations and rebuildings of the priory church are covered elsewhere in this book; what I have written here is related to the ongoing story of the conservation and restoration of the whole church and the addition of modern art since the late Victorian restoration undertaken by Sir Aston Webb and others.[8]

THE NORTH TRANSEPT AND LADY CHAPEL WROUGHT IRON SCREENS BY ASTON WEBB AND STARKIE GARDNER – 1893, 1897

Strictly speaking, the two wrought iron screens are part of the architectural fittings of the church, but as specifically designed interior additions they warrant comment in this assessment of modern art in St Bartholemew the Great.

When the restoration of the north transept took place in 1865, a late-medieval masonry screen of two four-centred arches was revealed. This originally formed part of the narthex or vestibule to the now-vanished Walden chapel.[9] In a later phase of the restoration, a wrought iron screen carrying heraldic coloured arms and decorations was set into the stone base. This screen is nearly contemporary with the Lady chapel screen; it was designed by Aston Webb (1849–1930) and made in 1893 by J. Starkie Gardner (1844–1930). It measures 2.19 m in height and 2.49 m in width. It provides a division through which the choir and the transept can connect. The screen consists of lateral bars spaced at intervals horizontally supported by upright bars forming spiked tops, crenellated.

There are ten individual armorial shields all painted in heraldic colours – four above the main frieze and six below. These were made by George William Eve (1855–1914) to honour 'the more notable people present at the opening of the transept in 1893'.[10] The order has been altered since Alfred Webb gave his description in 1921 (figs. 12.2 and 12.3).[11]

West panel
Upper row: St Bartholomew's Priory; the Royal Arms; Albert Edward, Prince of Wales (later Edward VII); the Bishop of London.
Lower row: Royal Arms; Sir Borradaile Savory (rector); St Bartholomew; the Hospital; Canon Frederick Phillips (patron)

7 See Evan McWilliams's chapter in this book for more on the tension between the medieval and modern during the Webb restoration.
8 For those other restorations and rebuildings, see the chapters by Nick Holder and Steven Brindle in this book.
9 For more on the Walden chapel, see the chapter by Christian Steer in this book.
10 Webb, *Records*, II, pp. 47–48, 478 (quote p. 48).
11 Webb, *Records*, II, p. 478.

12.2. The east panel of the north transept screen

12.3. Detail of the arms of St Bartholomew on the north transept screen

East panel
Upper row: St Bartholomew's Priory; the Archbishop of Canterbury; St Bartholomew; Sir Borradaile Savory (rector)
Lower row: the Bishop of London; the Archbishop of Canterbury; Albert Edward, Prince of Wales; the Hospital; the City of London

Set into the masonry above the screen is a Madonna and Child in stucco, almost certainly from the workshop of the fifteenth-century Florentine sculptor Lorenzo Ghiberti, given in 1933 by Lady Agnes Dixon-Hartland in memory of her husband.[12]

The Lady chapel was fully restored in 1897 as a part of Aston Webb's architectural programme. Dividing it from the ambulatory is a handsome Arts and Crafts wrought iron screen complete with gates (fig. 12.4). The screen was designed by Aston Webb in a similar style to the north transept screen and likewise made by Starkie Gardner. It stretches wall to wall at a width of 7.05 m, a height of 3.40m, reaching 6 m to the top of the cross. It consists of five bays formed with square bars subdivided. Running across the whole is a hammered iron frieze elaborately pierced and set in a broad wrought iron frame. At the centre are two hinged gates.

12 For more information on this image, see the note by Jeremy Warren in this book.

12.4. The Lady chapel screen

Across the top of the whole screen are a series of single candlesticks with shades. At the centre, surmounting the whole screen, is a tall Latin cross on which is a crucifix figure of silver. Embossed on the crossing band are the words

This Screen is a thank offering to God for and in loving memory of Emily Fuller Webb died Jan 20, 1896. The wife of one privileged to share in the Restoration of this church.

'The severity of the design of the lower part of the screen is in keeping with the massive character of the building, and the delicacy of the work above with the character of the dedi-cation,' wrote E. A. Webb of the screen in 1923.[13] The Emily Fuller Webb to whom the screen is dedicated was his beloved wife.

13 Webb, *Records*, II, pp. 85–86.

12.5. Detail of the pulpit in the choir screen with decorative carving above

THE WEST CHOIR SCREEN PANELS BY FRANK BERESFORD – 1932

Aston Webb's major restoration of St Bartholomew the Great not only included detailed restoration of the original fabric, but also the addition of new furnishings and fittings in an attempt to re-create something of the medieval splendour of the monastic church. At the west end of the building there is a set of richly ornamented choir stalls in the tradition of the great choir stalls central to the round of prayer which constituted the monastic daily offices and yearly liturgical cycle. These stalls and the benches in front of them – originally for the boys of the church choir – were erected in 1886 by Canon F.P. Phillips, patron, in memory of his parents. Above them is an exquisitely carved oaken choir screen, erected in 1889 to the memory of Rector Panckridge (fig. 12.5).[14] The words, from Isaiah 51:3, are the same as those formerly inscribed on the books held by the bedesmen on Prior Rahere's tomb.

In 1932, a set of painted panels in oil on wood depicting the life of Prior Rahere and telling the story of the foundation of the monastic community and hospital was inserted into the choir screen.[15] The liturgical vesture of the ecclesiastical figures represented in the

14 Webb, *Records*, II, pp. 48-49. The large wooden lectern in the middle of the choir was also designed by Sir Aston Webb and is made from old oak beams from the original Lady chapel roof. It reflects the monastic tradition of a larger central lectern to carry the principal liturgical books for the Offices and then after the Reformation the location where the Bible was placed for its study and reading. Webb's lectern replaced a brass lectern that had been given by Mrs John Hilditch Evans in memory of her husband, sometime church warden and treasurer of the restoration fund from 1868-85.

15 Rector Savage, in his appeal for funds, mentions that the drafts coming through the open panels in the choir screen were affecting the singers' health: The Rev'd Canon E. Sidney Savage, 'Rahere Yesterday and Today, and His Priory Church of St Bartholomew, Founded in 1123: Its chequered story and an appeal' (London: 1930).

12.6. Choir panels 5–7, by Frank Beresford, 1932

panels, which now appears highly antiquated, reflects the imperfect understanding available at that time on the proper form of medieval costumes and vestments.

The paintings on the panels from left to right are:

1. *Rahere the Minstrel*
2. *Rahere is blessed by Bishop Richard*
3. *Rahere sets forth on his Rome pilgrimage*
4. *Rahere returns to build his church and hospital*
5–7. *Three panels depicting Prior Rahere receiving the royal charter from King Henry I for the church and the hospital* (fig. 12.6)
8. *The vision of St Bartholomew to Prior Rahere* (signed and dated) (frontispiece to this volume)

They are treated in an almost mural form, linking each panel in content.

The artist Frank Beresford (1881–1967) was a British painter born in Derby. He was elected a Royal Academician. His early days were spent in St John's Wood attending the St John's Wood School of Art, where a number of budding artists were studying under figures such as Sir Lawrence Alma-Tadema and William Frederick Yeames. This was a training ground for families to send their talented sons and daughters to receive a classical art education without indulging in a bohemian lifestyle. Beresford was to retain his own

273

St John's Wood studio for over six decades. He painted landscapes, animals, interiors and 3,000 commissioned portraits of royalty, aristocrats, politicians and society figures. What was to become his most famous painting, *The Princes' Vigil: 12.15 am January 28th, 1936*, was painted in 1936 and depicts the lying-in-state of George V in Westminster Hall. This painting was later purchased by Queen Mary and became a part of the Royal Collection.[16]

It was in St John's Wood that Aston Webb met Beresford, which subsequently led to his commission to portray Prior Rahere and the beginnings of St Bartholomew's Priory in the revamped choir. Although Beresford was known as a portrait painter and muralist, he undertook the panels as one work linked by their choice of colours and design. Reading from left to right, the viewer is taken on a journey of discovery with the familiar figures in the story. It is generally thought that the face of Bishop Richard in the second panel is modelled on Sir Murland de Grasse Evans, school friend of Sir Winston Churchill and curate of St Bartholomew the Great at the time.[17]

THE SANCTUARY SILVER BY OMAR RAMSDEN – 1929–34

In the sanctuary of the church are a large silver cross and candlesticks commissioned for the priory church from the well-known Edwardian silversmith Omar Ramsden (1873–1939). These objects – fine examples of the Arts and Crafts Movement – display British design and craftsmanship at its very best.

The Arts and Crafts movement, inspired by the writings and work of artists like John Ruskin and William Morris, saw handiwork as personally ennobling and sought to elevate standards of design by promoting hand-crafted goods in preference to machine-manufactured products. In appealing to the image of the medieval craftsman and the power of handmade articles, the founders of the new movement returned to the traditional means of making artefacts by hand, using processes lost in the development of mechanized goods.

Omar Ramsden was deeply involved in the Arts and Crafts movement. In an address to the Royal Society of Arts in 1928, he spoke of the moment in which the decline of art, so evident in the first half of the nineteenth century, was reversed:

The real dawn of a new day, a day whose sun is not yet at its zenith, took place in the world of Fine Art – in that wonderful band of painters we call the pre-Raphaelites, with its off-shoot, the sturdy efforts of William Morris, whose ideas, leading to the arts and craft movement, have profoundly affected the present-day world of applied arts.[18]

Omar Ramsden and his long-term collaborator Alwyn Carr (1872–1940) were both born in Sheffield – a city deeply caught up in the Industrial Revolution and yet with its roots in medieval craftsmanship, giving it its foundation as a serious contender for the development of handicrafts. Ramsden and Carr met at the School of Art in Sheffield and subsequently set off together on a six-month tour of European cities. In 1898, they settled in London,

16 David Buckman, 'Beresford, Frank Ernest', *Artists in Britain since 1945* (Bristol: Art Dictionaries Ltd, 2006).
17 *Weekly Dispatch (London)*, 3 July 1932.
18 Omar Ramsden, 'English Silver and Its Future', *Journal of the Royal Society of Arts*, 77.3967 (1928), pp. 50–71 (p. 54).

12.7. The sanctuary being dressed for the Easter Vigil, showing Omar Ramsden's standard candlesticks, vases, and altar cross

and in 1904 they were both elected to the Art Workers Guild, which gave them leverage in prospective commissions and publicity. At the outbreak of the First World War, Carr joined the Army, leaving Ramsden in London to run the business. In 1918, their partnership was dissolved and they both established separate workshops.[19]

As the leading craftsman designer after the First World War, it was Omar Ramsden who was commissioned to make the liturgical silverware for an important restored medieval church in the City of London. The making of silver objects by hand using traditional methods was spoken of by Ramsden thus:

The true silversmith of today, as in the Gothic times, is a beater of metals. His eye, by instinct and a prolonged study of successful forms and decorations, selects a scheme that can be produced at first hand by hammer work, without the intermediate process of modelling, moulding, and casting. Please do not think by beaten work I mean hammer marks, such as those with which our West-End shops now sometimes pockmark their otherwise machine-made silver, in order to draw in the chance customer who has been told "if a thing is hammer-marked it is handmade and artistic".[20]

19 Ghenete Zelleke, 'Omar Ramsden and Alwyn Carr: An Arts and Crafts Collaboration', *Art Institute of Chicago Museum Studies*, 18.2 (1992), pp. 169–91.
20 Omar Ramsden, 'Silversmiths' and Goldsmiths' Work', *Journal of the Royal Society of Arts*, 58.2984 (1910), pp. 253–67 (p. 263).

12.8. Detail of the inscription running along the base of the candlesticks

Standing each side of the high altar are two handsome tall silver candlesticks bearing the date mark of 1933/34 and the maker's mark of Omar Ramsden (fig. 12.7). Cut into the bases and wrapping around the candlesticks is the inscription (fig. 12.8):

Presented Easter Day MCMXXXV wrought for the greater glory of God for use in the Priory Church of St Bartholomew the Great by the command of Sanyer and Margaret Atkin of Chelsea in loving memory of their dear and only son Montague Sanyer Atkin

The large central altar cross carries four detailed symbols of the Evangelists set at the heart of the meeting of the cross arms. This provides a break for the eye as it travels across the extent of the full object seen as the central focus of the high altar. It carries a date mark of 1933 and the maker's mark of Omar Ramsden (fig. 12.9). A handsome processional cross date-marked 1933/34 and displaying Ramsden's maker's mark recapitulates many of the design elements of the altar cross on a smaller scale (fig.12.10). It remains in weekly use.

En suite with the altar cross and seen at major feasts are two pairs of octagonal silver flower vases (now used as candle holders), originally designed and made by Ramsden to stand on the raised plinths of the altar gradine. The larger pair bear his maker's mark and the date mark 1933/34, but the smaller pair are copies by Leslie Gordon Durbin (1913–2005) – formerly Ramsden's apprentice and the leading silversmith of his own day – dated 1982 and made after the originals were stolen. Also seen at major services is a magnificent alms dish decorated with three chiselled figure panels telling the story of Rahere and the foundation of the Priory date-marked 1929/30, likewise made by Omar Ramsden and the gift of the Atkin family (fig. 12.11).

12.9. The altar cross, by Omar Ramsden, 1933

12.10. The processional cross, by Omar Ramsden, 1933/34

12.11. Detail from the alms dish of Rahere receiving his vision of St Bartholomew, by Omar Ramsden, 1929/30

The commissioned silver altar cross and candlesticks to be placed in the restored sanctuary of the priory church fitted exactly with the principles of the Arts and Crafts Movement. The hand-beaten, pure silver pieces are at an impressive scale and display minute attention to detail, with line incisions and lettering playing an important part in their design. It is significant that these objects are read in their architectural setting of dominant arches and the full height of the apse seen from a distance and also from closer views. Often the sanctuary furniture is taken for granted and sometimes not even noticed, but our Victorian and

Edwardian predecessors gave the new liturgical details serious thought. They re-planned the east end interior of the church with great care.

These objects made in silver give an indication of the liturgical tradition of St Bartholomew the Great in the 1930s. The commissioning of the large candlesticks and dominant altar cross along with the set of silver vases, chalices and other ecclesiastical articles (not on show) as well as the large processional cross suggests that this was a parish whose interest in formal liturgy was more than superficial. The value given to these silver liturgical artefacts in worship shows the revival of English liturgy as it had begun to develop in the first quarter of the twentieth century.

EXQUISITE PAIN BY DAMIEN HIRST – 2006

A more recent addition to the church interior is a work by Damien Hirst (1965–) which has been on loan from the artist since 2015 (figs. 12.1 and 12.12). The human figure provides the basis for a large number of religious works in churches and cathedrals across the world. Damien Hirst's *Exquisite Pain*, a two-and-a-half metre tall detailed anatomical study in gilt bronze, depicts the martyred Saint Bartholomew standing erect with his flayed skin draped over his arm and holding aloft the instrument of his martyrdom. Bartholomew, one of the original twelve disciples, was sent as an apostle to Armenia, where tradition holds that he was killed by being skinned alive. The classic iconography of the saint sees him naked, his muscles exposed, his skin hanging over his arm – and in his hand the instrument of his torture. *Exquisite Pain* conforms to this imagery with a unique twist: the instrument in the saint's upraised right hand is not a standard knife, but a scalpel, used in the hospital nearby which also bears his name. In his left hand, the figure holds a pair of scissors, which Hirst says was inspired by Tim Burton's film 'Edward Scissorhands' (1990). This additional instrument signifies, in the words of the artist, that 'his exposure and pain is seemingly self-inflicted. It's kind of beautiful yet tragic.'[21] On the tray on which the figure stands are various instruments of the sculptor's trade.

Asked about the inspiration for *Exquisite Pain*, Damien Hirst said, 'I like the confusion you get between science and religion [...] that's where belief lies and art as well'. The artist draws on a 1562 statue by the Renaissance artist Marco d'Agrate in the Duomo in Milan. The d'Agrate statue was a virtuoso display of the artist's anatomical knowledge of the stripped human form (*écorché*), employed as an integral part of a narrative. Other inspirations include etchings and paintings of the saint that Hirst was exposed to during his childhood education in a Catholic school. Hirst notes that 'the strict demarcation between art, religion, and science is a relatively recent development' and that depictions of Saint Bartholomew, patron saint of doctors and surgeons, were often used to aid anatomy studies.[22] Hirst also draws upon Titian's painting of *The Flaying of Marsyas* (c. 1570–76) and the wood engravings accompanying Andreas Vesalius's pioneering scientific publication on the anatomy of the human body appearing in Venice in 1453.

21 Damien Hirst quoted in: *Beyond Limits: Sotheby's at Chatsworth* (Bakewell, Derbs: Sotheby's, 2006).
22 Hans Ulrich Obrist, 'Interview: Damien Hirst', in *Beyond Belief* (London: Other Criteria/White Cube, 2008), pp. 26–27.

12.12. *Exquisite Pain* by Damien Hirst, 2006, gilt bronze
(© Damien Hirst and Science Ltd. All rights reserved. DACS 2022)

Exquisite Pain presently stands next to the baptistery, in ironic juxtaposition with the baptismal font – the place where new Christians are welcomed into the Christian family. Despite its bright gilding, it is a dark reminder of the cost of discipleship.

THE MADONNA AND CHILD BY ALFREDO ROLDÁN – 1999

The large oil painting of the Madonna and Child that forms the reredos above the Lady chapel altar was specifically commissioned for the purpose (fig. 12.13). It was unveiled in February 1999 and dedicated by Richard Chartres, then bishop of London.

Alfredo Roldán (1965–) is a self-taught Spanish artist with no formal training. He began by selling his work in street markets and, by the mid-1990s, after winning several competitions, he came to the attention of art galleries in Europe and America. Roldán works in

12.13. *The Madonna and Child* by Alfredo Roldán, 1999, oil on canvas

a communal studio in his home city of Madrid and this is the setting for his relationships to his models and for all his work. In 1994, Roldán won a prestigious award granted by the City Council of Madrid and was taken up by a major Spanish gallery, which promoted his work. His winning painting from the Council Award now hangs in the Museum of Modern Art in Madrid. In 1996 he was named Member of the Senate 'Honoris Causa' of the Academy

of Modern Art in Rome.[23] He uses the conventions of still life painting, surrounding his colourful figures with pots, bottles, vases, flowers and fruit. His setting is the home, a simple place of relaxation and rest, and his choice of exciting colours – rich variations of reds, blues and greens – are set against muted earthy shades of ochre and flesh tints.

Roldán's *Madonna and Child* displays the direct influence of the twentieth-century avant-garde, which used colour and shapes to define a painting almost in an abstract way. The figures are depicted in an almost flat plane, discarding the use of perspective and form. The flattened perspective, broken surfaces and stylization remind the viewer of cubism and abstract impressionism. There are direct parallels to Picasso and Juan Gris, and we see shades of Modigliani in his female studies and homages to Gauguin and Matisse in his use of colour. Roldán's female subjects are powerful symbols of the feminine whilst his faces are mask-like images of ancient Cycladic goddesses. The Virgin Mary of this painting is no exception: her eyes are empty – lacking pupils – which emphasizes a sense of the archaic and of otherness. They are mysterious – an appropriate treatment for the Mother of God and her child in the Lady chapel reredos.

Roldán, true to his cultural inheritance, brings something of Spain into his sunny colours and architectural form. Yet the gaze of the mother and the treatment of the child pay homage to Renaissance masters like Botticelli and Crivelli, who created images of the Virgin and Child that are both familiar and religious in character. It is interesting to see how the modern idiom is at home in a Gothic-style English Lady chapel. The painting is now seen against an empty wall of niches meant to contain the statues of saints as a focus of prayer and adoration. In the Middle Ages, the statues too would have been brightly coloured and gilded as a reredos in themselves.

THE RISEN CHRIST BY JOSEFINA DE VASCONCELLOS – 1957

In the north ambulatory aisle of St Bartholomew the Great a two-metre tall terracotta fired statue of the Risen Christ is placed significantly next to a stone coffin from the medieval Priory (fig. 12.14). This emphasizes the figure rising from the dead in tranquillity and peace.

Its sculptor, Josefina de Vasconcellos (1904–2005), was an international artist of some renown. Born in London to a Brazilian diplomat father and an English Quaker mother, she entered the Royal Academy Schools in 1929, winning the Prix de Rome competition. She lived in the Lake District whilst maintaining a studio in London. After the Second World War, de Vasconcellos and her husband, the artist and Anglican lay preacher Delmar Banner, exhibited together in a number of shows. In 1977, the Department of Peace Studies at Bradford University commissioned a sculpture that de Vasconcellos entitled *Reunion*. After the statue's restoration it was renamed *Reconciliation* and in 1995, to mark the fiftieth anniversary of the end of the Second World War, bronze casts of this sculpture were placed in the ruins of Coventry Cathedral and in the Hiroshima Peace Park in Japan. To mark the opening of the rebuilt Reichstag building in 1999, another cast was placed to commemorate the Berlin Wall. In 1957 a sculptural piece entitled *Virgin and Child* was donated to St Paul's

23 Alfredo Roldán biography, Albemarle Gallery. Archived at: <https://web.archive.org/web/20220801201153/https://albemarlegallery.com/artists/25-alfredo-roldan/biography/>.

12.14. *The Risen Christ* by Josefina de Vasconcellos, 1957, terracotta

Cathedral (now on show in the cathedral crypt) and her reputation as a sculptor of religious subjects increased. For years her emotionally moving figures in the outdoor crib in Trafalgar Square became a part of families' Christmas visits to London. The Holy Family figures of this set are now at Norwich Cathedral.[24]

In the Christ figure in St Bartholomew one can see something of the work of Donatello, and the Florentine Renaissance sculptors influenced her treatment of the human form and its movement. The texture of the figure, being in a fired clay, resonates with the different stone colours contained in the priory church architecture surrounding it and the light coming in from the window.

24 Josefina de Vasconcellos, obituary, *The Guardian* (21 July 2005); David Buckman, 'De Vasconcellos, Josefina', *Artists in Britain since 1945* (Bristol: Art Dictionaries Ltd, 2006).

12.15. *Golgotha* by Richard Harrison, 2003, oil on canvas
(Image courtesy the artist)

GOLGOTHA BY RICHARD HARRISON – 2003

The textured oil painting entitled *Golgotha*, also on loan to the church, is set high up on the south wall of the church near the altar, which captures the exact angle of the crucifixion perspective used by the artist himself (fig. 12.15). The thickness of the paint and the texture of the canvas all add to the power of the figure on the cross and its emotional impact on the viewer.

Richard Harrison (1954–) travelled widely during his career as a member of the Merchant Navy. He turned to studying medieval history at Cambridge, then attended the London College of Furniture and finally the Chelsea School of Art, where he completed a BA degree in Fine Art in 1987 and an MA in Painting in 1988.[25] Harrison is concerned with two types

[25] *Nothing Wasted: The Paintings by Richard Harrison*, ed. Brian Sewell and Richard Harrison (London: Peter Wilson, 2010), pp. 7–31.

of work, landscape painting and figure painting. His landscape work shows the power and influence of natural forces, while his figure works explore dark and emotive subjects drawn from mythical stories and the classical hierarchy of gods and the battle between good and evil. His earliest work was essentially abstract, and these abstract values have formed the core of all his later work.

The contrast between good and evil and the humiliation of the human form are central themes in Harrison's work. It is not surprising then that the artist moved to biblical and mythical narratives on large-scale canvases influenced by the painters from the High Renaissance and the Victorian figurative painters. In his exhibitions in the Albermarle Gallery in London from 2002 to 2016 his work has focused on the biblical vision in St John of the Four Horsemen of the Apocalypse and the Greek myth surrounding the figure of Andromeda.

Harrison is an interesting figure in the history of modern figurative and abstract painting at a time when these genres have long been out of fashion in British art and among the curators of national museums of modern art. His use of Christian themes and particularly that of the crucifixion brings his work into churches and cathedrals at a time when there seems to be a dearth of commissioning by the Church. In 2009 his large, monumental crucifixion triptych *At the End … A Beginning* was installed in the ambulatory of Liverpool Anglican Cathedral.

In *Golgotha*, Harrison sets the pale figure of Christ against a blood-red background supported only by a frail set of posts, setting the scene for an emotional portrayal of the suffering Christ. About the composition, the artist said:

In tackling the subject of The Crucifixion, I wanted to concentrate on the isolated figure of Jesus Christ [….] It was also essential to convey the suffering and humiliation that Christ endured, and the despair that he felt.

The cross I have painted is not the cross normally depicted, but rather a combination of a medieval rack-like contraption that unduly stretches Christ's body, and a catapult-like device that threatens to sling and discard the suffering Christ, as if he were just a piece of meat, onto the floor when his life is finally spent.

The black and red background, sliced through by a parched chasm or dried-up riverbed, emphasises the desolate and desperate situation in which Christ finds himself and echoes the sense of impending doom.

This deeply challenging work confronts viewers with the utter desolation of Jesus's fourth word from the cross: 'My God, my God, why hast thou forsaken me?'[26]

ST BARTHOLOMEW THE GREAT BY CHRISTOPHER GREEN – 2013

Hanging in the cloister on the west wall just inside the entrance door is a large composite pen-and-ink drawing of the interior of the priory church from the north ambulatory by Christopher Green (1979–). It is made up of one continuous view of the interior passing

26 Matthew 27:46.

12.16. *St Bartholomew the Great* by Christopher Green, 2013, ink on paper

beyond the natural perspective view into a vista encompassing the entire width of the building (fig. 12.16).

Christopher Green completed the Drawing Year at the Prince's Drawing School (now the Royal Drawing School) in 2008, after graduating with an MA in Fine Art from the Byam Shaw School of Art. He has had solo exhibitions in London and Leigh-on-Sea and exhibits regularly in group shows and prize exhibitions including the Lynn Painter-Stainer's and the Sunday Times Watercolour Prize. Green is a tutor on the Royal Drawing School's Foundation Year and at Drawing School Central. He specializes in large-scale, monochrome ink drawings of the landscape, London scenes, and interiors.[27]

Green is a consummate draughtsman obsessed with detail and devising for himself a new way of depicting architectural views impossible to see with the ordinary naked eye. His monochrome ink drawings of landscape, London scenes and interiors are now widely known as major graphic works of our time. They are full of detail and use texture and line to portray the exciting surfaces and shapes of a wide variety of architectural forms.

St Bartholomew the Great comes from a suite of drawings Green undertook of City churches over a period of three years. It was bought by the church as a part of its historic collection.

GOLGOTHA BY ELENA UNGER – 2018

Displayed in the south ambulatory is a miniature painting by Elena Unger that captures, in minute detail, the image of the empty cross perched upon the hill of Golgotha, the site of the Crucifixion. Below the cross, in an empty cavern, lies the skull of Adam, with the blood of Christ depicted as seeping through the stone and into it (fig. 12.17).

Elena Unger is an alumna of Central Saint Martins and Goldsmiths College, and also studied philosophical theology at the University of Cambridge. While primarily a painter,

[27] 'Christopher Green Artist' <https://www.christophergreen.info>.

12.17. *Golgotha* by Elena Unger, 2018, oil on panel
(Image courtesy the artist)

she combines painting, sculpture, performance, sound and film to produce immersive installations. Her artwork is inextricably linked to her philosophical work, which is concerned with the ontology of art making, and how works of art do not merely represent the divine but participate in it. She frequently exhibits across London in both group and solo exhibitions, including one at Saint Bartholomew the Great in 2017, and was previously a CHASE Junior Research Fellow at Goldsmiths' in Theology and Art.

Golgotha was envisioned by the artist during Good Friday at St Bartholomew's. On seeing the altars stripped, she imagined the empty cross as that which collapses the moments of the birth, death, resurrection and ascension of Christ into one moment beyond time.

MODERN ART IN CHURCHES AND CATHEDRALS

In one sense art is never finished, but is always developing and changing, building on the present and heralding the future. In just over one century, the priory church has attracted gifts of art, from silver liturgical articles, sculptures in bronze and terracotta, paintings in oil and other media to blown glass and wrought iron forms, all contained within a medieval church building displaying 900 years of creative ideas. The dominant art form is architecture – seen by us in its present state after centuries of destruction, new building, conservation and restoration. The vessel for all the modern art is the historic architecture of the church; where the art has been commissioned for a particular purpose and site it is most successful, where it has been randomly placed it is less successful.

The secret of Romanesque architecture is that it can tolerate additional forms of building inserted right into its centre. As is pointed out in other chapters in this book, by following the development of architectural styles one can see the historical growth of the priory building. Any addition of modern art must stand up to the power of the great rounded arches surmounted by the lighter Gothic tracery placed above and next to them. It is this dominance of treated stone which moulds the interior setting for any art created to enhance and respond to 900 years of Christian presence in what now constitutes the great medieval priory church.

As you visit and move around the present building your eye will be caught by the shimmering gilding of Damien Hirst's statue, the shining of the Omar Ramsden silver cross and candlesticks, and the muted colours of Frank Beresford's choir screen panels. As you gaze through the wrought iron screens to view the other images on show you will see the painted images of the Crucifixion by Richard Harrison or Josefina de Vasconcellos's *Risen Christ* or the detailed interior drawing of the church by Christopher Green.

What will the artists of the next centuries bring to St Bartholomew the Great? This will be governed by today's patrons, the congregation's tastes and the commissioning so crucial to modern religious art. Who knows? Might the celebration of the 900th anniversary of the foundation by Prior Rahere in itself provide an initiative for a new work of art marking our very own landmark in the history of this distinguished place of pilgrimage and peace? But for that we shall have to wait and hope that the generosity of the past is reflected in the new promise of the future.

Notes on the Sculpture and Lesser Artworks of St Bartholomew the Great

JEREMY HASELOCK AND JEREMY WARREN

A FIFTEENTH-CENTURY FLORENTINE IMAGE of the Virgin and Child, displayed on the stone screen dividing the crossing from the north transept chapel, is among the more unexpected treasures of St Bartholomew the Great (fig. 13.1). An ostensibly simple composition, the sculpture is remarkable for its subtle exploration of the intimate and tender relationship between mother and son. Their heads nestle against each other, whilst Mary's elegant hands and long slim fingers gently support the Christ Child who, cradling his own arms, echoes the protective gesture of his mother. In a gently humorous touch, Christ's feet stick firmly out from under his drapery. The relief is made from stucco, a form of tough plaster, and has been painted in naturalistic colours which, although clearly refreshed, may broadly follow the original scheme.

The compact and elegant design almost certainly originated in the workshop of the great goldsmith and sculptor Lorenzo Ghiberti (1378–1455), famous for his two great bronze doors for the Florence Baptistry. It is a closely related variant of a model of the Virgin and Child that is generally attributed to Ghiberti and must have been astonishingly popular, being known today through numerous replicas in stucco and in terracotta, most of which were doubtless produced in other workshops throughout Florence.[1]

Devotional sculptures of this type were made for display in homes and in churches, but also in tabernacles on prominent public sites such as street corners, often at much the height at which the Saint Bartholomew relief is displayed today. Paintings and sculptures of the Virgin and Child were crucial elements in devotion in medieval and early Renaissance Italy. Sculptures in particular were felt to possess a corporeal and tangible quality, allowing worshippers to feel that they were all but in the presence of holy figures. This was well recognized by preachers such as the Blessed Giovanni Dominici (1356-1419), who urged parents to keep painted and sculpted images of holy figures in their homes as examples for their children, who, he hoped, would even as babies 'be delighted [...] and will act according to the exemplar, with acts and signs appropriate to childhood'.

1 Jeremy Warren, *Medieval and Renaissance Sculpture: A Catalogue of the Collection in the Ashmolean Museum, Oxford*, 3 vols. (Oxford: Ashmolean Museum Publications, 2014), II, pp. 378–81, no. 96 (see esp. p. 381, n. 4).

13.1. *Madonna and Child*, Florentine, 15th century, model attributed to Lorenzo Ghiberti, stucco

THE LESSER PAINTINGS AND STAINED GLASS OF ST BARTHOLOMEW THE GREAT

In addition to the significant modern works of art reviewed in Peter Delaney's chapter, the church possesses a small number of earlier paintings of no great merit but worthy of listing here for completeness's sake.

Removed from the Lady chapel, where once it formed the altarpiece, and now displayed in the cloister is a late seventeenth-century painting of the Virgin and Child with St Elizabeth and the infant John the Baptist (fig. 13.2). The picture was given to Rector William Sandwith in 1910, some thirteen years after the restored Lady chapel was opened. For a long time considered to be a studio copy of a lost painting by Murillo (1617–82), it was identified in 1981 by a specialist from Sotheby's as an original work by an artist unknown, based on a painting known as *La Perla* by Raphael (1483–1520) and his pupil Giulio Romano (1499–1546) now in the Prado in Madrid. The pyramidal composition reflects Raphael's indebtedness to Leonardo da Vinci. The Raphael original was in the collection of Charles I until the dispersal of 'the late King's goods' in 1651, after which it passed via a number of hands into the possession of Philip IV of Spain, who considered it 'the pearl' of his collection. The version in St Bartholomew's would be held in higher esteem if it were carefully cleaned, whereupon the figure of St Joseph would emerge from the murky background on the left-hand side.

13.2. *Virgin and Child with St Elizabeth and John the Baptist*, after Raphael, artist unknown, last half of 17th century, oil on canvas

In the south vestry there hangs what has been tentatively identified as a self-portrait by Hamlet Winstanley (1698–1756) on the basis of its close resemblance to a documented self-portrait in the Walker Art Gallery in Liverpool, dated 1730. The picture is in the St Bartholomew's collection because it was believed by the donor to be a self-portrait by Winstanley's more famous contemporary William Hogarth, who, as an added inscription on the frame informs us, was baptized in the church on 28 November 1697. Winstanley's main claim to fame is that he was, albeit briefly, the teacher of George Stubbs. Trained in Sir Geoffrey Kneller's academy in London, he is otherwise best known as a copyist employed by James Stanley, the tenth earl of Derby, to paint versions of the works of great masters to adorn Knowsley Hall, his ancestral home in Lancashire. To that end, Winstanley spent the years 1723 to 1725 in Rome before returning to his home town of Warrington for the rest of his life.

Also in the south vestry is an early eighteenth-century portrait on board of a young boy, smartly dressed in a blue velvet suit and linen neck bands. He holds in his left hand a

closed book and in his right a scroll bearing the inscription *I WAS NAKED / AND YE / CLOATHED / ME* (cf. Matthew 25:36) (fig. 13.3). He appears to be just about to ascend a spiral staircase on the left of the painting, while on the right is a glimpse outdoors of a fine group of buildings. The painting is unsigned and unattributed but clearly dates from the first half of the eighteenth century and may possibly represent a pupil of Christ's Hospital, the first 'blue-coat' school, originally in Newgate, a short distance away from St Bartholomew the Great. The painting may be an actual portrait of a charitably educated boy as yet unidentified, but it could also be a representative figure illustrating the success of Christ's Hospital in raising foundlings and orphans and giving them a fine education. Its presence in St Bartholomew the Great may be attributable to the years in which the pupils of Christ's Hospital attended lessons in St Bartholomew's after their own premises in Newgate burnt down in the Great Fire of 1666.[2]

13.3. *Blue-Coat Boy* by an unknown artist, first quarter of 18th century, oil on panel

There is no surviving medieval stained glass in the priory church save for one small diamond-shaped quarry in the east window of the south aisle. This shows the rebus of Prior Bolton, the last but one prior of St Bartholomew's (in office 1505–32): a crossbow 'bolt' piercing a wine barrel or 'tun' in black outline and yellow stain within a narrow yellow border. This is likely to have originally been part of the domestic glazing of Prior Bolton's lavishly refurbished lodgings, which were on the south side of the church and accessed by the door to the south of the window.

In the central light of the same window is a representation in stained glass of the badge of a Knight Bachelor: *upon an oval medallion of vermillion enclosed by a scroll a cross-hilted sword belted and sheathed, pommel upwards, between two spurs, rowels upwards, the whole set about with a sword belt, all gilt.* Between 1968 and 2005, the space beneath the window was the chapel of the Imperial Society of Knights Bachelor with specially commissioned ornaments and fittings – including the stained glass – made by the church furnishers Faith Craft. The roundel was set in place in 1968, when the chapel was dedicated in the presence of Her Late Majesty Queen Elizebth II.[3]

2 The Blue Coat boys were in residence from 1666 to 1672, and again from 1680 to 1683: Webb, *Records*, II, p. 327. See also Steven Brindle's chapter in this book.
3 See also Jeremy Haselock's chapter in this book.

Afterword

MARCUS WALKER

ST BARTHOLOMEW THE GREAT is a church like none other. It stands at the intersection of so many different stories and memories. Its columns, walls and windows tell the story of tastes and styles developing over the centuries. Romanesque arches build up to Gothic windows; the discolouration of a column tells of a now-removed wall behind the altar, built to block off the sight of the curved apse. The Lady chapel bears the scars of having been a printers' workshop, the cloister of having been a stable, the north triforium of having been a school, and the north transept of having once housed an ironmonger's. The church, in its fabric, tells a story of grandeur and decline and recovery that encompasses a place of deep, deep prayer.

This is a parish that celebrates the different strands which make up its history. Vibrant high-church worship with incense and ceremonial and a choral tradition that uses so much music originally written for Roman Catholic churches pays homage to our 400 years as a priory. Our use of the Authorized Version of the Bible and the Book of Common Prayer celebrates our place within the Established Church and its rich liturgical and theological history. We also have one unique historical event which is marked liturgically each year: the appearance of the Blessed Virgin Mary to Canon Hubert. 'The Book of the Foundation' tells us that at some point, probably in the late twelfth century, the Blessed Virgin Mary appeared to one of the canons and told him that his fellow monks were not praying hard enough to her Son and that they needed to improve their act sharply. It is difficult to assess how much of a celebration was made of this event in the Middle Ages, but in recent years we have greatly enjoyed celebrating the only recorded appearance of the Virgin Mary in London. That the Lady chapel went on to be the site of the printing press that employed Benjamin Franklin during his first stay in the city only adds to the wonderful interweaving of time and place and events in this unique church.

St Bartholomew the Great is also a place of pilgrimage – pilgrimage in the basic sense of the term, a place of prayer to which people make an effort to come for its own sake – but also a place of pilgrimage for those in the hospital, including staff, patients and the friends and relatives of those patients who need an oasis of calm to think and pray. That oft-derided form of pilgrim, the tourist, is also often encountered in the church – more so since the end of the pandemic and the abolition of a charge for entry. Where, before Covid, the average number of visitors was 22 per day, we now regularly see over 100 people visiting, even on cold and blustery midweek days. Pilgrimage, even with a Lonely Planet guide, is thriving again.

The parish is a curious one. It is, as City of London parishes generally are, geographically very small. But, unlike most City parishes, it has a resident population – exactly 100 at the

14.1. The Rev'd Marcus Walker preaches during Mattins celebrating the Platinum Jubilee of Her Late Majesty Queen Elizabeth II

2011 census (which, no doubt, will increase once the 2021 census data is published). This is one of the reasons why, unlike most City churches, the focus of our services is Sunday morning. At the moment we are getting a lot more than 100 at services on Sunday – usually around 190 over our four Sunday services, which puts us safely in the top five percent of Church of England parishes. Once a month, the church is packed out to the tune of about 100 for Evensong in the City, pitched at young (and not-so-young) City workers who miss singing Evensong or miss attending it – and who get a solid meal and a glass of wine afterwards. The fact that most of these are people in their twenties and thirties shows how the combination of good liturgy and good music can attract a generation that is often the most difficult to reach for the church in the twenty-first century.

Most of these people are not parishioners in the strict sense of the term; numerically they simply could not be. At last revision of the electoral roll I entered all the postcodes into an app and discovered that only about thirty members of the 250-person roll lived within a thirty-minute walk of the church. This reflects a growing trend in London, where people's communities have become less geographic and more relational, often reflecting shared interests and aesthetics. This is not without its complications, but what is wonderful for us is that they have chosen to make their spiritual home at Great St Bartholomew.

The term Great St Bartholomew needs some explanation. Throughout most of the book, the contributors have been writing about the priory church of St Bartholomew the Great. While it is great in so many ways, the title really refers to the fact that the church has a little sister which was, until 2015, a separate parish church, the Hospital Church of St Bartholomew the Less. The boundaries of that parish were basically St Bartholomew's Hospital, which made sense when doctors, nurses – and, for a very long time, members of the public – lived within the bounds of the hospital. The way in which hospitals work nowadays means that this is no longer the case, and nobody at all lives within the old boundaries of that parish. Therefore, in 2015, the two parishes merged and took on the (slightly confusing) name of Great St Bartholomew, containing two churches, St Bartholomew the Great and St Bartholomew the Less.

Fully half of our parish's geographical space is now taken up by the hospital, which has around 600 patients and staff on any given night. This has changed the nature of the parish, and therefore an element of the parish's focus. We now have a full-time Hospitaller as a member of the clergy licensed to the parish, half of whose job is focused in the hospital as a chaplain, and half outside as an Assistant Priest. This has worked extremely well, and seen the relationship between the church and the hospital (and the wider Barts Health NHS Trust) blossom wonderfully.

While this has developed into one of the key relationships of the church, its longer-standing relationships – especially with the livery companies – continue in good health. Many of those who see themselves as connected to St Bartholomew the Great do so because of the livery company of which they are a member. The church now has some of the older liveries, including the Haberdashers and the Butchers, as well as some of the youngest, including the Information Technologists, the Hackney Carriage Drivers and the as yet unliveried Company of Communicators. The relationship between a livery company and its church varies from company to company. Most have an annual service, and some hold more

frequent acts of worship. Where the rector is the company's chaplain, they will be present and say grace at company dinners. This regular pattern of interaction builds up a relationship between members of the companies and the church and its clergy, which means we are often the first port of call for funerals, weddings and baptisms – but also for conversations about all the sorts of things people want to talk through with the clergy. We find a good number of the regular congregation started off attending their livery company's annual services.

These different companies also link the church to some of the great charitable work going on in the City and to some of its most interesting trades. The Butchers' Company and Smithfield Market right next door to the church represent one of the last significant historic trades still working in the Square Mile; information technologists and tax advisors are some of the newest. This is an exciting intersection of the ancient and modern traditions of the City, reflecting the way in which the church – a remarkable survivor through 900 years of City history – manifests that history in its fabric and relationships.

Alongside the liveries, we also have relationships with two military units: the 'Roughriders', a part of 68 (Inns of Court & City Yeomanry) Signal Squadron, and 600 Squadron RAuxAF. Now both a part of the Reserve Forces, each year they come to the church for an annual service, which is either a part of the main Sunday celebrations or a short act of remembrance immediately before them. Aside from these formal connections, it has been lovely to see members of these squadrons get married here over the last few years, including during the pandemic.

The year 2023 is our 900th anniversary – an opportunity to celebrate what we have been, who we are, and where we are going. We are fundraising to create an endowment to support the church's choral tradition for generations to come, and we have realised the degree to which we have not been using the space gifted to us by previous generations anywhere near as well as we should have done, with a triforium that sits idle and hidden gardens overrun by weeds. This is the opportunity to set the church up to take the twenty-first century in its stride and to reinforce our mission, especially in the parish.

This highlights one of the recurring strengths of the church: its ability to exist in its contemporary era while simultaneously pointing to a history which can be felt and seen in the physical reality of the building. This interweaving of threads in turn points to a deeper truth, to a God both so ancient and so new. This can be seen across the centuries: in the courtier, pointing the butchers, executioners and criminals of Smithfield towards the mercy of God he had discovered in the wreckage of the *White Ship* disaster; in the canons toiling to bring healing to a city beset by poverty and plague; in the Protestants and Catholics contesting how God should be worshipped, inside and outside the buildings; in the faithful men and women of the parish who kept the church going despite the noise and grime of industry physically placed within the building; in the wardens, clergy and laity who worked so hard to bring the whole physical footprint of the church back to the worship of God; in the curate and wardens who went up to the roof and kicked off the firebombs during the Blitz; in the team who worked hard to keep the church open during the Covid-19 pandemic, despite guidelines changing every other week. Each of these, and the hidden stories of each generation that have not come down to us, point us beyond these stones and these works of art to the God in whom we live and move and have our being.

APPENDICES

APPENDIX I: ANNUAL INCOME FOR THE PRIORY OF ST BARTHOLOMEW ACCORDING TO THE *TAXATIO ECCLESIASTICA* 1291[1]

London Parishes	Temporalities* £	s.	d.	Spiritualities+ £	s.	d.
St Dunstan in the West		17	6			
All Hallows Honylane	2	17	0			
St Mary, Staining.	1	5	0			
Allhallows the Wall		4	0			
St Gregory		2	0			
St Bartholomew the Less (by the Exchange)		8	0			
St Martin Outwich	1	0	0			
St Thomas Apostle		2	0			
St Mildred Walbrooke (Poultry)		2	6			
St Anthony		10	0			
St Botolph Aldersgate	7	3	6			
St Mary Woolnoth		15	0			
St Margaret Lothbury		12	2			
St John Zachary		2	0			
St Agnes Aldersgate		13	4			
St Stephen Jewry (Coleman)		6	4			
St Martin Ludgate	2	16	8			
St Bridget (Bride)		3	6			
St Peter Thames Street (Paul's Wharf)		8	0			
St Nicholas Tower (Acon)	2	0	4			
St Mary-le-Bow	4	10	0			
St Vedast Foster	1	9	0			
St Dunstan in the East	1	4	0			
St Michael Candlewick (Crooked Lane)		7	10			
St Augustine by the Gate		18	6			
St Lawrence Jewry	1	15	8			
Holy Trinity the Less	1	4	0			

1 Data comes from the transcription of the 1291 *Taxatio Ecclesiastica* in Webb, Records, 1, pp. 378–84. However, Webb's calculations were £9 under.
* Temporalities refers to land and tenements.
+ Spiritualities refers to income from religious tithes or a religious appointment.

297

London Parishes	Temporalities* £	s.	d.	Spiritualities+ £	s.	d.
St Matthew Friday Street		3	6			
St Alban Wood Street		5	0			
St Mary Aldermanbury		3	0			
St Andrew Holborn		2	0			
St Peter Wood Street (Cheap)	3	4	0			
St Alphage.		7	6			
St Michael Cornhill.		19	0			
St Michael in Hoggen-lane (Wood Street)		13	0			
St Andrew Baynard (Wardrobe)		18	0			
St Martin Pomary (or Pomeroy)	3	8	0			
St Giles, Cripplegate	1	18	8			
St Leonard next St Martin (Eastcheap)		3	0			
St Olave (Hart Street)		6	0			
St Bennet Woodwharf (Paul's Wharf)	3	0	0			
St Nicholas Coleabby		6	8			
St Mary Magdalen in Fish Street		11	4			
St Michael of the Corne (Querne)		13	4			
Islington, land rents and meadows	1	15	0			
Alhallows, Bread Street.	1	16	0			
St Michael Paternoster Church (Royal)		3	4			
Alhallows Grassechurch (Lombard Street)	1	13	4			
St Sepulchre Without Newgate	15	18	2			
St Michael's Bassishaw by a payment					2	0
Total London Parishes	71	7	8			
Middlesex						
In Tottenham (Middlesex), meadows		10	0			
Enfield (Middlesex), meadows		9	0			
Little Stanmore (Middlesex), lands, rents, and meadows	4	7	4			
Sunbury (Middlesex), a portion of the church				1	6	8
Little Stanmore (Middlesex), the church				2	0	0
Essex						
Meesden (Essex), lands and meadows		7	6			
Danbury (Essex), patronage of the church				3	0	0

London Parishes	Temporalities* £	s.	d.	Spiritualities+ £	s.	d.
Theydon Bois (Essex), the church				4	13	4
Bradfield (Essex), the church				8	0	0
Bobbingworth (Essex), rents		8	0			
Walthamstow (Essex), meadows	1	1	0			
Bradfield (Essex), rents	1	0	0			
Elmdon (Essex), rents		6	9			
Clavering and Langley (Essex), lands, meadows, rents, and customs	2	0	6			
Newport (Essex), lands, rents, and customs	6	0	1.5			
Chrishall (Essex), land and rents	1	1	0			
In Depden (Essex), land		10	0			
Birchhanger (Essex), rent		2	0			
Colchester (Essex), rent		5	7			
Buckinghamshire						
Mentmore (Bucks), land and rent			9	10		
Mentomore (Bucks) the church				8	0	0
Bedfordshire						
Hockliffe (Beds.), rent		10	0			
Hertfordshire						
Shenley (Herts.), land		10	0			
Amwell (Herts), meadows		12	0			
Suffolk						
Lowestoft (Suffolk), church				4	13	4
Lowestoft (Suffolk) vicarage				4	6	8
Gorleston (Suffolk), church				20	0	0
Gorleston (Suffolk) vicarage				6	13	4
Yarmouth (Little) (Suffolk), church				4	6	8
Yarmouth (Little) (Suffolk) vicarage				4	6	8
Mellys and Wenhaston (Suffolk), a portion of the church of Wenhaston				2	16	8
Thorpe (Suffolk), rent		15	0			
Totals	104	10	10.5			
Total assessed value of the income of the monastery in the year 1291	£176		7	6.5		

APPENDIX II: TESTAMENTARY EVIDENCE FOR THE PRIORY OF ST BARTHOLOMEW, SMITHFIELD, 1258–1540

Christine M. Fox and Christian Steer

The following table identifies testators from the probate courts of London and of the archbishop of Canterbury who left bequests to the Priory of St Bartholomew and / or were buried there. It has not always been possible to identify their craft or parish and ongoing research will reveal further information.

Key: LMA London Metropolitan Archives
 LPL Lambeth Palace Library
 TNA The National Archives, Kew

No	Date	First name	Surname	Craft or Title
1	1272	Elias	de Wycumbe	
2	1292	Reginald	Canoun	
3	1312	Thomas	de Brauncestre	
4	1314	John	de Honnesdone	chaplain
5	1314	Richard	de Ewelle	clerk
6	1318	Agnes	de Stanes	
7	1322	James	de Mohun	
8	1327	Robert	de Chiggewell	
9	1328	Richard	de Gloucestre	master
10	1329	Peter	de Newcastle	surgeon
11	1336	Stephen	de Clopton	janitor of the priory
12	1340	John	de Oxenford	vintner
13	1341	John	de Bredstrete	
14	1342	William	de Erthyngton	
15	1346	Henry	Frere	of Isledon [Islington, Middx]
16	1348	Roesia	Knopwede	widow of John Knopwede, late mercer
17	1348	Roger	de Creton	chaplain, brother of Robert de Creton
18	1349	William	de Isyldon	son of Martin de Isyldon
19	1349	John	Youn	
20	1349	Roger	de Ely	fishmonger
21	1353	Edmund	de Grymesby	rector of the church of Barrow-upon-Humber (Lincs)
22	1361	William	Stacy	Londoner living in St Michael Wood Street
23	1368	Robert	de Watford	carpenter
24	1368	Henry	de Yerdelee	fellmonger
25	1368	John	Hiltoft	goldsmith
26	1372	Simon	de Hattefeld	potter

Property or rent bequest to Priory	Cash bequest or gift to Priory	Burial at Priory	Court	Reference
✓			Husting	LMA, CLA/023/DW/01/013 (88)
✓			Husting	LMA, CLA/023/DW/01/021 (78)
✓			Husting	LMA, CLA/023/DW/01/041 (5)
✓			Husting	LMA, CLA/023/DW/01/042 (109)
✓			Husting	LMA, CLA/023/DW/01/043 (32)
✓			Husting	LMA, CLA/023/DW/01/047 (9)
✓			Husting	LMA, CLA/023/DW/01/051 (114)
✓			Husting	LMA, CLA/023/DW/01/055 (104)
✓			Husting	LMA, CLA/023/DW/01/056 (169)
✓			Husting	LMA, CLA/023/DW/01/057 (117)
✓			Husting	LMA, CLA/023/DW/01/065 (45)
	✓		Husting	LMA, CLA/023/DW/01/069 (93)
✓			Husting	LMA, CLA/023/DW/01/068 (129)
✓		✓	Husting	LMA, CLA/023/DW/01/070 (8)
✓			Husting	LMA, CLA/023/DW/01/074 (71)
✓			Husting	LMA, CLA/023/DW/01/075 (167)
✓			Husting	LMA, CLA/023/DW/01/076 (109)
	✓	✓	Husting	LMA, CLA/023/DW/01/077 (4)
	✓		Husting	LMA, CLA/023/DW/01/076 (155)
	✓		Husting	LMA, CLA/023/DW/01/076 (302)
✓			Husting	LMA, CLA/023/DW/01/082 (83)
	✓		Husting	LMA, CLA/023/DW/01/90 (115)
✓		✓	Husting	LMA, CLA/023/DW/01/096 (155)
✓			Husting	LMA, CLA/023/DW/01/097 (146)
	✓		Husting	LMA, CLA/023/DW/01/096 (102)
	✓		Husting	LMA, CLA/023/DW/01/101 (120)

No	Date	First name	Surname	Craft or Title
27	1374	James	Andreu	draper
28	1375	Roger	de Barneburgh	of Derby
29	1376	Margaret	Broun	widow of Thomas Broun
30	1378	John	Malmayn	esquire, husband of Elizabeth, countess of Athol (d. 1375)
31	1379	Adam	Rous	surgeon
32	1382	Henry	Bosele	of St Sepulchre
33	1382	John	de Guldeford	paneter [steward], of Stamford (Lincs)
34	1382	John	Chishull	priest, of St Sepulchre
35	1391	William	Neuport	fishmonger
36	1387	John	Royston	esquire, of St Sepulchre
37	1390	John	Bathe	
38	1393	John	Wrighte	janitor of the priory
39	1393	Martin	Elys	canon St Pauls
40	1394	Henry	Godechepe	of St Sepulchre
41	1395	William	Thomas	of St Giles Cripplegate
42	1396	John	Newport	esquire, of St Botolph Aldersgate
43	1397	Joan	Lovetoft	widow of Robert Lovetoft of Conington (Hunts)
44	1404	John	Walden	clerk
45	1406	Roger	Walden	bishop of London
46	1408	John	Wodecok	mercer
47	1409	Agnes	Tredehey	widow, of St Botolph Aldersgate
48	1409	Thomas	de Stanlo	of London
49	1413	Margaret	Goodcheepe	widow of St Sepulchre
50	1415	Richard	Bankes	baron of the Exchequer
51	1415	John	Deyster	drover
52	1415x19	Richard	Brigge	Lancaster herald
53	1417	John	Walden	esquire of the body of Richard II, M.P. for Middlesex (1414)
54	1417	John	Hovyngham	Archdeacon of Durham
55	1419	Margaret	Deyster	widow of John Deyster, of St Sepulchre
56	1420	Idonia	Walden [formerly Rote]	widow of John Walden and John Rote
57	1423	John	Westyerd	vintner
58	1426	Alice	Mendica	widow, beggar
59	1429	John	Loughborough	citizen of London
60	1431	John	Illicum [Illian]	carpenter
61	1432	John	Morys	of St Sepulchre
62	1432	William	Thirwall	esquire

Property or rent bequest to Priory	Cash bequest or gift to Priory	Burial at Priory	Court	Reference
✓			Husting	LMA, CLA/023/DW/01/102 (171)
	✓	✓	Commissary	LMA, DL/C/B/004/MS09171/1, ff. 18v-20
	✓		Husting	LMA, CLA/023/DW/01/109 (89)
		✓	Commissary	LMA, DL/C/B/004/MS09171/1, ff. 56v-57
✓			Husting	LMA, CLA/023/DW/01/108 (13)
	✓	✓	Commissary	LMA, DL/C/B/004/MS09171/1, ff. 82v-83
✓			Husting	LMA, CLA/023/DW/01/111 (159)
	✓	✓	Commissary	LMA, DL/C/B/004/MS09171/1, f. 95v
	✓		Husting	LMA, CLA/023/DW/01/119 (121)
	✓	✓	Commissary	LMA, DL/C/B/004/MS09171/1, f. 152v
✓			Husting	LMA, CLA/023/DW/01/119 (80)
	✓	✓	Commissary	LMA, DL/C/B/004/MS09171/1, ff. 288-288v
	✓		Husting	LMA, CLA/023/DW/01/122 (39)
		✓	Commissary	LMA, DL/C/B/004/MS09171/1, f. 328
		✓	Commissary	LMA, DL/C/B/004/MS09171/1, f. 338v
	✓	✓	Commissary	LMA, DL/C/B/004/MS09171/1, f. 370
	✓	✓	Commissary	LMA, DL/C/B/004/MS09171/1, f. 401v
	✓	✓	Commissary	LMA, DL/C/B/004/MS09171/2, ff. 54-54v
	✓		Lambeth	LPL, Register Arundel, i, ff. 227-228
	✓		Husting	LMA, CLA/023/DW/01/140 (61)
		✓	Commissary	LMA, DL/C/B/004/MS09171/2, f. 148v
		✓	Commissary	LMA, DL/C/B/004/MS09171/2, f. 141v
	✓	✓	Commissary	LMA, DL/C/B/004/MS09171/2, f. 302v
	✓	✓	Lambeth	LPL, Register Chichele, i, 285v-286v
		✓	Husting	LMA, CLA/023/DW/01/144 (43)
	✓	✓	Lambeth; Commissary	LPL, Register Chichele, i, 331-332; LMA, DL/C/B/004/MS09171/2, f. 25v
	✓	✓	Lambeth	LPL, Register Chichele, i, 310v-311
		✓	Prerogative Court of Canterbury	TNA, PROB 11/2B/162
	✓	✓	Commissary	LMA, DL/C/B/004/MS09171/3, f. 327v
✓		✓	Hustings; Prerogative Court of Canterbury	LMA, CLA/023/DW/01/155 (72); TNA, PROB 11/3/118
✓			Husting	LMA, CLA/023/DW/01/152 (42)
	✓	✓	Commissary	LMA, DL/C/B/004/MS09171/3, f. 152
✓		✓	Commissary	LMA, DL/C/B/004/MS09171/3, f. 222v
		✓	Commissary	LMA, DL/C/B/004/MS09171/3, f. 277v
		✓	Commissary	LMA, DL/C/B/004/MS09171/3, f. 327v
	✓	✓	Prerogative Court of Canterbury	TNA, PROB 11/3/282

No	Date	First name	Surname	Craft or Title
63	1433	Richard	Gray	
64	1433	John	Galby	chaplain
65	1434	Thomas	Belle	
66	1435	Thomas	Russel	
67	1436	Alice	Morys	widow of John Morys, of St Sepulchre
68	1436	Katherine	Brigge alias Lancaster	widow of Richard Brigge alias Lancaster
69	1438	Alexander	Sprot	vintner
70	1441	Nicholas	Triplow	fishmonger
71	1441	Christina	Loughborough	
72	1443	Ralph	Fuller	late of Fulham (Middx)
73	1444	William	Brockhurst	
74	1445	William	Estfeld	knight, alderman of London, mercer
75	1446	Thomas	Specheley	fishmonger
76	1447	Ralph	Say	
77	1448	Walter	Sherington	king's clerk, chancellor of the the duchy of Lancaster, prebendary of Lincoln, canon of St Paul's
78	1449	John	Lematon	gentleman
79	1450	Stephen	Grove	
80	1451	Walter	Whytefeld	
81	1452	John	Goldyng	king's carpenter
82	1452	Thomas	Felmysham	chaplain
83	1453	William	Andrewe	
84	1453	Walter	Shelley	clerk
85	1455	Thomas	Battaille	
86	1455	Richard	Ryder	
87	1458	Alice	Bysshop alias Derby	widow
88	1458	Gilbert	Haultoft	baron of the Exchequer, of Outwell (Norf.)
89	1459	John	Louthe	gentleman, of Louth (Lincs)
90	1463	John	Ludlowe	hurer
91	1472	John	Don	mercer
92	1474	John	Durham	baron of the Exchequer
93	1476	Hugh	[Atte] Fenne	Knight
94	1476	William	Scarlett	esquire, of West Wratting (Cambs.)
95	1477	Elizabeth	Durham	widow of John
96	1478	Robert	Threlkeld	gentleman

Property or rent bequest to Priory	Cash bequest or gift to Priory	Burial at Priory	Court	Reference
		✓	Commissary	LMA, DL/C/B/004/MS09171/3, ff. 340v-341
	✓	✓	Commissary	LMA, DL/C/B/004/MS09171/3, f. 350v
		✓	Commissary	LMA, DL/C/B/004/MS09171/3, f. 417v
	✓		Prerogative Court of Canterbury	TNA, PROB 11/3/365
		✓	Commissary	LMA, DL/C/B/004/MS09171/3, ff. 459-459v
	✓	✓	Prerogative Court of Canterbury	TNA, PROB 11/3/401
✓			Husting	LMA, CLA/023/DW/01/169 (49)
		✓	Commissary	LMA, DL/C/B/004/MS09171/4, f. 73
		✓	Commissary	LMA, DL/C/B/004/MS09171/4, f. 74v
	✓	✓	Commissary	LMA, DL/C/B/004/MS09171/4, f. 126
	✓		Commissary	LMA, DL/C/B/004/MS09171/4, f. 137v
✓			Husting	LMA, CLA/023/DW/01/175 (20)
		✓	Commissary	LMA, DL/C/B/004/MS09171/4, f. 190
✓			Commissary	LMA, DL/C/B/004/MS09171/4, f. 264
	✓	✓	Lambeth	LPL, Register Stafford, ff. 170-171v
		✓	Prerogative Court of Canterbury	TNA, PROB 11/1/170
	✓	✓	Prerogative Court of Canterbury	TNA, PROB 11/1/207
		✓	Commissary	LMA, DL/C/B/004/MS09171/5, f. 52
		✓	Commissary	LMA, DL/C/B/004/MS09171/5, f. 39v
		✓	Commissary	LMA, DL/C/B/004/MS09171/5, f. 43v
	✓		Commissary	LMA, DL/C/B/004/MS09171/5, f. 141v
	✓	✓	Commissary	LMA, DL/C/B/004/MS09171/5, f. 130v
	✓		Commissary	LMA, DL/C/B/004/MS09171/5, f. 171v
		✓	Commissary	LMA, DL/C/B/004/MS09171/5, f. 183v
	✓	✓	Prerogative Court of Canterbury	TNA, PROB 11/4/278
		✓	Prerogative Court of Canterbury	TNA, PROB 11/4/241 and PROB 11/4/260
		✓	Prerogative Court of Canterbury	TNA, PROB 11/4/339
		✓	Commissary	LMA, DL/C/B/004/MS09171/5, f. 336v
✓			Husting	LMA, CLA/023/DW/01/212 (17)
	✓	✓	Prerogative Court of Canterbury	TNA, PROB 11/6/211
	✓		Prerogative Court of Canterbury	TNA, PROB 11/6/439
		✓	Prerogative Court of Canterbury	TNA, PROB 11/6/391
	✓	✓	Prerogative Court of Canterbury	TNA, PROB 11/6/400
		✓	Commissary	LMA, DL/C/B/004/MS09171/6, ff. 221v-222

No	Date	First name	Surname	Craft or Title
97	1480	Thomas	Thorold	gentleman, attorney to Queen Elizabeth Woodville
98	1480	John	Herward	of the close of St Bartholomew's priory
99	1487	John	Shipman	gentleman
100	1487	John	Wildman	
101	1488	William	Campyon	barber
102	1493	Thomas	Peerson	
103	1494	John	Cotton	gentleman
104	1494	Alice	Hoole	widow, of the close of St Bartholomew's priory
105	1501	John	Mayland	
106	1503	John	Fitzherbert	baron of the Exchequer
107	1504	John	Brampton	of St Mary Matfelon (Brecknockshire)
108	1504	Edward	Hungerford	esquire
109	1507	John	Longe	chaplain
110	1508	John	Clerke	gentleman
111	1509	John	Agmondesham	gentleman
112	1513	Walter	Martyn	mason
113	1514	John	Alexander	
114	1514	John	Webbes	of Sandwich (Kent)
115	1516	Elizabeth	Thurlow	widow
116	1521	Heugh	Grannger	merchant of the Staple of Calais
117	1521	Bartholomew	Westby	of the close of St Bartholomew's priory
118	1522	Robert	Blagge	baron of the Exchequer
119	1523	Thomas	Pokeapart	
120	1523?	Alice	Ransley [formerly Westby]	of the close of St Bartholomew's priory
121	1524	Elizabeth	Westby [formerly Graunger]	of London, widow late wife of Thomas Grannger [late merchant of the staple at Calais]
122	1528	Nicholas	Burgh	gentleman
123	1528	James	Willey	gentleman
124	1528	Nicholas	Mynne	of the close of St Bartholomew's priory
125	1537	William	Martyn	gentleman
126	1538/9	Richard	Bellamy	gentleman

Property or rent bequest to Priory	Cash bequest or gift to Priory	Burial at Priory	Court	Reference
	✓	✓	Commissary	LMA, DL/C/B/004/MS09171/6, ff. 295v-296v
		✓	Commissary	LMA, DL/C/B/004/MS09171/6, f. 306
		✓	Commissary	LMA, DL/C/B/004/MS09171/7, f. 106
		✓	Commissary	LMA, DL/C/B/004/MS09171/7, f. 79v
		✓	Commissary	LMA, DL/C/B/004/MS09171/7, f. 138v
	✓	✓	Prerogative Court of Canterbury	TNA, PROB 11/9/247
		✓	Prerogative Court of Canterbury	TNA, PROB 11/10/219
	✓	✓	Prerogative Court of Canterbury	TNA PROB 11/10/229
		✓	Commissary	LMA, DL/C/B/004/MS09171/8, f. 249v
		✓	Prerogative Court of Canterbury	TNA, PROB 11/13/461
	✓		Prerogative Court of Canterbury	TNA, PROB 11/14/296
		✓	Prerogative Court of Canterbury	TNA, PROB 11/14/305
		✓	Prerogative Court of Canterbury	TNA, PROB 11/15/610
		✓	Prerogative Court of Canterbury	TNA, PROB 11/16/93
		✓	Prerogative Court of Canterbury	TNA, PROB 11/16/677
		✓	Prerogative Court of Canterbury	TNA, PROB 11/17/397
		✓	Prerogative Court of Canterbury	TNA, PROB 11/18/43
		✓	Prerogative Court of Canterbury	TNA, PROB 11/18/118
		✓	Commissary	LMA, DL/C/B/004/MS09171/9, f. 4v
	✓	✓	Prerogative Court of Canterbury	TNA, PROB 11/20/304
	✓		Prerogative Court of Canterbury	TNA, PROB 11/20/178
		✓	Prerogative Court of Canterbury	TNA, PROB 11/20/391
	✓	✓	Commissary	LMA, DL/C/B/004/MS09171/10, f. 21
			Commissary	LMA, DL/C/B/004/MS09171/10, ff. 17v-18
		✓	Prerogative Court of Canterbury	TNA, PROB 11/21/306
			Prerogative Court of Canterbury	TNA, PROB 11/22/474
		✓	Commissary	LMA, DL/C/B/004/MS09171/10, ff. 113v-114
			Prerogative Court of Canterbury	TNA, PROB 11/22/551
		✓	Prerogative Court of Canterbury	TNA, PROB 11/27/41
		✓	Prerogative Court of Canterbury	TNA, PROB 11/27/403

APPENDIX III: ACT OF SURRENDER FOR ST BARTHOLOMEW'S PRIORY[2]

To all the faithful in Christ to whom this present charter shall come, Robert by divine permission abbot of the monastery of Waltham in the county of Essex, and prior *in commendam* of the monastery or priory of St Bartholomew in Smithfield and the convent of the same place, sends greeting. Know ye that we the aforesaid abbot and convent for sure reasons and considerations at present particularly moving us, by our unanimous agreement and consent, and of our spontaneous will, have given granted and by this our present charter confirmed to our most excellent prince and lord, Lord Henry VIII, by God's grace King of England and France, Defender of the Faith, Lord of Ireland, and supreme head on earth of the English Church, all our aforesaid monastery and priory of St Bartholomew and the whole site of our late priory and all our demesnes, manors, churches, chapels, rectories, and vicarages and chantries [...] as well spiritual as temporal, as well in the counties of Middlesex, Hertford, Essex and in the City of London as anywhere else in the kingdom which belong to the monastery [...] and also all and every kind of our church ornaments, jewels and goods which we have in right of the said monastery; to have hold and enjoy all the aforesaid demesnes and manors to our lord the king, his heirs and successors for ever. And we the said abbot and convent and our successors will warrant against all peoples for the lord the king and his successors all the monastery and the demesnes and manors (etc.) with their appurtenances.

In testimony of which we have set our common seal to this our present charter. Dated at our chapter house the 25th day of October in the 31st year of the reign of our said lord the present king Henry the Eighth.

Acknowledged before me William Petre
one of the clerks of the Chancellery of the lord the king the day
and place written above by
me William Petre.

2 Translation from the Latin in: Webb, *Records*, I, pp. 253–54. Original: TNA 322/136.

APPENDIX IV: DEED TO THE CANONS AT THE PRIORY'S SUPPRESSION, DATED 20 NOVEMBER 1539[3]

The king to all to whom these presents shall come greeting. Since the late monastery of St Bartholomew in Smythefeld by London in our county of Middlesex is now being dissolved whereof a certain Robert Glasier at the time of that dissolution and sometime previously was sub-prior there.[4] We wishing that a reasonable yearly pension or promotion worthy of the same Robert should be provided for the better supporting his food dress and sustenance.

Know ye therefore that we, in consideration of the premises, of our special favour, and of our own sure knowledge and proper motion, by the advice and consent of the chancery and council of the Court of Augmentations of the revenues of our crown, have given and granted and by these presents do give and grant to the said Robert a certain annuity or yearly pension of fifteen pounds sterling; to have, enjoy and yearly receive the said fifteen pounds to the said Robert and his assigns from the feast of St Michael the Archangel last past to the end and for the term of the life of the said Robert or until the said Robert shall have been promoted by us to one or more ecclesiastical benefices or other promotion worth the clear annual value of fifteen pounds or over; to be paid yearly by equal portions at the feasts of the Annunciation of the Blessed Virgin Mary and of St Michael the Archangel, as well by the hands of the treasurer of the Revenues and Augmentations of our crown for the time being from our funds in his hands which happen to remain from the said revenues, as by means of the receipts, profits and revenues for the time being of the said late monastery out of the same profits and revenues; for the reason that express mention, etc. In testimony whereof, etc.

Witness, Richard Rich, Knight, at Westminster, the 20th November in the 31st year of our reign. By the said chancery and council by virtue of the said warrant.

[3] Translation from the Latin in: Webb, *Records*, 1, pp. 254-55.
[4] Webb, *Records*, 1, p. 254 notes that 'the grant of the pension was made to each canon by deed identically worded in each case, except for the amount of the pension and the name and office of the pensioner. Each deed was dated the 20th November, 31 Henry VIII (1539).' For a table of canons at the Dissolution and their pensions, see Christine Fox's chapter in this book.

INDEX

Illustrated pages marked in bold

Abbiss, John, rector of St Bartholomew's 27, 170, 172, 201-8, 225, 228, 230, 254
advowson 146, 156, 168-9, 201, 202, 223
aisles 60-1, 63, 65, 69-70, 72, 76, 77, 78, 79, 83-4, 85, 153, 157, 159, 164, 183, 213, 222, 226, 228, 239, 281, 291
alabaster 175, 177, 178, 180, 181, 184, 185, 188, 190, 191
ale 26, 36, 48, 49
Alexander V, pope 47, 49, 74
alms 33, 36, 48, 74, 116, 117, 131, 276
almshouses 147, 172, 181
ambulatories 60, 72, 79, 81, 84, 85, 93, 140, 153, 172, 254, 270, 281, 284, 285
Antiquaries, Society of 166, 167, 235
Ap Harry, Hugh 138, 139, 140
apse 60-1, 63, 65, 74, 172, 173, 204, 214, 226, 227, 232-3, 234, 235, 236, 237, 239, 241, 243, 277, 293
arcades 60, 61, 62, 63, 65, 68, 73, 78, 84, 93, 94, 95, 96, 163, 213, 234
archaeology 25, 93, 205, 226, 235
architecture *see* aisles; ambulatories; apse; arcades; capitals; choir; clerestory; cloister; crypt; Gothic style; nave; Norman style; piers; sculpture; tower, crossing; transepts; Transitional style; triforium; tympana; vaulting; windows
art, modern 27, 267-88
Arts and Crafts Movement 267, 270, 274, 277
Arundel, Thomas, archbishop of Canterbury 46, 102, 103, 104, 111
Augmentations, Court of 51, 52, 54, 137, 140-1, 179, 309
Augustinian Rule 35, 41
Austin Canons 22, 26, 35-6, 37, 38, 39-41, 42, 44, 45, 48-9, 51, 52, 53, 56, 59, 102, 104, 110, 114, 137-8, 142, 144, 149, 248-50, 293
Bacon, Thomas 91, 92, 105
Bartholomew the Apostle, St 28, 33
Bartholomew Chapel (Non-conformist meeting house) 166, 169, 203
Barton, John, master of St Bartholomew's Hospital 123, 127-8
beadles 134, 140, 210
Bedlam Hospital 131, 149
bells 38, 54, 114, 117, 139, 154, 156, 157, 159, 160, 161, 168, 180, 219, 249
belltowers 47, 54, 74, 79, 84, 114, 117, 139, 157
Benedictines 36, 39, 107, 142
Beresford, Frank 218, 272-4, 287
Beresford Hope, Alexander J. B. 170, 226, 234, 235
Betjeman, John 24, 221
Black Death 45, 47, 56, 92, 93, 100
Blackfriars, London 54, 142
blacksmithing 228, 231, 232
Blitz 22, 201, 219, 295
Blue Coat School (Blewcoat) 161, 195, 291
Bolton, William, prior of St Bartholomew's 22, 49-50, 51, 56, 57, 81-3, 93, 152, 157, 203, 291
'Book of the Foundation' of St Bartholomew's, 25, 26, 31, 93, 98, 249, 293

Boord, Joseph 172, 225, 228
box pews 161, 164
brasses 87, 92, 102, 104, 108, 109, 110, 111, 122, 177, 202
Brereton, John, master of St Bartholomew's Hospital 130-1, 132
breweries 120, 121, 132
Bridge, Richard 162, 252-3, 264
Brockless, Brian 259-61, 262
Bullisdon, Thomas 79, 159
Burgoyn, Thomas 123-4, 139
Butchers' Company 215, 219, 222, 294, 295
Canonbury, manor of 22, 50, 52
Cambridge, University of 49, 183, 257, 260, 282, 285
 Emmanuel 179
 Jesus College 157, 208
 Queens' College 192, 220
Canterbury, Kent 39, 40, 95, 233
 Cathedral 60
 St Augustine's Abbey 60
capitals 60, 61, 63, **64**, 65, 66, 68-9, 70, 72, 74, 76, 77, 84, 178, 213
Carpenter, R.C. 171, 204, 225
Carter, John 167, 169
Cary, Henry, 1st Viscount Falkland 154, 156
Cecil, William, Lord Burleigh 155, 179
cemeteries 33, 36, 38, 114, 117, 209
Chancery, Court of 123, 126, 185
chantries 91, 103, 126, 138, 155, 179, 308
chapels
 axial 59-60
 Lady *see* Lady Chapel
 of All Saints (Walden Chapel) 51, 77-81, 85, 88-9, 92, 99-105, 109, 110-11, 138, 151, 152, 155, 269
 of St Andrew 120
 of St John the Evangelist 107
 of St Katherine 123, 126
 of the Society of Knights Bachelor 222-3
 radiating 60, 65, 83, 84
Chapman, George 53, 138
chapter house 52, 59, 70, 74, 75-6, 85, 141, 143, 145, 154, 167, 169, 203, 214-15, 228, 244
Charity Commissioners 228-9, 240
Charterhouse 45, 51, 54, 55, 175, 177
charters 117, 134
 of 1133 34, 36, 40, 42, 48
 of 1157 207
 of 1272 37-8, 40
 of 1489 207
choir (architectural) 27, 37, 47, 59, 61, 62, 63, 65, 68, 70, 74, 78, 84, 85, 132, 140, 143, 144, 146, 147, 153, 225, 239, 269
 screen 217, 218, 267, 272-4, 287
 stalls 77, 236
choir (choral) 208, 211, 247, 249, 250, 251, 254-5, 256-7, 258, 259, 260, 261, 262, 263-5
churchwardens 159, 164, 194, 225, 230, 231, 252, 264
 minute books of 161
churchyard 20, 38, 59, 140, 144, 153, 162, 164, 196, 203, 213, 221, 233

Civil War, English 23, 27, 72, 81, 157-60, 166, 176
clerestory 47, 65, 70, 74, 84, 85, 167, 228
Clerke, John 106, 109
Clerkenwell 162, 169, 175, 177, 221, 252
Clerkenwell, priory of St John at 54, 151
Clifford, Richard, bishop of London 47, 118
clocks 159, 168
cloister 22, 25, 27, 59, 65, 74, 81, 85, 90, 109, 141, 142, 143, 154, 156, 164, **168**, 170, 172, 203, 214-15, 217, 221, 244, 258, 269, 284, 290, 293
Cloth Fair 20, 42, **143**, 144, 152, 157, 165, 172, 184, 191, **210**, 215, 221, 222, 231, 239, 240
Coach and Horses (inn) 164, 170, 172
Cockerill's Buildings 169, 204
Cok, John 120, 121, 122, 124, **125**, 127, 132, 134
Colman (née Bowes-Lyon), Mary 222
Colt, John (senior) 176
Colt, John (junior) 176-7
Colt, Maximilian 180, 183, 185
Common Pleas, Court of 123, 126
Common Prayer, Book of 147, 223, 250, 293
Commonwealth *see* Interregnum
conventual buildings *see also* chapter house; cloister; dormitory; frater; guest range; kitchen, monastic; refectory
courtiers 27, 32-3, 89, 154, 156, 176, 248, 295
Covid-19 264, 293, 295
Cromwell, Thomas 50, 51, 52, 137, 138, 145-6
crypt 60, 72, 172, 234, 241, 281
Cubitt, William 205, 226
Deane, John, rector of St Bartholomew's 139, 140, 146, 154-5, 156
Dee, David, rector of St Bartholomew's 156, 157
demolitions 74, 75, 76, 79, 140, 144, 146, 151-2, 153, 154, 157, 167, 169, 170, 172, 212, 213, 215, 225, 233, 241, 243
Dickens, Charles 169, 206
dissolution *see under* Priory of St Bartholomew
Dominican priory, St Bartholomew's as 27, 59, 85, 142-6, 149, 155
dormitory (dorter) 36, 74, 75, 76, 77, 83, 85, 143, 154, 156, 244
Dove Brothers 227-8, 236, 237
Dudley, Martin, rector of St Bartholomew's 25, 223, 261, 262, 263, 264
Durbin, Leslie Gordon 222, 276
education *see* schools
Edward I, king of England 40, 42, 116
Edward VI, king of England 79, 141, 142, 147, 179, 250
Edward VII, king of the United Kingdom 209, 269, 270
Edwardes, William, 1st Baron Kensington 156, 168
Edwardes, William, 2nd Baron Kensington 169, 201
electricity, installation of 211, 217, 218
Elizabeth I, queen of England 146-7, 179, 207, 250, 251
 monument in Westminster Abbey 176, **177**

310

Elizabeth II, queen of the United Kingdom 223, 256
Elizabeth, queen of the United Kingdom (Queen Elizabeth the Queen Mother) 221
Elms (gallows) 33, 120
epitaphs 88, 93, 103, 111, 184, 190
Evans, John Hilditch 226, 229–30
excavations *see* archaeology
excommunication 37, 38, 39, 40
Eyton *alias* Repyngdon, John, prior of St Bartholomew's 32, 46, 57, 98–9
Fair, Bartholomew 34, 42–3, 45, 47, 56, 78, 141, 151–2
Fire of London, Great 79, 161, 173, 175–6, 177, 203, 219, 291
fires 229
of 1830 27, 84, 169, 172, 173, 203, 215
floor tiles 79, 80–1
fonts 26, 80, 81, 109, 110, 111, 161, 279
'Foundation of St Bartholomew's' *see* 'Book of the Foundation'
Franklin, Benjamin 165, 293
frater 77, 154
fraternities 44, 48
Freshwater, Elizabeth 182, 183
Fuller, Robert, prior of St Bartholomew's/abbot of Waltham 50–1, 52, 53, 54, 55–6, 57, 137–8, 139, 149, 249
fundraising 59, 171, 172, 173, 205, 216, 217, 295
Fyndley, Stephen 51, 53, 139
Gardner, Starkie 269, 270
Garrett, John, rector of St Bartholomew's 159, 160
gatehouses 144, 145, 146, 213, 217, 218, 220, 244
George V, king of the United Kingdom 209, 215, 244, 274
George, Henry 53, 138
Ghiberti, Lorenzo 270, 289
Gilbert Scott, George 170, 227
Glasier, Robert, sub-prior of St Bartholomew's 53, 137, 309
glebe endowment 154, 156
Golding, John 106, 109–10
Goldsmith's College 258, 259, 285
Gothic style 26, 59, 70, 84, 267, 281, 287, 293
Great War 213–4, 215, 275
Grindal, Edmund, archbishop of Canterbury 155, 173
guest range 74, 154
Hagno the clerk, master of St Bartholomew's Hospital 34, 113
Hardwick, P.C. 226
Hardwick, Phillip 226
Hardwick, Thomas 76, 167, 225
Hargrave, Richard, Dominican prior of St Bartholomew's 146–7, 149
Harrison, Richard 27, 282–4, 287
Hayter Lewis, Thomas 171–2, 173, 204, 225, 234
Henry I, king of England 31, 32, 33, 34, 35, 36, 37, 40, 42, 43, 54, 60, 65, 68, 83, 84, 249
Henry III, king of England 37, 39–40
Henry IV, king of England (Bolingbroke) 43, 46, 101
Henry V, king of England 47, 124
Henry VI, king of England 48, 124, 127
Henry VII, king of England 49, 81, 131, 207
Henry VIII, king of England 49, 50, 51, 52, 55, 57, 81, 137, 138, 141, 147, 178, 179, 207, 265

heraldry 80, 87, 88, 91, 92, 99, 102, 107, 175, 181, 191, 192, 269
heresy 46, 47, 52, 251
Hexham, Northumberland 215–6, 220
high altar 47, 50, 74, 89, 92, 107, 153, 250, 254–5, 261, 262, 276
Hill, Rowland 139, 148, 149
Hirst, Damien 27, 278–9, 287
Holy Trinity, Aldgate 35, 36, 55, 48, 49, 55
Hospital, St Bartholomew's 21, 25, 27, 31, 33, 41, 45, 47, 51, 52, 84, 92, 98, 111, 113–34, 151, 172, 202, 205, 208, 209, 218, 272, 278, 293
as 'parish' 134, 294 *see also* Little St Bartholomew, parish of
bells of 114, 117
bequests to 45, 113, 114–5, 120–1
brethren of 35, 36, 37, 116, 119, 129–30, 133, 147
cartulary of 24, 118, 124, 125
chaplains of 121, 124, 131
disputes with the priory 24, 26, 37–8, 56
masters (proctors) of 34, 35, 36, 113–4, 116, 117–8, 119, 122, 124, 127, 128, 130, 131, 134
privileges of 24, 37, 124, 129
property of 43–5
re-foundation of 147–9
residents of 122–7, 138
sisters of 35, 125
visitations of 41, 48, 116
Hugh de Hendon, prior of St Bartholomew's 57, 89–90, 93, 105
indulgences 48, 74, 76
Industrial Revolution 200–1, 274
Interregnum 72, 81, 161, 175, 191
Islington 38, 50, 119
Jackson, W. H. 202, 225
James I, king of England 180, 181, 184, 207
Jarvais, Arthur 81, 156
John, king of England 37, 38
John de Carleton, prior of St Bartholomew's 45, 57, 105
John de Pekesden, prior of St Bartholomew's 45, 57
John de Watford, prior of St Bartholomew's 46, 47, 57, 105
Kellond, John 192, 193
King's Bench, Court of 91, 123, 155
kitchen, monastic 74, 154
Lady chapel 22, 27, 49, 59, 60, 72, 81, 85, 140, 146, 147, 152–3, 157, 165, 166, 172, 195, 208, 209, 212, 214, 227, 231, 234, 237, 238, 240–1, 243, 261, 267, 269–70, 271, 279, 281, 290, 293
Laudianism 27, 157, 222
Lincoln's Inn 108, 175, 180, 182, 183
Lincolnshire 107, 137, 176, 187
Little St Bartholomew (St Bartholomew the Less), parish of 138–9, 219, 294
Lollards 46, 47, 51
London, City of 19, 22, 25, 26, 32, 39, 40, 44, 55, 87, 91, 107, 131, 134, 147–9, 164, 169, 170, 173, 176, 201, 207, 219, 260, 275
Corporation of 172, 205, 206, 207, 208, 213
disputes with the priory 42, 43
Lord Mayors of 99, 134, 185, 205, 206, 215, 218
Union of Parishes Act (1907) 208
Long Lane 31, 42, 152, 191
Lord Chancellor 141, 156

Luyt, Thomas 123, 126, 127
Machyn, Henry 250, 251
McKie, William 255, 259
Malwayn, John 92, 105
marble 66, 89, 90, 92, 93, 98, 108, 109, 175, 177, 178, 179–80, 181, 183, 185, 188, 191, 193, 195, 255
Markeby, William 120, 123
Mary I, queen of England 59, 78, 85, 141–2, 146, 154, 155, 179, 181, 250, 251
Master, Streynsham 192–3, 194
Methodism 164, 200
Middlesex 44, 49, 100, 103, 114, 138
Sheriff of 151, 164
Middlesex Passage 83, 172
Mildmay, Walter 154, 155, 179–80
miracles 26, 31, 34, 93
monuments, funerary 87–112, 175–97
Morris, Andrew 259–60, 261
Morris, William 259, 260
nave 59, 60, 65, 68, 69, 70, 72, 74, 78, 79, 84, 109, 140, 143, 144, 146, 147, 153, 159, 164, 170, 172, 215
Newgate Prison 38, 119, 122, 131, 134
Newman's Row 152, 157
Newton, Robert, master of St Bartholomew's Hospital 118, 120
Non-conformists 166, 169, 200
Norwich, Norfolk 60, 65, 83, 88, 214, 233, 243, 281
Norman style *see* Romanesque style
organs 157, 161–2, 164, 209, 212, 236, 250–3, 255–7, 259–61, 263–4, 265
orphans 48, 113, 148, 291
Oxford, University of 45–6, 157, 201, 202
Christ Church 50, 212
Oxford Movement 200, 201, 254, 255, 263, 265
pageants 24, 217–18
Panckridge, William, rector of St Bartholomew's 27, 201, 208–9, 211, 216, 230, 231, 232, 233, 236, 237, 253–5, 272
parish of St Bartholomew the Great 27, 74, 76, 77–9, 84, 110, 117, 138–40, 144, 146, 149, 151, 153, 154–6, 157, 159, 160–4, 165, 167, 168–9, 171–3, 175, 176, 177–8, 180–1, 185, 187, 189, 190, 191, 192, 193–4, 199–201, 202, 205, 206, 207, 208, 210, 211, 212, 215, 216, 219, 220, 223, 230, 232, 254, 262, 264, 278, 293–4, 295
patrons, parochial 138, 139, 146, 155, 159, 160, 169, 195, 201, 230, 232, 233, 269, 272
Pearson, J.L. 227, 231, 232
pensions 47, 51, 52–3, 55, 116, 137, 138, 149
Perpendicular style 95, 173, 227, 228
Peryn, William, Dominican prior of St Bartholomew's 27, 142–4, 145, 146
Phillips, Frederick Parr 230, 232, 233, 234, 238, 269, 272
Phillips, William 195, 201
piers 22, 60, 61, 63, 65, 74, 77, 83, 84, 85, 94, 227
pilgrimage 20, 26, 32, 34, 60, 137, 263, 287, 293
plague 45, 161, 295
plainchant 247, 248, 250, 251, 259
plate, ecclesiastical 54, 127, 139, 156, 161
Pole, Reginald, archbishop of Canterbury 142, 146
polyphony 249, 250, 251, 262
Pope's Cottages 169–70, 204
Portealeyn, Alice 120, 123, 124

311

preaching 34, 46, 146, 157, 164, 202, 216–17, 230, 261, 264, 265, 289
Preservation of Ancient Buildings, Society for (SPAB) 232–6, 239, 244
printers 22, 165, 190–1, 293
Priory of St Bartholomew 31–112
 building works 32, 33–4, 47, 48, 49
 disputes with hospital 24, 26, 37–8, 56
 dissolution of 20, 22–3, 26, 43, 52–6, 109, 110, 137–42, 309
 endowments of 34, 38, 43–5, 54, 83
 foundation 23–4, 26, 31, 33–4
 hospitality of 22, 36, 48, 55, 110, 147
 prior's lodging (Middlesex House) 49, 54, 81, 83, 85, 152, 154, 156, 166, 169, 291
 water supply 38, 119
probate registers 87, 107, 110
pulpits 169, 202, 217, 218, 272
'Purgatory' chamber 74, 153
Puritanism 159, 173, 185, 251
Rahere 19, 21–2, 28, 31, 32–4, 56, 60, 83, 84, 87, 89, 113, 151, 199, 214, 223, 239, 248–9, 265, 287
 death of 26, 34, 37
 portrayals of 23–4, 217–8, 240, 273, 274, 276
 tomb of 21, 26, 34, 35, 88, 92–3, 100, 101, 105, 111, 253, 272
Ramsden, Omar 274–8, 287
Reading Abbey, Berkshire 60, 65, 66, 68, 84
refectory 36, 74, 143, 172
refurbishments 156, 160, 291
relics 34, 60, 137
Restoration, the 160, 176, 251
restorations 26, 48, 49, 56, 59, 93, 98, 151, 167, 169, 173, 205
 Committee 27, 170, 171, 203, 208, 211–2, 215, 216, 217
 of 1864-1928 (Webb restoration) 22, 23, 28, 63, 78, 93, 94–5, 157, 170–1, 172, 195, 199, 202, 209–14, 225–44, 253, 256, 265, 269, 272
Rich, Henry, Baron Kensington/1st earl of Holland 156, 157
Rich, Richard, 1st Lord Rich 27, 51, 52–3, 54, 55–6, 78, 137, 139, 140, 141–2, 143, 145–6, 147, 149, 151, 152, 153–5, 162, 168, 173, 201, 207, 213
Rich, Robert, 2nd Lord Rich 155, 157
Rich, Richard, 3rd Lord Rich 152, 156, 207
Richard, prior of St Bartholomew's 57, 84
Richard II, king of England 46, 95, 96, 99, 100, 101, 251
Richard de Belmeis, bishop of London 32, 34, 35, 274
Rivers, James 185–6, 187
Romanesque style 26, 267, 287, 293
Royalists 23, 160
Ruskin, John 232, 274
sacristy 166, 167, 169, 170
St Botolph Aldersgate 101, 138, 186, 191, 230, 251
St Giles, Cripplegate 34, 190, 191
St Helen's, Bishopsgate 55, 187
St Martin-le-Grand 100, 176
St Mary Graces 55, 138, 147
St Mary, Bishopsgate 35, 138, 147
St Mary Overy 35, 55
St Osyth, Essex 34, 37, 41, 49
St Paul's Cathedral 32, 39, 83, 102, 103–4, 111, 114, 122, 155, 157, 170, 208, 254, 261, 281
 school 121
St Sepulchre Without Newgate 44, 54, 79, 117, 132, 138–9, 157, 207, 223
St Stephen Walbrook 236, 253, 263
St Thomas of Acre, hospital of 48, 131
Sandwith, William Fitzgerald Gambier, rector of St Bartholomew's 27, 201, 212–5, 216, 256, 290
Savage, Edwin Sidney, rector of St Bartholomew's 22, 27, 201, 215–9, 256
Savory, Borradaile, rector of St Bartholomew's 27, 195–6, 201, 209–12, 216, 238, 255, 269, 270
Savoy, hospital of the 131, 149
Saye and Sele, Lady 172, 181
Scarlett, William 106, 107
schools 147 see also song, Sunday school
 Gatehouse School 220–1
 grammar school 43, 121–2
 parish 153, 157, 161, 164, 165, 172, 202, 204, 209, 210, 215, 228, 233, 234, 236–7, 238, 239, 240, 253, 293
Scott-Rogers, Jean 24, 218
Scudamore, Elizabeth 154, 180, 181
Scudamore, Philip 154, 180, 181
sculpture 27, 65, 68, 84, 169, 175, 177, 267, 281, 285, 286, 289–91
sextons 22, 159
sheriffs see under London, City of
Sherington, Walter 103–4, 106, 111
Shipley, Richard 120, 123
Shirley, John 122, 125
Short, Nigel 263
Simon de Papnei 89, 90, 91, 93, 105
Slater, William 170–2, 173, 204, 225–6, 227, 232, 233
Smithfield 20, 23, 26, 31, 33, 42, 43, 45, 46, 78, 80, 84, 98, 101, 119, 120, 123, 124, 126, 132, 140, 141, 144, 146, 160, 164, 169, 179, 189, 193, 199, 210, 212, 215, 219, 225, 244, 265, 295
song school 27, 249
Stafford, John 121, 124
Star Chamber, Court of 123, 128
Stationers Company 190, 191
steeple 79, 159
Steinitz, Paul 257–60
Stow, John 50, 78, 79, 84, 87, 88, 93, 102, 152, 157, 175
Sunday School 200, 208, 210
Supremacy, Act of (1535) 51, 131, 132
surgeons 131, 149, 278
Surynden, James 122, 125
taxation 39, 40, 42, 47, 55, 116, 138, 139, 188, 206, 295
temperance 200, 211
Temple Church 254, 257
tenements 44, 47, 56, 107, 110, 119, 120, 121, 122, 123, 124, 132, 138, 141, 146, 195
Thomas de Watford, prior of St Bartholomew's 57, 92, 105
Thomas of Osyth, prior of St Bartholomew's 56, 113
Thorold, Thomas 106, 108
Threlkeld, Robert 106, 108
Tite, William 171, 172, 226
tithes 44, 126, 138, 139
tombs see monuments, funerary
towers 47, 54, 63, 65, 72, 74, 78–9, 83, 114, 117, 139, 153, 157, 168, 219, 230, 239
 crossing 59, 77, 155
 of 1628 69, 84, 159, 181, 185
Tower of London 49, 101, 194
 Chapel of St John 60
 White Tower 60
Tractarianism 27, 170, 280, 211, 212, 254 see also Oxford Movement
transepts 22, 27, 59, 60, 65, 67, 68, 74, 75–6, 77–8, 83, 84, 85, 146, 152, 153, 159, 167, 169–70, 172, 203, 205, 209, 231, 234, 236, 238–40, 244, 269–70, 289, 293
Transitional style 59, 65, 68, 70
Trendell, David 261–4
triforium 63, 64, 65, 67, 68, 70, 81, 84, 85, 152–3, 157, 163, 166, 169, 172, 173, 203, 204, 215, 227, 228, 233, 234, 239, 293, 295
Turner, Thackeray 232, 235, 239
tympana 63, 75, 76, 85
Valor Ecclesiasticus 51, 55, 131, 138
Vasconcellos, Josefina de 281–2, 287
vaulting 59, 60, 61, 65, 68, 69–70, 72, 75, 76, 84–5, 93, 170, 172, 213, 215, 225, 239, 241, 244
Venables, Edmund 231, 234
vestry meetings 160, 161, 164, 173, 191, 201, 203, 204, 205, 206–8, 209, 213, 230, 252, 253
Victoria, princess 209, 240
visitations 39–41, 48, 49, 116
Wakeryng, John, master of St Bartholomew's Hospital 119, 120, 121, 122, 123, 124, 125, 126, 127, 131, 134
Walden, Roger, archbishop of Canterbury 26, 31–2, 47, 77, 78, 85, 88–9, 96–105, 110, 111
Walker, Marcus, rector of St Bartholomew's 27, 223, 264
Wallbank, Newell, rector of St Bartholomew's 27, 201, 218, 219, 220–2, 223, 257, 259, 260, 261
Wallbank, Phyllis 219, 220, 222
Waltham Abbey, Essex 50, 52, 55, 138
Webb family 20, 22
Webb, Aston 76, 78, 203, 208, 212, 213, 218, 225, 226, 229, 230, 231–4, 235, 243, 244, 269, 270, 272, 274
Webb, Edward Alfred 24, 25, 28, 59, 99, 175, 199, 216, 217, 230, 236, 237, 238, 239, 240, 241, 252, 254, 269, 271
Webb, Philip 199, 243
Weever, John 88, 102, 105
'Werge-Oram, E.' (pseudonym) 24, 217–18
Westfield, Thomas, rector of St Bartholomew's/bishop of Bristol 157–60
Westminster Abbey 36, 41, 70, 79, 80, 91, 95, 96, 101, 176, 177, 201, 223, 254, 256, 259, 260, 263
 Henry VII Chapel 49, 81
 restoration of monks to 142
White Ship, disaster of the 32, 33, 295
Whiting, John (d. 1681) 120–1, 189, 191–2
widows 124, 207
Willesden (Chamberlainwood) 32, 185
William I, king of England 32, 248
windows 49, 59, 69, 70, 72, 74, 75, 81, 82, 85, 121, 144, 152, 153, 157, 161, 162, 163, 164, 165–6, 173, 215, 219, 222, 227, 228, 234, 236, 239, 240, 241, 244, 282, 291, 293
Wolsey, Thomas, cardinal 50, 128–30
workhouses 149, 207
Yevele, Henry 95–6, 99

312